Prostor – architektura – interiér – design

For Kenneth Frampton
friendly
R. Švácha

Partners of the book

**Ministry of Regional Development
of the Czech Republic** www.mmr.cz
Metrostav www.metrostav.cz
Techo www.techo.com

PSJ Invest www.psjinvest.cz
Sipral www.sipral.cz

Nadační fond Arcus www.cka.cc
Real Estate Karlín Group www.karlin.cz
Rodop www.rodop.cz
Stavební veletrhy Brno www.ibf.cz

Nadace Český literární fond www.nclf.cz
Průmstav www.prumstav.cz

Acknowledgements
The publisher would like to thank all her regular
collaborators, as well as Jan Brejcha, Jana Hrušková,
Jan Kotlas, Aleš Najbrt, Zdenko Pavelka,
Marie Platovská, František Rejl, Hana Samuelová,
Petr Schnider and Šárka Šochová

CZECH ARC
AND ITS AU

Prague 2004

Rostislav Švácha
Fifty buildings 1989 – 2004

HITECTURE

STERITY

ISBN 80-903257-4-2

Contents

Preface

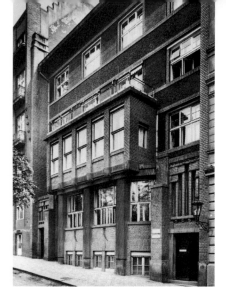

After seeing the exhibition Contemporary Czech Architecture, organized in London in February 2002 by the Czech Centre in London and Prostor company, the critic Catherine Croft did not try to hide her great disappointment. Post-1989 Czech architecture seemed blank to her, perhaps because it derives its inspiration excessively from its modernist past in the period between the world wars **"which may in retrospect be seen to be sadly restrictive".**[1] The Slovak architect Peter Pásztor adopted a critical stance on Czech architecture of the post-Velvet Revolution similar to Croft's: **"While in the 1920s and 1930s, one could still talk about progress"** – Pásztor stated in 2001 – **"I feel that what we have today is an anachronistic dwelling on positions of sorts, which makes the notion of architecture increasingly vacant and ultimately completely sterile."**[2]

The book you have just opened does not wish to engage in a polemic with these views. Instead, it aims to explain why contemporary Czech architecture is what it is. The text draws on the hypothesis that both the theory and practice of Czech architects throughout the 20th century, including the period after the Velvet Revolution, was deeply influenced by the ideological construct of Czech austerity, a complex phenomenon full of contradictions, whose effects may serve to explain both the good and bad features of modern Czech architecture. The introductory chapter focuses on the emergence of the phenomenon of Czech austerity, its ideological sources and typical arguments. It does not neglect to outline arguments of its opponents, who have, however, always been a minor voice. The second chapter outlines the main features of the context of architectural design in what is now the Czech Republic after November 17, 1989.

The core of the book consists of commentaries on fifty buildings arranged in chronological order of their construction, designed by both domestic and foreign architects and built in the Czech-speaking territory – Bohemia, Moravia and Czech Silesia – between 1989 and 2004. These are works that seemed important to the author from a cultural, political, and, last but not least, architectural, point of view. The commentaries follow one after another and may be read as a more or less cohesive text. The author attempted to reconstruct the architect's intent, together with the conditions to which the intent responded, captured fragments of the critical debate concerning contemporary Czech architecture and did not omit the reactions of the broader public. The views of critics subscribing to the austerity criterion enabled the author to include in his interpretation even those buildings that did not aim to be austere, first and foremost the Dancing Building by Gehry and Milunič.

The author would like to thank Milena Sršňová and Radek Váňa for their assistance in the gathering of bibliographic information. Critical comments provided by Matúš Dulla, Pavel Halík, Martin Strakoš and Pavel Zatloukal helped to improve the text. This book could not have been published without the publisher, Dagmar Vernerová, as well as all partners who supported the project financially.

Jan Kotěra, house of the publisher Jan Laichter, Prague 2-Vinohrady, Chopinova Street. 1908–1909

1 Catherine Croft, "Blank Czechs." *Building Design*, February 15, 2002, pp. 14–15.
2 Peter Pásztor, [jury member's views on the 2001 Grand Prix competition organized by the Society of Architects]. *Architekt* XLVII, 2001, Issue 5, p. 14.

Czech austerity and its enemies

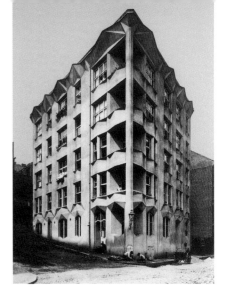

Kotěra and the Cubists

The contours of the concept of Czech austerity were undoubtedly first outlined already by the founder of modern Czech architecture, Jan Kotěra.[3] Kotěra brought his dislike for the Historicism of the 19th century and its **"deceitful pseudo-shapes"**[4] to Prague from his Viennese teacher, Otto Wagner, together with his conviction that truthful architecture needs to draw on purpose and construction, and should the need to adorn it arise at all, such adornments must **"help structure and enhance masses clearly expressed by construction".**[5] In his 1900 discourse "O novém umění" (On New Art) in which he formulated these theses, Kotěra warned architects to be wary of the **"utopia"** of formal apriorisms not rooted in purpose. And where structure and construction materials are concerned, Kotěra believed that neither one ought to be disguised by means of frontal decoration, but rather should be exhibited in plain view: **"I cannot like a straight traverse construction rendered as a stone architrave, I cannot like various materials imitating stone, I cannot like wood forced into forms of stone, and I cannot like any disguises and imitations because both are embarrassing and deceitful."**[6]

In his search for means to express his vision of truthful architecture, Kotěra first tested Wagner's forms, the forms of Belgian Art Nouveau, the architecture of English domestic revival, as well as Czech and Moravian traditional folk architecture. He abandoned this path when he encountered brick buildings by Hendrik Petrus Berlage in Holland in 1905. The degree of asceticism to which this impetus brought him is best shown in the Prague house of the publisher Jan Laichter (1908–1909), an extremely abstract depiction of the **"eternal natural theme of support and burden"** (1900), coated with a material mesh of brick, rough plaster and concrete. Kotěra's client, Laichter, published philosophical, sociological and moralist literature in his house. The key authors carried by his publishing company included the future

Czechoslovak president, the philosopher Tomáš Garrigue Masaryk, who realized as early as the end of the 19th century that both the European and the Czech societies could fall apart completely due to class conflicts. Masaryk believed that salvation could be attained by developing democracy and reaching a general consensus on fundamental ethic values, **"ideals of humanity"**, which according to him meant, however, that the rich would become more modest in their demands and would surrender excessive luxury.[7] We do not know just how deep Kotěra's study of Masaryk's books was. However, if we wished to determine which early 20th century Czech building best expressed the ethical charge of Masaryk's teaching, we could not disregard the architectural rhetoric of discipline and self-control expressed by Jan Kotěra in Laichter's house.

A group opposing Kotěra's austere architecture began to emerge from among younger Prague architects around 1910. The group consisted of Pavel Janák, Josef Gočár, Vlastislav Hofman and Josef Chochol.[8] Their spokesman, Pavel Janák – who had also studied under Wagner – began to feel that Kotěra's work was overly purpose-driven, that it succumbed to materialism, and that, in the absence of a stress on the spiritual or artistic dimensions of architecture, it merely reflected the laws of nature. Janák and his supporters opted for something that Kotěra warned against – the **"utopia"** of formal apriorism. They came to believe that it was precisely the voluntaristically shaped form that was to help architecture symbolize the victory of human spirit over nature and materiality. The term "Cubism" was coined for their crystalline style disguising construction materials under net masonry with a coat of plaster on the surface, definitely due to the fact that the four most prominent representatives of the emerging architectural movement were friends with Prague-based Cubist painters and sculptors and were really more interested in the events happening in Picasso's Paris rather than in Wagner's Vienna.

Josef Chochol, František Hodek's tenement house, Prague 2-Vyšehrad, Neklanova Street. 1913–1914

3 Vladimír Šlapeta (ed.), *Jan Kotěra 1871–1923. The Founder of Modern Czech Architecture.* Municipal House–Kant, Prague 2001.
4 Jan Kotěra, "Luhačovice". *Volné směry* VIII, 1904, pp. 59–60.
5 Jan Kotěra, "O novém umění" (On New Art). *Volné směry* IV, 1900, pp. 189–195.
6 Ibid.
7 Tomáš Garrigue Masaryk, *Ideály humanitní* (Ideals of Humanity). Praha 1901.
8 Rostislav Švácha, *The Pyramid, the Prism & the Arc. Czech Cubist Architecture 1911–1923.* Gallery, Prague 2000.

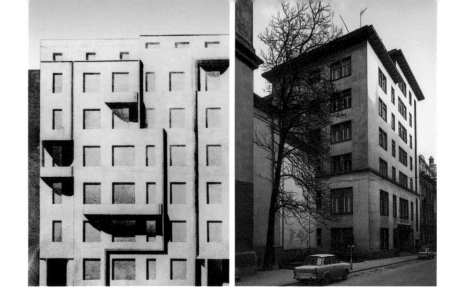

All the architects of the Cubist persuasion accepted Janák's opinion expressed in his discourse from early 1912, "Hranol a pyramida" (The Prism and the Pyramid), that a **"third"**, obliquely oriented force, needed to serve as a counterweight to the originality of architecture in the style of Wagner and Kotěra.[9] They seem not to have abandoned the ideal of austerity, however. Rather, they thought that Kotěra's austerity needed to be replaced with a different kind of this quality, or that perhaps some sort of a dramatic or fantastic element needed to be added. Josef Chochol, who designed the Prague tenement house of the builder Hodek built in 1913–1914, was concerned at the time with a non-ornamental appearance of architecture, which he promoted with a zeal close to that of Adolf Loos in his "Ornament and Crime" essay. In his 1913 discourse, "K funkci architektonického článku" (On the Function of the Architectural Element), Chochol writes:

"We do not wish to disrupt that rare, pure and smooth effect of modern work, austere yet fantastic, by tripping unbearably over lots of ornaments and details that we do not care about." [10]

In the same year, the architect Vlastislav Hofman contemplated the content of the word "objectivity", a notion he had undoubtedly borrowed from the period German aesthetic debate on the **Sachlichkeit**. In his 1913 articles on the relationship between modern art and Post-Impressionism, the said word meant something **"bare and naked"**, a reduction so radical that the purpose and material nature of things cease to affects us and are replaced with a purely spiritual effect.[11] Josef Chochol was more successful than Hofman in rendering this Minimalist vision in a series of sketches in 1914. Chochol continued to develop the concept, frequently in a form that was a convincing forecast of the forms of Purist-Functionalist **new architecture** of the 1920s and 1930s, and published a new series of sketches in 1921. In his manifesto "Oč usiluji" (What I Am Striving to Do), which accompanied the new series,

the author returned to the scene the word **"purpose"**, against whose rule over architectural form Prague Cubist architects rebelled too much after 1910. By 1921, Chochol wanted the form to **"embody the purpose its expresses"** and to **"be limited to the precise function of such purpose, free of any unnecessary embellishments"**. However, Chochol did not arrive at the purely Functionalist mechanism of "form follows function": form is not to be determined solely by purpose but perhaps by **"a transcendental or even mystical idea"**.[12] Chochol's slogans were directed against two of his former colleagues from the Cubist foursome: Pavel Janák and Josef Gočár. After the foundation of the Czechoslovak Republic in October 1918, these men decided that the new state would be best represented by colorful, lively and merry architecture, whose round-shape ornaments were to reflect the patterns employed in Czech and Moravian traditional art.[13] Just like Chochol who did not want his own buildings to resemble the **"face of an Iroquois chief"** (1921), Janák and Gočár's **"National Style"** or **"Rondocubism"** was viciously attacked by the Brno-based aesthetician, Bohumil Markalous, who believed, together with Loos, that by stooping down to folklore, modern man casts himself out of civilization.[14] In 1924, Markalous founded a Czech-German journal, **Bytová kultura / Wohnungskultur** (Housing Culture) in Brno. Aside from Adolf Loos himself, he invited the Brno architect Ernst Wiesner[15] to join the editorial staff; Wiesner's buildings in the style of purified Neo-Classicism served as the same jumping board on the road toward new architecture as Chochol's drawings. Janák and Gočár's National Style on the one hand, and Chochol and Wiesner's stance on the other, entered into competition for an adequate architectural expression of the new Czechoslovak democracy.[16] At the same time, they had to compete with the monumental Neo-Classicism of Wagner's students Antonín Engel and Bohumil Hypšman, who designed several large ministerial edifices in Prague, as well as the highly

↖ Josef Chochol, study of a department store facade. 1920 or about. Reproduction from the *Musaion* II journal, 1921

↑ Ernst Wiesner, building of Česká banka Union, Brno, Beethovenova Street. 1923 –1925

9 Pavel Janák, "Hranol a pyramida" (The Prism and the Pyramid). *Umělecký měsíčník* I, 1911–1912, pp. 162–170.

10 Josef Chochol, "K funkci architektonického článku" (On the Function of an Architectural Element). *Styl* V, 1913, pp. 93–94.

11 Vlastislav Hofman, "Moderní umění v poměru k neoimpresionismu" (Modern Art in Relation to Neo-Impressionism). *Volné směry* XVII, 1913, pp. 152–160. — Vlastislav Hofman, "Umění postimpresionistické" (Post-Impressionist Art). *Přehled* XII, 1913–1914, pp. 217–218.

12 Josef Chochol, "Oč usiluji" (What I Am Striving to Do). *Musaion* II, 1921, p. 47.

13 See footnote 8

14 cf. Markalous's articles from 1919–1921, in particular his criticism of the Brno Koliba association, in: Bohumil Markalous, *Estetika praktického života.* (Practical Aesthetics). Praha 1989, pp. 347–350, 387–396, 445–446.

15 Petr Pelčák – Jan Sapák – Ivan Wahla (eds.), *Brněnští židovští architekti / Brno Jewish Architects.* Obecní dům, Brno 2000.

16 Rostislav Švácha, *The Architecture of New Prague, 1895–1945.* The M.I.T. Press, Cambridge, Mass., and London 1995.

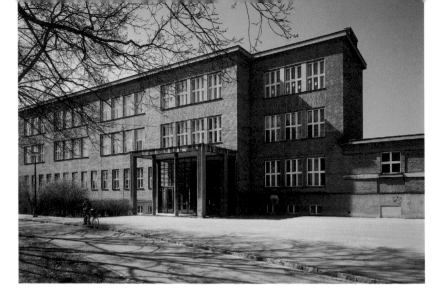

individualist and creative Neo-Classicism of Josef Plečnik, who was commissioned by president T. G. Masaryk in 1920 to reconstruct the Prague Castle in order to turn it into a **"castle for a democratic president"**, and who built the Church of the Sacrosanct Heart of Christ in the Jiřího z Poděbrad Square in Prague in 1928–1932.[17] Janák and Gočár's style underwent transformations during the 1920s. They returned to Kotěra's austere buildings combined with the impetus of newer Dutch architecture of Berlage and Dudok's persuasion, whose plain geometric forms and fair face brick surfaces seemed particularly appropriate to certain participants in the debate on architectural representation of democracy at the time. For instance, in 1923, Chochol spoke about **"Berlage's democratic brick"**.[18]

Functionalism and Karel Teige
The axis of this debate increasingly leaned towards the conviction that the issue of democratic architecture does not consist so much of a stylish representation of a new political form, but rather of the ability of as many of people as possible to enjoy the benefits of architecture. The more numerous the supports of this belief, the stronger the stand of the pioneers of Functionalism was, as they claimed that their methods of rationalization, standardization, typization, normalization and such would reduce construction costs to a minimum and soon all people, regardless of their economic status, would be able to use quality architecture.
The popularity of Functionalism in the Czechoslovakia was rooted also in the progressivist mentality of the middle class, as well as the fact that the new republic wanted to present itself as a modern industrial state, and this **image** was again promoted very well by the latest Functionalist architecture. Important episodes in the sweeping onset of this movement included: the victory of Oldřich Tyl's Functionalist design in the competition for the Prague Trade Fair Palace (1924); the winning submission of Kotěra's students, Josef Štěpánek and Jaromír

Krejcar, in the competition for the new parliament building in Prague (1928); and the construction of Functionalist pavilions designed by Bohuslav Fuchs, Bohumír Čermák, Emil Králík and others for the Exhibition of Contemporary Culture in Brno (1928) on the occasion of the celebrations of the republic's tenth anniversary. Functionalism also involved an extreme reduction of architectural form. For many Czech architects, the decisive guideline for such reduction became Le Corbusier's Purism, **"simply a box used as a house"**.[19] It is, however, symptomatic that as early as in the first manifesto of Czech Functionalism, the declaration of the Architects' Club and **Stavba** journal, "Náš názor na novou architekturu" (Our Views on New Architecture) from 1924, its authors discretely disavow the artistic and aesthetic aspects of Le Corbusier's work. According to them, new architecture will create its forms scientifically, **"according to a uniform principle lending them a unity that Le Corbusier accomplishes through his abstract geometric order"**.[20]
Karel Teige, an editor of **Stavba**, and at the same time the leader of the Prague avant-garde group Devětsil, took part in the drafting of the manifesto.[21] The programme of scientific architecture outlined by the manifesto reverberated with Teige's positions. This dynamic and influential theoretician was of the opinion that the period where architecture could perhaps be viewed as a sort of art was over and has given way to a period where architectural design has become a science based on facts and knowledge gleaned from physics, statics, medicine, sanitation science, and many other scientific disciplines, including Taylor's scientific work management. The architect-scientist needs to clearly defined the purposes to be served by his building as a perfectly functioning **"instrument"**, and such purposes or functions will determine architectural form completely automatically: **"it will be found if it is not sought"**, as observed as early as 1922 by Teige's friend, Jaromír Krejcar.[22] No artistic demands of the

Josef Gočár, primary schools, Hradec Králové, V lipkách Street. 1926–1927

17 Damjan Prelovšek (ed.), *Josip Plečnik. An Architect of Prague Castle.* Prague Castle, Prague 1997.
18 Josef Chochol, "Jan Kotěra". *Časopis československých architektů* XXII, 1923, pp. 165–171.
19 Rostislav Švácha, *Le Corbusier.* Odeon, Praha 1989, p. 22.
20 "Náš názor na novou architekturu" (Our Views on New Architecture). *Stavba* III, 1924–1925, pp. 157–158. — English translation in: Gustav Peichl–Vladimír Šlapeta, *Czech Functionalism, 1918–1938.* Architectural Academy, London 1987, p. 163.
21 See Otakar Máčel, "Karel Teige und die tschechische Avantgarde". *Archithese* No. 6, 1980, pp. 20–25, 32. — Manuela Castagnara Codeluppi (ed.), *Karel Teige, Architettura, Poesia, Praga 1900–1951.* Electa, Milano 1996. — Eric Dluhosch–Rostislav Švácha (eds.), *Karel Teige 1900–1951. Enfant Terrible of European Avant-Garde.* The M. I. T. Press, Cambridge, Mass. 1999. — Dita Robová–Soňa Ryndová–Rostislav Švácha (eds.), *Forma sleduje vědu / Form Follows Science. Teige, Gillar and European Scientific Functionalism, 1922–1948.* Jaroslav Fragner Gallery, Prague 2000.
22 Jaromír Krejcar, "Architektura průmyslových budov" (The Architecture of Industrial Buildings). *Stavitel* IV, 1922–1923, pp. 65–71. — English translation in: Klaus Spechtenhauser–Antonín Tenzer–Rostislav Švácha, *Jaromír Krejcar 1895–1949.* Jaroslav Fragner Gallery, Prague 1995, pp. 25–27.

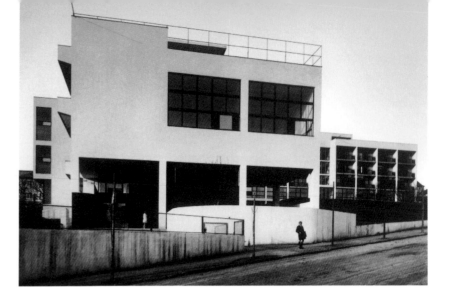

architect's subject may enter into the relationship between function and form because these demands represent a mere superfluous and uneconomical **"extra"**, a **"plus"** that disturbs the process of the automatic emergence of form from purpose. Teige certainly would have viewed the **"transcendental and perhaps even mystical idea"** referred to by Josef Chochol in 1921 as one such superfluous **"extra"**, and undoubtedly also considered superfluous Le Corbusier's composition aids, including the golden section and **"tracés régulateurs"**, denounced by Teige in his famous criticism of Le Corbusier's Mundaneum project in **Stavba** in 1929. According to Teige's assessment of 1929, Le Corbusier's architecture represents an obsolete architectural opinion because the Paris architect is enchanted with the idea of monumental palaces and Mexican pyramids and did not cease to feel as an artist:

"It is simply the opinion that for a substantive solution to become worthy architecture, something extra – a plus – must step in. Such plus can either contribute to the usefulness and enhance the function; however, then it is also useful and functional and no plus. Or it may detract from it, and then it is a minus. Or it may be neither beneficial nor detrimental, and then it is superfluous and useless, and as such also a minus. The criterion of usefulness, the sole reliable quality criterion of architectural production, made modern architecture abandon >the mammoth bodies of monumentality< and cultivate the brain: instead of monuments, architecture produces instruments." [23]

The criterion of usefulness, the extent to which architecture became science, together with **"doing away"** with all artistic and aesthetic apriorisms, created a platform from which Teige oversaw both the domestic and European architectural scenes and assessed their performance. It goes without saying that any rebellion against usefulness – Cubism, Poelzig and Taut's Expressionism, the Amsterdam school, Janák

and Gočár's National Style, and Plečnik – failed to withstand the test. According to Teige, even the works of Dutch architects from the De Stijl group and the production of the Bauhaus under Gropius's directorship suffered from an excessive quantity of artistic and aesthetic **"extras"**. Le Corbusier succumbed to **"the error of monumentality"**. However, there were also architects who earned a plus, for instance, the members of the Swiss ABC group headed by Hannes Meyer who, after he succeeded Gropius, invited Teige in early 1930 to lecture at Bauhaus. This category further included Soviet Constructivists, Ginsburg and the Vesnin brothers, whom the Prague theoretician believed to be most advanced in the development of scientific principles of architectural design. Of Czech Functionalists, Teige was impressed by the **"realist engineering mentality"** of one of the authors of Trade Fair Palace in Prague, Oldřich Tyl. However, the architect closest to Teige's heart was his friend from the Devětsil group, Jaromír Krejcar, although he berated him for his reluctance to deny architecture the status of an art. Teige disliked having to describe the forms of individual architectural works since he was concerned only with general principles. He made an exception in the case of Krejcar's Prague building of Private Clerk's Union built in 1930–1931. He liked it because the architect chose a **"pragmatic, sober, somber and ascetic"** solution. [24]

Teige was not aware that his programme of scientific architecture involved risks and could be misused. To do only what I can rationalize well, to claim that whatever lacks purpose cannot also be beautiful – such attitude could suit perfectly a particular kind of human mentality that the 19th century called **"Philistine"**, which would probably be called "down-to-earth pragmatism" in this day and age. The architects from Teige's Devětsil knew that their leader was neither a Philistine nor a pragmatic. However, the obviously pragmatist aspects of Teige's programme of scientific Functionalism prevented them from embracing it wholeheartedly.

Bohuslav Fuchs – Josef Polášek, Vesna association's vocational school for girls, Brno, Lipová Street. 1928–1930

23 Karel Teige, "Mundaneum". Stavba VII, 1928–1929, pp. 145–155. — English translation in: K. Michael Hays (ed.), Oppositions Reader. Princeton Architectural Press, New York 1998, pp. 585–597.
24 Karel Teige, Práce Jaromíra Krejcara (The Works of Jaromír Krejcar). Václav Petr, Praha 1933, p. 36.

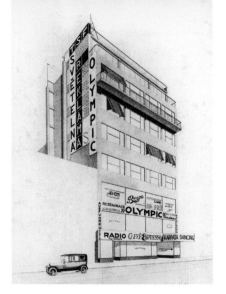

For instance, they were attracted to the idea of adding an element of Poetism to Functionalism, Poetism being a poetic movement that emerged from within Devětsil, with a significant contribution by Teige, and that wished to sing the praises of the metropolitan boulevards in keeping with the spirit of Baudelaire and Apollinaire's poetry. This must have been what Krejcar had in mind when creating his 1926 Olympic department store project: its Functionalist body is adorned with **"extras"** in the form of gaudy corporate logos, neon signs, aerials and striped awnings. Teige would probably say something to the effect that Poetism was a matter of poetry, rather than architecture, and his analysis of Olympic in Krejcar's 1933 monograph ostentatiously ignores the Poetist ornamentics of the project.[25] According to the architect and poet Vít Obrtel, scientific Functionalism is able to satisfy man's physical needs but ignores the **"hyperphysical"** demands of the human spirit. **"The transcendental cannot be locked up in a matchbox"**, Obrtel wrote in 1931.[26] Another architect from Devětsil, Karel Honzík, soon came to suspect that the exclusion of anything that cannot be justified by purpose from contemporary modern architecture is perfectly suited to the pragmatic thinking of penny-pinching and thrifty developers and builders. In his article "Estetika v žaláři" (Aesthetics in Prison), magnanimously published by Teige in 1927 in **Stavba**, Honzík states:
"We could say that the principle of >whatever is useful, is also beautiful<, perceived in a certain fashion, evoked a mood in which the natural thing to do seems to adorn all efforts at construction with the laurel that the aesthetics themselves have tore off their heads." [27]
The authority of Teige's programme of scientific Functionalism gained in strength during the Great Economic Crisis. The Crisis crippled the Czechoslovak economy, shook up the middle classes, and sparked an unhealthy degree of interest in radical leftist solutions of social problems on the part of the Czechoslovak intel-

ligentsia; this interest was then strengthened in 1938 when the western democratic countries surrendered Czechoslovakia to Hitler's expansion by virtue of the Munich Agreement. Teige became an idealistic Marxist as a young man. In the 1920s, he adopted the view that the rationalism of modern architecture was to serve as an instrument for criticism of irrational Capitalist order.[28] What is more, he believed that a truly scientific Functionalism will develop as an **"embryo"** of a new Communist order in the womb of Capitalism, and prompted his supporters among architects to focus on those types of projects that would facilitate and speed up the transition of the society towards Socialism and Communism. Therefore, many architects from Devětsil and its successor group, Levá fronta (Left Front) designed collective housing in the early 1930s: houses with single residential cabins for emancipated males and females, with collective cafeterias, launderettes, crèches, kindergartens and clubs. Teige and his supporters hoped to eradicate all Capitalist hangovers from architecture, and the concept of Czech austerity was thus assuming new contours.
During the years of the economic crisis, Teige's criticism targeted in particular **"bourgeois"** individualism and subjectivism, an inauspicious carrier of various **"extras"**. For instance, bourgeois individualism typically continues to insist on the obsolete institution of a complete family, thus forcing modern architects to design an obsolete construction type of single-family houses with master bedrooms, the **"stage for Strindbergian dramas"**.[29] Moreover, individualism requires architects to look for forms distinguishing one house from another, thus making them serve the typically bourgeois and Capitalist institution of **"originality"**. According to Teige, such quality will become superfluous in the upcoming Socialist order because it will be ruled by the working class, whose members do not demand any particular rights for themselves, and are satisfied with complete uniformity. [30] However, while Capitalism prevails, its competition and market system forces us to

Jaromír Krejcar, project of the Olympic department store, Prague 1-Nové Město, Spálená Street. 1926

25 Ibid., p. 26.
26 Vít Obrtel, "Právo na teorii" (The Right to Theory). *Kvart* I, 1930–1931, pp. 117–118.
27 Karel Honzík, "Estetika v žaláři" (Aesthetics in Prison). *Stavba* V, 1926–1927, pp. 166–169, 172. — English translation in: Karel Honzík, *Beyond the Horizon of Objectivity* (ed. Dita Dvořáková). Arbor Vitae, Prague 2002, pp. 49–55.
28 Karel Teige, "K teorii konstruktivismu" (On Constructivist Theory), in: Karel Teige, *Moderní architektura v Československu*. MSA 2. Odeon, Praha 1930, pp. 242–255. — English translation in: Karel Teige *Modern Architecture in Czechoslovakia* (ed. Jean-Louis Cohen). Getty Research Institute, Los Angeles 2000, pp. 287–299.
29 Karel Teige, *Nejmenší byt*. Václav Petr, Praha 1932, p. 163. — English translation in: Karel Teige, *The Minimum Dwelling* (ed. Eric Dluhosch). The M.I.T. Press, Cambridge, Mass. 2002.
30 Karel Teige, "Minimální byt a kolektivní dům" (The Minimum Dwelling and a Collective Building). *Stavba* IX, 1930–1931, p. 47.

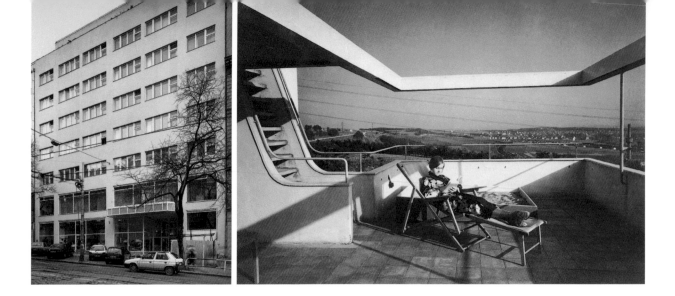

be original, as it by definition requires architects to produce **"fancy and fashionable goods"**.[31] Teige hoped that such situation would soon end and the vision of Functionalist standardization and normalization would materialize – see his 1933 book **Práce Jaromíra Krejcara** (Jaromír Krejcar's Works):

"Hopefully, the time is not far when architects will be required to design functional and effective, rather then original, buildings, just like you do not expect a physician to treat you in an original fashion but wish for an effective therapy with good results. Yes, we must not disregard the role and merit of an invention, discovery, initial research and individual courage in the history of human spirit and architecture: Christopher Columbus's act is of greater importance than the practice of the captains of ocean liners of today, and yet, the transportation industry was obliged to perfect the route taken by Columbus, rather than wonder, in an original fashion, on endless journeys."[32]

In the early 1930s, Teige viewed as akin to the desire to be original the effort to be unique – the opposite of a mass-produced and standard product. A young supporter of Teige, Karel Janů, an architect from the radical leftist PAS group, succinctly indicated that the unique will not have a place in the new society in his review of an exhibition of Soviet architecture, organized in Prague in 1932 by the Left Front:

"Temporariness and quantity, mass production, are all that compete here with the monument and uniqueness of western architects, artists and individualists. Free competition here calls for difference and an individual approach, while mass production there requires things normal and standard, where efforts follow capabilities."[33]

The core of this rhetoric was in the message that any subjectivism, any emphasis on artistic and aesthetic aspects of architectural production, any effort to be original and unique, is harmful to society. The idea that unnecessarily

"artistic" elements of an architectural work may constitute a social injustice was first hinted at already in the manifesto published in **Stavba** in 1924, "Náš názor na novou architekturu" (Our Views on New Architecture). This belief took on absurd dimensions in the early 1930s. Teige came to believe at the time that Le Corbusier's work exhibits anti-social, and thus amoral, aestheticism. Teige and his associates entertained equally negative sentiments with respect to Ludwig Mies van der Rohe and his Brno Tugendhat Villa built in 1928–1930.[34] The fact that Czech journals completely ignored Mies's brilliant achievement mentioned above is symptomatic of the Czech architects' attitude. If it was mentioned at all by Teige or perhaps Jaromír Krejcar, it was only to denounce the unique and original nature of Mies's art. Krejcar, who himself designed buildings as extraordinary and non-standard as the Machnáč sanitarium in Trenčianské Teplice (1930–1932) or the Czechoslovak pavilion for Paris Expo (1936–1937), made this quaint statement about the Tugendhat Villa in 1932:

"From the perspective to the progress of civilization, such works are of a much lesser importance than a decision of a village council in Forgetsville to build a primitive sewage system."[35]

Teige and his friends were taken aback by the developments in Soviet architecture after 1932. The society that according to the Prague theoretician's beliefs was the first in the world to follow the laws of science, began to ask architects to design monumental palaces in a Neo-Classical style having no bearing on the programme of scientific Functionalism. This turnaround, allegedly caused by the **"dumas and dreams of ill-adjusted Soviet academics and bureaucrats"**[36] was criticized by Teige with a growing vengeance, e.g., in the 1936 book **Sovětská architektura** (Soviet Architecture), and without surrendering his Marxist beliefs, he was one of the first to draw the parallel between Soviet Socialist Realism on the one hand, and Troost and Speer's Neo-Classicism of Hitler's Third Reich.[37]

↖ Jaromír Krejcar, buliding of private clerk's union, Prague 2-Vinohrady, Francouzská Street. 1930–1931

↑ Ladislav Žák, terrace of Miroslav Hajn's villa, Prague 9-Vysočany, Na vysočanských vinicích Street. 1932–1933

31 Karel Teige, *Práce Jaromíra Krejcara* (cited in footnote 24), pp. 76, 78.

32 Ibid., p. 78.

33 Karel Janů, "K výstavě sovětské architektury" (On an Exhibition of Soviet Architecture). *Stavba* XI, 1932–1933, pp. 33–35.

34 "Stavba arch. Mies van der Rohe v Brně" (Mies van der Rohe's Bulding in Brno). *Žijeme* I, 1931–1932, p. 275.

35 Jaromír Krejcar, "Hygiena bytu"(Apartment Hygiene). *Žijeme* II, 1932–1933, pp. 132–33.

36 Karel Teige–Jiří Kroha, *Avantgardní architektura* (Avant-garde Architecture) (ed. Josef Císařovský). Československý spisovatel, Praha 1969, p. 79.

37 Ibid., pp. 180–181. — Karel Teige, *Surrealismus proti proudu* (Surrealism Against the Flow). Praha 1938.

Jiří Voženílek, collective house, Zlín, Osvoboditelů Street. 1948–1950.

38 Cf. Rostislav Švácha, "Surrealismus a architektura" (Surrealism and Architecture), in: Lenka Bydžovská–Karel Srp (eds.), *Český surrealismus 1929–1953* (Czech Surrealism 1929–1953). Galerie hlavního města Prahy–Argo, Praha 1996, pp. 268–279. — Dita Robová–Soňa Ryndová–Rostislav Švácha (eds.), *Forma sleduje vědu* (cited in footnote 21), pp. 79–97.

39 Karel Honzík, *Tvorba životního slohu* (The Creation of the Lifestyle). Václav Petr, Praha 1946, p. 392.

40 Karel Honzík, "Úvaha o výrazu českého stavebnictví" (An Essay on the Expression of Czech Buildings). *Architektura ČSR* VII, 1948, pp. 250–252. — English translation in: Karel Honzík, *Beyond the Horizon of Objectivity* (cited in footnote 27), pp. 105–112.

Teige, however, also wondered whether the fall of Soviet avant-garde architecture could have been caused by its own errors – errors that could have been present in his own architectural vision. Teige concluded that the weakness of the theretofore notion of scientific Functionalism was in a lack of interest in the demands of human psyche, emotions, and subconsciousness. This was something that Vít Obrtel and Karel Honzík had been criticizing for a long time. However, Teige was brought to this realization by his enchantment with Surrealism, André Breton's theories and Freudian psychoanalysis. Around the mid-1930s, texts by Teige's associates began to feature words like **"libido", "subconsciousness", "pleasure", "psychic indices"**.[38] Organic curves and other emotionally effective shapes found their way into the projects of Czech scientific Functionalists. Adherents of Surrealism supposedly addressed the question why Functionalism **"prohibited"** the use of such shapes until then. Karel Honzík testified to this fact in the 1946 book **Tvorba životního slohu** (The Creation of the Lifestyle): **"At one time (around 1933), Surrealists strove to identify the reason behind this prohibition in architecture. They interpreted it as >flagellantism of middle-class intelligentsia that wants to punish itself for the sins of its own class<. This may have been a rather extravagant analysis but it did provide food for thought. It certainly seems that this effort to be inconspicuous, >not to impress the viewer<, not to leave a visual or sensory impression, can no longer be driven solely by an attempt at usefulness, but at the same time also a certain repression, an internal barrier of some sort."** [39]

The post-war period

Kotěra's version of austerity served as a guarantee that architecture is honest and truthful, and at the same time is an expression of a social consensus. Leftist Functionalists began to use austerity as a tool of political criticism and self-criticism. In the 1940s, the suggestions that austerity in modern architecture was something specifically Czech finally appeared in Karel Honzík's 1948 article "Úvaha o výrazu českého stavebnictví" (An Essay on the Expression of Czech Buildings), in which this architect and theoretician joined an international debate on the potential of modern architectural Regionalism. Honzík noticed that Czech Functionalist buildings were typically heavy-handed, cautious and pedantic, exhibited a dislike for sharp contrasts, and generally **"lacked visual joyfulness"**. His explanations revolved around the climate, the quiet nature of the Czech landscape lacking the sea and high mountains, as well as the Protestant tradition in Czech thinking, an obstinate passion for truth that resulted in the outbreak of the Hussite revolution in the 15th century, and continued to survive in the Czech national subconsciousness up to the modern era, to be then – without Honzík mentioning this fact – resurrected by T. G. Masaryk's philosophy. That is the reason why modern Czech architecture is so different for instance from French architecture with its esprit and lightness: **"The architecture here was really stripped of its formalist gestures, cleansed of all unnecessary elements, and steeped in the spirit of practical thinking, until only the bare bones of the building craft remained. The search for truth here often resulted in a denial of plasticity, in non-architecture. This applies in particular to mediocre buildings designed mainly by entrepreneurs and architects on their payrolls. It is interesting how differently one and the same functionality is conceived and tackled in different countries. Of several equally functional alternative solutions, a Frenchman would pick the most elegant one, a German the one most reminiscent of German Gothic, and a Czech the alternative that is as simple and as unshowy as possible."** [40] Honzík sought the explanation for the frugality and austerity of Czech architecture of the

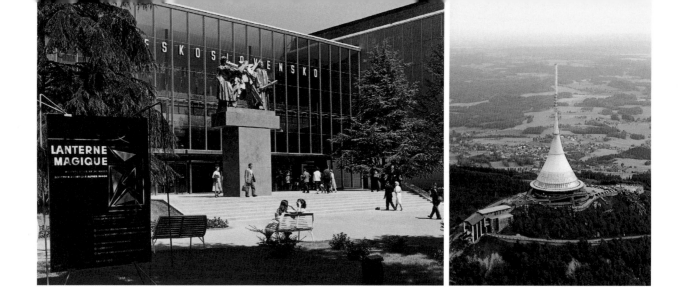

20th century also in the special nature of the Czech society that lost its aristocracy over the centuries, and as such lacks any greater class distinctions. The drawback of this situation was an excessive egalitarianism, and a tendency to promote a kind of equality that is hostile to outstanding individuals and original and creative ideas.

"We resemble a strict professor who, a bottle of red ink and a stylus in hand, searches for mistakes in the pupil's homework", the architect Ladislav Žák described this Czech dislike for extraordinary achievements in 1947.[41] A remarkable talent who designed the best Functionalist villas in Prague in the 1930s and wrote an original book, **Obytná krajina** (Habitable Landscape) (1947), in which the world architectural thinking probably for the first time crossed significantly with environmental protection, Žák despaired after World War II over the fact that Czech society showed no appreciation for creative people:

"...lack of invention and intuition was proclaimed to be one of the conditions and requirements of quality, lack of creative force and ability is virtually elevated to the status of a requisite principal virtue. We have voluntarily accepted the stance that any idea found to have any value, validity and importance must come from abroad; we have grown accustomed to the belief that nobody can and may discover or create anything new."[42]

Since the early 1930s, Žák ranked among the closest friends of Karel Teige, who wrote a preface on a Surrealist note – his last architectural discourse – for **Obytná krajina** (Habitable Landscape). Žák in his work followed up on everything in Teige's work that we consider poetic and unpragmatic today. However, other architects were busy developing the doctrinist aspect of Teige's teaching, in particular the thesis that scientific Functionalism will lead to an industrialization of the entire building industry. Members of the PAS group, Jiří Voženílek and Karel Janů, were particularly strong proponents of this idea.

The former, Voženílek, joined the design and project office of Bata's company in Zlín in 1937. He was dazzled by the level achieved by this pilot company of Czech Capitalism in the mass production of both industrial halls and single-family houses for workers, and decided to transform the Zlín version of Taylorism into a model for the industrialized architecture of the future Socialist Czechoslovakia.[43] Karel Janů's 1946 book, **Socialistické budování** (Socialist Building), was supposed to serve as a theoretical basis for this Communist appropriation of the most advanced Capitalist methods of building production. Janů already took it for granted that construction in the post-war republic would be centrally planned, and that mammoth state-owned enterprises would carry it out. At the same time, he was aware that only repetitive building operations and quantity can be centrally planned and then checked, while elements and operations of a qualitative nature do not suit the system. Anything in any way related to quality is created in an intuitive, subjective and individualist manner, which is why Janů felt compelled to exclude the same, or to transform it into quantity indicators, into **"measurable quantities"**. According to Karel Janů, only this method of **"objectivization"** would enable us to avoid gigantic mistakes in the mass production of apartments:

"...because a mistake, error or defect caused by the empirist-intuitive method in Capitalist construction was a defect in a unique product on the one hand, and it merely made ill use of an appropriated value, in Socialist construction such error and defect could be replicated in thousands, tens and hundreds of thousands of specimens, and cause both malfunction of a huge quantity of products and the waste of labor."[44]

Voženílek and Janů's version of scientific Functionalism forecast the practice of mass housing construction in Czechoslovakia up to 1989. These architects were able to put forward their visions thanks to their prominent political posi-

↖ **František Cubr – Josef Hrubý – Zdeněk Pokorný, Czechoslovak pavilion for EXPO 1958, Brussels. 1956–1958**

↑ **Karel Hubáček, TV tower and hotel, Ještěd Mountain by Liberec. 1964–1973**

41 Ladislav Žák, "Podstata, nikoliv jen obraz!" (The Essence, Not Just the Image!). *Volné směry* XXXIX, 1947, pp. 217–229.

42 Ibid.

43 Pavel Halík, "Zlín", in: *Kulturní fenomén funkcionalismu / The Cultural Phenomenon of Functionalism* (ed. Ludvík Ševeček). State Gallery, Zlín 1995, pp. 25–27.

44 Karel Janů, *Socialistické budování* (Socialist Building). Eduard Grégr a syn, Praha 1946, pp. 8–9.

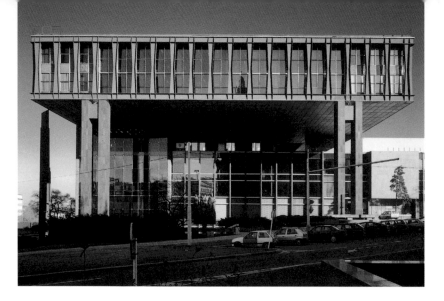

tions. The architecture of an overwhelming majority of residential building was indeed disassembled into endlessly repeatable elements – prefabricated blocks – assembled by means of endlessly repeatable operations to form thousands of tiresomely box-like prefabricated houses – **paneláky**, houses that were no longer referred to as such but instead as **"housing units"** and bore a number indicating the number of units per box. Of all the different precedents of this technocratic system, it was closest to the designs and theoretical interpretations of the German scientific Functionalist, Ludwig Hilberseimer, in his 1928 book, **Grossstadtarchitektur**; Karel Teige's ideas were significantly more humane. However, the events that took place after the Communist coup in February 1948 prevented a swift introduction of this system into reality.

The coup practically immediately replaced a market economy with a centrally planned economy that might have seen to offer an ideal environment for technocratic experiments. So as to exclude any and all disruptions from this technocratic system, the regime abolished the institution of private ownership and nationalized all banks, trading and manufacturing companies, from large factories to the smallest shops and workshops. The institution of a private architectural clientele immediately ceased to exist. Architects had to close down their studios and join large state design institutes, Stavoprojekts. Those who did not leave for the West and did not want to become state employees stood no chance of success. The state alone decided what would be commissioned, who would design it and which state company would build it. Together with such total nationalization of 1948, totalitarian Stalinist ideology entered Czechoslovakia, together with Stalinist aesthetics, which was not something that technocratic scientific Functionalists had bargained for.

Stalin and Zhdanow's instructions that the architecture of the Soviet block must be conceived in the spirit of **"Socialist Realism"**, i.e., that it needs to be **"Socialist in content and national in form"**, were adopted in particular by young graduates of schools of architecture who felt that the generation of the Functionalist avant-garde from the period between the wars still had enough strength to keep them from large tasks. Young zealots eagerly searched for deviations from the method of Socialist Realism that were then readily interpreted as manifestations of disguised class enemies and bourgeois **"cosmopolitans"** [45] Karel Honzík was forced to engage in humiliating self-criticism; Ladislav Žák permanently withdrew; Teige was labeled as a Trockist, and a hate campaign in 1951 drove him to his death. They claimed that although the avant-garde of the period between the wars may have "subjectively" felt leftist, it "objectively" served the Capitalists; Functionalism earned the absurd denunciation of **"formalist"** style, together with all the other modernist styles. According to Stalinist theoreticians, the architecture of Socialist Realism was to have followed Soviet examples, or follow up on the **"progressive"** traditions as found in Czech national history – the Renaissance, the 19th century Neo-Renaissance, the building tradition of the village folk. Similar preferences at first jeopardized even conservation efforts. However, the state wished to prove that it could take better care of its cultural monuments than the defeated Capitalists, and entrusted conservation to old, experienced experts who knew how to avoid ideological selection of monuments. [46] Where new buildings were concerned, however, the rule was that the **"achievements of the working classes"** were duly celebrated only by that architect who was able to lend the desirable ideological force to historicizing Neoclassical, Neo-Renaissance or folklorizing vocabulary. Fortunately, this period did not last long, and a greater number of its architectural products remained only near the centers of heavy industry and mining: Ostrava-Poruba, the new city of Havířov by Ostrava; Most; and Ostrov nad Ohří. It was ended by the criticism of **"superfluousness"**, i.e., historicizing ornaments, and the denunciation of Stalin's cult in the Soviet Union

Karel Prager–Jiří Albrecht–Jiří Kadeřábek, building of the Czechoslovak Parliament, Prague 2--Vinohrady, Vinohradská Street. 1966–1972

45 Pavel Halík, "Ideologická architektura" (Ideological Architecture). *Umění* XLIV, 1996, pp. 438–460.
46 Rostislav Švácha, "Co se stalo s Prahou, 1948–1989. Bitva o devatenácté století" (Whatever Has Happened to Prague, 1948–1989. The Battle over the 19th Century), in: *Pro arte. Sborník k poctě Ivo Hlobila*. Artefactum, Praha 2002, pp. 389–396.

in 1954–1956. Teige's old friend from Devětsil, Jaroslav Fragner, was able to denounce the Stalinist era as a **"maze of bad errors and mistakes"** as early as the beginning of 1956.[47] Czech architects were once again able to forge contacts with the more advanced West, as well as their own modernist past. This turnover was aptly illustrated by Czechoslovakia's successful participation in EXPO 1958 in Brussels; the Czechoslovak pavilion was designed by František Cubr, Josef Hrubý and Zdeněk Pokorný, all of whom remembered the golden days of Czech Functionalism.

However, the fall of Stalinism did not bring ideological review of architectural designs to an end. After 1956, neither architects nor theoreticians and critics ceased to view the Capitalist West as a declining and festering social system. They were concerned that Czech architecture could become infected with the typically Capitalist liking for decadence, extravagancies, exclusivity, swift swings of temporary fashions, subjectivism and individualism. This relapse of Teigeian thinking, although significant in that Teige's existence was not mentioned by anyone, was accompanied by calls for soberness and discipline as qualities born out of the Czech modernist tradition and particularly well suited to Socialism or Communism. The distinctive feature of Socialist architecture was to be its mass nature, repeatability, preparedness for industrialization and prefabrication; as the concept of the Brussels pavilion was described by Cubr, Hrubý a Pokorný in 1958, its **"assembly nature"**[48] That is supposed to be the only correct path towards a truly Socialist architectural aesthetic, a Socialist **"stylishness"**, as the theoretician Jiří Gočár stated a year later in his book **Od pyramid k panelům** (From Pyramids to Prefabricated Panels). According to Gočár, this presupposition did not apply only to mass construction of housing – prefabricated blocks of flats that began to be built en masse precisely in the late 1950s – but also the architecture of solitaire buildings that ought to be disciplined and assume the prefabricated appearance.

Atypical buildings will become Socialist **"if we design them according to the principles that need to be applied in mass construction"**, Gočár wrote in 1959 in his book, interspersed with hateful attacks at Le Corbusier's **"monstrous"** chapel at Ronchamp, as well as other purported manifestations of western irrationalism and subjectivism.[49] The threesome of Cubr–Hrubý–Pokorný made the same, rather toned-down, claims, both in their commentaries on the Brussels pavilion and texts published at a later date (1963):
"A good example of Czechoslovak architecture well before World War II was its discipline in terms of morphology and expression, a sense of scope and proportionality of construction, form and economy. We believe that these positive features need to be promoted and developed. Let us strive to design progressive and truthful architecture, let us not choose the path of seeming successes of showy shapes; they do not agree with our mentality and economy."[50]
During the 1960s, however, a growing number of architects began to think that a little bit of **"showy forms"** would actually be good for Czech architecture. Some of them were disenchanted with the first large housing projects, although it is apparent today that those built in the late 1950s, early 1960s – Invalidovna and Novodvorská in Prague, Lesná in Brno, Sítná in Kladno – actually turned out the best.
"A hypertrophy of boxiness" – in the words of the architects Ivo Loos and Jindřich Malátek in 1965[51] – was not exhibited only by houses within housing projects but also atypical buildings serving cultural, educational and administrative purposes; according to Loos and Malátek, many an architect is quite satisfied **"with a neutral grey mass of some sort, clad in a Constructivist, or, if you like, Functionalist, morphology"**.[52] The architect Jan Čejka attributed this fact to the provincial Czech mentality in 1967:
"I hate to say this, but provincialism is at play here. First there are the smirks and

Jan Šrámek–Jan Bočan, building of the Czechoslovak Embassy in London, Kensington Palace Gardens. 1966–1969

47 Rostislav Švácha, "Česká architektura 1956–1970" (Czech Architecture 1956–1970), in: *Česká architektura / Czech Architecture, 1945–1995*. Obec architektů, Prague 1995, pp. 40–51.

48 František Cubr–Josef Hrubý–Zdeněk Pokorný, "Československý pavilon a expozice na světové výstavě v Bruselu" (The Czechoslovak Pavillion and Exhibit at the Brussels Expo). *Architektura ČSR* XVII, 1958, pp. 664–671.

49 Jiří Gočár, *Od pyramid k panelům* (From Pyramids to Prefabricated Panels). Československý spisovatel, Praha 1959, pp. 88–89, 96.

50 Josef Hrubý–Zdeněk Pokorný, [Critical review of Hotel International in Brno]. *Architektura ČSSR* XXII, 1963, pp. 93.

51 Ivo Loos–Jindřich Malátek, "Nad výstavou >Praha ve výstavbě – 1965<" (On the Exhibition >Prague under Construction –1965<). *Architektura ČSSR* XXIV, 1965, pp. 697–700.

52 Ibid.

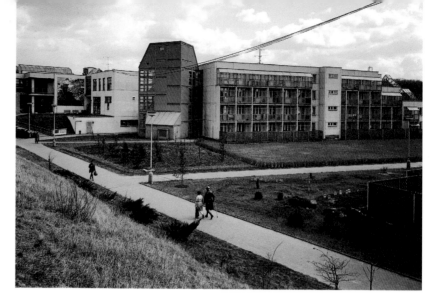

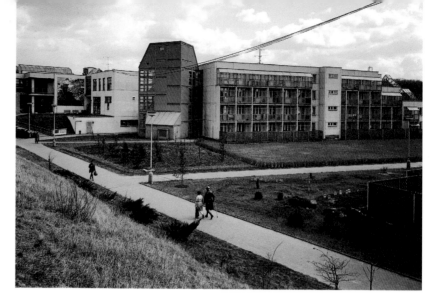

a superficial denouncement of anything new that is born in pains elsewhere. Then comes the timid and clumsy imitation, always with a delay of some five years. And finally we moan and groan that we have missed the train, and try to catch up as well as we can, whilst something new is being born in the true metropolises of world architecture in the meantime." [53]

These statements indicate that during the 1960s, Czech architects were freeing themselves of ideological supervision. Instead of contemplating what was and what was not appropriate for Socialist or Communist Architecture, they began to ask themselves what was appropriate for quality architecture. Politics and ideology ceased to seem relevant to the value of their work, and instead, they began to focus on a **"vision"** freed from the pressure of these two factors. The terms **"autonomous visual idea"**, or even simply **"vision"**, were used, at the same time, in 1963, independently of each other, by the theoretician Dalibor Veselý and the architect Karel Prager, the main author of the design of the new parliamentary building near the Prague National Museum (1966–1972).[54]

The more liberal the conditions in the Czech society, the more daring forms were found in the until-then-so-austere architecture. During the five years before the rise and tragic failure of the attempt at a reform of the Soviet model of Communism, the Prague Spring of 1968, even Sculpturalist projects, referred to as **"monstrous"** by Jiří Gočár as late as 1959, were not an isolated occurrence in the context of Czech architecture; there were also clearly Brutalist and Machinist projects, projects that could not have passed the ideological muster before. Only such conditions could have given birth to the most successful post-war building, the TV tower on Ještěd mountain near Liberec (1964–1973, awarded the Auguste Perret Prize by UIA), whose architect Karel Hubáček and the structural engineer Zdeněk Patrman conceived the building as a spaceship. Czech architects were sometimes so relaxed and liberal as to

shock foreign critics who unwillingly adopted the position of Czech austerity. For instance, the sculptural sides of the state building of the Czechoslovak Embassy in London, designed by Jan Bočan and Jan Šrámek (1966–1969), according to the English reviewer, David Rock, are in no way justified, and look that way **"simply because the architects wanted to make them such"**.[55]

The Soviet military intervention in August 1968 brought to power a neo-Stalinist regime that ruled Czechoslovakia up to November 1989. The regime strengthened the mechanisms of central economic planning. New housing estates lacked the last remnants of any effort to convey some architectural quality to the prefabricated boxes because the central planning was only able to assess quantifiable elements and performance, perfectly in line with Karel Janů's ideas expressed in his 1946 **Socialistické budování** book. Architects adopted the prejudice that the word **"urban planning"** means the positioning of prefabricated buildings within large housing estates, and the term was then banished from debates in circles opposing the regime. The focus on prefabrication in the Czechoslovak building industry had disastrous consequences for maintenance and conservation of older housing stock. Old crafts virtually vanished, having had to give way to experts specializing in the production and assembly of prefabricated elements. Prefabricated houses began to replace 19th century development, and in many cases penetrated the very medieval centers of Czech towns, as later depicted by the playwright and president Václav Havel in his 1987 play **Asanace**.[56]

The regime did not dare to resurrect the programme of Socialist Realism. However, it did not give preference to architects who kept abreast of new architectural tendencies in the West. Those who did attempt to keep pace could not be provided with the requisite technology because the regime only had facilities for the assembly of prefabricates at its disposal. Good architects then had to work with such

Jan Línek–Vlado Milunič, home for senior citizens, Prague 8-Bohnice, Na Hranicích Street. 1972–1982

53 Jan Čejka, "Architektura veřejných budov" (The Architecture of Public Edifices). *Architektura ČSSR* XXVI, 1967, pp. 133–143.

54 Dalibor Veselý, "Nad dílem Josefa Havlíčka" (On Josef Havlíček's Work). *Výtvarná práce* XI, 1963, Issue 18, pp. 1, 3, 4. — Karel Prager, "Sklo ve stavebnictví" (Glass in Construction). *Architektura ČSSR* XXII, 1963, p. 385.

55 David Rock, "Million pound Czech". *The Architect's Journal* CIL, July 9, 1969, Issue 28, pp. 2–5.

56 Václav Havel, *Asanace. Hra o pěti jednáních* (Redevelopment. Five-act play). Rowohlt, Hamburg 1987. — English translation in: Václav Havel, *Selected Plays*, 1984–1987. London and Boston 1994, pp. 141–207.

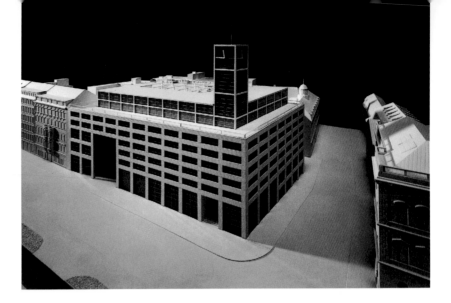

prefabricated technology and to design clever, do-it-yourself, jack-of-all-trades solutions, as can be seen in works by Jan Línek and Vlado Milunič with a Neo-Functionalist vision, or by other authors – the Brix brothers, Václav Králíček, Martin Kotík – who began to favor the Postmodernist style in the 1970s.

The regime successfully maintained a provincial and egalitarian mentality among the people, supporting the belief that whoever shows no interest in public affairs and takes care not to stand out and provoke, can live contentedly and enjoy the small blessings of a consumerist way of life. During the **"normalization"** period, the regime was willing to provide more substantial funding only for spectacular projects, such as the Prague subway system, palaces of culture, as well as hotels and office buildings for the high echelon of the Communist Party. This strange mixture of consumerism, egalitarianism, the inability to produce quality residential architecture, and to build pompous and bombastic state buildings instead, seemed dangerous to some architects, if only because it corrupted people's taste and destroyed the sense of correct and true values in their minds.

An article on the design of hotels, published by the Prague architect Alena Šrámková in 1974 in the Slovak journal **Projekt**, sounded as an appeal to architects' conscience and ethics. Without holding back, she confessed that she herself views architecture as an educational, pedagogical tool that strives **"to distinguish the necessary from the unnecessary, and the good from untruthful"**. Šrámková called unethical the conduct of architects who seem to **"try to go out of their way to cater to the taste of the broad masses, offering precisely what is wrong, rather than try to educate them in this area through good and honest architecture"**.

According to Alena Šrámková, such tool that would bring people to better values ought to exhibit ordinary, unostentatious and pure forms: **"The purity of the environment ought not to be perceived solely as the use of easy to clean materials; it ought to be an inherent property of the design. It is advisable to avoid objects of unusual design, operation and shape."** [57]

The rhetoric of Czech austerity in the late 1950s and early 1960s turned against purported unusual and extravagant solutions seen in the West in order to secure the Socialist nature of Czech architecture and to make it serve the interests of the Communist state. Alena Šrámková, however, discreetly turned the rhetoric against everything it had previously protected – against the state-building line within Czech architecture, and against the Czechoslovak official cultural policy of the 1970s and 1980s. Many young, non-conformist architects felt this shift. Words like **"soberness"**, **"ordinariness"**, or **"humility"** were the frequently used both by those who really wished to design sober and ordinary buildings, and those who were enchanted by the witty and ironic plays of western Postmodernism. When attempting to imitate them, the latter usually failed to relax adequately and to rid themselves of the self-discipline unwillingly imposed on them by the moralist content of Alena Šrámková's discourses. The Postmodernist critic and theoretician, Jiří Ševčík, was aware of the paradox of the situation and encouraged his friends to liberate their thinking and language of moralist bondage;[58] however, except for Michal Brix and his playful spa pavilions in Mariánské Lázně, designed in the 1980s, no other Czech architect seems to have succeeded in that respect. The Postmodernist stance was with a growing frequency disguised under the more austere mask of Neo-Functionalism that was at same time able to evoke **the golden age** of Masaryk's democracy in the period between the wars.

In the meantime, Alena Šrámková was driven by her desire for simplicity to attempts at abandoning all the **-isms**, and thus to rid architecture of anything indicative of style and, consequently, time period. The building of ČKD on Wenceslas Square in Prague (1977–1983, designed together with Jan Šrámek) still manifests

Alena Šrámková–Tomáš Novotný, project of the Tuzex department store, model. Prague 2-Nové Město, Karlovo Square. 1988

57 Alena Šrámková, "Jeden z problémov pri navrhovaní hotelov" (One of the Issues Related to Hotel Design). *Projekt* XVI, 1974, Issue 181 (4), pp. 52–53.

58 Jiří Ševčík–Jana Ševčíková, "Modernismus, postmodernismus, manýrismus" (Modernism, Post-Modernism, Mannerism). *Architektura ČSR* XL, 1981, pp. 135–140. — Jiří Ševčík–Jana Ševčíková, "Postmodernismus bez pověr, ale s iluzí" (Post-Modernism without Superstitions but with an Illusion). *Umění a řemesla* 1983, Issue 2, pp. 44–52, 67–68.

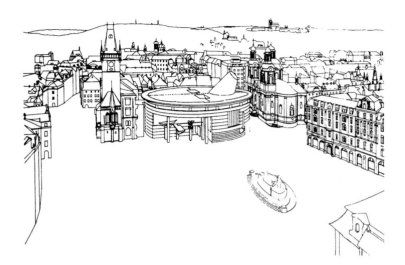

hints of western architectural movements of the 1970s, and as such can be dated to this period. The unrealized 1988 project of the Prague department store Tuzex, designed by Šrámková and Tomáš Novotný, exhibits a modernist timelessness of a sort: a condensation of the entire experience of modern architecture of the 20th century into an abstract and reduced shape. In the late 1960s, an association of architects and engineers, SIAL, was formed around the architect Karel Hubáček, the author of the TV tower on Ještěd mountain. Its foundation was accompanied by the establishment of an informal post-graduate school for gifted young architects, Školka SIAL ("SIAL Kindergarten"), headed by Miroslav Masák.[59] The association managed to win interesting commissions and maintain a free-thinking atmosphere within the group even after it was forced to return to the Liberec Stavoprojekt during the **"normalization"** era. The works of John Eisler, Martin Rajniš, Mirko Baum, Zdeněk Zavřel, Helena Jiskrová, Jiří Suchomel, Emil Přikryl and other members of SIAL and Školka SIAL display a broad range of various **-isms** of the 1970s and 1980s, from Machinism and high tech, through Neo-Functionalism to Postmodernism. This broad scope of various styles and stances gained a more synthetic form in projects submitted by SIAL in important international competitions, e.g., the reconstruction of Tegeler Hafen in West Berlin (1980) or Opera Bastille in Paris (1983).

Hubáček took pains to ensure that formal thrusts in SIAL were supported by technological innovations, development of new structural solutions and new construction materials. However, he shared Alena Šrámková's belief that the work of an architect needs to be firmly rooted in ethics, humility, self-control, and **"pure soul"**, and he also believed that an emphasis on such moral values is best displayed in the unshowiness and ordinariness of an architectural solution. As in the case of Kotěra or Teige, in Karel Hubáček's standpoints, austerity – that is, ordinariness and modesty – serves as a guarantee

of the architect's social responsibility, as well as a sign that the architect had not violated the ethical rules of his or her profession and waged a successful battle with the subversive pressures wielded by the establishment. In his single text published in the period between the Soviet invasion and the Velvet Revolution, his contemplation "O tvorbě architekta" (On the Architect's Work) from 1985, Hubáček states:

"Every creator reaches a crossroads where he can choose between roads that are ordinary, better, embellished and golden. The ordinary road is always the hardest one to travel. It demands honor." [60]

Two years before the collapse of the Communist regime, in conditions influenced by Gorbachov's **perestroika** from the faraway Moscow, a competition for an annex to the Old Town Municipal Hall was held in Prague. The jury consisted of representatives of official architecture who selected only projects appealing to their obsolete and lowly tastes. Non-conformist architects no longer remained silent, protested vocally against the results of the competition and made their own lists of the best solutions of this difficult task.[61] A leading position was occupied by a design of a nursling of Hubáček's SIAL association, Emil Přikryl. Přikryl's 1987 project of the annex to the Old Town Municipal Hall was far from ordinary, and was a cross of several –isms, with its references to Plečnik's Neo-Classicism, the Purist crematorium in Nymburk by Bedřich Feuerstein (1922–1924), and to Le Corbusier's Brutalism, without the end result conveying an incoherent impression. What was truly remarkable was the architect's treatment of the themes of morale and truth, the core of the concept of Czech austerity. Přikryl wanted to place hard concrete seats in the assembly hall inside the elliptic groundplan of the new wing of the municipal hall, so that the representatives of the regime would not meet in comfort. The hall would provide the councilors with a view of the memorial of a famous Czech martyr for the truth, the medieval church reformer and moralist, John Hus.

Emil Přikryl, competition project of an annex to the Old Town Municipal Hall, Prague 1-Staré Město, Old Town Square. 1987

59 Udo Kultermann, *Zeitgenössische Architektur in Osteuropa*. Du Mont, Köln 1985, pp. 139–150. — "Stavoprojekt Liberec, Studio 02 SIAL". *Casabella* č. 512, April 1985, pp. 4–13.

60 Karel Hubáček, "O tvorbě architekta" (On the Work of the Architect). *Umění a řemesla* 1985, Issue 2, pp. 10–11.

61 Jiří Ševčík–Rostislav Švácha, "Praga: cento anni di progetti per la Piazza del Municipio". *Casabella* č. 549, September 1988, pp. 16–25. — *Umění* XXXVI, 1988, pp. 385–480.

After the Velvet Revolution

ŽENSKÁ POSTAVA

Vlado Miluníč, concept sketch of a multi-purpose building for the plot of the Dancing Building, Prague 2-Nové Město, Jiráskovo Square. 1990–1991

The liking for austerity became too deeply ingrained in the minds of Czech architects to be shifted by this or that political turnaround. The forgotten thoughts of Karel Honzík, Ladislav Žák and other prominent figures suggest that it is a stereotypical thought process connected with the Czech national mentality that does not change to a great degree over time. Following the Velvet Revolution in November 1989, at least the conditions to which the concept of Czech austerity has to adapt have changed. Some of the fifty medallions in the second part of the book will show how Czech austerity has been faring, and what kind of debate has been ongoing in this respect. It is still worth our while, however, to at least outline in rough contours what important developments have occurred in the Czech lands after 1989 and constitute what we refer to as conditions.

The borders have opened up. Czech architects were able to start traveling all over the world and glean first-hand, **in situ** knowledge of buildings previously seen only in pictures in the modest quantity of imported magazines and obtain employment in the studios run by their western colleagues. Those in turn search for interesting commissions in this country. On the tail of foreign architects, foreign investors and developers arrive in Prague and other Czech cities. At the moment, they still do not have a great trust in Czech studios, and tend to evaluate architects not so much according to their designs, but rather according to the speed with which they are able to obtain permits for their projects from building and conservation authorities.

The institution of private ownership and enterprising has been restored. The state returned – restituted – buildings and land confiscated after February 1948 to private citizens. The state disposed of a large volume of its assets through other privatization methods. Restituents and new businesses that wish to repair or reconstruct their buildings, or have new buildings built, frequently realized for the very first time that they needed an architect and were surprised to discover that architects were able to design something other than prefabricated houses and had to learn to formulate what exactly they wanted from the architects.

The state design institutes, the former Stavoprojekts, disintegrated. Many architects established their own private studios and started learning how to deal with private clients. Large state-owned construction companies also disintegrated or were privatized. The successor companies had to part with the narrow range of prefabricated buildings and offer to both architects and their clients a broader range of technologies and materials.

Czechoslovakia, a state born in 1918 through the efforts of T. G. Masaryk, was split up into two states at the end 1992: the Czech Republic and the Slovak Republic. The Czech architectural scene has been impoverished by this divorce because its Slovak partners seemed to have been cultivating architecture that is more relaxed than Czech austerity requires. The Czech Republic's borders, however, remain open in the east as well, and Czech architecture continues to be exposed to opinions of Slovak critics; there are Czech and Slovak architectural studios, and Czech universities continue to be sought by a large numbers of students from Slovakia.

After 1989, teachers compromised by their close ties with the Communist regime left the schools. The weakness of Czech universities, including schools of architecture, is nonetheless lacking funding; aside from other things, schools are unable to hire professors accustomed to the western standards. For the same reason, the best architects are reluctant to teach, with the exception of Alena Šrámková, Emil Přikryl, Ladislav Lábus, Roman Koucký, Ivan Kroupa, Jiří Suchomel and several other enthusiasts.

The Czech educational system and culture remain undernourished probably as a result of failed economic experiments in the first half of the 1990s, which after all had an impact also on the unfortunate Czech and Slovak political

divorce. Instead of supporting its schools and cultural institutions, the Czech state continues to finance ill-managed or defrauded banks. Before they went bankrupt or obtained state aid, these banks managed to build in the main streets of many Czech cities numerous peculiar Postmodernist-Deconstructivist buildings, where the contracting parties – as well as the architects – longed to imitate, at least to some degree, the Prague Dancing Building by Frank Gehry and Vlado Milunič.

When the common state of Czechs and Slovaks fell apart, Czech MPs and senators started thinking about a building to house the two chambers. Rather than to continue to use the late modernist Parliament building designed by Karel Prager's team – a memorial to the political wishes of the Prague Spring and the art of technology of the period[62] – the democratic institutions of the Chamber of Deputies and Senate of the Czech Republic decided to leave Prager's building and move into the feudal Baroque palaces under the Prague Castle instead. It has not occurred to any of the influential politicians that the democracy newly reinstated after 1989 could have its own, topical architectural representation, and that a competition for a project of a new Parliament and Senate building could perhaps be organized.

One of the few Czech architects who were saddened by this turn of events, a professor at the Prague Academy of Fine Arts, Emil Přikryl, concluded in 1996 that the absence of interest on the part of Czech democratic institutions in an adequate architectural expression was due to a lack of civic awareness.[63] He may have been courting bad luck that subsequently affected one of the few projects that he worked on in the 1990s. In 1996, Přikryl won a competition for the siting and pedestal of the Prague monument of T. G. Masaryk. The idea behind Přikryl's design was that the figure of the founder of the Czechoslovak state would be placed in front of the Baroque building of the Parliament in Sněmovní Street, and his strict gaze would discipline Czech MPs. However, the MPs ve-

toed the proposal by objecting that they would have no space to park their cars, thus initiating a debate involving a civic initiative that opposed the outcome of the competition from the very beginning. As a result, a much worse monument placed on a much worse pedestal today stands opposite the Prague Castle at the corner of Hradčanské Square.

It was perhaps due to incidents of this kind that the theoretician Petr Kratochvíl complained in 1999 that contemporary architecture is yet to become a **"public topic"** in the Czech Republic.[64]

And if that is the case of architecture, urban planning is even less of a public topic, especially since many Czech architects and investors believe to this day that it is merely a relic of the Communist days that stands in the way of their desire to create and carry out daring deals. The situation has been evolving a little better outside Prague in some instances. However, as regards the metropolis of the Czech state, the State Regulatory Commission for Greater Prague, established during Masaryk's days and at the time enjoying a status close to that of a ministry, has been degraded to one of the many offices of the Prague Mayor, and lacks both the authority and the will to contemplate the future development of Prague from a point of view other than a narrowly conceived bureaucratic one. The products of Prague urban planning workshops, organized in the early 1990s by the then advisor to president Havel, Miroslav Masák, and attended by famous western architects, meant nothing to Prague communal politicians. These politicians do not wish for the Prague urban planning office to set out any stringent regulatory rules in any case, out of concern that it might restrict business initiative. On the one hand, a great room for corruption is thus created; on the other, the situation in Prague has become such that whether they like it or not, the function of the urban planning offices is discreetly assumed by authorities entrusted with monument conservation who, understandably, do not wish to see any great changes.

Emil Přikryl, cooperation Martin Škarda, competition project for T. G. Masaryk's memorial, Prague 1-Malá Strana, Sněmovní Street. 1996

62 Karel Prager – Jiří Albrecht – Jaroslav Kadeřábek, "Extension de l'assemble nationale, Prague". *L' architecture d'aujourd'hui* č. 141, December 1968 – January 1969, pp. 42 – 46.

63 Jiří Horský, "Hovoříme s Emilem Přikrylem" (Talking to Emil Přikryl). *Architekt* XLII, 1996, Issue 1 – 2, p. 23.

64 Petr Kratochvíl – Pavel Halík, *Česká architektura / Czech Architecture 1989–1999*. Prostor – architektura, interiér, design, Prague 1999, p. 15.

This situation gives rise to insurmountable conflicts between architects on one hand, and lovers of architectural monuments on the other. A civic organization, klub Za starou Prahu (Old Prague Lovers Club), established in the Czech metropolis as early as 1900,[65] has in the last few years been trying to find a way out of the disputes between the supporters of the conservative and progressive positions, or at least to initiate a dialogue between them.

The unrestrained development of suburban areas can be explained by the absence of interest in urban planning and regulation on the part of politicians. Without a plan, not only giant shopping centers, but also huge residential estates are mushrooming in suburban areas for clients who became rich either through honest business activities or thanks to the rash privatization in the early 1990s. Such houses, usually conceived in the mock-Postmodernist style, the **"nouveau rich Baroque"**, are built side by side, depending only on how generously the fields returned to restituents and sold by realtors are parceled. When a quality house designed by a good architect, even if he or she is a supporter of Czech austerity, happens to find its way into such **"Beverly Hills"**, as such satellites of each larger Czech town are invariably called in popular speech, the main worry of the architect is how to ensure that his or her clients would not see the houses of their less enlightened neighbors, and where possible, would not see them at all.

Czech architects could be criticized for their lack of interest in conceptual issues related to urban planning; they do not campaign to make politicians create better conditions to resolve such issues. Few of them ask questions transcending the boundaries of their profession and concerning the entire Czech society, thus exposing themselves to the risk that the society will not be particularly aware of their profession in the first place. This reluctance, if not passivity, could perhaps be excused by the fact that the Czech architects of today do not want to have anything to do with the social engineering of the leftist avant-garde of the 1920s through 1940s. Instead, they hope to gain prestige through the quality of their work, or through their professional organization, the Czech Chamber of Architects. I believe, nonetheless, that the Chamber has so far failed to win adequate authority in Czech society. Its main failure is that it failed to protect from various lateral pressures the institution of public architectural competitions – a tool that, notwithstanding all of its conceivable shortcomings, guarantees that where a difficult architectural task is concerned, a solution will be carefully selected, in public sight and with a potential educational effect on the broad public. Investors who decide to disregard the results of a competition, for instance, by assigning the project to someone else than the winner, are unfortunately able to do that quite easily because they do not expose themselves to any legal sanction by so doing, and even the public opinion does not find such incidents scandalous. Many good projects are wasted in this fashion, and many leading architects prefer not to take part in competitions. A competition of a different kind has been experiencing dwindling participation as well: Grand Prix, in which authors of new buildings, reconstruction and landscaping projects carried out in the Czech Republic can submit their projects. The competition was established in 1993 by the second architectural organization that, unlike the Czech Chamber of Architects, has voluntary membership: Obec architektů (Society of Architects). Thus far, the Society of Architects has always managed to appoint an international jury of high quality that has, remarkably so, practically always preferred austere, almost Minimalist works, as if there was some kind of a secret pact at play. The stable educational effect of this event is weakened by the fluctuating mass media attention. On the other hand, national dailies and popular magazines, such as **Reflex**, or the channels of the state TV, cannot be said to have been ignoring contemporary architecture, at least not in the last few years.

John Pawson, cooperation Jan Soukup, a church for a Trappist monastery, interiors, Nový Dvůr near Dobrá Voda. 2000–2004

65 Milena Sršňová, "Cena klubu Za starou Prahu" (Old Prague Lovers Award). *Stavba* X, 2003, Issue 2, pp. 38–39. — "Památkáři oceňují novostavby" (Conservationists Showing Their Appreciation for New Buildings). *Architekt* IL, 2003, Issue 3, pp. 58–59.

A phenomenon that probably has no equivalent anywhere in the world is the mass popularity of the series **Šumná města** (Dashing Towns), in which the architect, actor and comedian, David Vávra, introduces TV viewers to modern architecture in towns in Bohemia, Moravia and Silesia, and often succeeds in generating public interest in the very new buildings whose authors are sometimes used by Vávra and the director, Radovan Lipus, in their comic sketches. Examples of quality architecture, including architecture of the austere persuasion, have been finding their way onto the pages of popular housing and lifestyle magazines that catered only to poor mass taste in the 1990s. For people interested in high-brow culture, contemporary architecture is gradually becoming a conversation topic as natural as the theatre, music or photography. The above skeptical statement of Petr Kratochvíl no longer applies to them.

If contemporary Czech architecture is to become a legitimate cultural discipline, which it used to be until the total transition to the prefabricated technology in the 1960s through 1980s, it needs well provisioned institutions catering to its cultural operations: museums and galleries, study and educational centers engaged also on foreign relations, publishing houses and book stores, magazines providing ongoing critical commentaries on architectural practice. Czech architecture already has some of these elements at its disposal in an adequate extent – some function to some degree, some are still lacking completely. The departments of architecture of the Museum of the City of Brno, the National Gallery in Prague, and the National Technical Museum play the role of museums; unfortunately, the ample collections of models, plans and old photographs of the National Technical Museum in Prague were damaged by the floods in 2002.[66] The Foundation for Czech Architecture manages an exhibition hall in Starobrněnská Street in Brno, and Jaroslav Fragner's Gallery at Betlémské Square in Prague; the specialized architectural book store, Fraktály, recently moved its seat to the premises of the latter institution. Jaroslav Fragner's Gallery experienced a particularly important period filled with frantic exhibition and editorial efforts in 1994–2001 when the then director, Soňa Ryndová, attempted to build an institution similar to West European centers or houses of architecture. Yearbooks and books on contemporary Czech architectural production are published by Prostor, a non-profit company managed by Dagmar Vernerová. Last but not least, there are five professional journals: **Architekt**, **Zlatý řez**, **Fórum architektury a stavitelství**, **Stavba** and **Era**.

The weakness of this cultural system lies in the fact that the funding circulating inside it is inadequate, and many components of the system thus have to rely on the energy and enthusiasm of the players alone. The Czech state supports it by means of subsidies and grants but is not wealthy enough to finance it to a greater extent; the same could be said of the Foundation for Czech Architecture. Private sponsors are more generous with their funds. However, a greater support is lacking also on the part of Czech architects. There are some who believe that only architecture proper is a meaningful fruit of their labors, and they view all the incidental cultural operations as a superfluous, parasitic **"extra"**. A justified fear of false and misleading **"media attention"** goes hand in hand with down-to-earth pragmatism that views any overlaps of architecture into the cultural sphere with distrust equal to the one with which Karel Teige and his associates once viewed the overlaps of architecture into arts. This may not be a specifically Czech feature. And yet, I feel that even this down-to-earth pragmatic attitude disguises one of the less likeable aspects of the tradition of Czech austerity.

66 "SOS Archiv architektury" (SOS Archives of Architecture). *Architekt* XLVIII, 2002, Issue 9, p. 2.

This book was published on the occasion of the Czech Republic joining the European Union

01

Hana Zachová, pavement in the historical center of Český Krumlov, Široká, Soukenická, Panská and Dlouhá Streets. 1989–1992

After 1948, the Communist state enacted stringent laws for the protection of architectural monuments. However, it did not take good care of monuments due to lack of funding. As a result, not only individual historical buildings but the overall environment of historical towns was falling into disrepair, including ancient pavement patched up with bitumen. This fact made the municipal council of one of the most beautiful towns in Bohemia, Český Krumlov, still before the Velvet Revolution of 1989, commission a new design of the pavement of the historical core from the Prague architect Hana Zachová. Her design executed in 1992 had a peculiar, natural feel to it. She did not want to imitate historical pavement pattern, and yet, her design seems to have been in the town from time immemorial. At the same time, it does not look like a new work created at a particular time "according to an >apriori< project scheme", to quote the critic Josef Holeček who commented on Hana Zachová's pavement designed for the town of Telč at a later date.[67] In her commentary on her work for Český Krumlov, Zachová gave the express instruction that the paving stones ought to be hewn by hand.* At the same time, she asks herself "what the extent of new additions can be without the town losing its unique nature", and rejects overly modern and fashionable paving patterns that look new only for a short while and then age rapidly.*
She thus defined the ideal of timelessness pursued by some other Czech architects in the 1990s.

67 Josef Holeček, "Dlažby" (Pavements). *Architekt* XLVI, 2000, Issue 8, pp. 32–34.

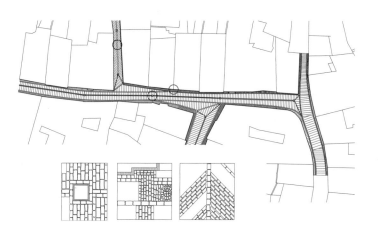

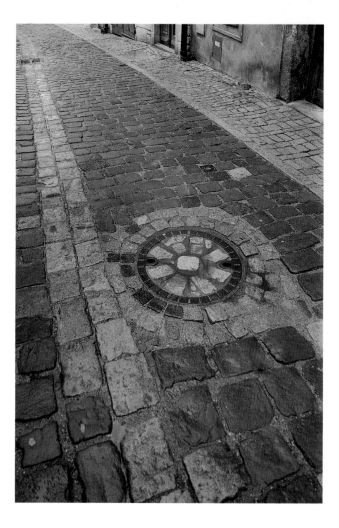

01

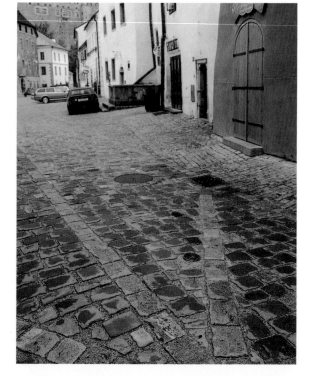

* Hana Zachová, "Dlažba jako trvanlivost, účelnost, krása". *Architekt* XL, 1994, Issue 5, pp. 1, 3.

 Hana Zachová, "Dlažby v historickém jádru Českého Krumlova". *Československý architekt* XXXV, 1989, Issue 7, pp. 1, 4.

 Jan Sedlák, "Poněkud netradiční ukázka >památkové< rekonstrukce". *Architekt* XL, 1994, Issue 5, p. 3.

Long before Hana Zachová, Alena Šrámková, perhaps the most important Czech 20th century female architect, contemplated the need for architectural timelessness. She was one of the first Czech representatives of the profession who clearly realized that they lived in a consumer society and viewed architecture as the tool that could perhaps help limit the unfortunate impact of consumerism on human mentality. According to Šrámková, not just any architectural work may serve as such an educational tool: only a piece of work that would not bother people with a conspicuous shape, a marked fashionability, or a conspicuous "idea" could. From the 1970s, Šrámková maintained that good architecture may be ordinary and that the sort of eternal and timeless idea of a "house with windows" was sufficient. She was hard-pressed to find clients to realize her idea. One of the few interesting commissions came in the early 1990s from a prominent Czech mathematician who wanted to build an addition – a study and a room for informal meetings with friends – to his old house in the Košík village. The fact that Šrámková opted for the form of a tower when designing the addition to the mathematician's house made reviewers of her work search for precedents to such a solution in world cultural history: they referred to Einstein's tower, Jung's tower, and even to a well-known discourse by Erwin Panofsky: "In Defense of the Ivory Tower".*

The architect Vratislav Vokurka argued that they elevated a small wooden structure to the status of a masterwork,** something that the Czech architectural criticism

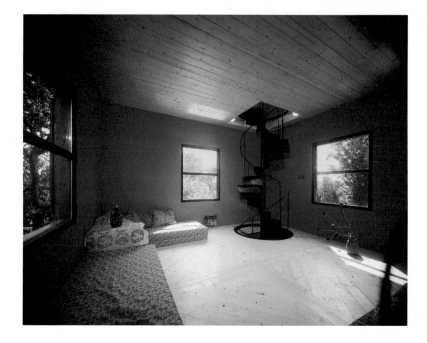

02

* Rostislav Švácha, "Věž". *Architekt* XL, 1994, Issue 3, pp. 1, 3.

** Vratislav Vokurka, "Recenze na recenzi >Věž<". *Architekt* XL, 1994, Issue 7, p. 12.

Alena Šrámková, "Přístavba k rekreační chalupě v Košíku".
Architekt XL, 1994, Issue 3, pp. 1, 3.

Rostislav Klíma, "Věž pro vědeckého pracovníka". *Zlatý řez*, No. 8, Winter 1994, pp. 34–37.

"Věž Aleny Šrámkové", *Architekt* XLI, 1995, Issue 8, pp. 1, 5.

"Haus in Tschechien". *Detail-Einfaches Bauen*, 1995, No. 3, pp. 426–429.

Vladimír Šlapeta (ed.), *Baustelle: Tschechische Republik. Aktuelle Tendenzen Tschechischer Architektur*. Akademie der Künste, Berlin 1997, pp. 62–64.

"Tower for a scientist". *Space Design* 9702, 1997, No. 2, pp. 34–35.

Alena Kubová (ed.), *Un Salon tchéque. Architecture contemporaine et design en République Tchéque*. Institut francais d'architecture, Paris 2002, pp. 58–61.

Václav Alda – Petr Dvořák – Martin Němec – Jan Stempel, office building in Prague 2-Vinohrady, Římská Street 499/15. 1993–1994

Buildings designed by Alena Šrámková and actually built are not great in number. Her way of thinking, however, attracted many younger architects, especially those who worked in the same studio with her. In the 1980s, when she joined the Liberec-based SIAL studio whose project was used to reconstruct the Functionalist Trade Fair palace in Prague, she encountered the young architects Martin Němec and Jan Stempel. In 1990, the two architects won the tender for the Czechoslovak pavilion for EXPO 1992 in Seville, and established their own studio shortly afterwards. Their first Prague commission was the office building of the German investment firm OMG. The architects conceived a rational modular ground plan for the building, and its external appearance was also supposed to be as rational and universal as possible, "almost bland", as the architects admitted in 1995.*** They wanted "the final result to look like there was not so much to it", because "a simple dress is perfectly adequate for a beautiful woman".[68] OMG's representatives were allegedly puzzled by the concept, and asked the architects to come up with "more architecture".[69] The building managed to confuse critics of architecture as well, for instance, the American David Polzin* or the Viennese Jan Tabor.** Both appreciated that the building strives to follow up on the famous traditions of Czech Functionalism from the period between the wars. However, Polzin did not know what to make of its departures from the "correct" appearance of Functionalist style: the heavy stone facings of the facades, and wooden window crosses. "The manner of horizontal expression is not exactly typical of Prague", Polzin wrote in 1994 in the *Architekt* journal,* referring to the elongated windows typical of Prague Functionalist houses from the 1920s and 1930s. However, the architects' aim was not to imitate Functionalism, although they admired it and designed certain purely Neo-Functionalist works after 1989. Rather, they were attracted by the idea of simplicity, similar to what Alena Šrámková had in mind. The fact that they succeeded in expressing this idea was appreciated by the editorial board of the Italian journal *Domus* which devoted several color spreads to the OMG building in 1996.

68 From a conversation between Jan Stempel and the author of this book in 1993.
69 Rostislav Švácha, "Krabice na knihy" (Crates for Books). *Architekt* XLII, 1996, Issue 14–15, pp. 24–29.

03

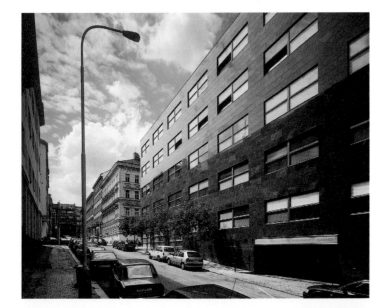

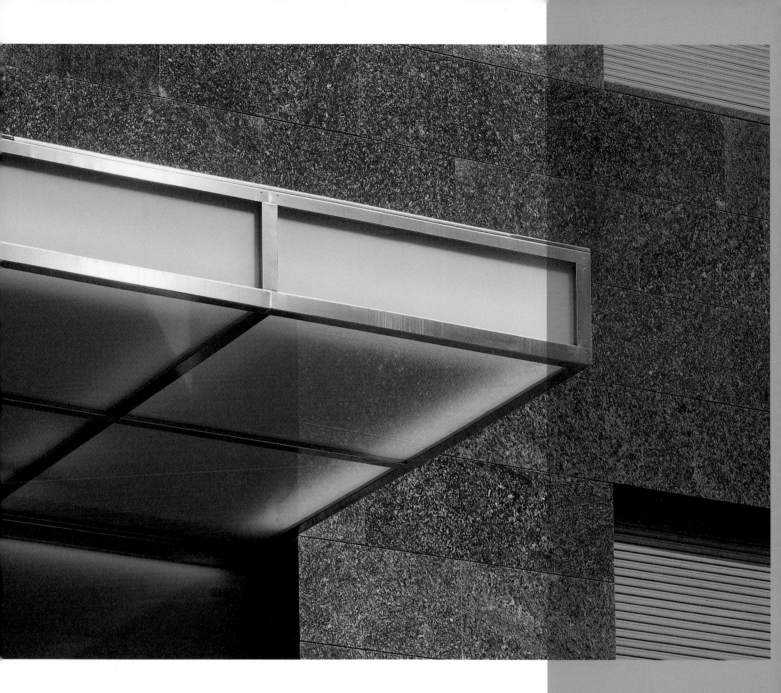

* David Polzin, "Kritika tří projektů pro Prahu". *Architekt* XL, 1994, Issue 5, p. 4.

** Jan Tabor, "Kostka do hry". *Architekt* XL, 1994, Issue 23, p. 3.

*** "Nájemní kancelářská budova". *Fórum architektury a stavitelství* I, 1995, Issue 1, pp. 16–17.

Vladimír Šlapeta, "Bürogebäude in Prag". *Baumeister*, 1995, No. 7, pp. 24–29.

Vladimír Šlapeta, "Bürogebäude Balbínova Strasse, Prag". *Bauwelt* LXXXVI, October 1995, pp. 2318–2321.

Vladimír Šlapeta, "Edificio per uffici a Praga". *Domus*, Issue 781, 1996, pp. 18–23.

"The Czech Republic". *World Architecture*, 1996, No. 46, p. 47.

"Hintern Wenzelsplatz: Grüner brasilianischer Granit". *Stein* 1996, No. 6, pp. 14–15.

Vladimír Šlapeta (ed.), *Baustelle: Tschechische Republik. Aktuelle Tendenzen Tschechischer Architektur*. Akademie der Künste, Berlin 1997, pp. 32–33.

Petr Kratochvíl–Pavel Halík, *Contemporary Czech Architecture / Tschechische zeitgenössische Architektur*. Prostor – architektura, interiér, design, Prague 2000, pp. 94–96.

04

After November 1989, a work by Emil Přikryl, another former SIAL member and a professor of architecture at the Prague Academy of Fine Arts, the reconstruction of Benedikt Rejt Gallery in Louny, elicited the greatest response in foreign scholarly press, namely in *Ark/Arkkitehti*, *Architectural Record*, and *L'architecture d'aujourd'hui*. The Benedikt Rejt Gallery specializes in purchasing Czech abstract and Minimalist art and has been occupying an old brewery in the historical core of the city of Louny since the 1960s. Alterations were to have been made to the brewery to suit the purposes of the gallery, whereby a new lower section, with an atrium in the centre, was to be added to the historical building. However, there was little construction progress until a new director, Dr. Alice Štefančíková, joined the gallery in 1989. In 1992, Štefančíková commissioned a new study of the reconstruction from the architects Emil Přikryl, Tomáš Bezpalec and Tomáš Novotný. Their design shifted the emphasis on the old brewery building; as to the newer addition, the architects wished to leave only three wings in the manner of a court of honour, as shown in their published drawings.* Following consultations with the client, Přikryl eventually decided to leave only one part of the annex – a single wing adjoining the brewery building. A simple batten flooring with clamped-in concrete columns was laid down in the empty space in front of the gallery. External alterations designed by Přikryl are limited to new detailing of window and door apertures and remarkable modeling of the illumination cannons above the remaining wing added in the 1960s. The architect's achievements in the interior have since become legendary, however, and most certainly constitute the single most important accomplishment of Czech architecture of the 1990s. The author himself likes to claim that he did "virtually nothing" in the gallery, and only had the interiors newly painted. He does add, however, that his alterations strove to discover the hidden logic of work performed by the previous builders of the brewery building in the 18th through 20th centuries, and that he endeavoured to enhance the geometry already inherent in the building before he became involved. On the ground floor, the architect interconnected the insides of two concrete boxes, with their brutal impact softened by beautiful proportions and a subtle combination of daylight and artificial light. The first underground storey, once vaulted over by means of eight Bohemian or Prussian cap vaults, is accessed either via caracoles on the edges of the exhibition space or by lift, whose concrete case was placed by the architect in the centre of the gallery's ground plan. The author stripped all the interior apertures of their frames in order to emphasize the purity of the different bodies forming this geometric mystery.

The critic Marie Platovská was intrigued by the degree to which Přikryl's work resembles the drawings of interiors in the book *Perspectiva* (1599) featuring the Mannerist painter and architect, Jan Vredeman de Vries.** "…it is rather like a dream… the author seems to have created the vaults and old apertures himself", the critic Josef Holeček wrote about the gallery premises. He went on to say, however, that after Přikryl's alterations, the gallery could well exist without any exhibits, as "the space steals the show from the works on display",*** an opinion shared by virtually all the reviewers of art exhibitions held in the gallery after 1998. Whatever the case may be, the architect never had another opportunity to create a work of this stature. He devotes his time exclusively to

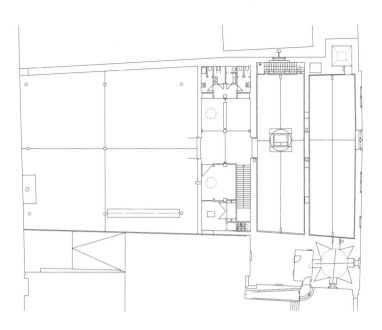

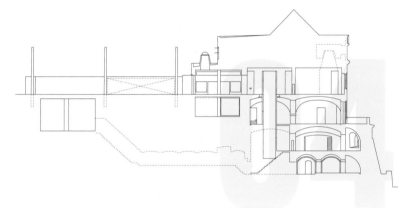

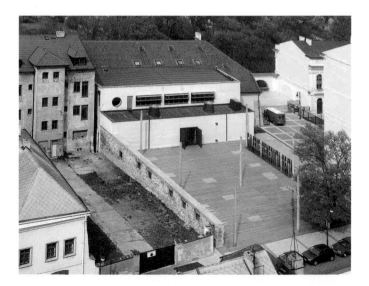

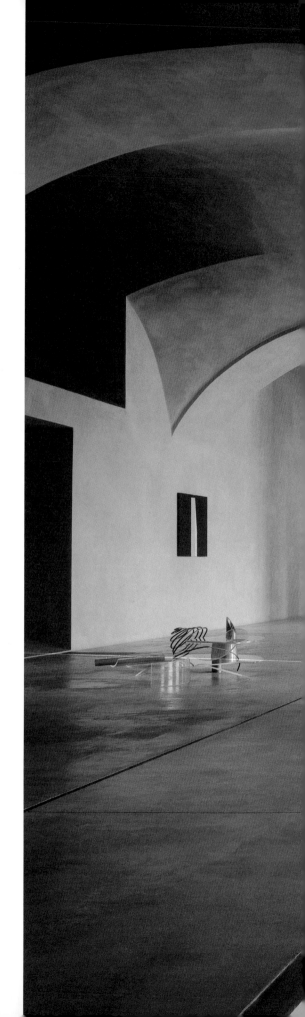

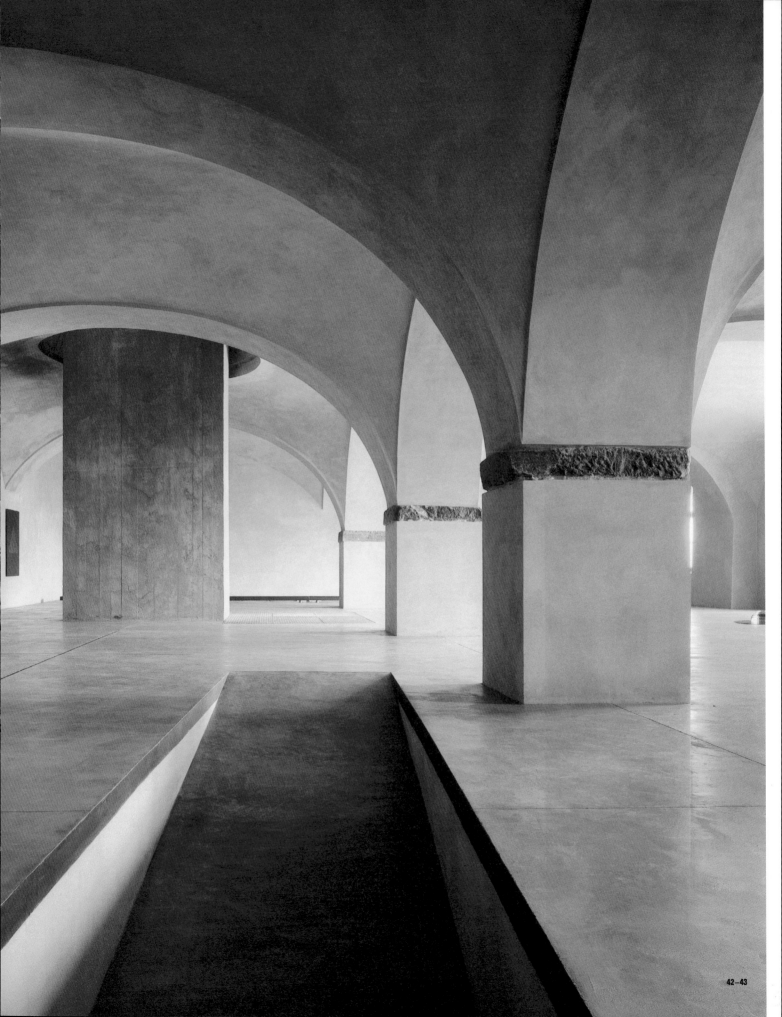

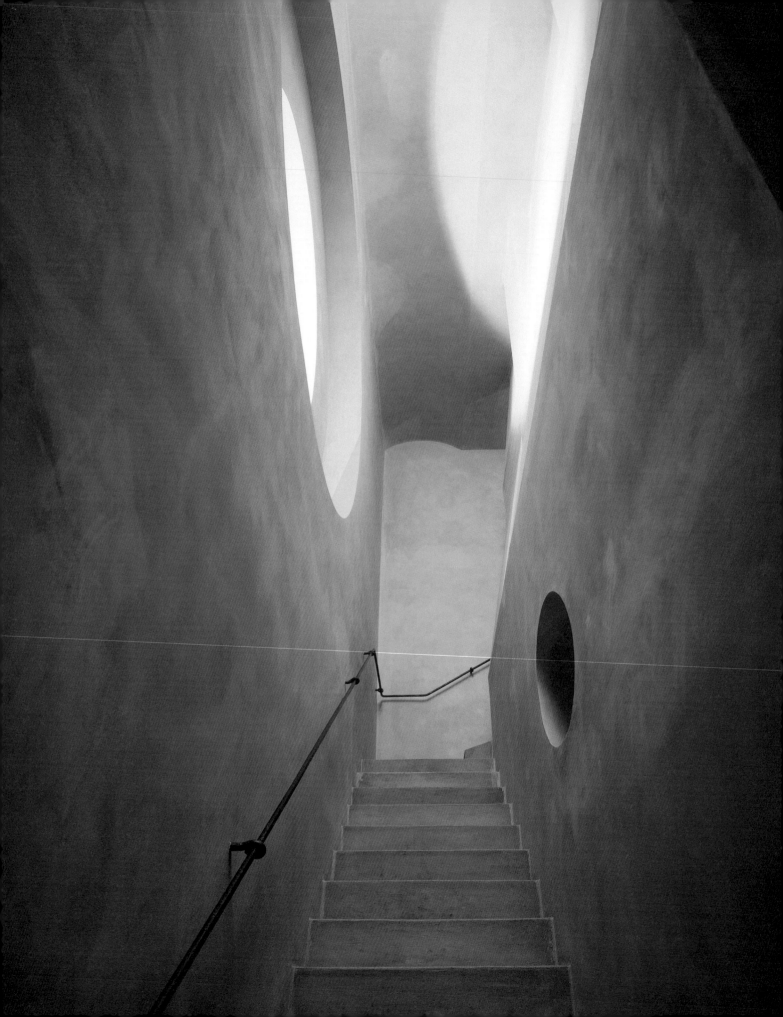

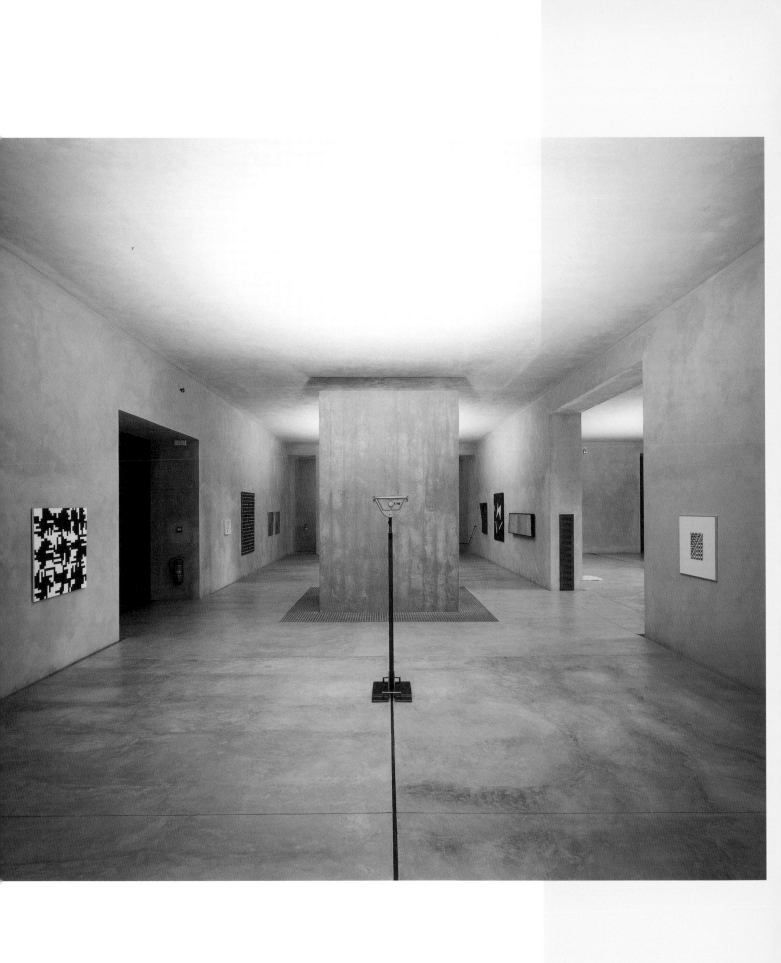

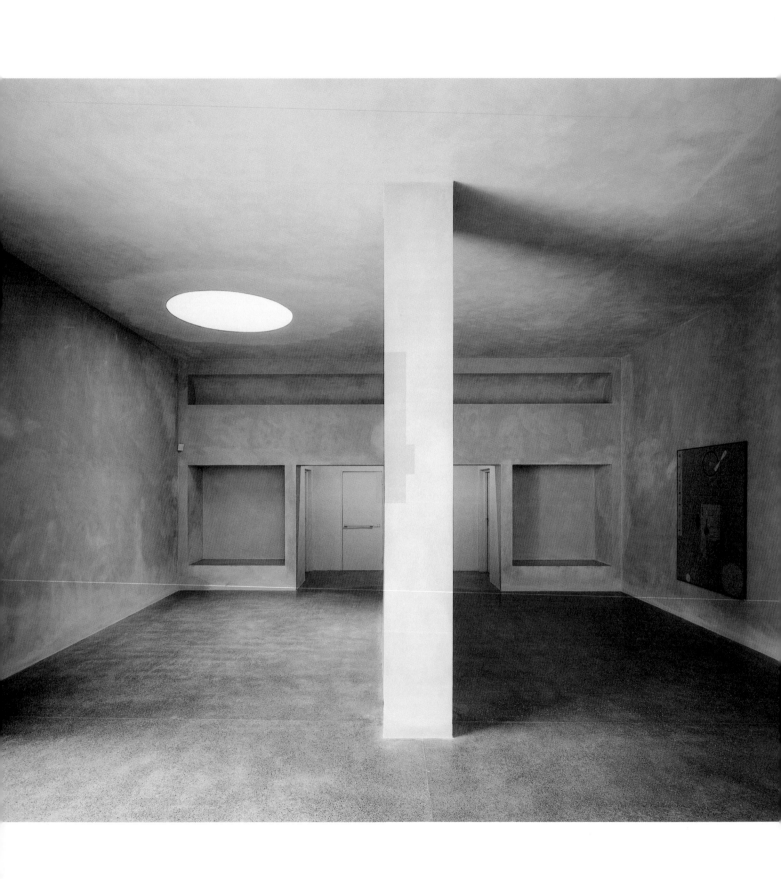

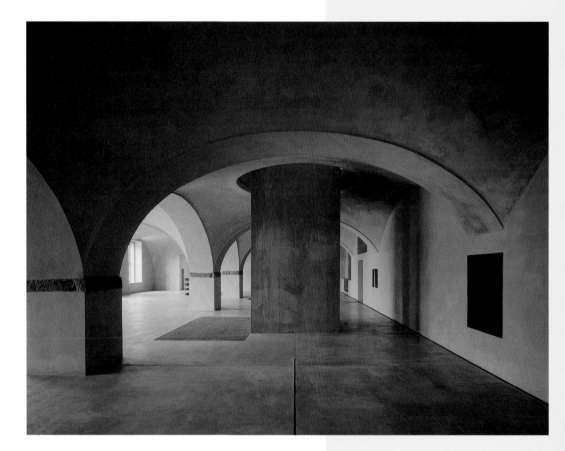

 * Alice Štefančíková, "Emil Přikryl. Projekt galerie v Lounech". *Zlatý řez* No. 4, February 1993, pp. 16–21.

 ** Marie Platovská, "Koncentrovaná energie labyrintu". *Architekt* XLV, 1999, Issue 5, pp. 59–60.

*** Josef Holeček, "Prostor jako naléhavý sen". *Architekt* XLV, 1999, Issue 5, p. 6.

Hana Vrbová, "Galerie Benedikta Rejta v Lounech". *Architekt* XXXIX, 1993, Issue 6-7, pp. 4–5.

Emil Přikryl a jeho škola. Galerie Jaroslava Fragnera, Praha 1995, pp. 34–35.

Antonín Hruška, "Jak zachránit Galerii Benedikta Rejta v Lounech". *Fórum architektury a stavitelství* 1997, Issue 8–9, pp. 61–62.

"Galerie Benedikta Rejta v Lounech. Rekonstrukce pivovaru". *Architekt* XLIV, 1998, Issue 15–16, pp. 17–34.

Rostislav Švácha, "Geometrie, světlo, syrovost reality". *Architekt* XLV, 1999, Issue 5, pp. 57–58.

Vladimír Šimkovič, "Vše potřebné k přežití". *Architekt* XLV, 1999, Issue 5, p. 60.

Sarah Amelar, "Record Interiors 99". *Architectural Record*, 1999, No. 9, pp. 131–166.

S. A. Miller, "A Baroque Brewery is Reincarnated as the Benedict Rejt Gallery in Bohemia". *Architectural Record*, 1999, No. 9, pp. 160–166.

Petr Rehor, "Benedikt Rejtin Galleria, Louny". *ARK / Arkkitehti / Arkitekten*, 1999, Issue 2, pp. 78–79.

"E. Přikryl, Galerie d'art a Louny, République Tchéque". *L'architecture d'aujourd'hui*, Issue 323, Julliet 1999, pp. 54–59.

Palmiro Decyewski, "Galeria v browarze". *Architektura / Biznes*, 1999, No. 5, p. 49.

Jana Tichá, "Emil Přikryl: galerie Benedikta Rejta in Louny". *Piranesi* VI, 1999, No. 9–10, pp. 86–93.

Milena Sršňová–Rostislav Švácha, "Muzea a galerie". *Stavba* VI, 1999, Issue 2, pp. 30–39.

Petr Kratochvíl–Pavel Halík, *Contemporary Czech Architecture / Tschechische zeitgenössische Architektur.* Prostor – architektura, interiér, design, Prague 2000, pp. 42–46.

Alena Kubová (ed.), *Un Salon tchéque. Architecture contemporaine et design en République Tchéque.* Institut francais d'architecture, Paris 2002, pp. 42–45.

The Phaidon Atlas of Contemporary World Architecture. Comprehensive Edition. New York–London 2004, p. 589.

The austere, even Minimalist, architecture designed after 1990 by architects like Alena Šrámková, A.D.N.S. and Emil Přikryl could not earn a warm reception from the broad public. Moreover, the public had bad experience with the unintentional caricature of Minimalism, the box-like, building-blocks-like prefabricated housing estates from the 1960s through the 1980s, that discouraged any ordinary Czech from displaying any interest in contemporary architecture. A turnover in this respect occurred when the Dancing Building was built in Prague. This work designed by the American architect Frank Gehry and the Prague-based architect Vlado Milunič has both admirers and opponents here and abroad. Those who reject the Dancing Building, for good reasons, e.g., that it is not architecture, but rather a sculpture, should not ignore the social dimension of Gehry and Milunič's undertaking – the broad and warm response of many members of the general public. Thanks to this extravagant building, many Czechs came to realize for the first time that there was something like contemporary architecture. And it is hardly surprising that some of them viewed the Dancing Building as a symbol of liberation from the boxy boredom of prefabricated housing.

In the prehistory of the new building sited at the corner of Jiráskovo Square and Rašínovo Embankment, Vlado Milunič's drawings for the same plot dating back to 1990–1991 played an important role: their playful and unscrupulous nature was probably the most vivid architectural expression of the carnival mood of the Velvet Revolution.* Frank Gehry translated Milunič's idea of a house that starting moving and began to dance into his own architectural language, after the plot was purchased in 1992 by the Dutch insurance company, Nationale Nederlanden. Thanks to its developer, Paul Koch, who was well versed in the Prague conditions, Milunič was able to remain involved in the project as Gehry's partner for the purpose of negotiations with local authorities. The two architects were ironing out the details until the fall of 1993. Gehry was at first not opposed to presenting the Dancing Building project under the popular nickname "Ginger and Fred". However, he eventually disavowed this metaphor, allegedly so as not to expose himself to critics who might accuse him of importing Hollywood kitsch to Prague. After Gehry completed the house – which was soon outshined by Gehry's even more extravagant projects for Bilbao and Seattle – the interiors of three office stories were designed by the Czech-English architect Eva Jiřičná.

Unlike the general public, Czech architects first responded in a rather perplexed manner, although not because an American had invaded their domain. The debate concerning the Dancing Building was influenced by the fact that some architects viewed it through the eyes of Alena Šrámková, and through her prism of ordinariness and lack of showiness. The strongest critical attacks on the Dancing Building came in 1993 from Zdeněk Jiran and Michal Kohout, young architects who first practiced in Alena Šrámková's studio. Jiran would have liked a house of a more responsible shape in the place concerned, a building firm and untwisted,** while Kohout criticized it for a violation of regulatory rules, for "dancing outside the dance floor".*** These opinions did not carry much weight in the official assessment of Gehry and Milunič's project. They were, however, symptomatic of the tendency taking root in the awareness of the Czech architectural elite in the early 1990s.

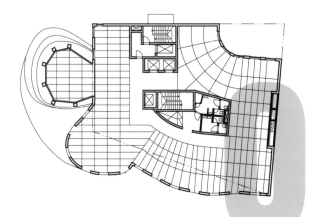

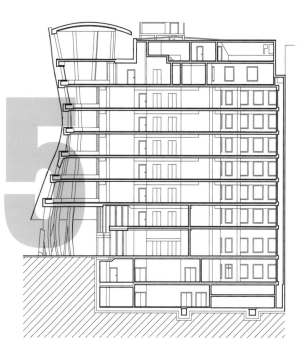

05

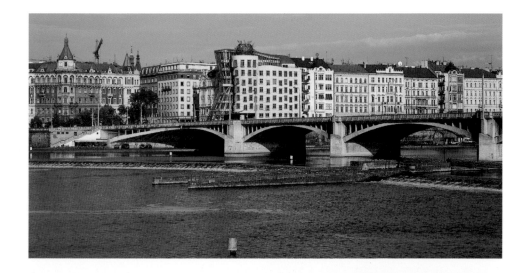

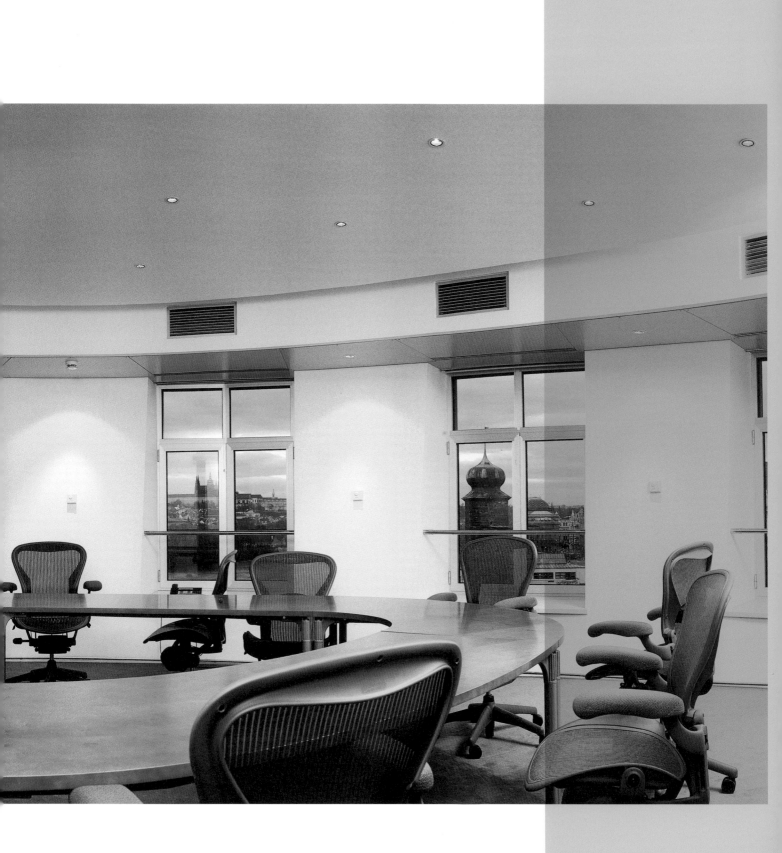

 * Vlado Milunič, "Pohled do černé kuchyně". *Ateliér* IV, 1991, Issue 6, p. 8.

 ** Zdeněk Jiran, "Zodpovědnost na nábřeží". *Architekt* XXXIX, 1993, Issue 5, p. 4.

*** Michal Kohout, "Tanec mimo parket". *Respekt* 1993, Issue 24, p. 22.

Vlado Milunič, "Budova Nationale Nederlanden". *Architekt* XL, 1994, Issue 1, p. 14.

Rostislav Švácha, "Letter from Prague. Reactions to the Dancing House". *ANY. Architecture New York*, No. 11, 1995, pp. 8–9.

Andreas Janser, "Triumfující zdrženlivost". *Architekt* XLII, 1996, Issue 14-15, pp. 17–23.

Milena Sršňová, "Nationale Nederlanden Praha". *Stavba* III, 1996, Issue 5, pp. 14–15.

Bohdan Kasper, "Technický popis stavebního řešení". *Stavba* III, 1996, Issue 5, pp. 16–18.

Eva Jiřičná, "Interiér pro Andersen Consulting v Praze". *Zlatý řez* 13, Winter 1996, pp. 18–19.

Friedrich Achleitner, "Frank was here". *Domus* No. 790, February 1997, pp. 16–17.

Petr Kratochvíl, "Socha v kontextu". *Fórum architektury a stavitelství* 1998, Issue 1, pp. 4–11.

Dagmar Vernerová, "Tančící dům se nám prostě stal". *Fórum architektury a stavitelství* 1998, Issue 1, p. 15.

Petr Kratochvíl–Pavel Halík, *Contemporary Czech Architecture / Tschechische zeitgenössische Architektur*. Prostor – architektura, interiér, design, Prague 2000, pp. 119–125.

"City focus – Prague. Unfinished symphony". *World Architecture*, 2000, No. 86, p. 49.

Jan Šesták-Marek Deyl, "Nationale-Nederlanden Building. Dostavba přízemí a suterénu". *Architekt* XLVII, 2001, Issue 2, pp. 35–37.

Irena Fialová (ed.), *Frank Gehry, Vlado Milunič, Dancing Building*. Zlatý řez – Prototype Editions, Prague–Rotterdam 2003.

Irena Fialová, "Tančící dům / Co se do knihy nedostalo". *Zlatý řez*, No. 24, Summer 2003, pp. 72–79.

Martin Krupauer – Jiří Střítecký, Czechoslovak Commercial Bank in České Budějovice, Lannova Avenue 3. 1993 –1994

The risk associated with the success of Gehry and Milunič's project with laymen was that many other clients wished to have "something dancing" built, without having an architect of Gehry's stature available. The input of the Dancing Building was thus devalued, while Czech austerity was gaining in authority. The two most influential foci of Czech architecture of the 1990s, Prague and Brno, boasted only a few professionals courageous enough to challenge the austere line, provided we are talking about architects considered to be the best. More auspicious conditions for more liberal architectural endeavours thus tended to emerge in other cities unaffected by the Prague and Brno debate. For instance, Martin Krupauer and Jiří Střítecký established their creative base in České Budějovice. Their reconstruction of a Neo-Renaissance bank in Lannova Avenue could be viewed as a rebellion against rationalism: an outburst of creative energy that, in the architects' own words, "permeates the entire house: the colors, the dynamics of details, the segmentation of the space".** At the same time, Krupauer and Střítecký wished to challenge the "established cliché of bank buildings from stone".** In a review of their work by the Prague critic Vladimír Czumalo, admiration is mixed with criticism. In his description of the interior, Czumalo used words like "jungle" and "gluttonous feast", and when looking at the street facade, he could not help the feeling that it was "some sort of a hard-to-grasp mishap".*

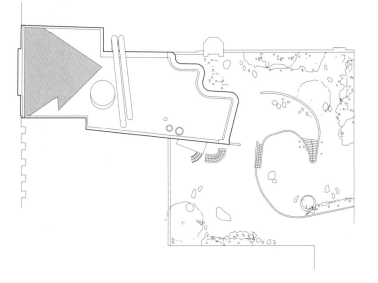

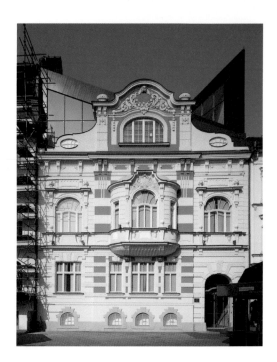

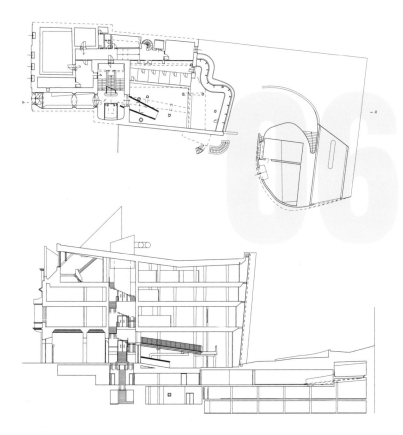

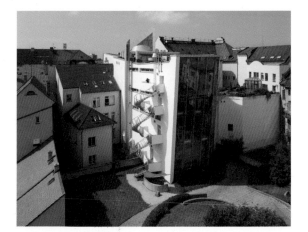

* Vladimír Czumalo, "Poetický stroj". *Architekt* XLI, 1995, Issue 21–22, pp. 3–5.

** Jiří Střítecký – Martin Krupauer, "Československá obchodní banka, Lannova tř. 3, České Budějovice". *Stavba* II, 1995, Issue 4, pp. 22–27.

Miroslav Masák, "Six years after revolution". *Architectural Design Profile*, 1996, No. 119, pp. 6, 36–37.

Petr Kratochvíl – Pavel Halík, *Contemporary Czech Architecture / Tschechische zeitgenössische Architektur*. Prostor – architektura, interiér, design, Prague 2000, pp. 30–33.

Martin Krupauer – Jiří Střítecký, "ČSOB České Budějovice". *Stavba* VIII, 2001, Issue 6, p. 12.

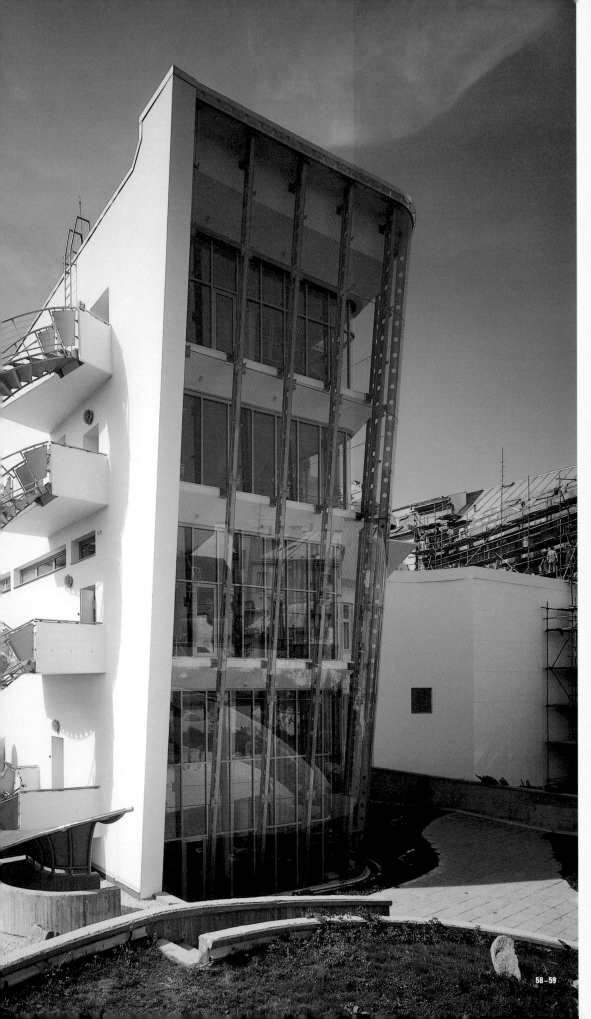

07

The twisted and falling forms of Krupauer and Střítecký's bank in České Budějovice certainly have a lot in common with Deconstructivism. The same thought occurs to us when we look at the grammar school building in Orlová, designed by Josef Kiszka and Barbara Potyszová. However, the architects did not employ "dynamizing" elements solely to prove that they were able to respond to the developments taking place in the West. Both live in Havířov, close to the border with Poland, and have been carefully following the Polish architectural scene, which in the 1990s created criteria different from those of Czech austerity. Moreover, they were forced to place the grammar school, which also serves as a regional cultural and sports centre, in the middle of a large prefabricated housing estate from the 1960s and 1970s, and thus felt the need to enter into its context with forms that would lend their new building an individual character. The tension between a full and vacant volume, between a solid core and ragged edges, has after all been present in both architects' designs from the beginning of their careers. Kiszka and Potyszová became interested in Deconstructivism precisely because it helped them to adequately express such tension.

The critics Jason P. Boisvert and Michal Janata showed in their reviews of the grammar school building how well versed they are in Deconstructivist philosophical discourse. Their references to the "obvious break-down of the world"* or "cracking the authority of the code"** can be applied not only to the description of the building's exterior, but also to identify its place in the development of school building types. The Velvet Revolution of 1989 was accompanied by calls for changes in education. The reformers wished to finally break free from the old Austro-Hungarian tradition, according to which a school is to serve primarily as a tool for strengthening discipline. The school of today is to encourage greater activity on the part of the students, topple the barriers between individual subjects, and communicate with the outside world to a greater extent. The authors of the Orlová grammar school found their own path to the notion of a school as an open institute, regardless of the fact that some of the local teachers were none too pleased with this approached. The architects expressed their idea by selecting a rather less common type of a school building: a building with hall rather than corridors and cleverly incorporating the outside

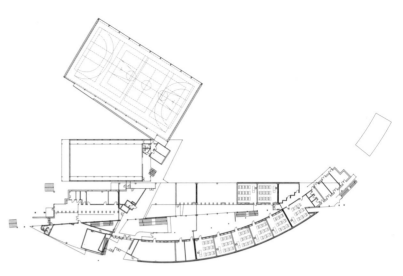

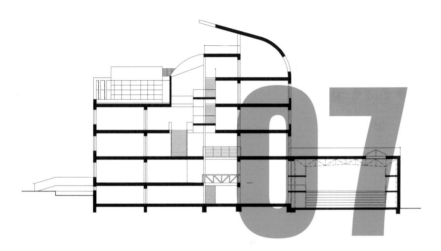

07

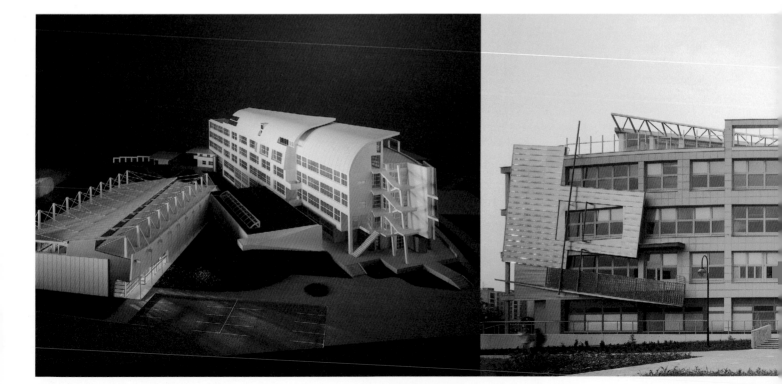

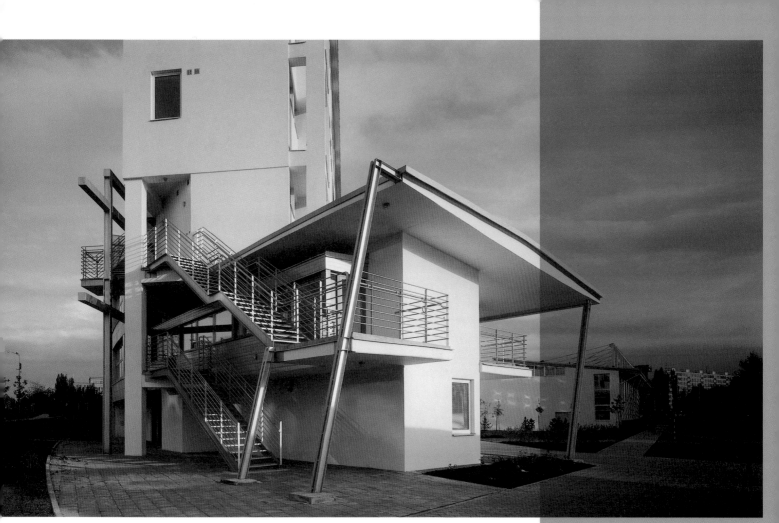

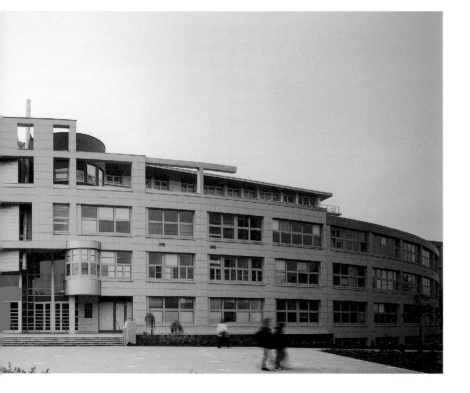

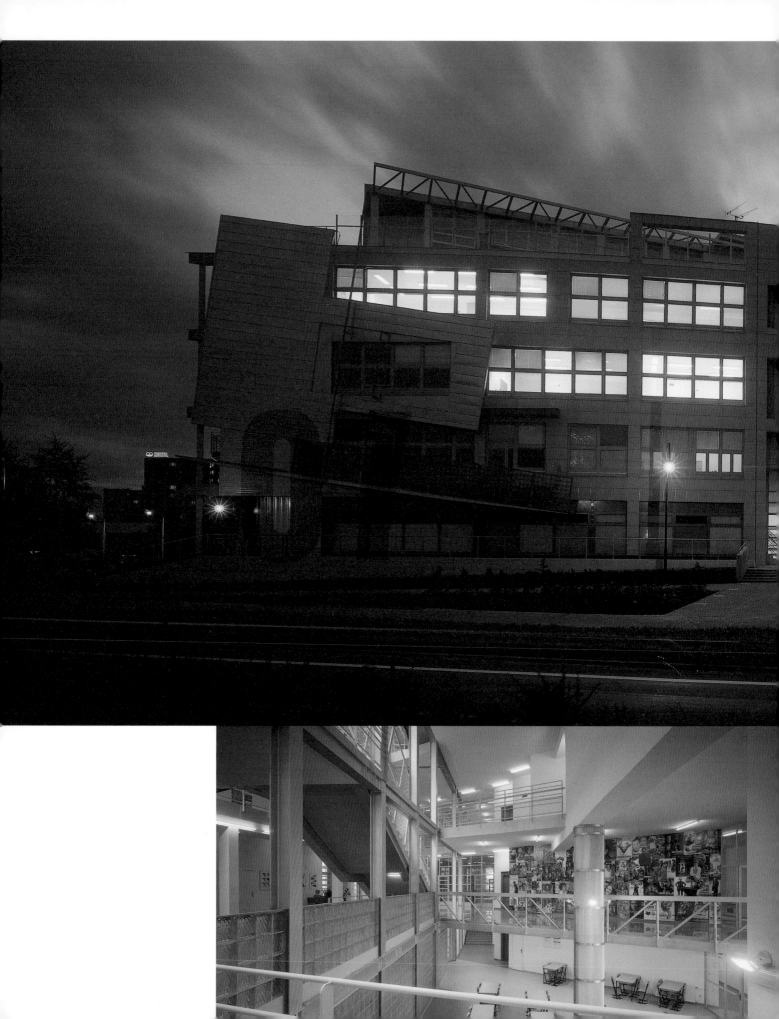

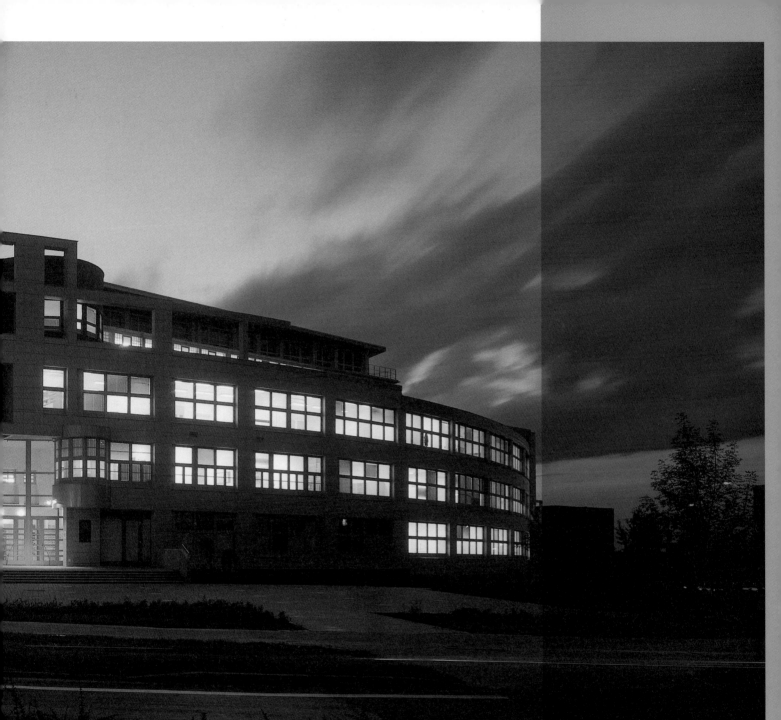

* Jason P. Boisvert, "Zrod a zánik jedno jsou". *Architekt* XLII, 1996, Issue 22, p. 25.
** Michal Janata, "Prolomení autority kódu". *Stavba* VI, 1999, Issue 6, pp. 32–33.

Josef Kiszka–Barbara Potysz, "Gimnazjum w czeskiej Orlowej". *Architektura / Biznes,* 1996, No. 12, pp. 13–15.
Milena Sršňová, "Architektonické studio ARKISS/Josef Kiszka". *Stavba* III, 1996, Issue 2, pp. 88–92.
Josef Kiszka–Barbara Potyszová, "Z autorské zprávy". *Architekt* XLII, 1996, Issue 22, pp. 20–25.
Josef Kiszka–Barbara Potyszová, "Novostavba gymnázia v Orlové". *Stavba* III, 1996, Issue 5, pp. 20–24.
Josef Kiszka–Barbara Potyszová, "Gymnázium v Orlové". *Architekt* XLIII, 1997, Issue 4–5, pp. 12–13.
"Gymnázium v Orlové". *Fórum architektury a stavitelství* 1997, Issue 4, p. 28.
Petr Kratochvíl–Pavel Halík, *Contemporary Czech Architecture / Tschechische zeitgenössische Architektur.* Prostor – architektura, interiér, design, Prague 2000, pp. 116–118.

Josef Pleskot – Radek Lampa – Vladimír Krajíc – Jana Vodičková, town hall in Benešov, Masarykovo Square 100, 1993–1995

After November 1989, aside from educational institutions, people wished to reform or reinstate cultural, and in particular political, institutions from political parties, the Parliament and Senate, to municipal governments. While the Czech top political echelon, with the exception of president Havel, showed absolutely no interest in contemporary architecture, and while it did not occur to it at all that the reinstituted Parliament and Senate ought to be given a new architectural appearance, councilors and mayors of several smaller towns were not as improvident and returned to the old tradition of public architectural patronage.

This trend was first manifested in the reconstruction of the town hall in Benešov, designed by the Prague architect Josef Pleskot and his colleagues. The mayor of Benešov, Mojmír Chromý, commissioned the project in 1993 from an architect who found, in the last stage of the Communist regime, the courage to join forces with a local civic initiative and oppose the conversion of the last remnants of old Benešov into a prefabricated housing estate. The town hall was located in two old houses on the northern side of the Benešov square. Pleskot added a long rear wing to one of them, connected the two houses from within, and added an extra storey. The architect had the house on the left, sited on the longitudinal axis of the square, painted red, and added a clock as a typical symbol of a town hall. Remnants of Rondo-Cubist ornaments from the 1920s were preserved in the facade of the house on the right, so as not to strip the house of its original identity completely. The critic Vladimír Czumalo "fumbled" in his search for the correct ratio between the "memory of the building" and the "architect's innovations":* Conservationists on the other hand criticized the architect for having removed the old wooden roof beams in the house on the right. *** The beams had to give way to a new peristyle inside the town hall, a four-storey hall that, in Pleskot's own words, "carries the meaning of a free democratic space striving not to succumb to fashions and to serve as a good and permanent standard at any time".**

When Christian Norberg-Schulz, the author of the famous book *Genius loci*, was asked in 1990 what features he considered specific to the Central European or Czech architectural tradition, he responded that there was a special subtlety of sunlight that the architects of the past were able to employ to create a subtle play of shadows on facades plastered in light colors.[70] Frank Gehry made exactly the same comment on this topic in Prague. The observations of these prominent figures may serve as a guideline to architects who wish to lend a regional touch to their works. Such architects are not numerous in the Czech Republic, but Josef Pleskot referred to himself as such in the 1990s. He would sometimes use the means described by Norberg-Schulz to this end. Sunlight undoubtedly helps shape the expression of the rear wing of the Benešov town hall with its shaded ambulatory. The architect made an even more marked use of it in the inwardly curved wall of the annex facing the square, with the concave portion of the wall marking the meeting place of the municipal council.

70 Petr Kratochvíl – Pavel Halík, "Rozhovor s Christianem Norbergem-Schulzem" (An Interview with Christian Norberg-Schulz). *Architekt* XXXVI, 1990, Issue 16, pp. 1, 6.

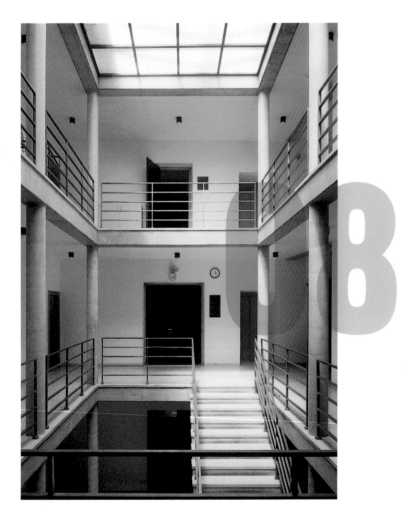

* Vladimír Czumalo, "Cestou pokory". *Architekt* XLI, 1995, Issue 14–15, pp. 1, 3, 4.

** Josef Pleskot, "Autorský komentář". *Architekt* XLI, 1995, Issue 14–15, p. 3.

*** Jiří Škabrada, "Cestou pokory?". *Architekt* XLI, 1995, Issue 18, p. 27.

Mojmír Chromý, "Vyjádření starosty". *Architekt* XLI, 1995, Issue 14–15, p. 4.

„Rekonstrukce a dostavba radnice v Benešově". *Fórum architektury a stavitelství* 1996, Issue 2, pp. 31–32.

Jan Man–Jiří Horský, "Interview s Mojmírem Chromým". *Architekt* XLII, 1996, Issue 4, pp. 3, 13–19

Josef Pleskot. AP atelier. Galerie Jaroslava Fragnera, Praha 1997, pp. 40–43.

Wolfgang Jean Stock, "Die Hauptstadt weiterbauen". *Der Architekt. Zeitschrift des Bundes Deutscher Architekten BDA*, 1999, No. 8, p. 39.

Petr Kratochvíl–Pavel Halík, *Contemporary Czech Architecture / Tschechische zeitgenössische Architektur*. Prostor – architektura, interiér, design, Prague 2000, pp. 39–41.

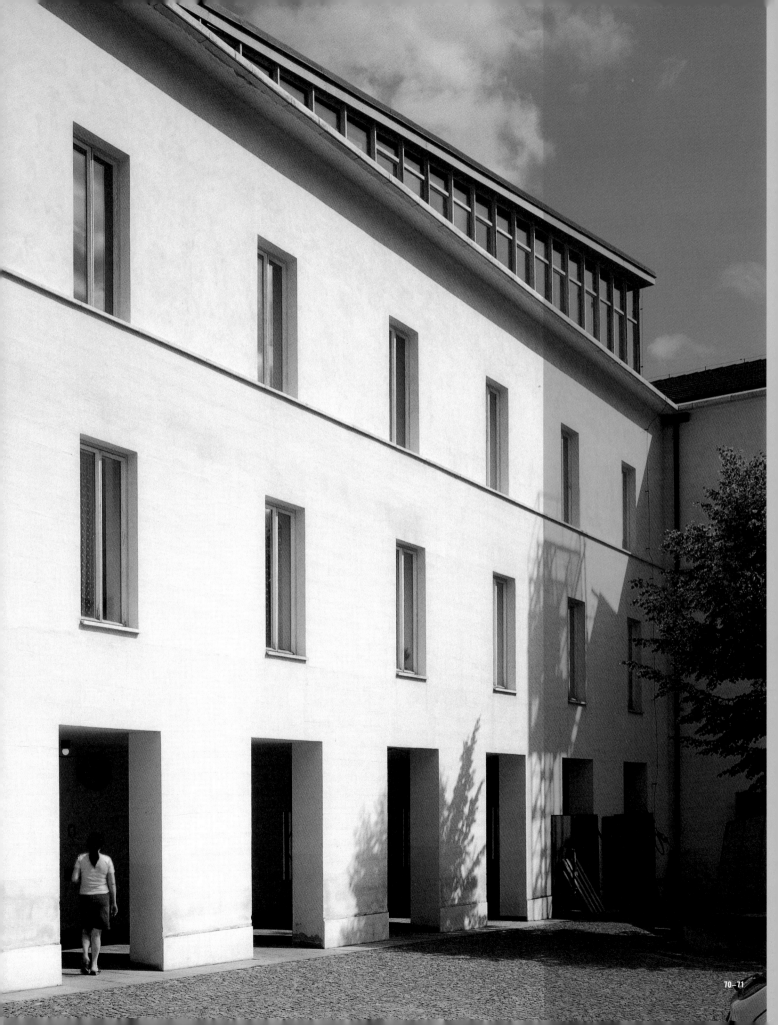

Petr Hrůša – Petr Pelčák, office and laboratory building in Olomouc, U Dětského domova Street 263. 1994 –1995

The programme of modern Regionalism did not elicit a great response in the Czech Republic, mainly because in the oppressive times of the Iron Curtain, non-conformist Czech architects had a greater need to use their works to express their affinity to the West, rather than their Czech identity. Nonetheless, the Brno-based architects Petr Hrůša and Petr Pelčák have rather more complex reasons for their distaste for intentional Regionalism. They are both convinced that any good architecture ought to be "universal" within the meaning of Catholic universalism. As if citing the 19th century Romantics, Augustus Welby Pugin or John Ruskin, they both contend that a good work needs to relate first and foremost to the vertical dimension, to God, and only then should it firmly rest in its place and respond to the regional specifics of the place.[71] Hrůša and Pelčák's pleas for quality craftsmanship, which experienced a real decline after 1948 and which needed to be improved again after Velvet Revolution, carry a similar Pugin-Ruskinian note. A building housing offices and laboratories for the testing of the quality of river water, built by the two Brno architects in a bend of the Morava River at the periphery of the city of Olomouc, became a manifesto of such architecture, well built from stone and brick. They confessed that while working on the building, they had in mind "a solid craft, instead of an assembly of designed elements".* The art historian Pavel Zatloukal who was interested in references to older Central European traditions noticed "Viennese-Brno" windows standing off the front side, and mainly the corbelled cornice reminiscent of the cornices used around

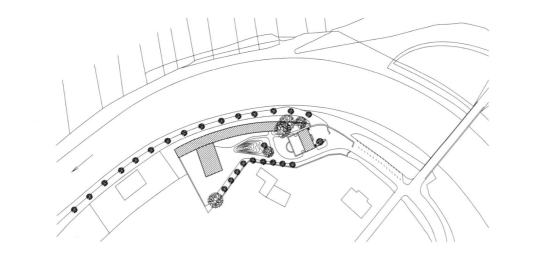

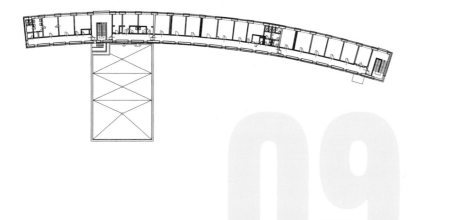

09

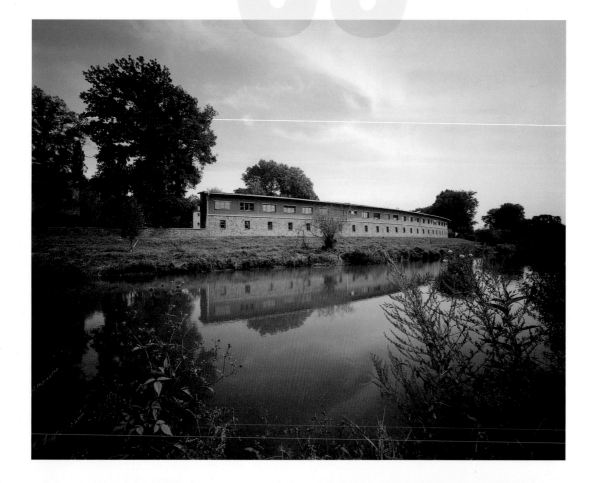

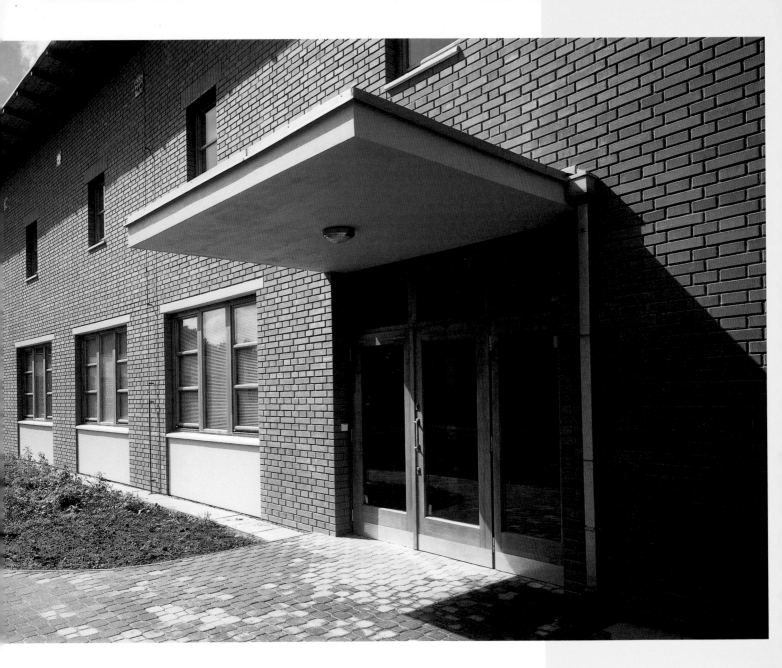

 * Jiří Horský, "O normálním domě hovoříme s Petrem Hrůšou a Petrem Pelčákem". *Architekt* LXII,
 1996, Issue 19, p. 16.
 ** Pavel Zatloukal, "Tvrz v ohybu řeky". *Architekt* LXII, 1996, Issue 19, p. 25.

 "Ze zprávy autorů". *Architekt* LXII, 1996, Issue 19, p. 23.
 Aleš Burian – Petr Pelčák – Jindřich Škrabal – Ivan Wahla (eds.), *Obecní dům / Brno / 1988 – 1997.*
 Obecní dům, Brno 1997, pp. 16 – 17.
 Petr Kratochvíl – Pavel Halík, *Contemporary Czech Architecture / Tschechische zeitgenössische
 Architektur.* Prostor – architektura, interiér, design, Prague 2000, pp. 54 – 56.

Aleš Burian – Gustav Křivinka, office building in Brno, Lazaretní Street 13. 1994–1996

In 1989, the architects Hrůša and Pelčák established an association, Obecní dům, in Brno. The association organizes exhibitions and publishes catalogues on 20th century architecture in Brno. In the process of his art historical research on this topic, Pelčák arrived at the conclusion that there was a sort of a triangle, or perhaps a region, formed by Vienna – Bratislava – Brno, from which a strong tradition of purified Classical architecture emerged. What Pelčák has in mind are the works by architects active in the first third of the 20th century: Vienna-based Otto Wagner, Adolf Loos, and Josef Frank; Bratislava-based Friedrich Weinwurm; and Brno-based Ernst Wiesner. Pelčák and his associates appreciate Wiesner's buildings more than the works by the idol of Brno Functionalism, the author of the Avion hotel (1927–1928), Bohuslav Fuchs. They argue that Wiesner's houses are of a stronger construction, built with better craftsmanship, and as such "resist the passage of time" better than Fuchs's overly experimental works.[72] In the first half of the 1990s, Pelčák's friends from Obecní dům, Aleš Burian and Gustav Křivinka, subscribed to the legacy of Wiesner's purified Classicism. In 1994, Geodis, a company engaged in geodetic and cartographic services, retained the two architects to design its office building to be located at the periphery of Brno, next to a small railway station. Following the model of Wiesner's buildings from the 1920s, the architects conceived the building as an austere "house with windows" spaced along the facade in classically balanced proportions. Larger glazed surfaces that bring the building closer to the topical architecture of the 1990s were used only for the illumination of the staircase and an atrium spanning three floors: a kind of "soul" of the building, placed in the centre of the V-shaped ground plan.

Burian and Křivinka described their introverted concept of Geodis as follows: "An austere face does not necessarily mean an austere soul".*

72 Petr Pelčák, "Dílo Bohuslava Fuchse pohledem architekta"(Bohuslav Fuchs's Work through the Eyes of an Architect), in: *Pocta Bohuslavu Fuchsovi* (Homage to Bohuslav Fuchs). Fakulta architektury VUT v Brně, Brno 1995, pp. 65–68.

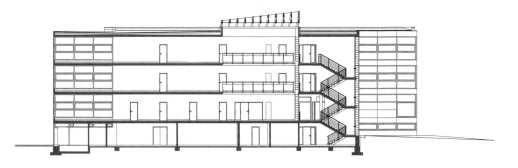

10

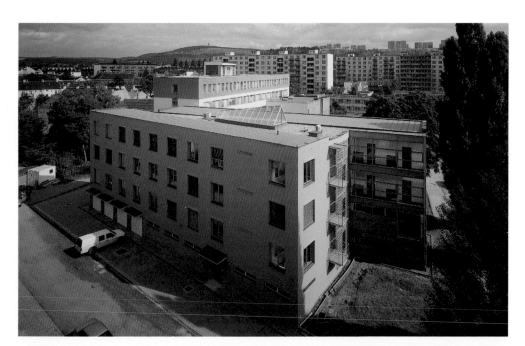

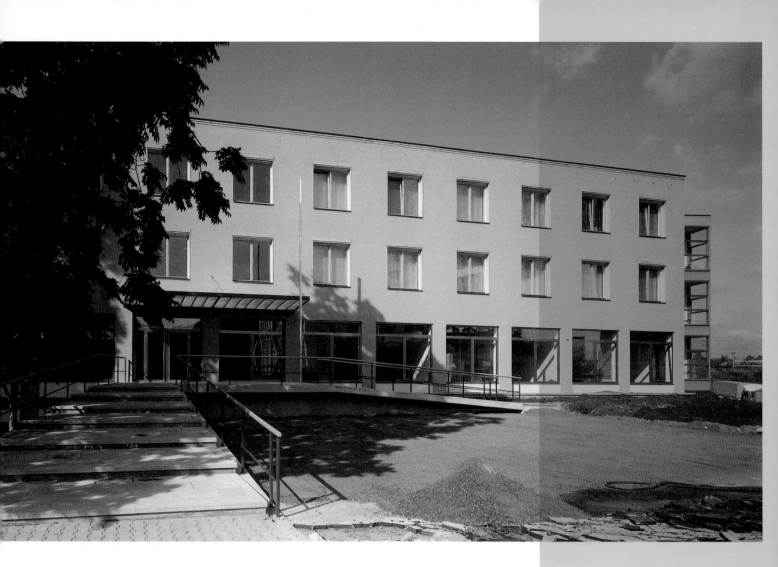

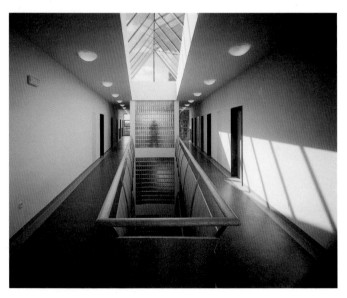

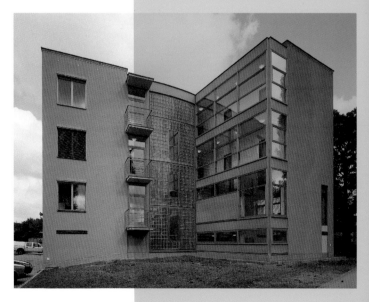

* "Z autorské zprávy". *Architekt* XLII, 1996, Issue 4, p. 27.

Aleš Burian – Petr Pelčák – Jindřich Škrabal – Ivan Wahla (eds.), *Obecní dům / Brno / 1988–1997.*
Obecní dům, Brno 1997, p. 23.
Vladimír Šlapeta (ed.), *Baustelle: Tschechische Republik. Aktuelle Tendenzen Tschechischer*
Architektur. Akademie der Künste, Berlin 1997, p. 77.
Aleš Burian – Gustav Křivinka, "Geodis Brno". *Zlatý řez*, No. 11, Spring 1996, pp. 30–32.
Aleš Burian – Gustav Křivinka, "Geodis Brno". *Architekt* XLIII, 1997, Issue 4–5, pp. 12–13.

Ladislav Lábus – Lenka Dvořáková – Zdeněk Heřman, assisted living houses in Český Krumlov-Vyšehrad, 1994–1997

Burian and Křivinka wished to approach their Geodis building in a contextual manner. After a thorough study of the environs, however, they concluded that there was nothing to go by. When Prague-based architect Ladislav Lábus worked on assisted living housing for seniors with Zdeněk Heřman and Lenka Dvořáková, commissioned by the town of Český Krumlov in 1994, he found himself in a similar situation. The municipality selected a plot on the top of a hill, in the midst of chaotic modernist development from the 1950s and 1960s but with a beautiful view of the historical centre. Lábus sought the context for his project precisely there, in the historical core, paved so well by Hana Zachová not long before that. Lábus became interested in the motifs from Český Krumlov depicted in the paintings by the Austrian Expressionist painter, Egon Schiele: the method employed by Schiele to capture the town's "depression and crowdedness, amalgamation and variety of expression", as Lábus referred to it himself in 1997.* He moved the building housing a tiny café, a club room, physicians' offices and other services for the seniors to the side, and arranged the three residential houses in a condensed, jagged formation evoking the curvature of the lanes of the old Krumlov. "The horizontal and linear nature of the southern facade and the abstract rendition of the northern one respond to the crowdedness and layering of Krumlov's historical development, as well as the frailty of its open corridors" – that is how the architect described the "essence" of his design.*

Lábus practiced in Alena Šrámková's studio for a long time in the 1980s. He adopted her belief that architecture should not impose conspicuous and unusual forms on people. When he contemplated the Český Krumlov commission, he concluded that it ought to be accommodating to the users of the new complex, i.e., senior citizens, by being conservative and traditional in both concept and details to a certain degree. The architect's effort to be traditional and inconspicuous sometimes results in the most modern Minimalism, as shown inter alia by the gazebo – a sort of an enlarged sculpture by Sol Le Witt. The main objective pursued by Lábus in Český Krumlov, however, was a deliberate suppression of any elements that might evoke the atmosphere of a hospital, the atmosphere of an "institution". According to Lábus, the building should not be ostentatious and visibly pride itself on the good done onto senior citizens. It will suffice for it to be functional, simple and pleasant, without the notoriously empty corridors and entrance halls. According to Lábus's 1999 statement, any redundant and excessively large space evokes the atmosphere of an institution.** That is the reason why the area of the café in the Krumlov complex is only 25 square meters, and why the architect decided against adding balconies to the residential houses. His patient observation of how old people live showed

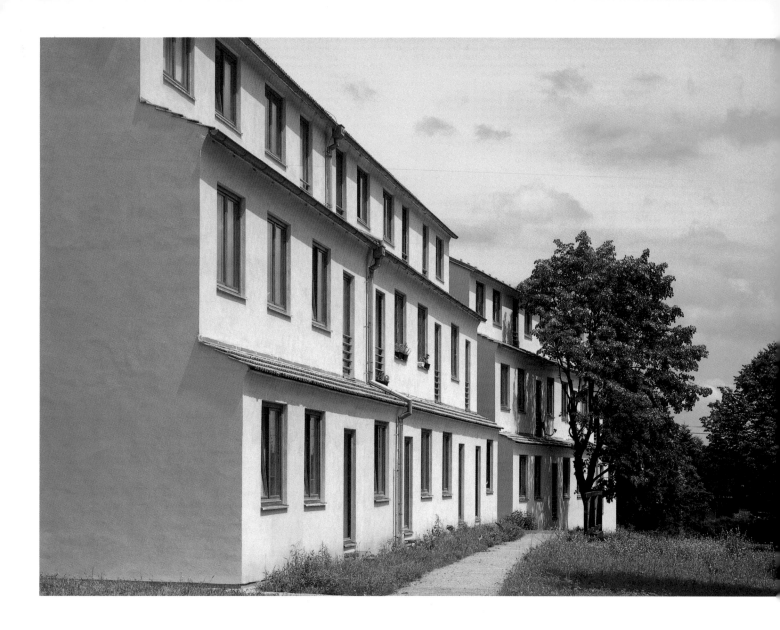

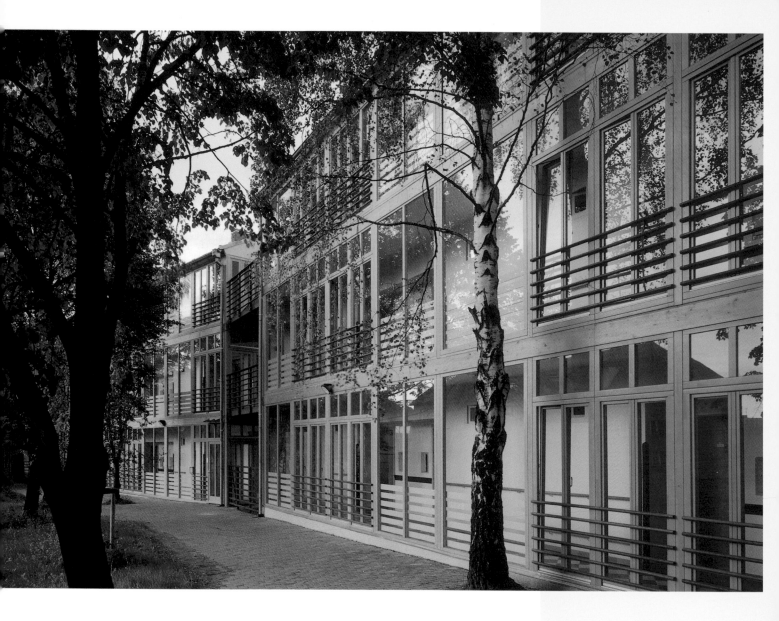

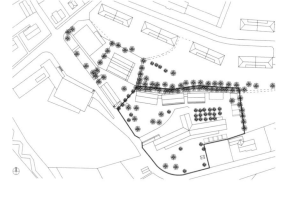

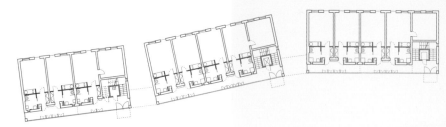

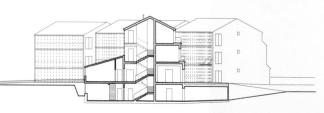

 * "Autorská zpráva". *Architekt* XLIII, 1997, Issue 16–17, pp. 16–17.
 ** Ladislav Lábus, "Komunikace versus bariéry aneb skrze zdi". *Fórum architektury a stavitelství* 1999, Issue 5–6, pp. 42–45.

Rostislav Švácha, "Péče proti instituci". *Architekt* XLIII, 1997, Issue 16–17, p. 20.
"Dům pečovatelské služby v Českém Krumlově". *Stavba* IV, 1997, Issue 6, pp. 34–39.
Petr Kratochvíl–Pavel Halík, *Contemporary Czech Architecture / Tschechische zeitgenössische Architektur*. Prostor – architektura, interiér, design, Prague 2000, pp. 81–83.
Radomíra Sedláková–Marie Platovská (eds.), *Architekt Ladislav Lábus*. Galerie Jaroslava Fragnera, Praha 2004, pp. 62–67.

Vlado Milunič, residential complex Hvězda in Prague 6-Břevnov, Na Okraji, Křenova, Na Petřinách Streets. 1994–1999, 2000

Lábus's houses for senior citizens in Český Krumlov are among the few examples of social housing sponsored by the Czech state in the 1990s. The Czech state had no significant interest in projects of this kind. Even today, right-wing politicians recommend that citizens take care of their housing themselves and believe that the housing shortage will be resolved by deregulation of rents. Only private companies build larger numbers of apartments. The Hvězda residential complex, designed in 1994 by one of the authors of the Dancing Building, Vlado Milunič, was one such private enterprise. His creation stands on the edge of Petřiny, Prague's first prefabricated housing estate from the late 1950s. The architects Martin Feistner, Jiří Hůrka and Vítězslava Rothbauerová, who competed with Milunič for the same commission, took a liking to Petřiny and wished to respect its rational urbanist scheme in their project. Milunič on the other hand denounced Petřiny as a "pseudo-town", and began to refer to his own programme as a "departure from the Charter of Athens".* The jagged lines of the complex, accentuated by octagonal towers at the corners – allusions to the nearby Mannerist Hvězda folly of 1555 – reflect the architect's liking for the organic ground plans of medieval towns and townships adhering to the coast of the Mediterranean Sea. Milunič, however, did not wish to hide behind the "established Minimalist cliché" *** even with respect to the design of the houses themselves, as well as their details, compared by the critic Martin Sedlák to "something akin to primal schemes from the construction and carpentry textbook". To put it simply, according to Milunič, the architecture of Czech austerity lags behind the variety of real life. In his own words: "I think that the Minimalist register of Functionalist means of expression falls short of real life".**

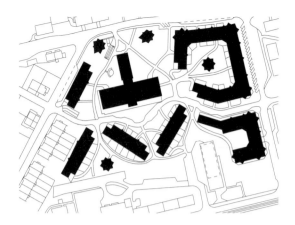

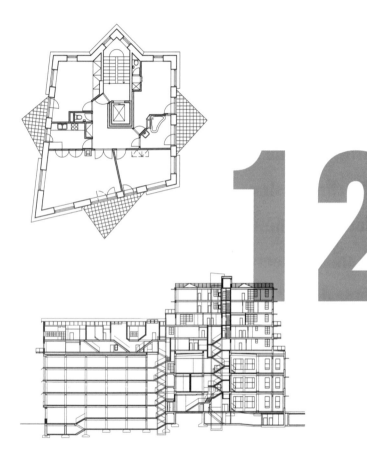

12

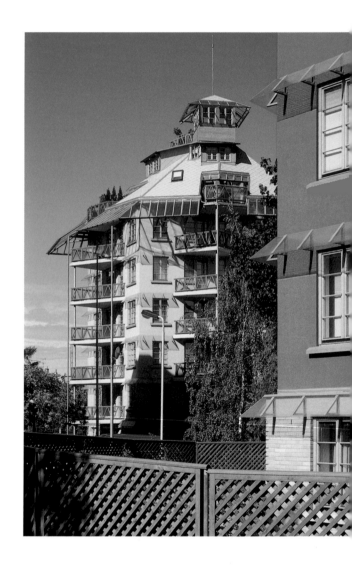

* Vlado Milunič, "Odklon od Athénské charty". *Architekt* XLII, 1996, Issue 3, p. 28.
** Milena Sršňová, "Obytný areál Hvězda na Petřinách". *Stavba* V, 1998, Issue 6, pp. 15–21.
*** Vlado Milunič, "Odklon od Athénské charty". *Architekt* XLV, 1999, Issue 10, pp. 3–12.

Vlado Milunič, "Areál Hvězda-Petřiny". *Stavba* II, 1995, Issue 1, pp. 5–7.
Vlado Milunič, "Imploze aneb druhý dech sídliště". *Architekt* XLII, 1996, Issue 10, p. 38.
Vladimír Czumalo, "Chytřejší podstruktura na Petřinách". *Architekt* XLV, 1999, Issue 10, pp. 8–9.
Josef Holeček, "Miluji – nemiluji". *Architekt* XLV, 1999, Issue 10, pp. 9–11.
Martin Sedlák, "Nová lokalita sídliště". *Architekt* XLV, 1999, Issue 10, pp. 11–12.
Vlado Milunič, "Areál Hvězda – dostavba sídliště". *Fórum architektury a stavitelství*, 1999, Issue 5–6, pp. 24–25.
Vlado Milunič, "Bydlení v bývalé továrně". *Fórum architektury a stavitelství*, 2000, Issue 5–6, pp. 24–25.
Ivan Margolius, "Hvězda housing development. Eastern block". *World Architecture*, 2000, No. 86, pp. 54–59.

13

Jan Línek, family estate at Kostelec nad Černými lesy. 1995–1998

Milunič accepted the role of an opponent of Czech austerity also because he did not stop believing in the Postmodernist values of narration, irony, and allusiveness that he had adopted in the 1970s and 1980s. Even then, he did what he could to work around the systems of prefabricated building blocks that he was forced to use in the construction of the homes for senior citizens in Prague quarters of Bohnice and Malešice. He designed those together with Jan Línek, who established his own studio after 1990. Línek's family estate on the edge of the historical core of Kostelec nad Černými lesy, designed in 1995, testifies through its organic and slightly historicizing forms to the fact that this architect did not favour the Minimalist aesthetics in the 1990s, either. In an interview given in 1999, Línek claims that Minimalism inspires the feeling of "hopelessness" in him, and he himself is not satisfied by simply "feeding a box into the computer and designing windows in a regular grid".[73] The clients – owners of a ceramics factory – approached the architect with a romantic idea of a yeoman stronghold, which was an ideal match for Línek's organic architecture. The architect also felt that sombre geometry would feel alien in the context of the irregular structure of the medieval township. Two old barns and long stone walls of a large garden served as the basis for the estate.

Línek remodelled these parts, added a residential building and a new stone tower as an "analogy"* to the towers of the local church and château. The metal coping of the tower, as well as other forms of the estate, inspired by Deconstructivism, nonetheless show that the architect did not strive for a straightforward Historicism. In 1998, Línek wrote about his Kostelec project that he was rather interested in a "penetration of modern morphology into the historical".*

73 Radek Váňa–Jiří Horský, "Profil: Jan Línek" (Profile: Jan Línek). *Architekt* XLV, 1999, Issue 9, pp. 36–39.

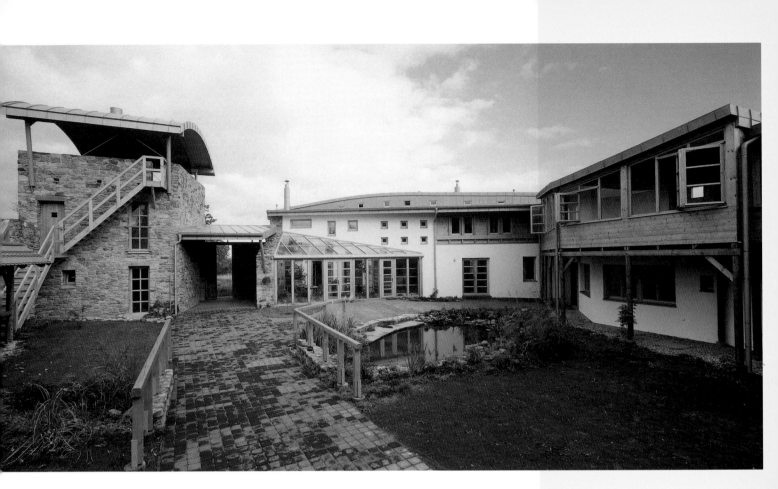

* "Rodinná usedlost v Kostelci nad Černými lesy". *Architekt* XLIV, 1998, Issue 24, pp. 33–38.

 Rostislav Švácha, "Nekrabicovitá architektura". *Architekt* XLIV, 1998, Issue 24, p. 38.
 Petr Kratochvíl–Pavel Halík, *Contemporary Czech Architecture / Tschechische zeitgenössische Architektur*. Prostor – architektura, interiér, design, Prague 2000, pp. 91–93.
 Milena Sršňová, "Zemanská usedlost". *Stavba* IX, 2002, Issue 3, pp. 54–56.

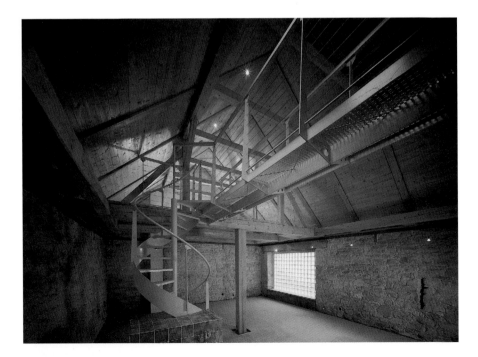

Josef Pleskot – Radek Lampa – Vladimír Krajíc – Jana Vodičková – Marco Švimberský, villa at Vrané nad Vltavou, Březovská Street. 1994–1995

After the Communist coup in 1948, the institution of small private clientele virtually ceased to exist. When some people became rich after the Velvet Revolution and wished to have family mansions built, they usually asked the architects to design a romantic building with a traditional roof, a fireplace and a smoking chimney. At Kostelec nad Černými lesy, Jan Línek "idealized" such assignment, but had in fact respected it. Other architects decided to tread the more difficult path of re-educating the clients and their tastes. Josef Pleskot underwent this anabasis a year before Línek's Kostelec project when an affluent Prague banker commissioned the design of a villa at Vrané nad Vltavou from him.

The villa at Vrané went down in the history of Czech architecture of the 1990s as something of a milestone: the type of a neo-modern family house was defined clearly for the first time after 1989, the definition being so loud and clear that few of the later-day works in this category are able to compete with it. It was also the first clear manifestation of the onset of "materials" aesthetics made world-famous in the 1990s, mainly through the efforts of architects from the German-speaking Swiss cantons. In the villa at Vrané, it is manifested by an ample use of natural wood from which the architects assembled the upper vista floor; however, it is first and foremost shown in the way both architects work with raw concrete. In an interview given in 1995, Pleskot admitted that in the Czech Republic, concrete appeared to be an almost prohibited material because people associate it with "all their negative experience with prefabricated housing".** He himself liked solidified concrete, viewing it as a "beautiful monolith of stone", and had the client's bunker-like study and the reticulated "ostentatious" wall that separates the villa's interior from the public road cast in concrete.*

In the review for the 1995 *Architekt* by a young Prague architect Jan Šépka, Pleskot's project is criticized for its trapezoid motifs in the ground-plan of the habitable rooms, and its general excess of shapes and combinations that "jeopardizes the purity of solution". Nine years later, Šépka's critique seems overly strict. However, perhaps it revealed the hidden polemic features of Pleskot's concept, a wish to depart from the line of Czech austerity to some less austere architecture. Pleskot admitted later on that the villa does feel "rather overdone".[74] However, he never accepted the criticism that when he designed the villa at Vrané, he did not consider its context, clearly defined by the small weekend cottages scattered around it. His disputes with authorities entrusted with monument conservation in the 1990s brought him to the conclusion that contextuality did not consist in imitating the appearance of the building's immediate surroundings.[75] It was more likely the monumental modelling of the local landscape above the Vltava River, the "morphology of the terrain", that the architects responded to in the generously conceived forms of their villa.***

74 "S architekty o bydlení ve městě – AP atelier, Josef Pleskot" (With Architects about Living in the City – AP atelier, Josef Pleskot). *Stavba* X, 2003, Issue 4, pp. 57–58.
75 Aleš Burian – Petr Pelčák – Ivan Wahla (eds.), *Litomyšl a soudobá architektura / Litomyšl and contemporary architecture*. Obecní dům, Brno 2001, p. 13.

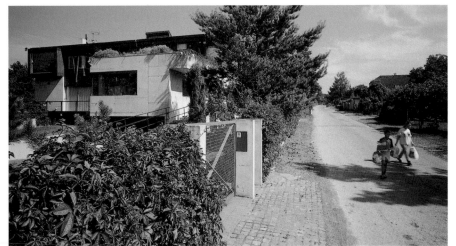

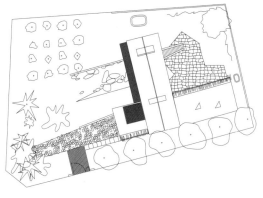

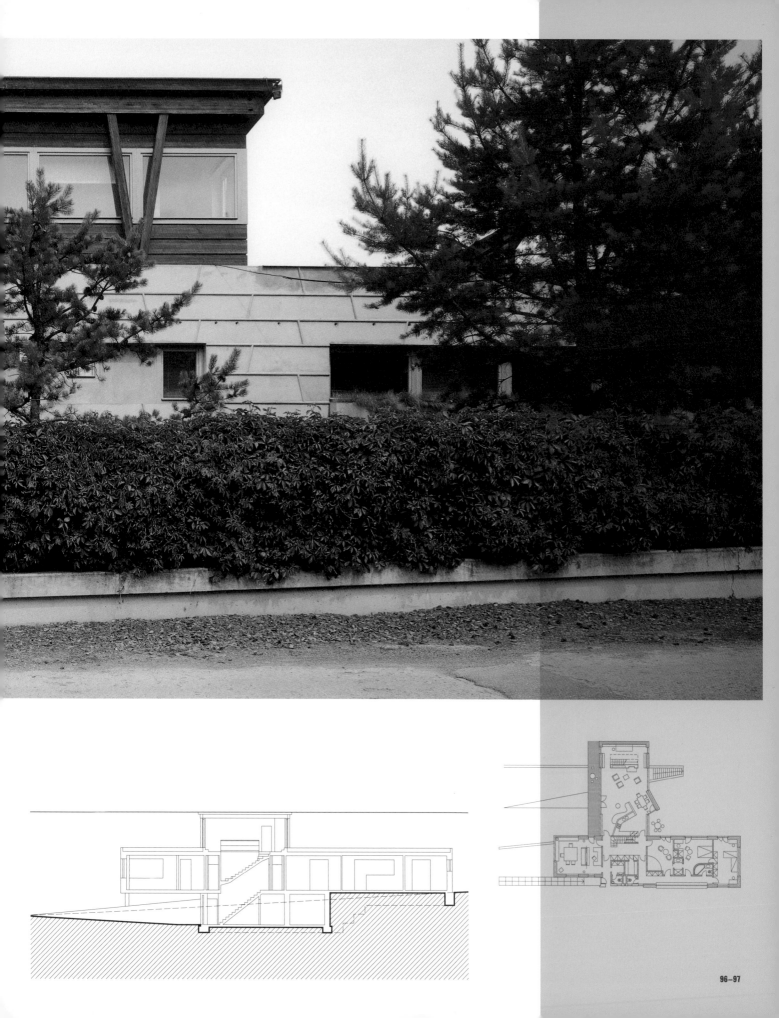

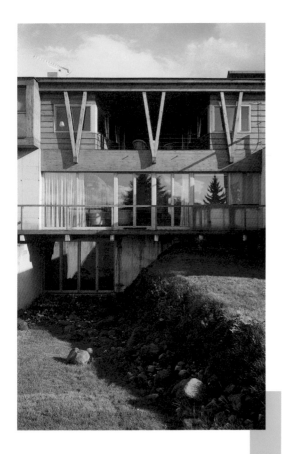

14

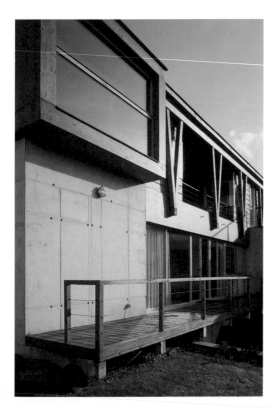

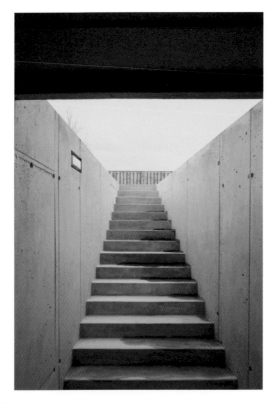

 * Milena Sršňová, "Josef Pleskot / AP atelier". *Stavba* II, 1995, Issue 1, pp. 36–39.

 ** Milena Sršňová–Rostislav Švácha, "Novostavba vily ve Vraném nad Vltavou". *Stavba* II, 1995, Issue 2, pp. 16–23.

*** "Z autorské zprávy". *Architekt* XLII, 1996, Issue 4, pp. 32–34.

581 Architects in the World. TOTO Shuppan, Tokyo 1995, p. 234.

"Villa in Vrané nad Vltavou". *Bauwelt* LXXXVI, 1995, Issue 41, pp. 2325–2327.

Jan Šépka, "Vila ve Vraném nad Vltavou". *Architekt* XLI, 1995, Issue 18, pp. 3–5.

Josef Pleskot. AP atelier. Galerie Jaroslava Fragnera, Praha 1997, pp. 44–49.

Vladimír Šimkovič, "Josef Pleskot a intelektuální abstrakce." *Architekt* XLIV, 1998, No. 9, p. 59.

Petr Kratochvíl–Pavel Halík, *Česká architektura / Czech Architecture 1989–1999*.

Prostor – architektura, interiér, design, Prague 1999, pp. 93–95.

Andrász Balász, "A bontás sokkal merészebb tett, mint az építés". *Octogon – architecture design*, 2001, No. 3, pp. 60–65.

Ivan Kroupa – Radka Exnerová, family house and garden house-studio at Mukařov, Lesní Street. 1995–2000

The comment of the American architect and critic, Luis Marques, on a building that "self-confidently, almost rebelliously distances itself from the surrounding, architecturally mediocre development" *** would aptly describe Pleskot's unwillingness to subordinate the form of his villa at Vrané to the difficult to grasp structure of the adjacent weekend colony. When Marques made this statement in 2001, however, he was referring to a different architectural undertaking: a house built at Mukařov by Ivan Kroupa for himself and his family. The construction was commenced in 1995. As it was taking rather long, the architect built next to the house proper a small wooden house--studio, whose perfected form earned him admiration from many Czech and foreign connoisseurs. For instance, the critic Pavel Halík characterized this small building designed by Ivan Kroupa and Radka Exnerová as a "a small temple of perfection, escaping day-to-day reality".* The vision of perfection, in part almost Platonian, in part inspired by similarly conceived projects of the Czech architect active between the wars, Kamil Roškot, directed Kroupa's hand also in the design of the adjacent, larger house. The architect conceived the interior as a vertical continuum, a single space without enclosed rooms and doors, and built each of the four floors on a different ground plan. The complexity of the spatial composition is reflected in the thrillingly asymmetrical configuration of the four facades. The expression of the house changed during the process of construction. The original idea of a white, transparent building, gave way to a vision of an experiment in colors, a castle, a cave, a "compact, carved--out stone".** As a true Neo-Platonist, Kroupa noted in 2001 that the actual condition and atmosphere of the house were impossible to document in any way,** and decided to temporarily cease publishing his works in Czech architectural journals.

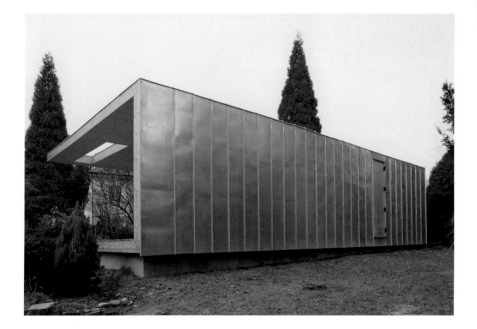

15

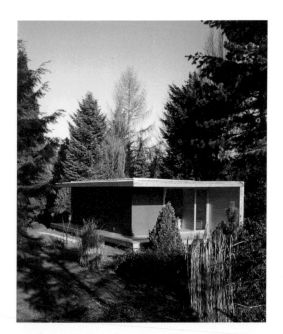

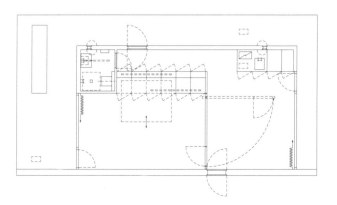

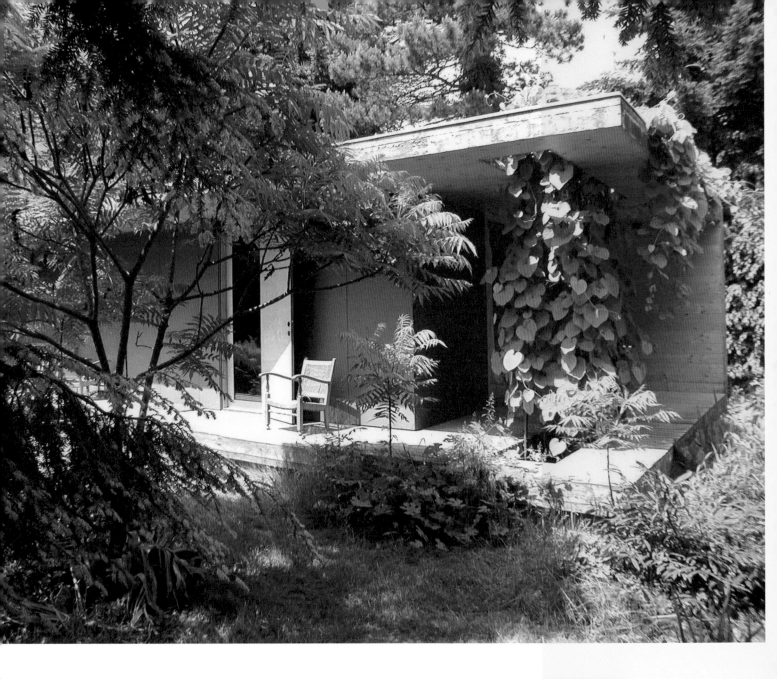

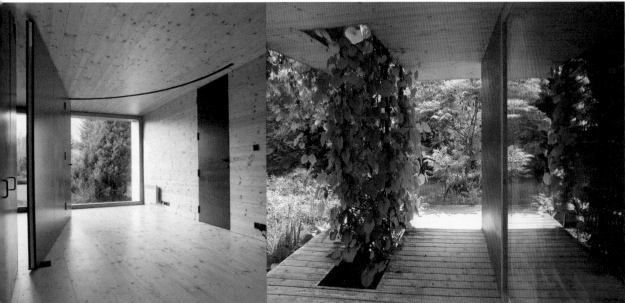

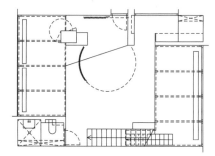

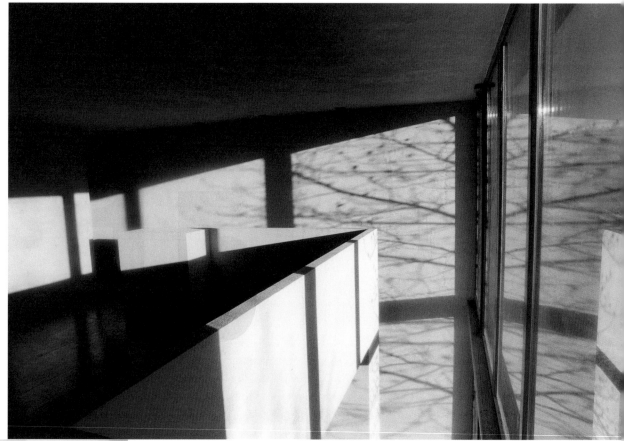

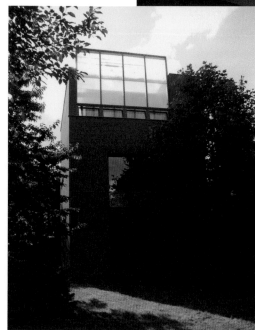

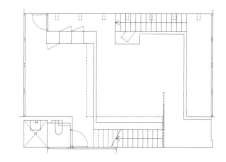

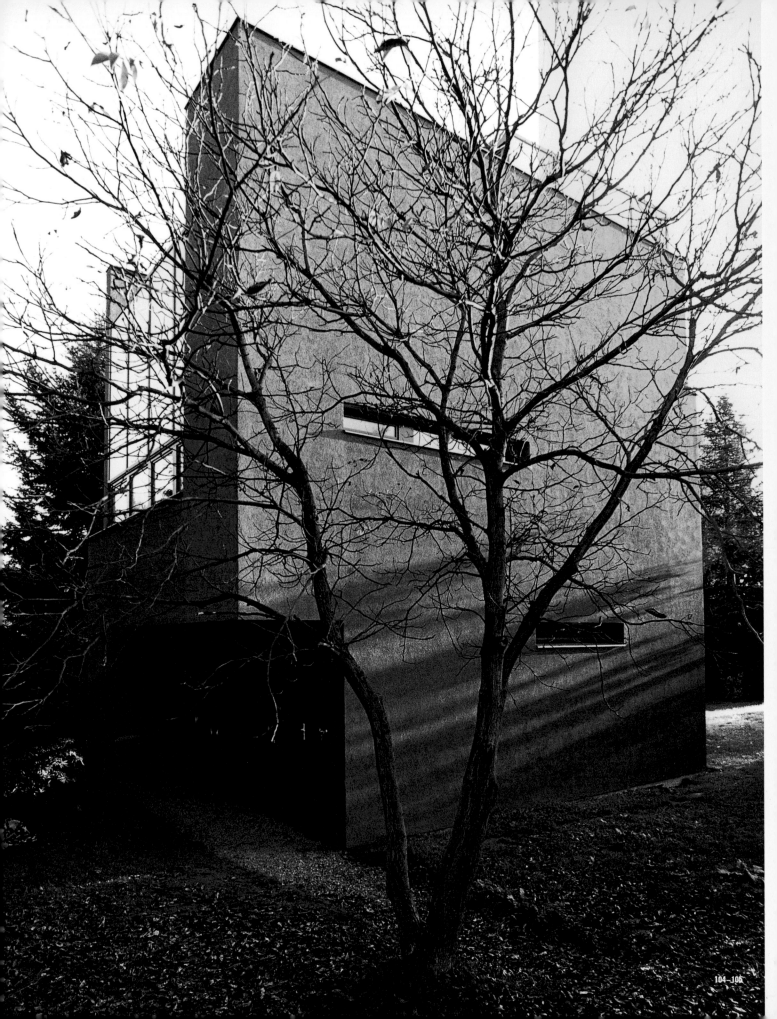

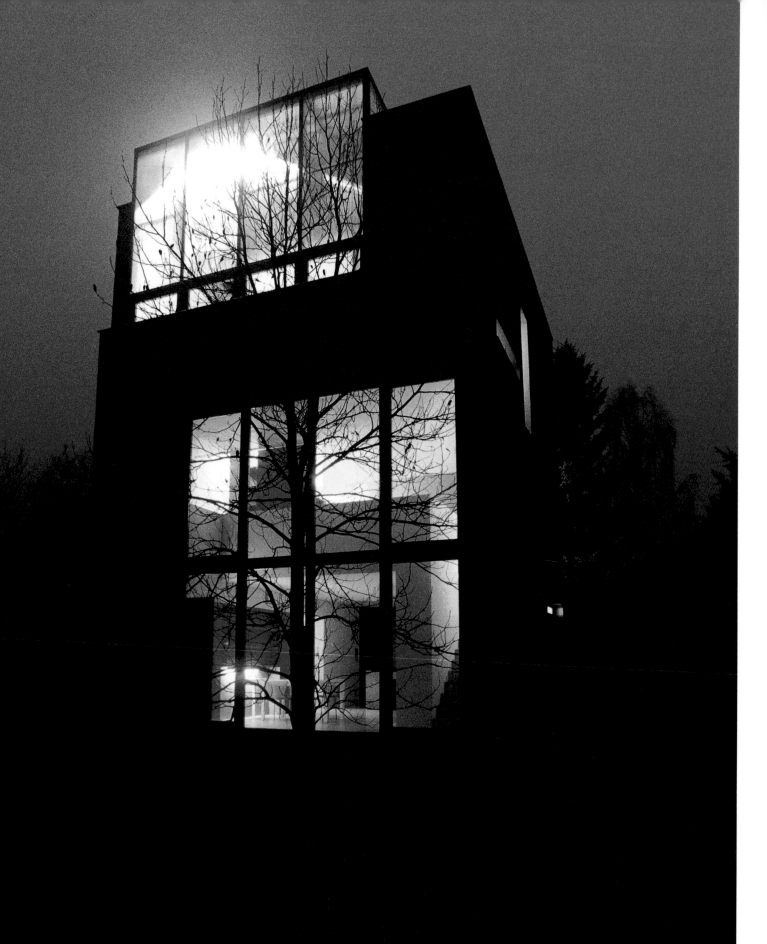

* Pavel Halík, "Rodinný domek – dřevěný artefakt". *Architekt* XLIV, 1998, Issue 22, p. 31.

** Ivan Kroupa, "Rodinný dům v Mukařově". *Architekt* XLVII, 2001, Issue 11, pp. 3–5.

*** Luis Marques, "Podstata lokality – autonomie a svébytnost". *Architekt* XLVII, 2001, Issue 11, p. 15.

Ivan Kroupa, "Rodinný dům v Mukařově". *Stavba* IV, 1997, Issue 2, pp. 18–19.

"Dřevěný domek v Mukařově". *Architekt* XLIV, 1998, Issue 22, pp. 28–31.

Lenka Žižková et al. (ed.), *Český interiér a nábytkový design / Czech Interior and Furniture Design 1989–1999*. Prostor – architektura, interiér, design, Prague 2000, pp. 116–118.

Ivan Kroupa, "Rodinný dům v Mukařově". *Fórum architektury a stavitelství* 2000, Issue 5–6, pp. 38–39.

"Autorská zpráva". *Architekt* XLVII, 2001, Issue 5, pp. 34–35.

"Wohnhaus in Mukařov". *Bauwelt* XCIII, 2002, No. 10, pp. 24–25.

Ivan Kroupa. *Realizace a projekty* 1988–2003. Praha 2003, pp. 30–51.

"Little house in forest". *Iau*, 2003, No. 2, pp. 94–95.

The Phaidon Atlas of Contemporary World Architecture. Comprehensive Edition. New York–London 2004, pp. 598–599.

Petr Hájek – Jaroslav Hlásek – Jan Šépka, Improvements at Horní Square in Olomouc. 1995–2001

The staunch critic of the villa at Vrané, Jan Šépka, was given the opportunity to gain the experience of a practicing architect in 1995. He marked the coming of a new generation which attended schools of architecture after the Velvet Revolution. In 1995, Šépka and his peers, Petr Hájek and Jaroslav Hlásek, won a competition for the pavement of the Horní Square in Olomouc. The City of Olomouc held the competition thanks to the efforts of Pavel Zatloukal, an art historian, director of the local Museum of Art and a member of the municipal council. The competition winners viewed the space of the square, with its landmarks dominated by a 15–16th century town hall and an enormous Baroque Trinity Column, as if it were a parlour or a living room. They wished to furnish it with smaller furniture themselves, but felt it was first necessary to fix its carpet, the pavement. Before the competition, this surface consisted from a variety of different types of pavement, from cobblestones from the first half of the 19th century to the smooth, monumental pavement in front of the town hall entrance. The architects decided to preserve this status and to leave all of the random patches in the carpet: to conceive it – in their own words – as "an illustration of development at individual stages".* Unlike the pavements in Český Krumlov, designed by Hana Zachová and evoking the impression of a uniform texture of a difficult to guess time of origin, Horní Square gained the appearance of a collage from different textures created at different moments in time.

Brass plaques indicating the directions of individual sections of the pavement, the design of movable benches and bicycle stands, a metal model of the town and a new fountain created by a native of Olomouc, the Czech-French sculptor Ivan Theimer,

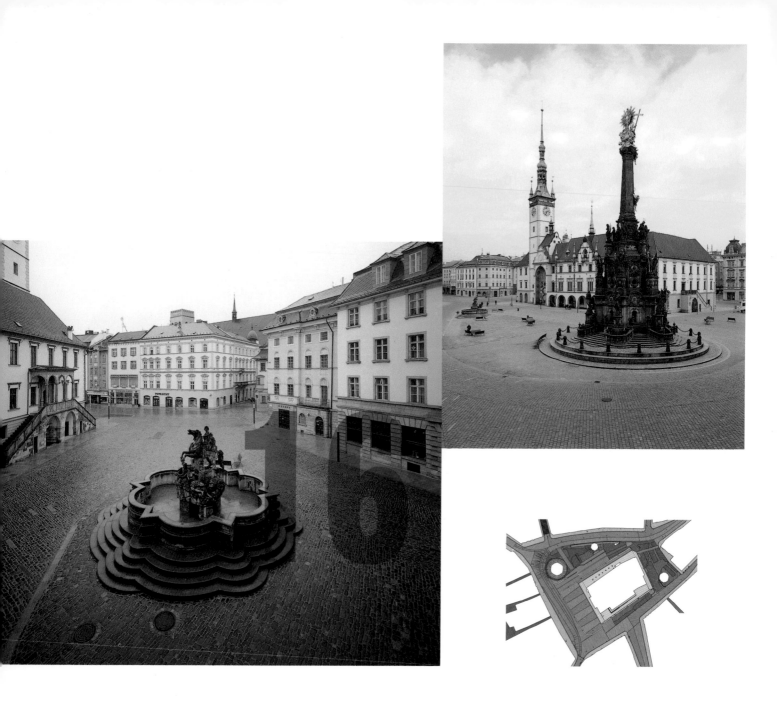

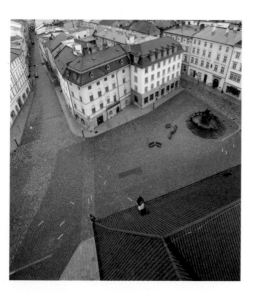

* "Z autorské zprávy". *Architekt* XLII, 1996, Issue 10, pp. 21–22.

Rostislav Švácha, "Bez stropu". *Stavba* VII, 2000, Issue 3, pp. 56–62.
Markéta Cajthamlová (ed.), *Česká architektura / Czech Architecture 2000–2001. Ročenka / Yearbook*. Prostor – architektura, interiér, design, Prague 2002, pp. 66–69.
Milena Sršňová-Lidmila Cihlářová (eds.), *Architektura 2002. Ročenka realizovaných staveb v České republice*. BertelsmannSpringer CZ, Praha 2002, pp. 106–107.
Rostislav Švácha, "Náměstí jako pokoj s kobercem". *Architekt* XLVIII, 2002, Issue 1, pp. 12–13.
"Úpravy Horního náměstí v Olomouci" *Architekt* XLVIII, 2002, Issue 5, p. 8.
"Neugestaltung des Marktplatzes in Olmütz". *Bauwelt* XCIII, 2002, No. 2, pp. 34–35.
Petr Hájek–Jaroslav Hlásek–Jan Šépka, "Úpravy Horního náměstí v Olomouci".
Fórum architektury a stavitelství, 2002, Issue 4, pp. 26–29.
"Pavement of the Upper Square, Olomouc". *Piranesi* IX, 2002, No. 15–16, pp. 80–81.
Petr Hájek–Jan Šépka, "Město, prostor a život". *Stavba* IX, 2002, Issue 4, pp. 58–59.

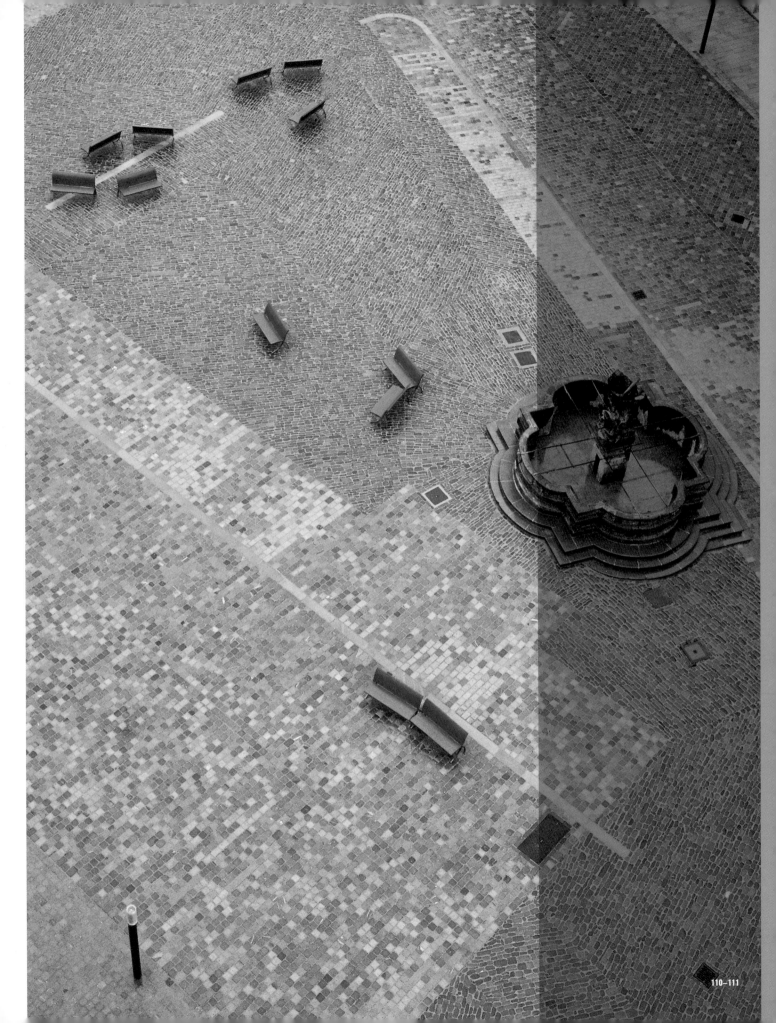

Aleš Burian–Gustav Křivinka, school and sports hall in Litomyšl, Masarykova Street 1145. 1995–1998

The modifications at Horní náměstí in Olomouc rank among good examples of municipal architectural patronage. However, the town that can boast the greatest number of contemporary architectural commissions of high quality after November 1989 is the East Bohemian town of Litomyšl. Thanks to the mayor, Miroslav Brýdl, and the town's architect, Zdenka Vydrová, a member of the Brno association Obecní dům, leading architects from both Brno and Prague found interesting tasks in Litomyšl. As a patron, the mayor Brýdl proved to possess both perseverance and the ability of diplomatic maneuvering. He did not waver in his support of neo-modern architecture despite conflicts with monument conservation authorities that sometimes guard the historical core of Litomyšl overanxiously, nor the fact that he himself is of the view that the austere architectural line is a "cold lady".[76] Brýdl could sense which architects were good, trusted them, and strove to convince the citizens of Litomyšl to trust them as well. Such a moment occurred in connection with the construction of T. G. Masaryk School, designed by the Brno architects Aleš Burian and Gustav Křivinka.

The name of the school commemorating the first Czechoslovak president testifies to a certain nostalgia for the First Republic that existed between the wars and that is remembered by the people as a model of democracy. The Neo-Functionalist architecture of the school speaks the same language, evoking a style with which the Czech society in the period between the wars almost completely identified. The column portico at the school's corner may actually be deciphered as a reference to the work of the architect Josef Gočár in whose public buildings in Hradec Králové the ideals of the First Republic found their most credible building manifestation. Unlike Josef Kiszka and Barbara Potyszová, who designed the building of the grammar school in Orlová, Burian and Křivinka did not engage in any substantial typological experiments: they opted for a traditionally conceived school building with corridors, the same type employed in Litomyšl as early as the 17th century by the local Piarists in the construction of their Baroque grammar school. The architects planned to achieve a form suited to the 1990s through well lit interiors and transparent walls. In their own words: "This transparency confirms the open, democratic nature of the school".*

When the school was completed in 1997, the building of a sports hall was added to it, enclosing the south-west side of the school yard. Burian and Křivinka opened up the walls of their school by means of large windows not only to symbolize the transparency of democracy but also to enable the students to watch the panorama of the old Litomyšl. The concept of the sports hall is completely dominated by this idea: whoever stands above the hole, on a gentle slope, may see the view through the windows, through the entire hall, as a "veduta of the town", as was the case of the critic Michal Janata. This reviewer on the staff of the *Architekt* and *Stavba* journals, however, was particularly impressed by the interior of the hall, lined with brick and roofed over by means of a construction whose wooden footing beams will remind many of hanging bosses in Late Gothic churches. Other critics, when inside the hall, even thought of the interior of the Prague Church of the Sacrosant Heart of Christ by Masaryk's favourite architect, Josef Plečnik. One of the most profane buildings in Litomyšl thus achieved, according to Janata, "the level of festivity".**

76 Aleš Burian–Petr Pelčák–Ivan Wahla (eds.), *Litomyšl a soudobá architektura / Litomyšl and contemporary architecture*. Obecní dům, Brno 2001, p. 15.

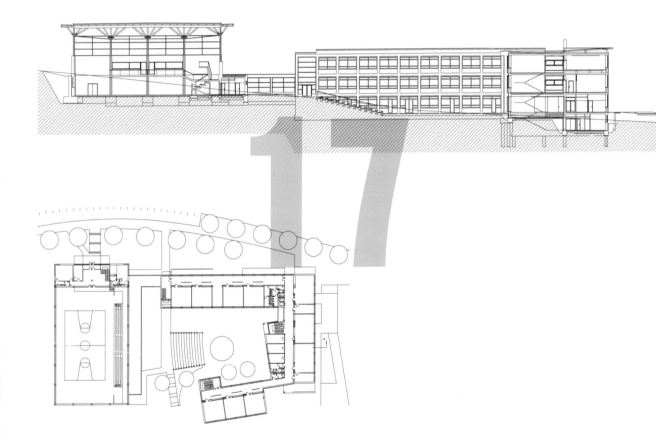

17

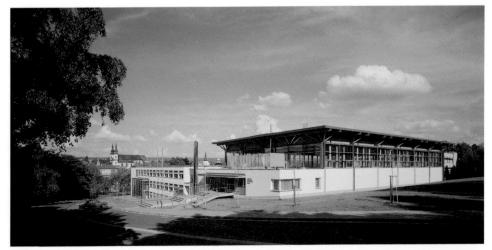

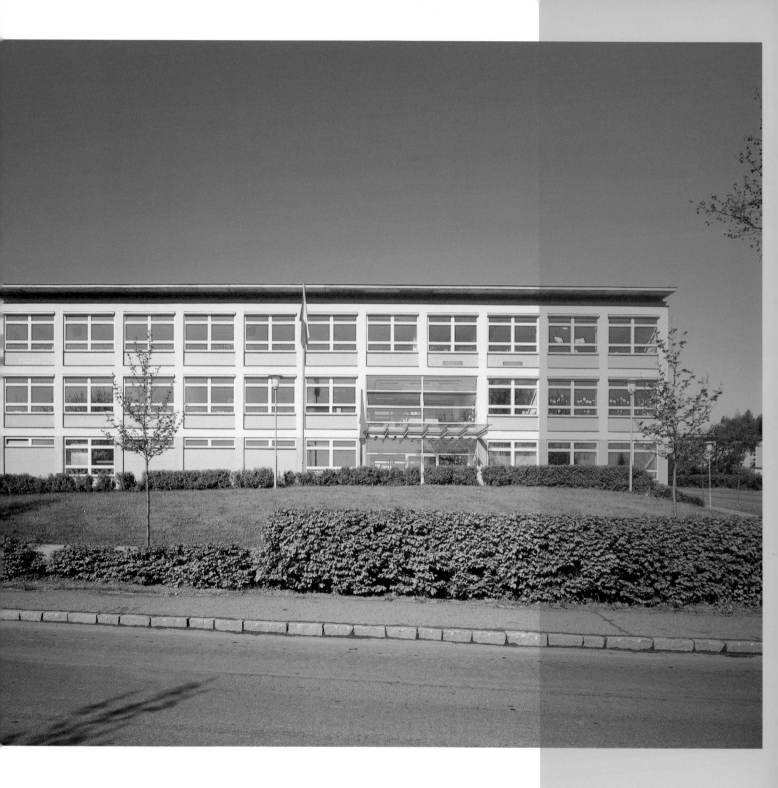

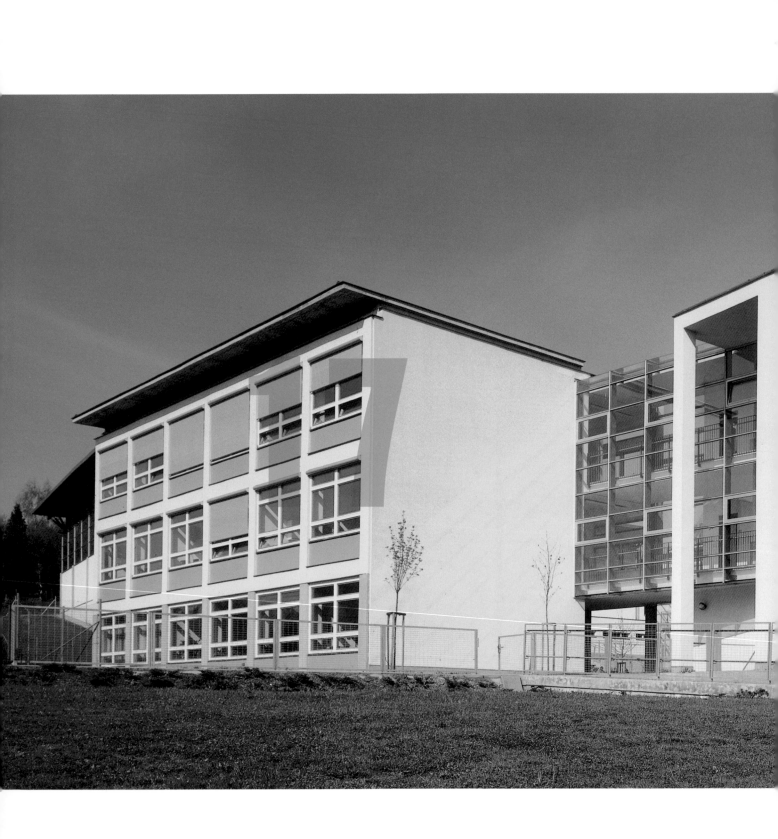

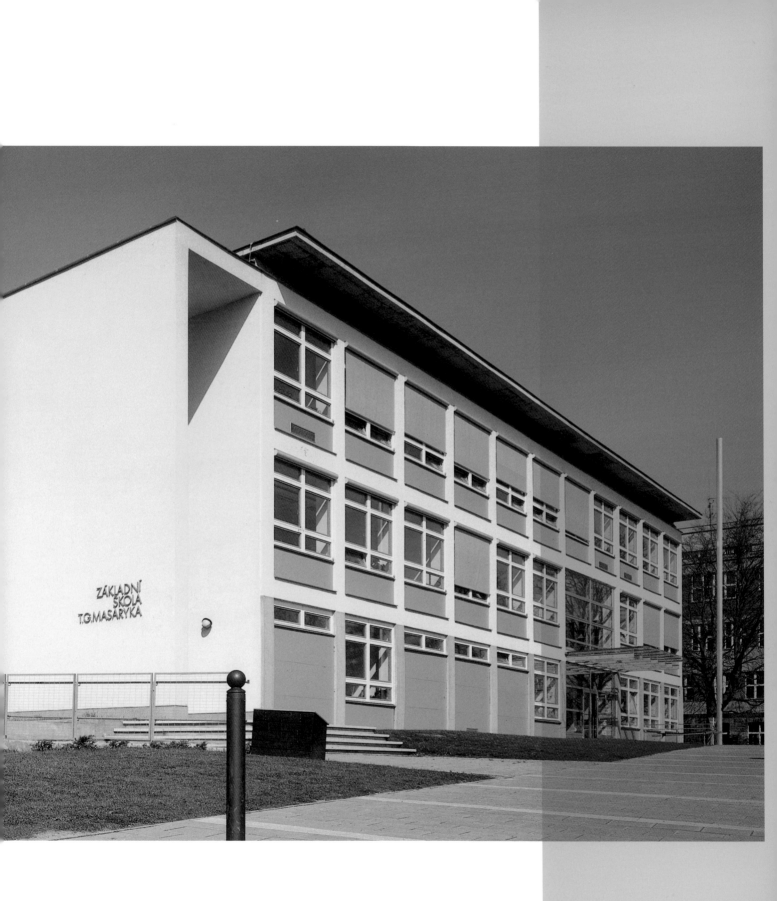

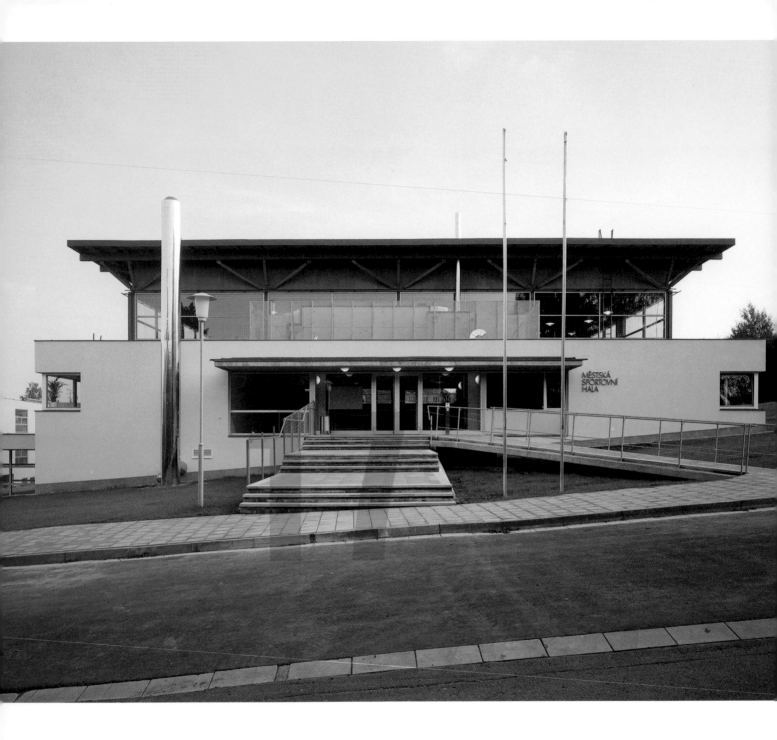

* "Z autorské zprávy". *Architekt* XLIV, 1998, Issue 4, p. 20.

** Michal Janata, "Skromnost domu je jeho slávou: tělocvična jako veduta". *Architekt* XLIV, 1998, Issue 22, p. 18.

Petr Kratochvíl, "Dům s příběhem". *Architekt* XLIV, 1998, Issue 4, p. 24.

"Autorská zpráva". *Architekt* XLIV, 1998, Issue 22, pp. 13–18.

"III. Základní škola v Litomyšli" *Architekt* XLV, 1999, Issue 5, p. 11.

Michal Janata, "Škola jako pandán historie". *Stavba* VI, 1999, Issue 6, pp. 28–29.

Petr Kratochvíl–Pavel Halík, *Contemporary Czech Architecture / Tschechische zeitgenössische Architektur.* Prostor – architektura, interiér, design, Prague 2000, pp. 50–53.

Aleš Burian–Petr Pelčák–Ivan Wahla (eds.), *Litomyšl a soudobá architektura / Litomyšl and contemporary architecture.* Obecní dům, Brno 2001, pp. 54–59.

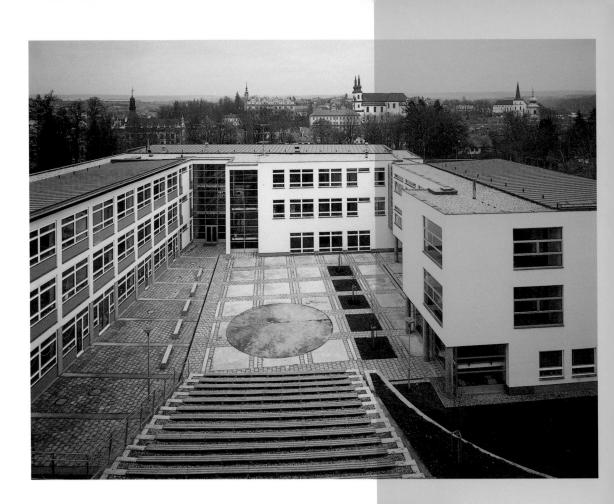

18

Radim Kousal, State scientific library in Liberec, Rumjancevova Street 1. 1995–2000

In the 1990s, the Czech state unfortunately did not turn out to be as good a patron as the municipal self-governments of Litomyšl, Benešov, České Budějovice or the tiny Horažďovice. There is a prominent exception to the rule: the Státní vědecká knihovna (State Scientific Library) in Liberec, designed by Radim Kousal. For a long time, the Liberec library occupied premises in several distant locations and generally suffered from a lack of space, despite the fact that its funds include, among other things, a unique collection of German-language literature from the Czech Lands, also referred to as sudetics. Until 1938, the plot selected for the new library building was occupied by a synagogue, destroyed by the Nazis during the Crystal Night. In the 1990s, the local Jewish community decided to donate the plot to the state, provided that a new synagogue is built on it together with the library. The funds for the synagogue were eventually donated by the Czech-German Reconciliation Fund, and this fact inspired president Havel to refer to the project as a "building of reconciliation", a metaphor that seems to have stuck to the library.

In 1990–1991, the architect Radim Kousal was practicing in the Paris studio of Jean Nouvel. At the same time, he became a member of the Liberec association SIAL, which was not going through an auspicious period in the 1990s, although its architects worked on numerous projects both in Liberec and elsewhere and even founded a university-level school of architecture there in 1994, the fifth one in the Czech Republic. While working on the Building of Reconciliation, Kousal had to overcome a host of difficulties: to site the building on a slope with an 18-meter difference in elevation, to combine the traditional operation of a library with the non-traditional operation of a mediatheke, to incorporate the separate triangle of the synagogue into the groundplan of the library building, as the library, according to the interpretation of Kousal's committed investor, Dr. Věra Vohlídalová, was supposed to "protect" the synagogue symbolically.*** Kousal imagined the library as a glass body on a concrete base, as a "simple, compact and dynamic form",* whose cascading space is transparent from the bottom all the way to the top. The synagogue, on the other hand, was conceived as a closed stone block with a mysterious interior. The architect protected the glass sides of the library and its tilted rear side from the sun by means of a mesh of metal lamellas, while the entrance front is shaded with a typical Nouvelian "visor". Aside from other critics, the new building was reviewed by Kousal's colleague from SIAL and the founder of the Liberec school of architecture, Jiří Suchomel. He compared the Library of Reconciliation to Prague's Golden Angel by Jean Nouvel, and concluded that the library was better than "that Nouvel in Prague".**

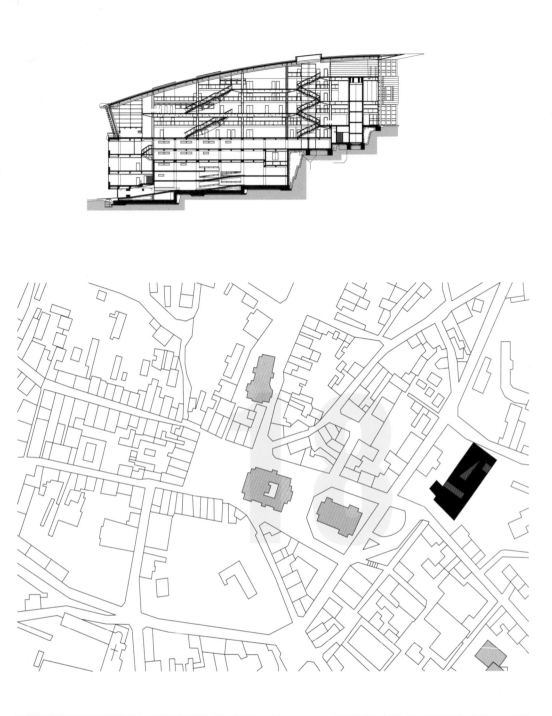

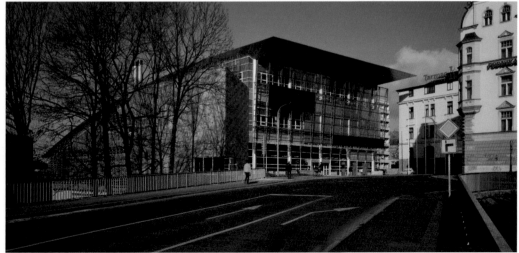

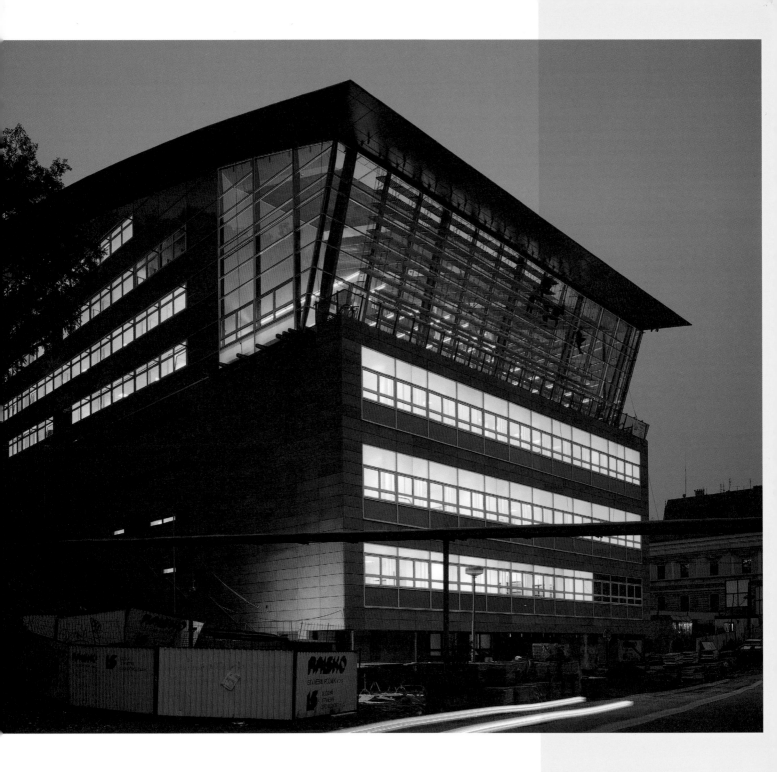

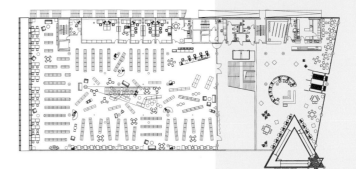

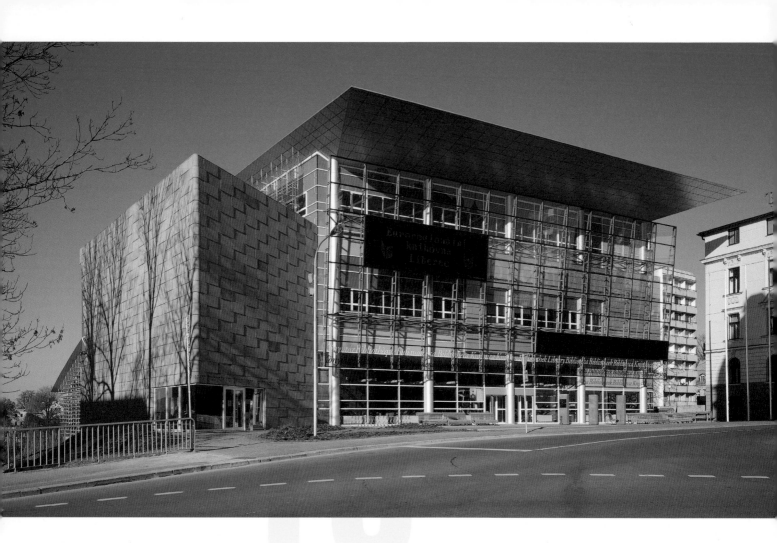

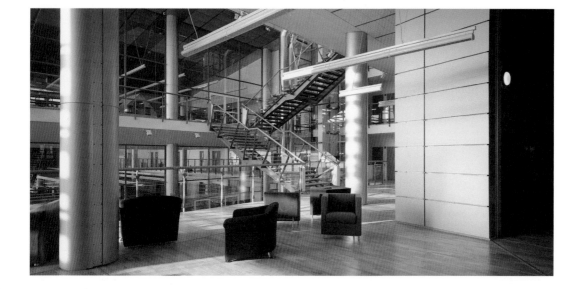

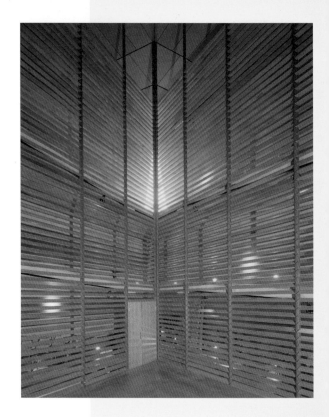

* "Z autorské zprávy". *Architekt* XLVI, 2000, Issue 2, p. 75.
** Jiří Suchomel, "Sebevědomá a korektní". *Architekt* XLVI, 2000, Issue 12, p. 9.
*** Martin Verner, "Interview s Věrou Vohlídalovou, ředitelkou Státní vědecké knihovny v Liberci, o stavbě smíření". *Architekt* XLVI, 2000, Issue 12, p. 49.

Vladimír Šlapeta (ed.), *Baustelle: Tschechische Republik. Aktuelle Tendenzen Tschechischer Architektur*. Akademie der Künste, Berlin 1997, pp. 90–91.
Milena Sršňová, "SIAL, s.r.o., Liberec". *Stavba* V, 1998, Issue 2, p. 26.
"Autorská zpráva". *Architekt* XLVI, 2000, Issue 12, p. 10.
Pavel Halík, "Knihovna jako transparentní dům". *Architekt* XLVI, 2000, Issue 12, p. 12
Petr Pelčák (ed.), *Česká architektura / Czech Architecture 1999–2000. Ročenka / Yearbook*. Prostor – architektura, interiér, design, Prague 2001, pp. 74–77.
Milena Sršňová–Libor Štěrba (eds.), *Architektura 2001. Ročenka realizovaných staveb v České republice*. BertelsmannSpringer CZ, Praha 2001, pp. 52–53.
Radim Kousal, "Stavba smíření". *Fórum architektury a stavitelství,* 2001, Issue 5, pp. 14–19.
Radim Kousal, "Stavba smíření". *Stavba* VIII, 2001, Issue 2, pp. 32–33.
Jan Randáček, "Křišťálová knihovna". *Stavba* VIII, 2001, Issue 2, pp. 34–35.
Michal Janata, "Jak otřást uspávajícím chodem přirozeného života". *Stavba* VIII, 2001, Issue 2, pp. 36–37.

Stanislav Fiala, Sipral factory in Prague 10-Strašnice, Třebohostická Street 5a. 1995 –1996

The critic Pavel Halík found industrial metaphors in Kousal's library: to him, it appeared to be an "efficient cultural factory". Other reviewers described its style as high tech. Such descriptions could also be easily applied to the Prague seat of Sipral, if only because it truly is an industrial building – a factory manufacturing glass and metal prefabricated facade elements. Despite all the similarities between the Building of Reconciliation and Sipral, the concept of the Prague factory differs in many respects. First and foremost, the author of Sipral, Stanislav Fiala, did not exert himself in the direction of superficial high tech effects. He was not concerned by the fact that his "tech" looks a little "low". This is an attitude that can boast some level of tradition in the Czech Republic. Prior to 1989, the architects Jan Louda, Tomáš Kulík and Zbyšek Stýblo subscribed to the "low tech" programme: while they admired the western stars, Richard Rogers and Norman Foster, they were well aware that unlike the aforesaid Englishmen, they could not obtain technology of such sophistication from their poor state. Fiala, therefore, opted for, in his own words, an "economical, industrially somber concept of materials" *. It was also because he respected the limited financial resources of his client, Ing. Leopold Bareš. "Surprisingly, financial constraints sometimes have a positive impact in that the building is not overdone", Fiala went on to say.**

Fiala's Sipral departs from the doctrine of highly technical architecture in one more respect: materials. Following consultations with Bareš, the architect divided his building into two parts: the administrative front and the manufacturing back. In both of them, he amply employed the high tech principle of dry assembly. However, in addition, the architect inserted a number of clearly visible elements from concrete, a wet and heavy substance that high tech architecture does not like to use in its dogmatic form, into the front section of the building through which Sipral presents itself to the public and customers. Ostentatious contrasts of metal, fragile glass and raw concrete thus indicate that the technicist concept of Fiala's Sipral was also influenced by the material aesthetics of Swiss provenance.

19

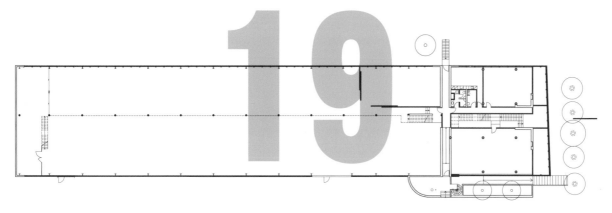

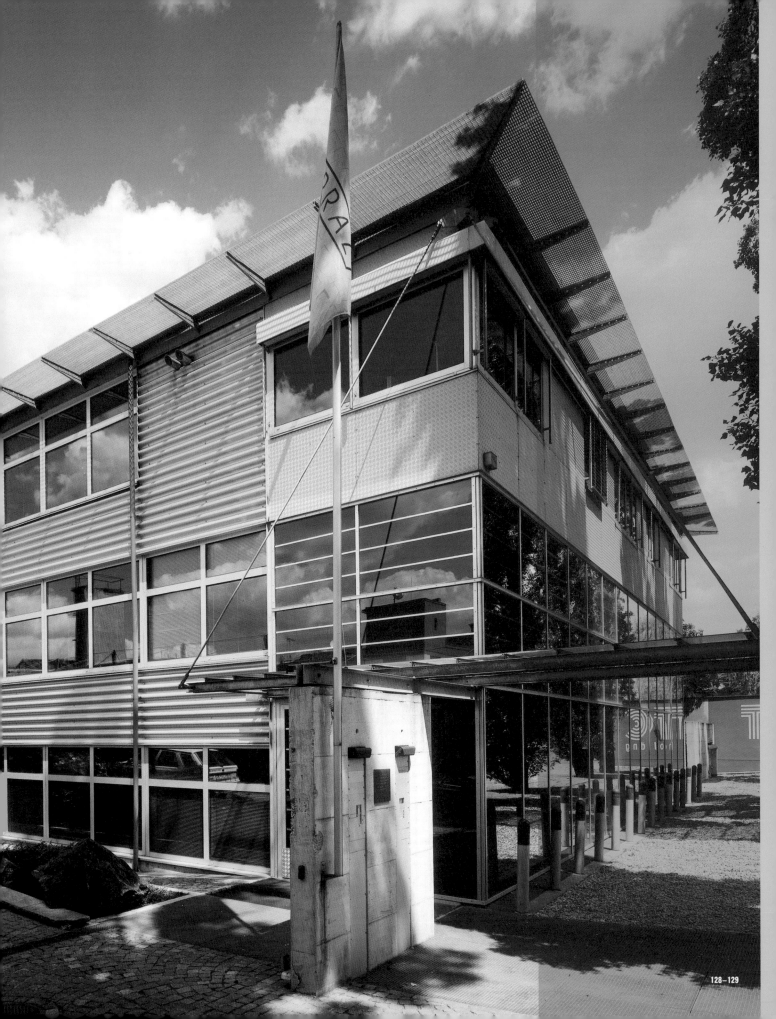

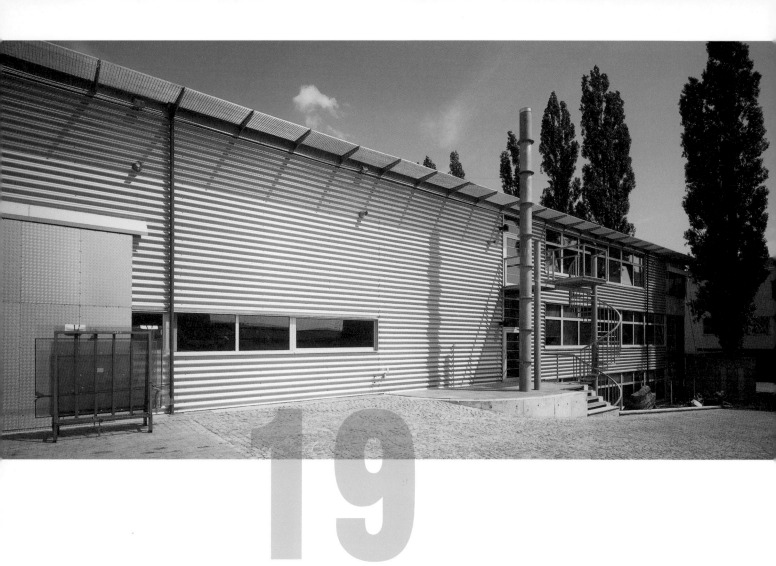

19

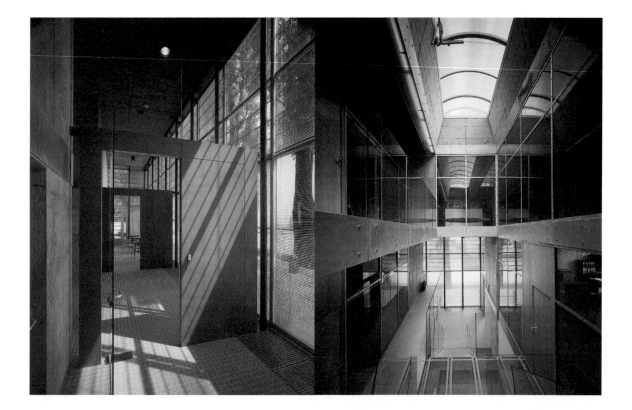

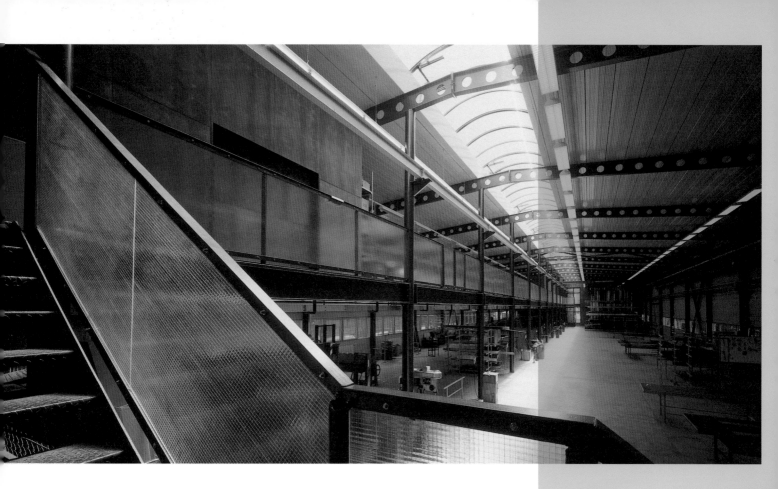

* "Sipral". *Architekt* XLII, 1996, Issue 16–17, pp. 21–30.

** Michal Janata–Jiří Horský, "Přesnost na desetiny milimetrů". *Architekt* XLIII, 1997, Issue 6, pp. 12–13.

Irena Fialová, "Terrain vague. A Case of Memory", in: *Present and Future. Architecture in Cities*. Barcelona 1996, pp. 270–273.

Jiří Kroupa, "Světlo, kov a sklo". *Architekt* XLII, 1996, Issue 16–17, p. 30.

Zdeněk Lukeš, "Pavel Štecha. Fotografování architektury je řemeslo". *Umění a řemesla*, 1997, No. 1, p. 30.

Irena Fialová, "Arquitectura en la República Checa". *CPAU*, 1999, No. 3, pp. 27–29.

Petr Kratochvíl–Pavel Halík, *Contemporary Czech Architecture / Tschechische zeitgenössische Architektur*. Prostor – architektura, interiér, design, Prague 2000, pp. 67–71.

"Sipralblok". *Architekt* XLVIII, 2002, Issue 2, pp. 11–14.

20

Eva Jiřičná – Duncan Webster, orangery in the Royal Garden of the Prague Castle. 1995–1998

High tech architecture in its pure form probably appeared in the Czech Republic only once, although even in that particular case it was accompanied by the original license of its author. Eva Jiřičná, who designed the new orangery in the gardens of the Prague Castle, not far from the Renaissance building of the Ball Games Hall, has been living in England since 1968 and has become familiar with all of the technical and aesthetic subtleties of high tech architecture. Interiors of luxury stores and night clubs became her specialty: there, she would frequently install impressive staircases with glass steps and stainless steel constructions as subtle as lace. While the assembly of staircase components was conducted in strict compliance with high tech rules as dry assembly, the components themselves were not mass produced by a factory, as the originator of the movement, Richard Buckminster Fuller, required, but rather were made in a blacksmithy somewhere outside London, more or less by hand. The technology used to make the construction components for the orangery at the Prague Castle did not differ greatly from this approach. While they were made in a factory, they still needed to be finished by hand. The architect set a subtle metal frame of a semi-circular cross-section and horizontal bracing onto the ruins of the old, Renaissance orangery, and hung a glass "skin" on it from below.* The critic Josef Holeček praised the interior of the new orangery for its "subtle mass akin to a gem". He was, nonetheless, rather perplexed by the fact that a great amount of hard work, skill, and concentration went into creating an architectural curiosity with "a strangely marginal purpose (and many would say meaning) (in the olden days, we would have said "absurd" in an existentialist tone)."**

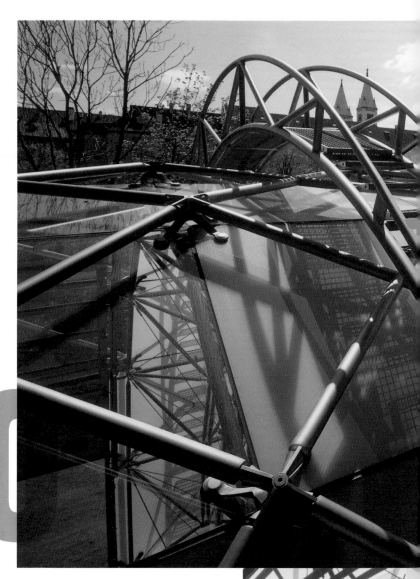

20

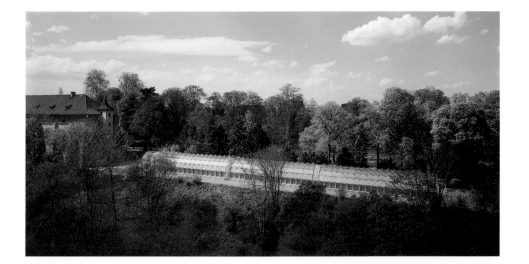

* "Autorská zpráva". *Architekt* XLV, 1999, Issue 7, p. 30.
** Josef Holeček, "Obraz v srdci". *Architekt* XLV, 1999, Issue 7, p. 33.

Ivo Koukol, "Oranžerie". *Architekt* XLII, 1996, Issue 1–2, pp. 20–21.
Eva Jiřičná, "Projekt oranžerie na Pražském hradě". *Zlatý řez*, No. 13, Winter 1996, pp. 20–21.
Architect´s Journal – Steel Design Supplement, 1998, No. 11.
Benjamin Fragner – Petr Kratochvíl, "Eva Jiřičná na Pražském hradě". *Fórum architektury
a stavitelství*, 1998, Issue 8–9, pp. 6–10.
Eva Jiřičná – Ivo Koukol – Jiří Studnička – Zbyněk Ransdorf, "Oranžerie na Pražském hradě". *Stavba*
V, 1998, Issue 6, pp. 36–40.
Building Design, 1999, No. 10.
Royal Academy of Arts magazine, 2001, No. 11.
"City focus – Prague. Unfinished symphony." *World Architecture*, 2000, No. 86, p. 52.
Alena Kubová (ed.), *Un Salon tchéque. Architecture contemporaine et design en République
Tchéque*. Institut francais d'architecture, Paris 2002, pp. 30–33.
The Phaidon Atlas of Contemporary World Architecture. Comprehensive Edition. New York – London
2004, p. 595.

Petr Kolář– Aleš Lapka, rowing club in Prague 5-Smíchov, Nábřežní Street 87/2. 1996 – 2000

The orangery at the Prague Castle is probably not typical of Eva Jiřičná's works, as the architect has not had many opportunities to try her hand at new buildings. She excels through her ability to adorn buildings and spaces previously built by others with her gems: staircases, furniture, display cabinets, and tent constructions from canvas. Petr Kolář and Aleš Lapka, who collaborated with Jiřičná in the first half of the 1990s, were clearly enchanted with this architectural jewelry-making. Their project of the Slavia Praha rowing club from 1996 looks almost as if Kolář and Lapka decided to simulate a situation in which Jiřičná typically finds herself when they worked on their first independent project. The club building sited on the Vltava River alluvium was designed as a seemingly ordinary engineering skeleton; they intended to adorn it subsequently with reinforced canvas canopies and marquees. When the project was assessed by Jason P. Boisvert in 1997, he viewed these canvas ornaments as nautical symbols reminiscent of "sails and rigging", justified by the purpose of the building and its location on the river.* However, the client was not able to pay for all these ornaments. After some of them were abandoned, the skeleton construction, glazed and fitted with additional wooden elements, turned out to be adequate in itself for the building to retain its architectural impact. This was thanks to its rhythm and proportions, dosed by the architects in such a way so as to initiate a dialogue with the modulation of large houses on the embankment above the club, as well as its lightness or its "floating nature", appreciated already in Boisvert's review.

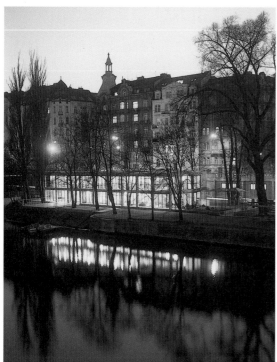

* Jason P. Boisvert, "Lehkost a strohost". *Architekt* XLIII, 1997, Issue 9, p. 27.

"Z autorské zprávy". *Architekt* XLIII, 1997, Issue 9, pp. 25–27.
Jiří Severa, "Rekonstrukce Veslařského klubu Slavia Praha. Řešení spodní stavby". *Stavba* V, 1998, Issue 4, pp. 60–63.
Petr Pelčák (ed.), *Česká architektura / Czech Architecture 1999–2000. Ročenka / Yearbook.* Prostor – architektura, interiér, design, Prague 2001, pp. 28–31.
"Veslařský klub Slavia Praha". *Architekt* XLVII, 2001, Issue 5, pp. 40–43.

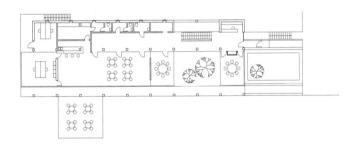

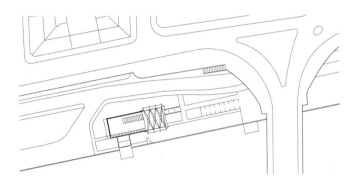

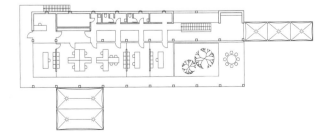

In 1996, the French architect Jean Nouvel also ran into the problem of how to justify a certain kind of ornamentation, specifically that of a building built in the same neighborhood as Kolář and Lapka's club. "That Nouvel in Prague", as the Liberec-based architect Jiří Suchomel referred to him with some degree of disdain, has been coming to the capital of the Czech Republic since the early 1990s. At the time, the Nationale Nederlanden insurance company commissioned a study of an extensive remodeling of the Prague quarter of Smíchov, built during the Czech industry boom in the 19th century. Nouvel sensed that the heart of this quarter was the busy intersection of Nádražní and Plzeňská Streets, called Anděl (Angel) since the early days. When the Dutch investors toned down their ambitious plans, Nouvel focused on the project of a commercial and administrative center, Zlatý anděl (Golden Angel), which was supposed to lend a new image to the intersection on the one hand, while "protecting" it symbolically on the other. The architect subdivided the form of the center into several relatively independent volumes in order to depict the fragmented and semi-peripheral nature of the surrounding development. The technicist metal sheet facades of several new structures and their overall appearance as industrial halls refer to the working class and industrial history of Smíchov. According to Martin Sedlák's review, Nouvel's creation viewed as a whole looks like "a Smíchov factory with well-dressed workers operating computers".**

The rippled rear side of the tower-shaped structure above the intersection resembles an angel's wing. The critics, shortly before annoyed by the anthropomorphous imagery of "Ginger and Fred" in the Dancing Building by Gehry and Milunič, denounced the angelic motif as evidence of Nouvel's simplistic thinking. The architect, however, had the facades of his Prague creation adorned with even more simplistic ornaments. He had them printed with verses about angels and the beauty of Prague written by various poets, and placed a screened photographic image of a human angel, as presented by the actor Bruno Ganz in the *Wings of Desire*, a film by the German director Wim Wenders. Serigraphy-printed glass panels were made by Sipral for this purpose. Certain people, including architects and intellectuals, could not understand why Nouvel's building poses as an anthology of poetry. "My perception of architecture is more comprehensive than a mere image or the graphic rendition of a facade", the critic Karel Doležel wrote.* Prague councilors in turn were outraged that a Prague intersection was to be protected by an angel from Berlin, and managed to have Ganz's face changed so as to strip it of its individual features.*** Nouvel defended his intentions by reference to the specific architectural tradition of Prague; he argued with his opponents that similar images and inscriptions appeared on numerous Prague houses in the era of the "Czech" Neo-Renaissance.

However, the rather mixed reception of Golden Angel by Czech architects was probably due to the French lightness and the carelessness with which Nouvel managed both the project as a whole and the various details: he did not worry too much that many loose ends would remain and that many would be improvised. The difference between Nouvel's approach and Czech austerity and seriousness becomes clearly apparent if we compare the work with the commercial and hotel complex built by Nouvel's Prague colleagues behind Golden Angel, along both sides of Plzeňská Street. "Nouvel's >frivolity< is rather alien to us" said Martin Sedlák, and as if he was speaking for the architects in question: "Our buildings seem more serious, perhaps more heavy-handed, if you like, but they emanate a greater certainty."**

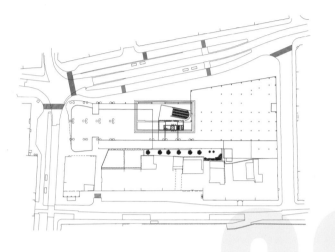

22

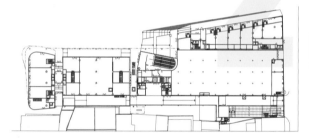

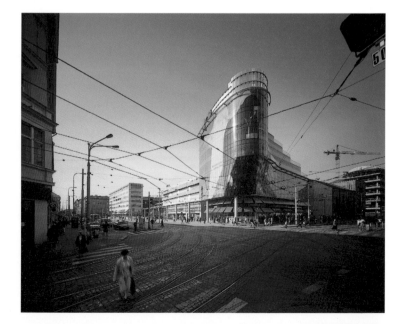

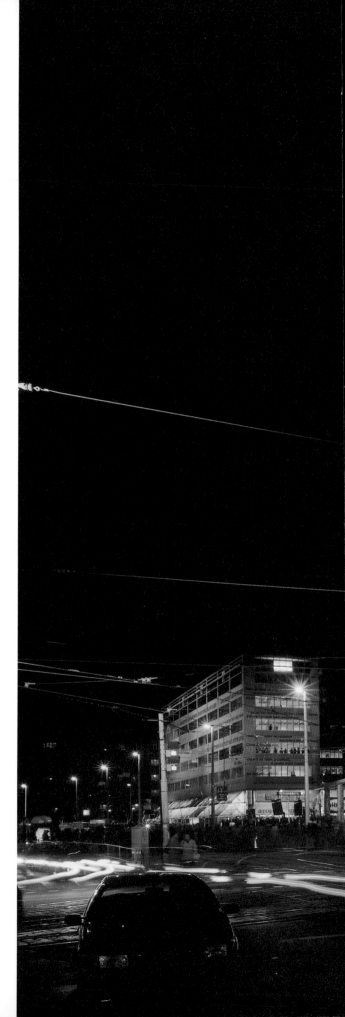

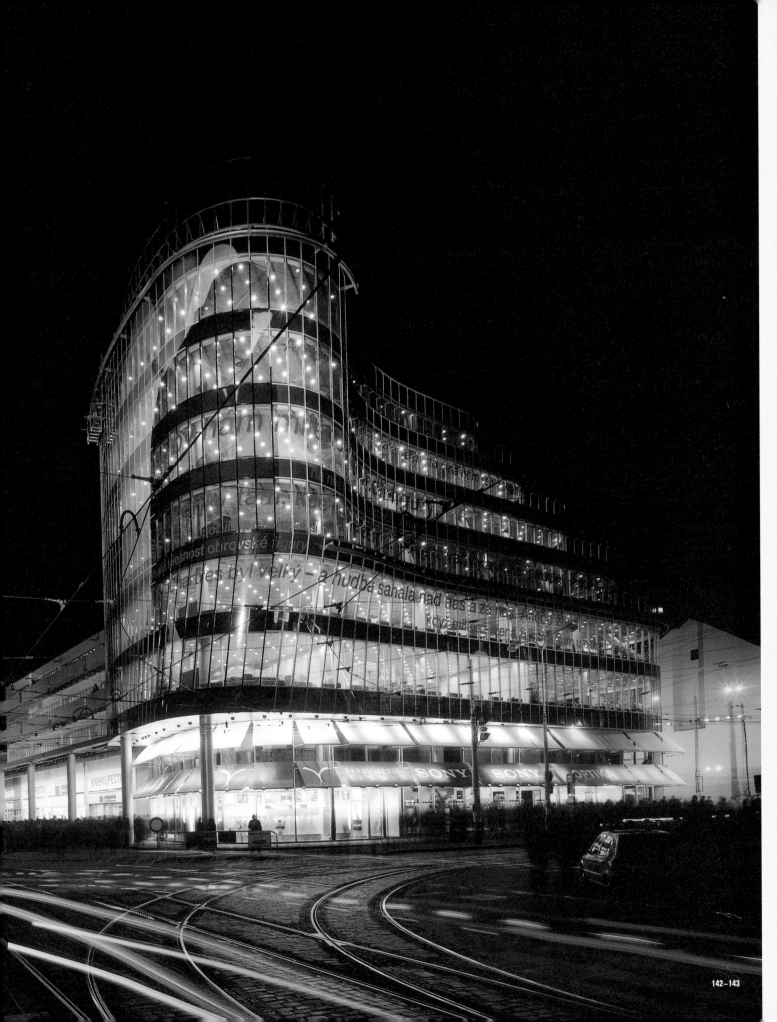

který je dost dlouhý,
 aby mu zpřístupnil všechny okrsky země,
ale přece pouze tak dlouhý,
 že ho nic nemůže vytrhnout z hranic země.
Zároveň je však také svobodným
 a zajištěným občanem nebes,
neboť je uvázán na podobně
 vypočtený nebeský řetěz.
Chce-li na zemi na zem,
 škrtí ho nebeský obojek,
chce-li do nebe, pozemsky.
 A přesto může cokoliv a cítí to:
ba dokonce odmítá si přest
 to všecko na chybu při prvním stvoření.

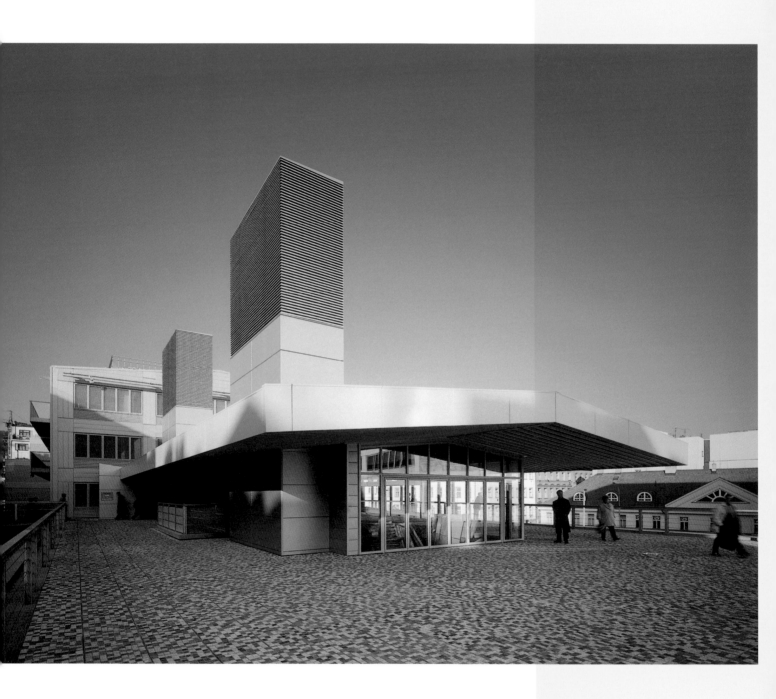

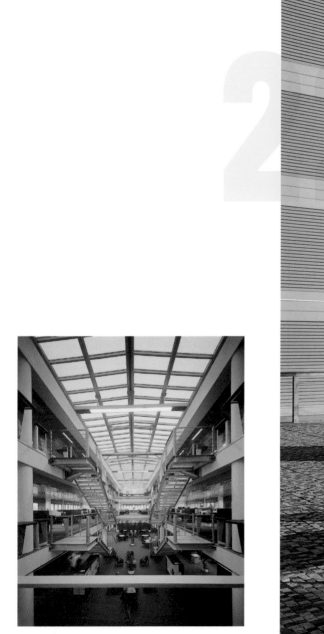

* Karel Doležel, "Dvakrát Anděl". *Architekt* XLVII, 2001, Issue 2, p. 14.

** Martin Sedlák, "Továrna pro poetické úředníky". *Architekt* XLVII, 2001, Issue 2, p. 15.

*** Rostislav Švácha, "Ochránce Anděla". *Architekt* XLVII, 2001, Issue 2, pp. 16–17.

Jean Nouvel, "Dvě studie na Smíchově". *Architekt* XLIII, 1997, Issue 24, pp. 26–27.

Rostislav Švácha, "Ke zdrojům Nouvelova myšlení". *Fórum architektury a stavitelství, 1998*, Issue 10, pp. 6–11.

"Jean Nouvel". *Stavba* V, 1998, Issue 5, pp. 20–21.

Irena Fialová (ed.), *Zlatý Anděl / Jean Nouvel / v Praze.* Zlatý řez, Praha 2000.

Irena Fialová, "L'art, c'ést le faire – Umění je dělat to". *Stavba* VII, 2000, Issue 2, pp. 60–61.

"City focus – Prague. Unfinished symphony." *World Architecture*, 2000, No. 86, p. 51.

Milena Sršňová – Libor Štěrba (eds.), *Architektura 2001. Ročenka realizovaných staveb v České republice.* BertelsmannSpringer CZ, Praha 2001, pp. 20–21.

"Autorská zpráva". *Architekt* XLVII, 2001, Issue 2, pp. 6–12.

Hana Vinšová, "Šest let s Andělem". *Architekt* XLVII, 2001, Issue 2, pp. 80–81.

A 8000, "Zlatý anděl". *Fórum architektury a stavitelství,* 2001, Issue 5, pp. 8–13.

Josef Pleskot, "Anděl". *Stavba* VIII, 2001, Issue 5, p. 46.

Monika Mitášová, "Kniha o architektúre tvorenej ako kniha". *Stavba* VIII, 2001, Issue 5, pp. 47–49.

Irena Fialová, "Vývoj a realizace sérigrafie na fasádě projektu Zlatý anděl". *Stavba* VIII, 2001, Issue 5, pp. 62–63.

23

The very same heavy-handed honesty that Martin Sedlák perceives in the buildings designed by Czech architects was considered to be something specifically Czech by Karel Honzík some fifty years earlier. In his 1948 "An Essay on the Expression of Czech Building", this Functionalist architect contemplated whether certain national or regional features emerged within Functionalism which had originally subscribed to an international ideology.[77] However, Honzík did not suspect that the present age would consider precisely the Functionalist architecture of the 1920s and 1930s specifically Czech. While the same was not terribly original, it became wide-spread throughout the entire territory of what was then the Czech state and left a clear mark on the scenery of many Czech cities and towns. Nothing similar had occurred in other European countries. When words such as "vernacular", "contextualism", "genius loci" or "Critical Regionalism" began to appear in the 1960s, the question whether programmatic requirements of these notions could not have been fulfilled by a "different repetition" of Functionalism that had to arise sooner or later.

Aside from other architects and critics, this very question was contemplated in 1994 by David Polzin and Jan Tabor when they reviewed the OMG building in Římská Street in Prague, designed by the A.D.N.S. association. The same architects built another house on an adjacent plot as a clear continuation of the Neo-Functionalist line. The project was commissioned in 1996 by Czech Radio, which has been occupying a Functionalist building (!) on an adjacent plot at the parallel Vinohradská Avenue since 1932. The client was in dire need of a large number of new recording studios and offices that would not fit into a regular-sized house, and given the size of the plot, a skyscraper would have to be built. The architects, however, did not wish to violate the old regulation of the quarter and, therefore, divided the new building into two parts: a lower section that faces the street and houses offices, and a taller section hidden in the courtyard and containing the recording studios. The two new buildings are separated by a tall atrium with a glass ceiling.

The street facade with its rows of windows arranged in continuous bands and the configuration of the street and courtyard buildings, amply precedented in the Prague of the period between the wars, capitalize on the Functionalist tradition. However, the authors have innovated the tradition that had after all been the case even of the neighboring OMG house. It was in particular their use of materials in the spirit of Swiss architecture of the 1990s that lent a novel touch to their Neo-Functionalist style. The architects had the facade faced with red sandstone, while the appearance of the atrium is defined by "bare concrete" that is to impart, in their own words, a "clear impact".*

We can sense from Alena Šrámková's review just how complex it is to combine the tradition of Czech Functionalism with that of Czech austerity. Šrámková compared the new building of the Czech Radio with the older OMG house and noted that A.D.N.S.'s more recent work is "of better quality, less elegant, and more authentic"; it manifests "a lesser desire to be successful". Despite all this praise, the reviewer felt that "creative risk" was lacking in the radio building.**

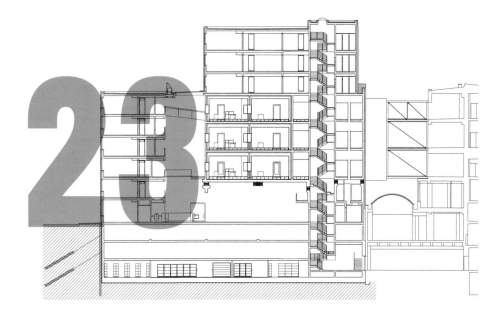

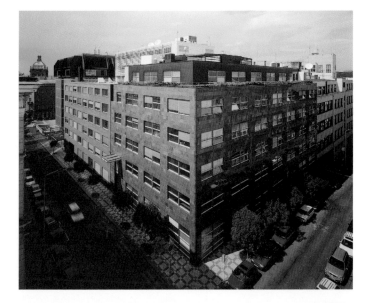

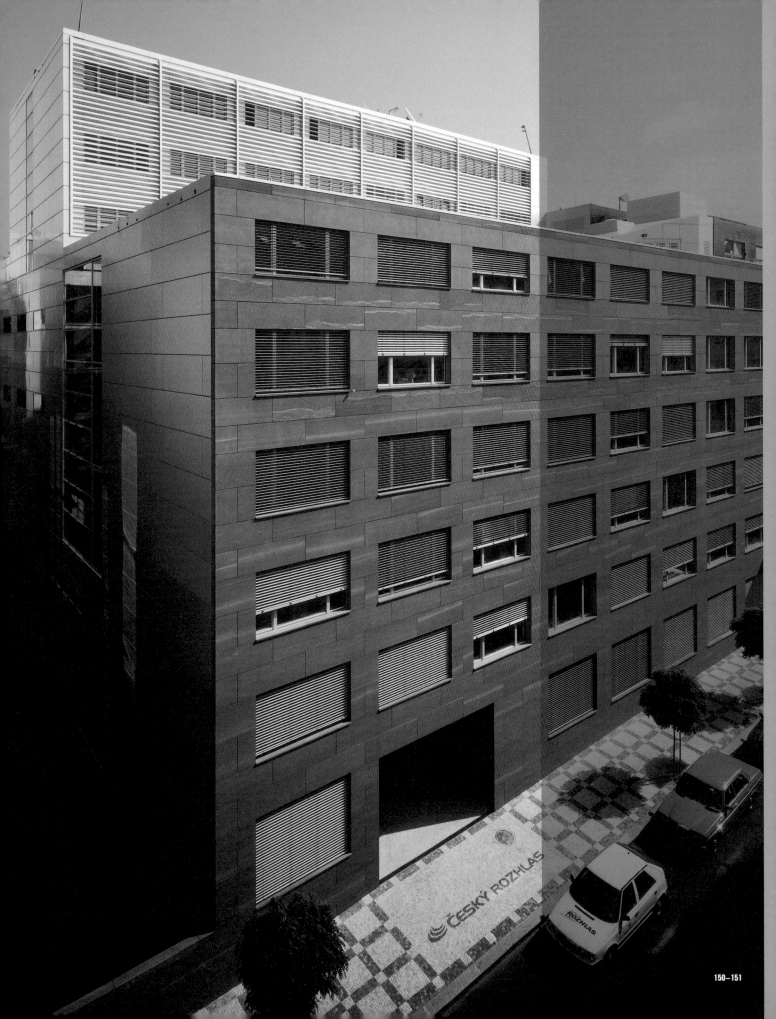

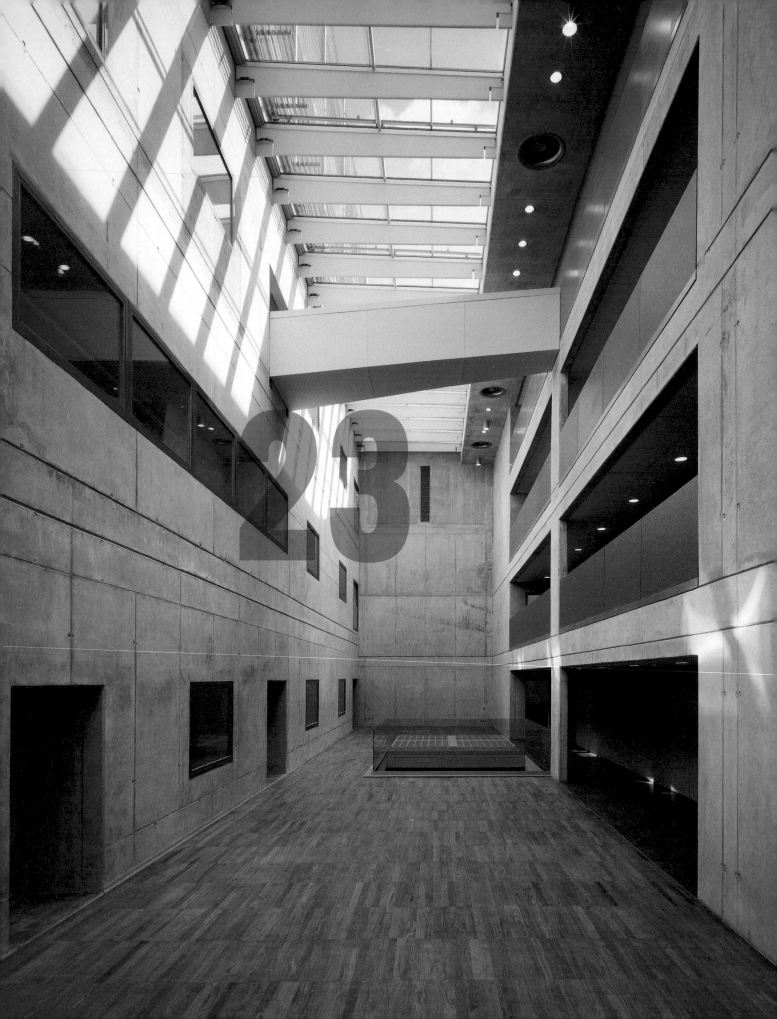

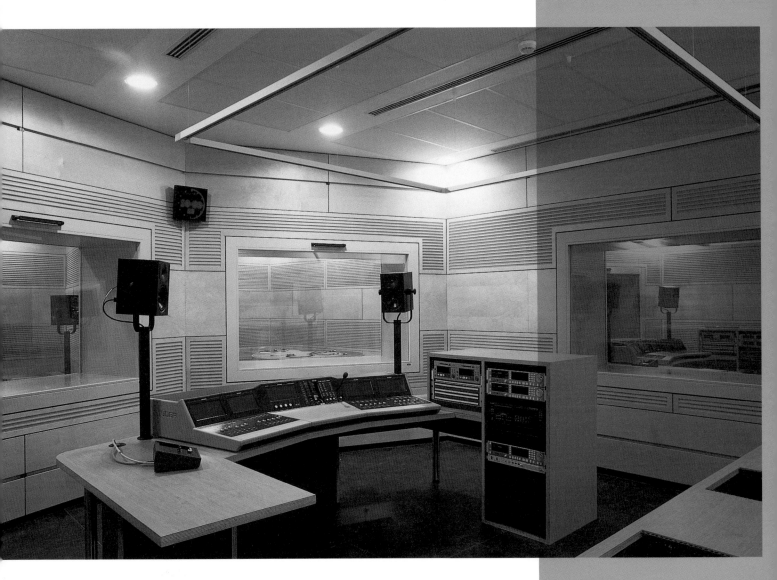

* "Autorská zpráva". *Architekt* XLVII, 2000, Issue 9, p. 36.
** Alena Šrámková, "Cestou do evropského povědomí". *Architekt* XLVII, 2000, Issue 9, p. 40.

Petr Pelčák (ed.), *Česká architektura / Czech Architecture 1999–2000. Ročenka / Yearbook.*
Prostor – architektura, interiér, design, Prague 2001, pp. 58–63.
"Studiový dům – novostavba Českého rozhlasu". *Fórum architektury a stavitelství*, 2001,
Issue 5, p. 64.
Alena Kubová (ed.), *Un Salon tchéque. Architecture contemporaine et design en République
Tchéque.* Institut francais d'architecture, Paris 2002, pp. 6–9.

24

Jindřich Smetana – Tomáš Kulík, theatre Alfred ve dvoře in Prague 7-Holešovice, Františka Křížka Street 36. 1996 – 1997

So as not to harm the architects, Alena Šrámková in her review did not comment on the problems that A.D.N.S. had with its client. Czech Radio's employees were shocked by "bare concrete", and they moan and groan up to this day that the building not only looks bad, but also serves them badly. This is a very frequent outcome of cooperation with a multiple-headed client, or a client that is completely or half anonymous. The architect is always more likely to reach an agreement better with an individual rather than with an institution. Jindřich Smetana and Tomáš Kulík were lucky in that respect when they were approached in 1996 by the mime Ctibor Turba. They designed a pantomime theater for the foundation managed by Turba in the courtyard of a house recovered by the client after the Velvet Revolution in the property restitution process. The mime wished for the theatre to look like a "huge logo" indicative of its artistic focus.* The architects responded to this challenge by designing a building that is interesting already by the magnitude of associations it evokes. Turba himself can see a "maxitransformer", "nuclear shelter", and "metal camera" in it.** Kulík and Smetana conceived the theater as a series of five broad portals that seem to slide inside one another telescopically. Sunlight penetrates the interior through cracks between the portals. Turba's metaphor of a "metal camera" refers to the fact that the architects had the concrete mass of the portals faced with sheet metal on the outside, sheet metal that is sometimes used to make pathways, footbridges, or drop doors in elevators. Turba formulated his commission well and found architects who knew how to design theatre buildings – they had built several before and after. The client claims responsibility for the errors that manifested themselves – the stage is too shallow and the light cracks disturb the actors when rehearsing during the day – and is delighted

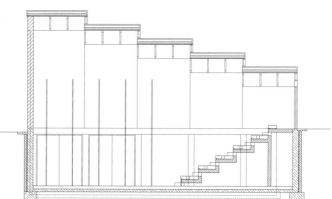

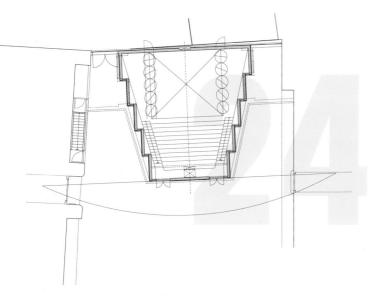

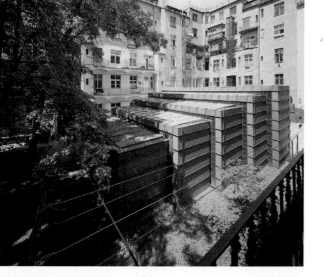

* Ctibor Turba, "Nejjednodušší forma prostoru pro komorní komedie". *Architekt* XLIII, 1997, Issue 12, pp. 11–13.

** Světlana Kleinerová, "Divadelní architektura posledních deseti let". *Stavba* VII, 2000, Issue 6, pp. 53–59.

"Z autorské zprávy". *Architekt* XLIII, 1997, Issue 12, p. 16.
Pavel Halík, "Pod krunýřem trilobita". *Architekt* XLIII, 1997, Issue 12, p. 17.
"Divadlo pantomimy Alfred ve dvoře". *Architekt* XLIV, 1998, Issue 12, p. 16.
Petr Kratochvíl – Pavel Halík, *Contemporary Czech Architecture / Tschechische zeitgenössische Architektur*. Prostor – architektura, interiér, design, Prague 2000, pp. 72–74.

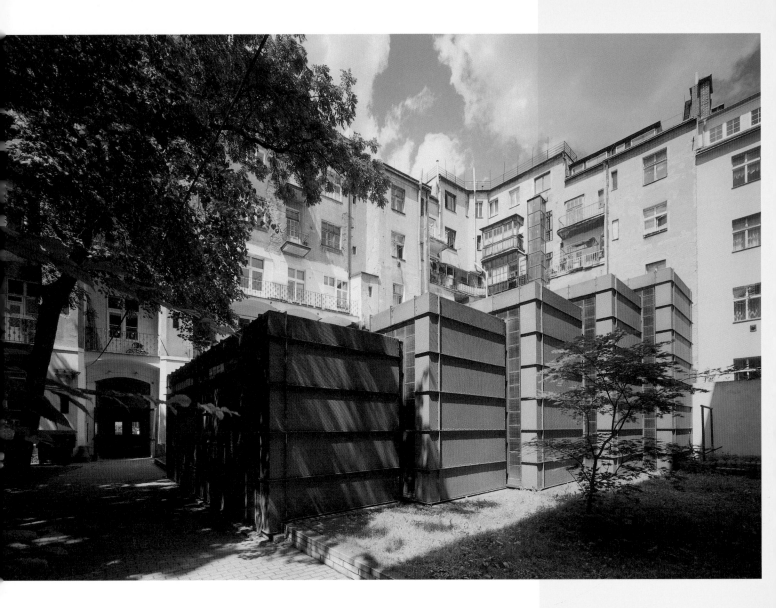

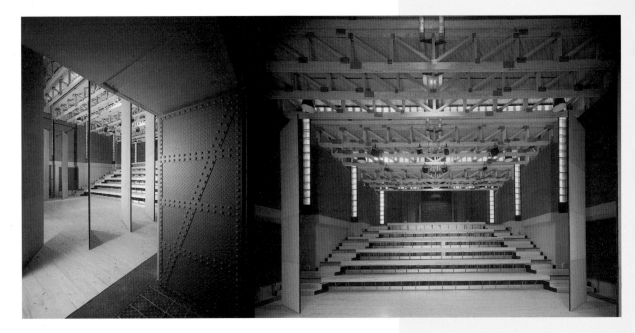

The client came into contact with the architect Lábus through a developer who rented land at Vonoklasy and wished to build a present-day analogy of the 1930s Prague Functionalist estate, Baba. However, nothing like Baba II was created at Vonoklasy. Some of the clients did not like the current neo-modernist style, and, therefore, opted for houses in romantic form, thus disturbing the uniform style of the project. Lábus's client – a manager of a large, Prague-based industrial company – also had the idea of his future house being in romantic style, but finally let the architect talk him into something different. He ended up so enchanted by the achievements of modern architecture that he began visiting its highlights all over the world while the construction of his house was still under way. The client's entire family is equally enthusiastic in this respect. When designing the family house, Lábus strove to preserve the feeling of living in the country, in a landscape. The villa was, therefore, conceived as a more or less single-storey building with the interior lying close to the ground, while opening up into the garden and the landscape. The interior space of the villa is ensconced within tectonic frames that could be used to create the classical enfilade motif. The journey through such enfilade, however, continues to change its direction, and even runs up towards the bedrooms. As regards the exterior, the architect strove to achieve a country look in particular by means of the large scale as observed in old country barns or farms. However, Lábus did not intend to draw on more than scale – a sense of "generous naturalness" – from such traditional country dwellings, as their mimetic imitation would be "unauthentic".*

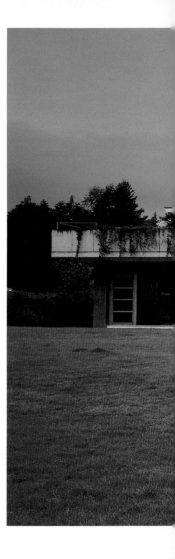

25

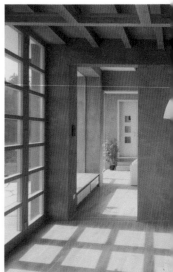

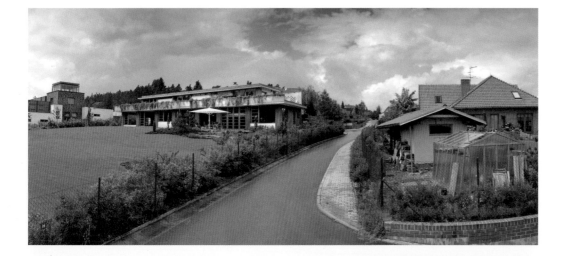

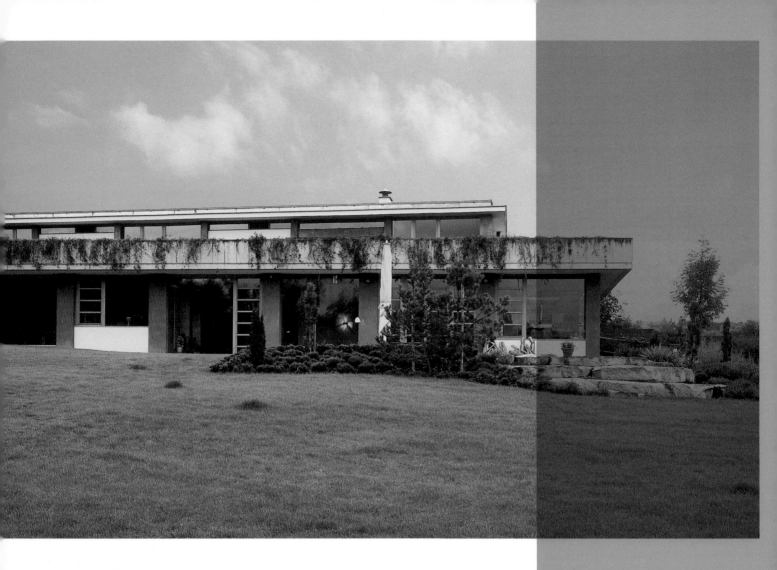

* "Autorská zpráva". *Architekt* XLV, 1999, Issue 5, p. 29.

"Z autorské zprávy". *Architekt* XLV, 1999, Issue 5, p. 14.
Rostislav Švácha, "Co je to vila". *Architekt* XLV, 1999, Issue 6, p. 21.
Ladislav Lábus, "Komunikace versus bariéry aneb skrze zdi". *Fórum architektury a stavitelství*, 1999, Issue 5–6, pp. 4–45.
Lenka Žižková et al. (ed.), *Český interiér a nábytkový design / Czech Interior and Furniture Design 1989–1999*. Prostor – architektura, interiér, design, Prague 2000, pp. 100–102.
Radomíra Sedláková–Marie Platovská (eds.), *Architekt Ladislav Lábus*.
Galerie Jaroslava Fragnera, Praha 2004, pp. 80–84.

26

Ladislav Lábus – David Mareš – Lenka Dvořáková – Zdeněk Heřman – Pavla Burešová, Langhans palace in Prague 1-Nové Město, Vodičkova Street 37. 1996 – 2002

Lábus found clients with a capital "C" in the Czech-Swiss couple, the Wismers. Mrs. Meisnerová-Wismerová comes from a family of Prague photographers, the Langhans family. She studied photography and film in Prague and then she married into Switzerland. In the early 1990s, the Czech state returned to her the old family seat, the Langhans palace between Vodičkova Street and the Franciscan Garden in the historical core of Prague. Mrs. Meisnerová-Wismerová commissioned the design of a remodeling of this complex "drenched in developing solution", as she says,*** from Ladislav Lábus in 1996, and then underwent with him the martyrium of negotiations with the Prague building and monument conservation authorities. She was rewarded with an unexpected discovery that placed the remodeling of the Langhans palace firmly into the realm of mythology: during construction, the bricklayers found an old cabinet containing hundreds of glass negatives with portraits of prominent Czech cultural and scientific figures taken by the Langhans studio in the late 19th and early 20th centuries.

Lábus had the old Neo-Renaissance and Art Nouveau part of the complex restored, added a new structure to its additive configuration, and with the exception of the pavilion by the Franciscan Garden where the client established a photographic gallery, added new residential floors protected with copper jalousies on top of all of the buildings. The subtlety of all these additions, as if randomly set onto the heavier blocks of "houses with windows" is to evoke the appearance of semi-permanent studios, which members of the Langhans family occasionally built on top of their palace. The architect made a clear demarcation line between the old and the new, both in the exterior and in the interiors housing apartments, offices and photographic technology shop. However, by distinguishing between the old and the new, Lábus came into conflict with the "synthetic doctrine" of present day Czech monument conservation, whose internal circulars even today do not view the remodeling of the Langhans palace as an example worth following.[78] According to this doctrine, outlined in the second third of the 20th century by the Italian heritage protection theoreticians, Roberto Pane and Cesare Brandi, together with their Czech follower, Václav Wagner, any additions to historical buildings, if at all necessary, ought to have the nature of mere discreet retouching so as not to disturb the overall aesthetic impression of the monument.[79] This concept was much debated in Prague in connection with Gehry and Milunič's Dancing Building because whatever applies to alterations of solitaire monuments ought to apply equally to new buildings within the historical town as a whole.

Lábus on the other hand argued that his approach to the remodeling and additions to the Langhans palace was synthetic, and that he also wished for the remodeling to create an aesthetically impressive whole. His comments on this piece of work, published in journals, suggest that while working on the concept, he contemplated the typical features of the old Prague in greater depth than that possessed by the rather one-track-minded staff of the conservation authorities. Through his variations on the topics of addition and gradation, layering and extending, he even supposedly aimed to achieve what is typical of the old Prague development: he hoped to reveal its characteristic features through his work in "a more surprising and romantic Central European form".* This yearning for a revival of the Central European architectural tradition found a response in a review by the Swiss-Austrian Walter Zschokke, who compared Lábus's Langhans to the remodeling of monuments by the Viennese architects Hermann Czech and Franz Kneissl. Looking at Lábus's work, Zschokke nonetheless thought of the unusually flexible nature of the Czech language, its "numerous constructions", "declensions", "exceptions", "irregular forms and such".**

78 Praha 2002. Zpráva o průběžném sledování památky zapsané na Seznam světového kulturního
 a přírodního dědictví UNESCO (Prague 2002. UNESCO Listed Site Monitoring Report Update).
 Státní památkový ústav v hlavním městě Praze, Praha 2003, p. 55.
79 Václav Wagner, Umělecké dílo minulosti a jeho ochrana (Work of Art of the Past and its
 Protection). Praha 1946.

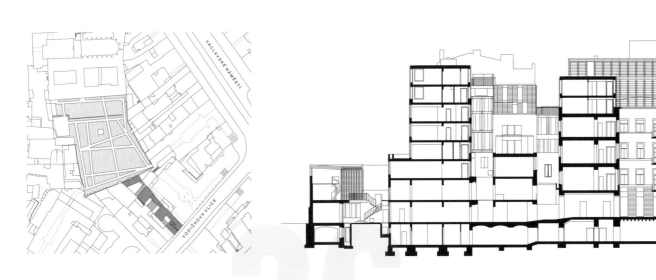

26

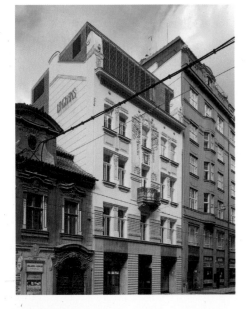

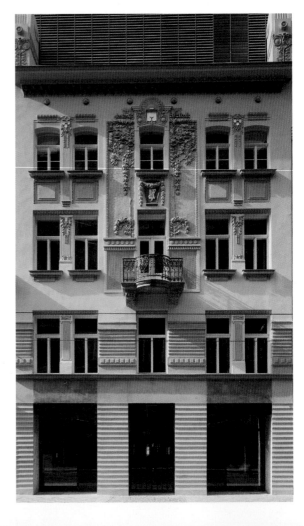

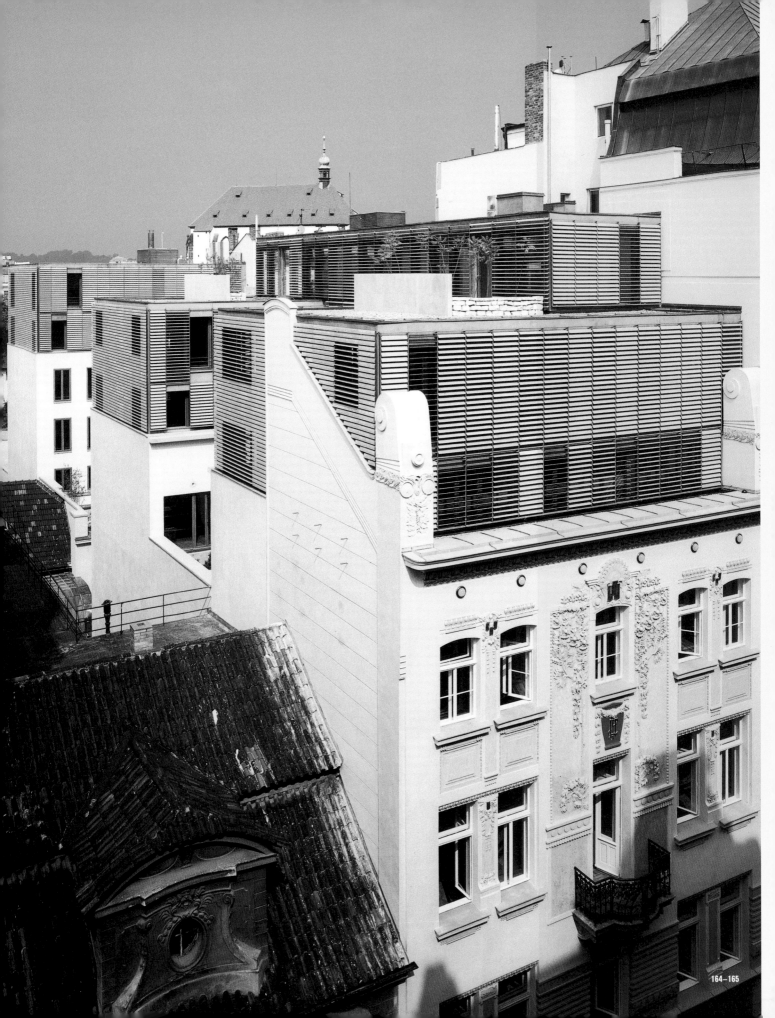

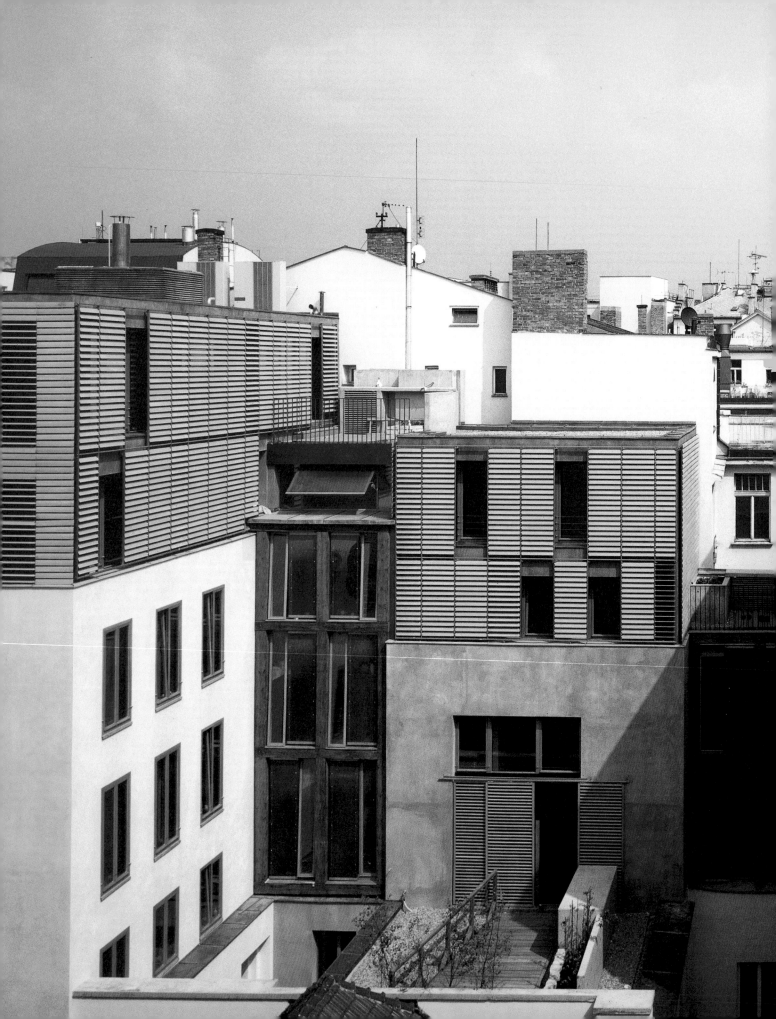

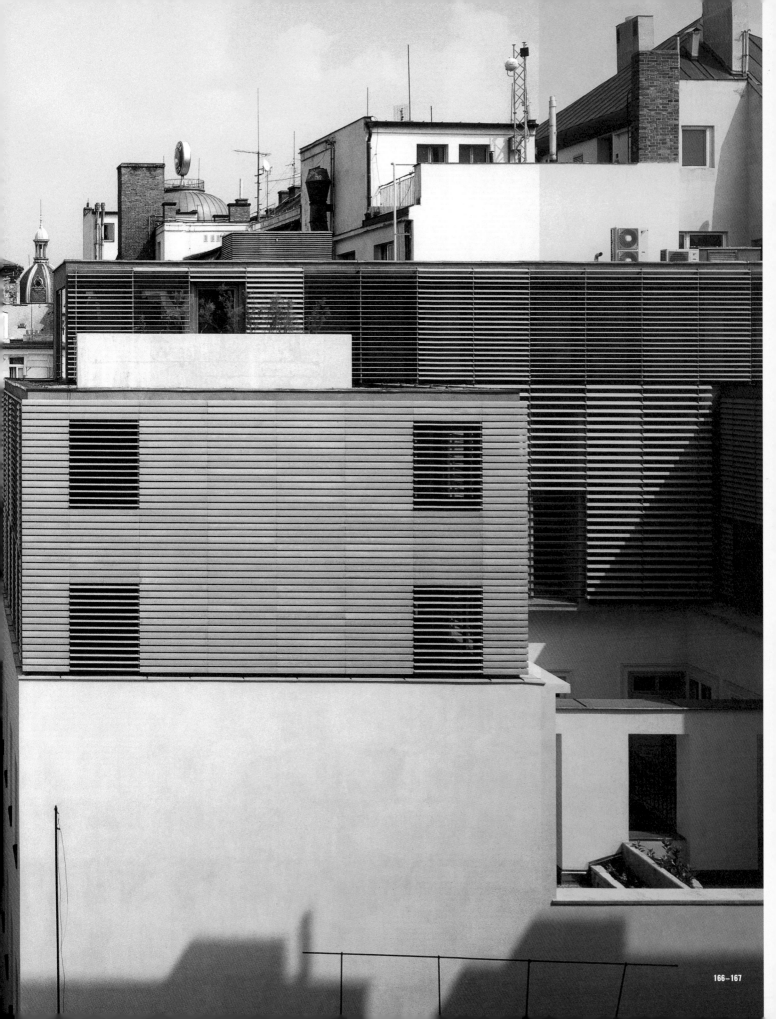

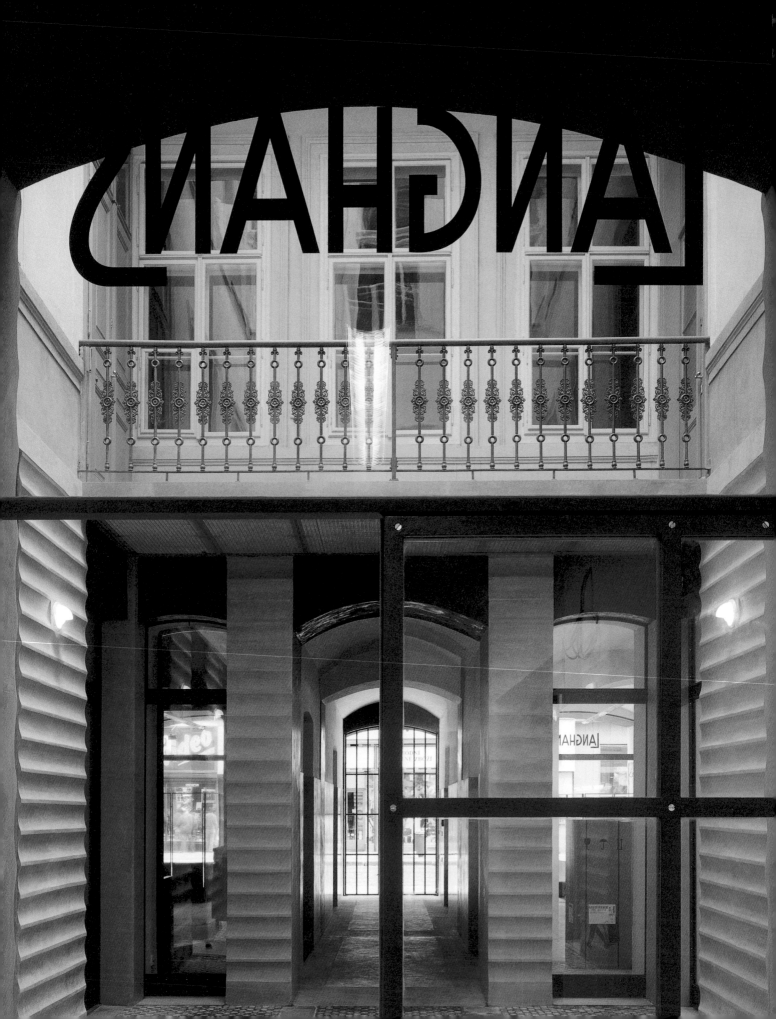

 * "Studie paláce Langhans". *Architekt* XLIII, 1997, Issue 21, pp. 26–29.
 ** Walter Zschokke, "Příběhy jednoho domu". *Architekt* XLVIII, 2002, Issue 11, pp. 12–13.
*** Milena Sršňová–Zuzana Meisnerová-Wismerová, "Historie domu Langhans pokračuje". *Stavba* IX, 2002, Issue 5, p. 44.

Jakub Roskovec, "Proč publikovat běžné studie?". *Architekt* XLIV, 1998, Issue 1–2, p. 83.
Ladislav Lábus, "Rekonstrukce paláce Langhans". *Fórum architektury a stavitelství*, 2000, Issue 1–2, pp. 22–23.
Alena Kubová (ed.), *Un Salon tchéque. Architecture contemporaine et design en République Tchéque*. Institut francais d'architecture, Paris 2002, pp. 38–41.
"Autorská zpráva". *Architekt* XLVIII, 2002, Issue 11, p. 4.
Rostislav Švácha, "Langhansův dům: chvála analytického přístupu". *Stavba* IX, 2002, Issue 5, p. 46.
Ladislav Lábus, "Poznámky k rekonstrukci paláce Langhans". *Stavba* IX, 2002, Issue 5, p. 48.
"Poétique et construction". *Techniques et architecture*, 2002, No. 10–11, pp. 91–98.
Lidmila Cihlářová–Milena Sršňová (eds.), *Architektura 2003. Ročenka realizovaných staveb v České republice*. BertelsmannSpringer CZ, Praha 2003, pp. 36–37.
Michal Kohout (ed.), *Česká architektura / Czech Architecture 2001–2002. Ročenka / Yearbook*. Prostor – architektura, interiér, design, Prague 2003, pp. 58–63.
Rekonstrukce paláce Langhans, *Architekt* IL, 2003, Issue 5, pp. 4–5.
Radomíra Sedláková–Marie Platovská (eds.), *Architekt Ladislav Lábus*. Galerie Jaroslava Fragnera, Praha 2004, pp. 96–105.

Jindřich Škrabal – Jan Sapák – Ludvík Grym, office building Kapitol in Brno, Rašínova Street 4. 1996 – 2000

According to the head of the Brno-based association Obecní dům, Petr Pelčák, there is no such thing as Central Europe today. In one of the debates on this topic, Pelčák wholeheartedly agreed with the Austrian critic, Jan Tabor, who called the region of Central Europe a mere construct, a "fabrication" of the Italian writer Claudio Magris and American intellectuals.[80] Pelčák considers deliberate cultivation of architectural Regionalism to be equal nonsense. Such skepticism, however, does not prevent him from investigating the traditions of 20th century Brno architecture and whatever is specific about it, as compared to the overly dominant Prague, for instance. Pelčák finds support for these cultural activities in other members of Obecní dům, e.g., in Jan Sapák, a specialist in the reconstruction of Brno Functionalist buildings, or in Ludvík Grym and Jindřich Škrabal, who have been compiling a catalogue of Brno store portals from the 1920s and 1930s and have carried out outstanding repairs of some of them. In 1996, the architects Škrabal, Sapák and Grym won a competition for the Kapitol house in Rašínova Street in Brno, in close proximity of the Gothic St. James church. The story goes that the plot was made available in the late 19th century at the recommendation of Camillo Sitte. The famous Viennese architect allegedly proposed that the corner be cut off a closed block of buildings so that a piazzetta would be created in front of the church.** The regulation of Rašínova Street was thus broken down into two parallel street lines that were not easy to interconnect by means of a new building. The three Brno architects responded to Sitte's idea of a "semi-square" by the principle of "two fronts >merged< into a single house".* The architects conceived the house itself as a Functionalist building with elongated windows. The authors, surprisingly, do not mention in their comments on Kapitol whether the selection of style was driven by their respect for Brno traditions of the period between the wars, or the fact that the ample occurrence of Functionalist buildings creates the "context" of the old part of the city. In their texts in the *Architekt* journal, they instead write about the simplicity of the skeleton construction that did without "unnecessary experimenting",* about the perfection of details and craftsmanship – something they worship with a Ruskinian-Morrisean zeal – and the choice of quality metal, wood and stone materials that are almost sufficient to lend an expression of the topical "materials" of the architecture of the 1990s to the Functionalist scheme. Only the appreciative review by Walter Zschokke added, speaking for the authors, that the "carefully mastered >craft<" was based on "thorough knowledge of [interwar] modernism and its buildings".***

80 cf. Rostislav Švácha, "Předmluva" (Preface), in: *Regionalismus a internacionalismus v soudobé architektuře* (Regionalism and Internationalism in Contemporary Architecture). Česká komora architektů, Praha 1999, pp. 7–9.

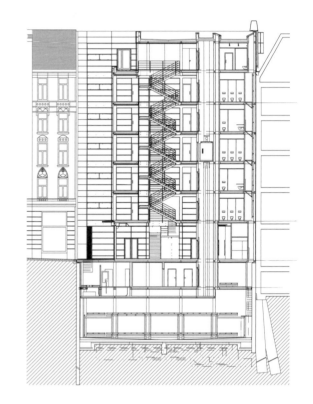

27

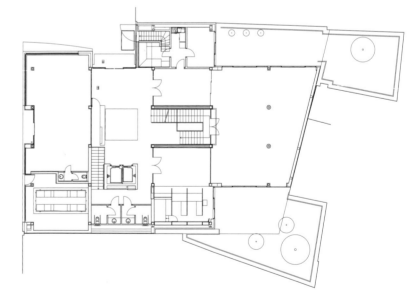

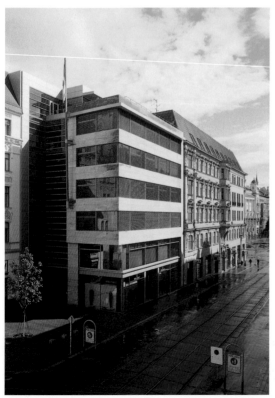

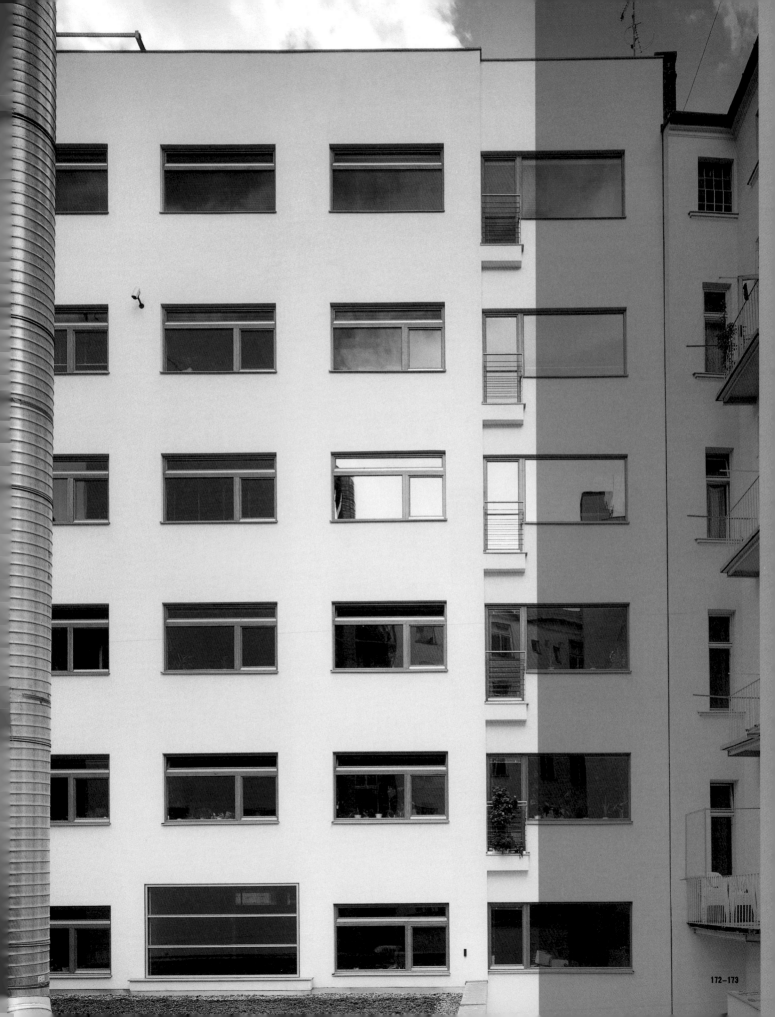

27

* "Z autorské zprávy". *Architekt* XLII, 1996, Issue 21, p. 29.

** "Autorská zpráva". *Architekt* XLVI, 2000, Issue 10, p. 4.

*** Walter Zschokke, "Téma vedle kostela". *Architekt* XLVI, 2000, Issue 10, p. 4.

Petr Pelčák (ed.), *Česká architektura / Czech Architecture 1999–2000. Ročenka / Yearbook.*
Prostor – architektura, interiér, design, Prague 2001, pp. 138–141.

Aleš Burian–Petr Pelčák–Jindřich Škrabal–Ivan Wahla (eds.), *Obecní dům / Brno / 1988–1997.*
Obecní dům, Brno 1997, p. 41.

28

Svatopluk Sládeček – Luděk del Maschio – Dušan Mikolášek – Alice Šimečková, municipal office at Šarovy, Šarovy 100. 1996–1997

The popularity of Functionalism in Czech society in the period between the wars was such that it actually resulted in something like a folk version of this style. In the 1930s, weekend cottages erected on the outskirts of large cities by all classes of the Czech population for recreation purposes were built in the form of simplified Functionalist houses. The difference between "authentic" Functionalism and its spontaneous vernacular form was perhaps only in the wood used in the construction of the cottages, and their tilted roofs. The Zlín-based beginner architects, Svatopluk Sládeček and Luděk del Maschio, opted for the form of a wooden cottage, a sight so familiar to every Czech, when they designed the building of the municipal office in the village of Šarovy, regardless of the fact that the institution of local self-government seemingly ought to be symbolized by a more dignified architectural form. However, it was precisely a polemic with the established ideas of institutional representation – similar to that conducted by Ladislav Lábus in connection with the home for senior citizens in Český Krumlov – that was the essence of Sládeček and del Maschio's architectural intent. "We wished to execute a building without symbols", the architects wrote in 1997.* They wished to do that because an office building with overly conspicuous signs of dignity could discourage certain citizens from entering, could "discriminate them".* The building further serves as a local library and even as a museum showcase, as a historical fire-engine can be seen through a large window on the side. The jury deciding on the 1998 Grand Prix of the Society of Architects awarded an honorary mention to the Šarovy municipal office, thus continuing the tradition of respect for small and inexpensive buildings.

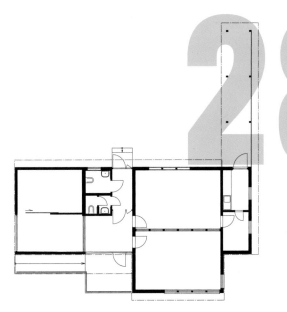

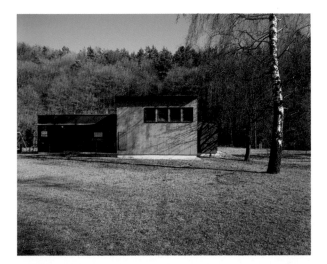

* "Poznámka autorů". *Architekt* XLIII, 1997, Issue 25–26, p. 25.

Rostislav Švácha, "Nářečí chatové, ale důstojné". *Architekt* XLIII, 1997, Issue 25–26, p. 27.
"Obecní úřad a místní knihovna Šarovy." *Architekt* XLIV, 1998, Issue 12, p. 17.
Pavel Škranc, "Nad výsledky Grand prix Obce architektů 1998". *Architekt* XLIV, 1998, Issue 15–16, p. 9.
Helena Pišková, "Kuriozita roku – obecní úřad v Šarovech u Zlína". *Prostor Zlín* VI, 1998, No. 4, pp. 18–19.

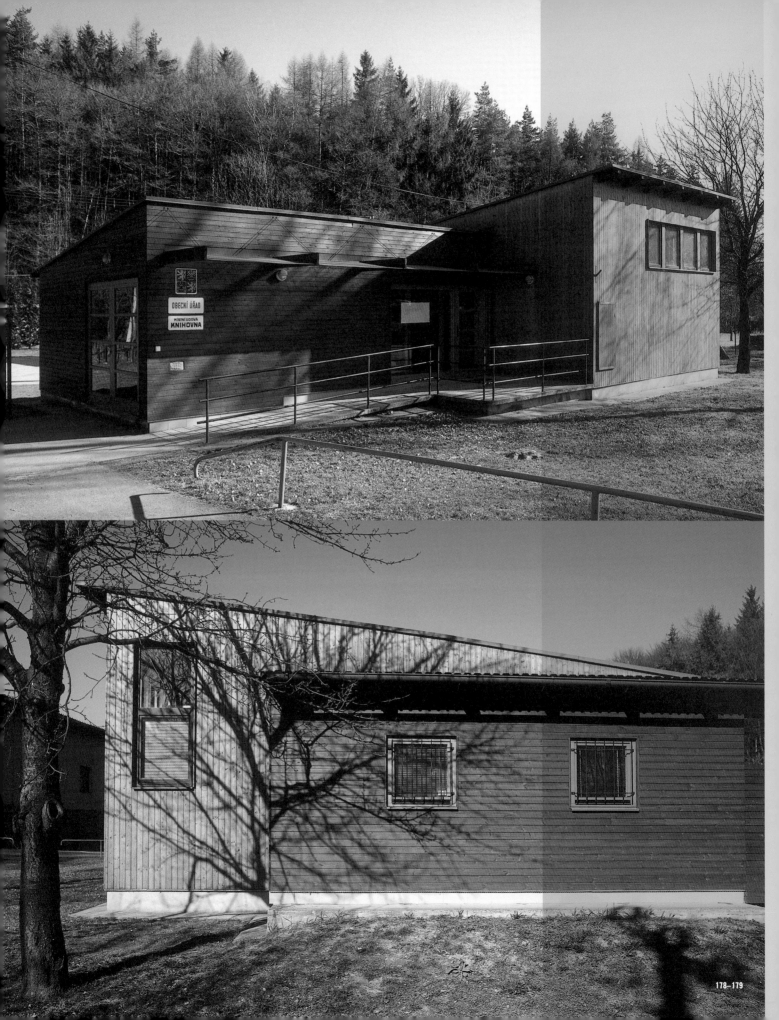

29

Ladislav Kuba, chapel of Queen Virgin Mary at Jestřebí near Brtnice. 1996–1998

"A special award, >curiosity of the year<, could be introduced for cases such as the toolshed of a municipal office at Šarovy or Ivan Kroupa's studio", the critic Pavel Škranc discontentedly commented on the success of Sládeček and del Maschio's work in *Architekt* 1998. Unlike the Grand Prix jury, he had forgotten that even small and inexpensive architecture may convey a strong idea. The examples of such small but strong buildings undoubtedly include the Chapel of Queen Virgin Mary designed in 1996 for the village green at Jestřebí by Ladislav Kuba. The center of the village of Jestřebí was damaged in the second half of the 20th century by demolitions and various amateur additions and annexes. Kuba, Emil Přikryl's student and a member of the Brno Obecní dům, felt the need to reinstate a country feel to the center of the village, to "save the situation".*

He arrived at the belief that for the task at hand – the design of a chapel – no strikingly modernist solution, otherwise rather common with respect to sacral architecture in the countries of the former Soviet bloc, would be appropriate. According to Kuba, ambitious modern forms would further aggravate the chaos. Another concern was that the architect's excessive requirements in terms of technology and materials would not go beyond the skills of the locals who built the chapel more or less themselves. The walls of the chapel are from bricks with a coat of plaster, it is roofed over by means of a wooden construction with bent rafters, covered with shingles no longer made in the country but still frequently used for reconstructions of medieval monuments. Tradition became the basis for the chapel's form. However, the architect did not arrive at it through clear references to this or that old model: rather, he strove to embrace the tradition "an sich"; to grasp the "essence of tradition",* as he himself wrote in 1999.

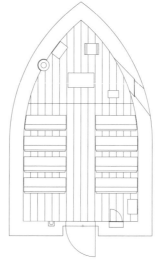

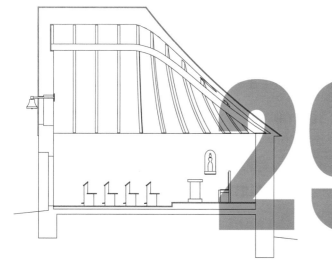

29

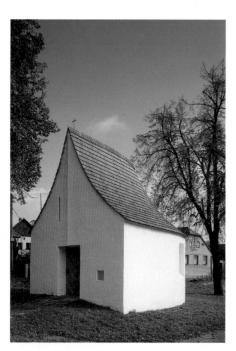

* "Autorská zpráva". *Architekt* XLV, 1999, Issue 4, p. 4.

Markéta Večeřáková-[Svobodová], "Návrat k tradičním hodnotám". *Architekt* XLV, 1999, Issue 4, p. 6.
Ladislav Kuba, "Kaple Panny Marie-Královny". *Zlatý řez*, No.18, 1998, pp. 52–53.

Josef Pleskot – Čestmír Dobeš – Jana Kantorová – Jitka Svobodová – Jiří Trčka – Zdeněk Rudolf – Isabela Grosseová, pathway through the Deer Moat at the Prague Castle. 1996 – 2002

If Kuba's definition of timelessness has any more specific roots, we probably ought to look for them in vernacular architecture, whose tradition Kuba abstracted and summarized. The architect who in the 1920s worked for T. G. Masaryk and designed changes at the Prague Castle to turn it into a "Castle for a democratic president",[81] Josef Plečnik, based his idea of timeless perpetuity on the aggregate of Classical traditions. The reinstatement of democracy after 1989 presented Czech architects with an uneasy task: to follow up on Masaryk and Plečnik's efforts at a democratization of the old feudal seat of Czech kings. Attempts at a revival of the inimitable – for these purposes – Classicism of Plečnik's "architectura perennis" turned out to be unfeasible. President Václav Havel was first and foremost intent on "opening up" the Castle, on providing access to interiors and exteriors closed to everyone under the former regime. The opening of the gardens on the northern side of the castle complex was connected with the construction of a new orangery by Eva Jiřičná. The space between the northern gardens and the castle promontory is occupied by the deep Deer Moat (Jelení příkop), a semi-wooded valley of the Brusnice brook that was bridged over in the 18th century by a wide escarp called Powder Bridge (Prašný most). Josef Pleskot's studio has been working to make the Deer Moat accessible and to connect its two sections since 1996.

Pleskot's solution is based on a tunnel cutting through the escarp of the Powder Bridge and thus providing an uninterrupted pathway through the Deer Moat. Before the digging of the tunnel was commenced, an access road had to be built first. One section of the access road leads along the escarpment of the castle promontory. The line of Pleskot's pathway winds slightly in order to avoid all trees, and consists of foot bridges made from wooden boards and suspended from vertical metal poles driven as deep into the ground as possible.* From the Malostranská subway station, the path can be accessed via metal grids bridging the gaps between the old pillars of Chotkova Road. Sensible footwear is thus recommendable.

In his concept of the tunnel, Pleskot tried to prevent a sense of close space. He is of the opinion that a rectangle space with a flat ceiling and walls could evoke a feeling close to claustrophobia: "A rectangle crack, a crack in a rock, is great as long as it does not have a ceiling. Otherwise, there is a great range of dark shadows, dark corners and sharp boundaries. And the perception of sharply refracted light deep underground evokes a sense of danger." *** Only the entrances at both sides of the tunnel are thus rectangle; the rectangular shape, however, quickly gives way to an oval, and the soaring form of the cavity is moreover dematerialized by virtual pillars of light from spotlights built into the concrete floors. Optic and haptic sensations are joined by the gurgling of the Brusnice brook, hidden under a long grate. The architect had the walls of the tunnel assembled from bricks, which made the critics Luis Marques and Dušan Seidl compare Pleskot's work to Plečnik's tunnel and staircase used by T. G. Masaryk to walk up to his apartment up at the Prague Castle when he alighted from the presidential limousine.** Unlike Plečnik's smooth texture, however, the bricks in Pleskot's tunnel are positioned vertically, upright, so that they look like "the wicker in a wicker basket", as the architect himself had heard from the enchanted visitors. After Přikryl's Benedikt Rejt Gallery, Czech architecture of the 1990s reached its second apex in this project – I am not aware of a third one – as confirmed by the European Brick Award 2004 conferred on the architect for his tunnel.

81 Damjan Prelovšek (ed.), Josip Plečnik. *An Architect of Prague Castle* (cited in footnote 17), p. 27.

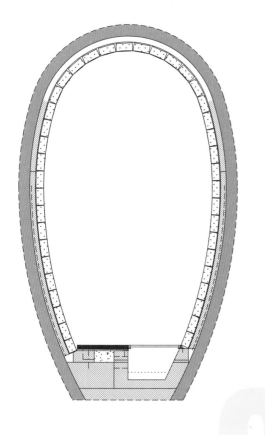

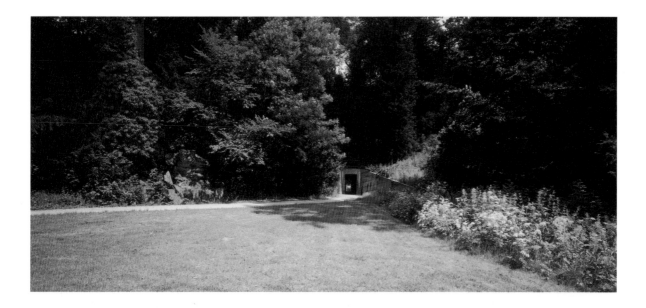

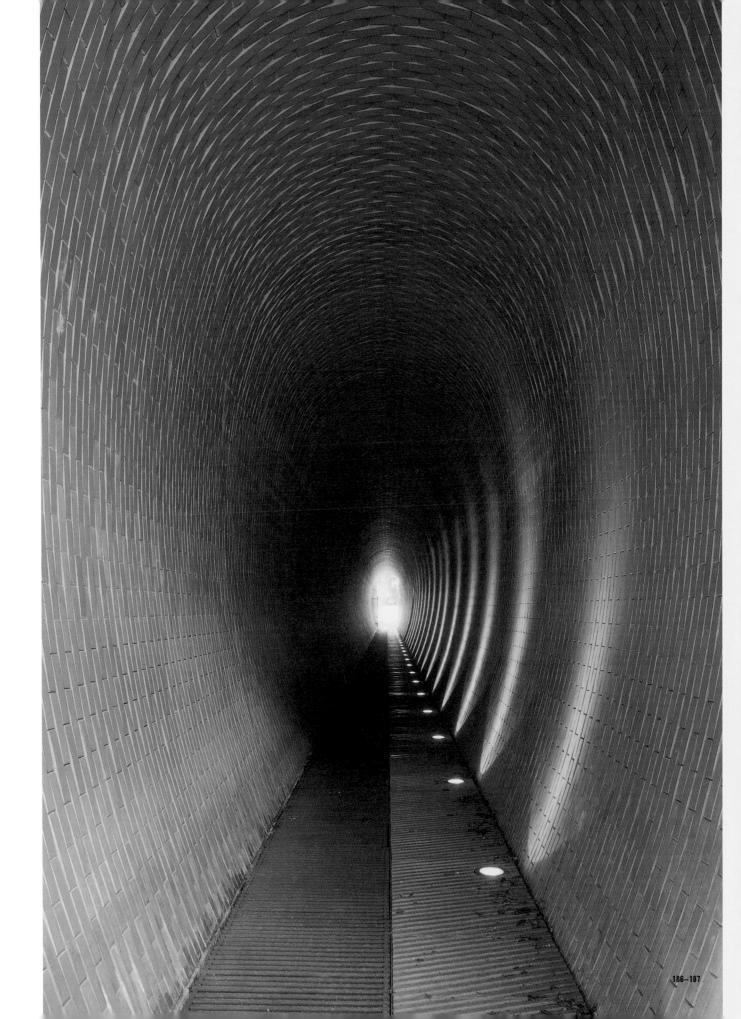

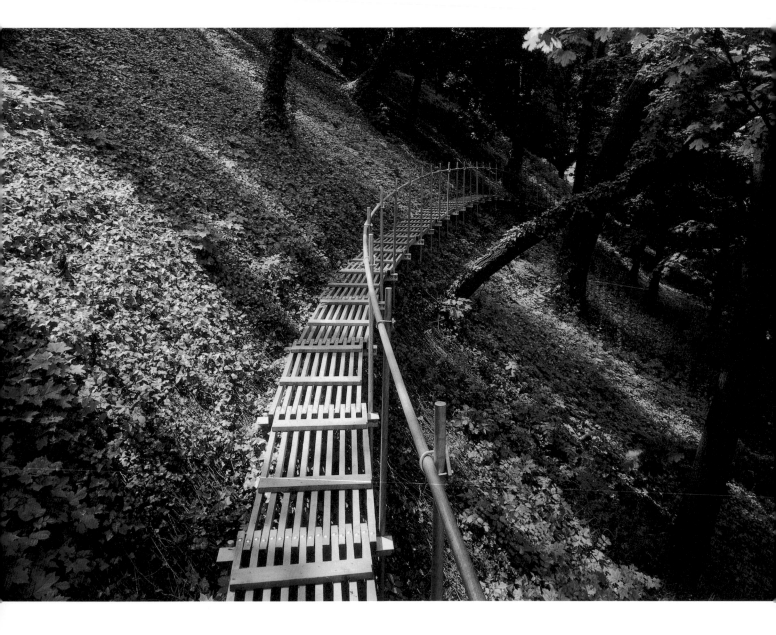

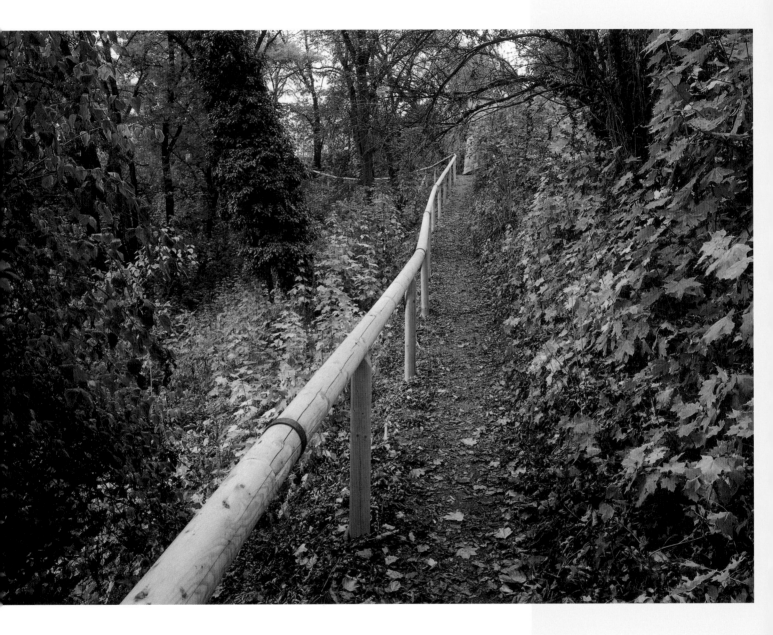

* Josef Pleskot–Pavel Rydlo–Jiří Trčka–Filip Tittelbach, "Dolní Jelení příkop". *Architekt* XLV, 1999, Issue 7, pp. 23–28.

** Luis Marques, "Architektura a stát: mezi tajemstvím a transparencí". *Architekt* XLVIII, 2002, Issue 10, pp. 32–33. Dušan Seidl, "Pražský hrad krásnější a popletenější". *Architekt* XLVIII, 2002, Issue 10, pp. 34–35.

*** Monika Mitášová–Josef Pleskot–Milena Sršňová–Rostislav Švácha, "Průchod valem Prašného mostu". *Stavba* X, 2003, Issue 2, pp. 50–57.

Vladimír Czumalo, "Poutníkova cesta do Jeleního příkopu". *Architekt* XLV, 1999, Issue 7, p. 26.

Josef Pleskot–Pavel Rydlo–Filip Tittelbach–Jana Kantorová–Jitka Svobodová, "Průchod valem Prašného mostu". *Architekt* XLV, 1999, Issue 7, p. 27.

Kurt Gebauer, "Návrh úprav Jeleního příkopu Pražského hradu". *Architekt* XLV, 1999, Issue 7, p. 28.

Josef Pleskot, "AP galerie a cesta Jelením příkopem". *Fórum architektury a stavitelství,* 1999, Issue 12, pp. 38–39.

Josef Pleskot, "Cesta z Opyše do dolního Jeleního příkopu". *Stavba* VI, 1999, Issue 4, pp. 50–51.

"Cesta z Opyše do dolního Jeleního příkopu". *Architekt* XLVI, 2000, Issue 5, p. 25.

"Autorská zpráva". *Architekt* XLVIII, 2002, Issue 10, p. 26.

Lidmila Cihlářová–Milena Sršňová (eds.), *Architektura 2003. Ročenka realizovaných staveb v České republice*. BertelsmannSpringer CZ, Praha 2003, pp. 140–141.

Michal Kohout (ed.), *Česká architektura / Czech Architecture 2001–2002. Ročenka / Yearbook.* Prostor – architektura, interiér, design, Prague 2003, pp. 22–23.

"Pathway through the Deer Moat". *C3Korea*, 2003, No. 226, pp. 124–129.

"Erschliessung der Prager Burg-Lichter Tunnel". *Deutsche Bauzeitung*, 2003, No. 11, pp. 42–45.

"Landscaping and Tunnel". *The Architectural Review* CCXIII, 2003, No. 1272, pp. 32–33.

Brick, '04. Brick Award 2004. Die beste europäische Ziegelarchitektur. Callwey Verlag, München 2004, pp. 16–21.

The Phaidon Atlas of Contemporary World Architecture. Comprehensive Edition. New York–London 2004, p. 594.

"AP atelier, Josef Pleskot. Pathway through the Deer Moat". *A+U 401*, 2004, No. 2, pp. 100–105.

"Fussgänger Tunnel in Prag". *Detail* 44, 2004, No. 6, pp. 660–663.

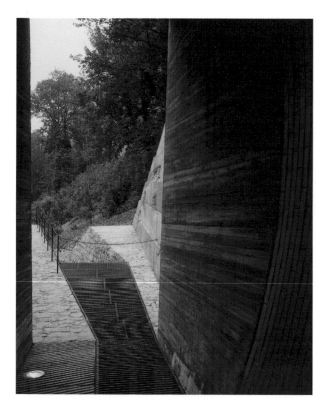

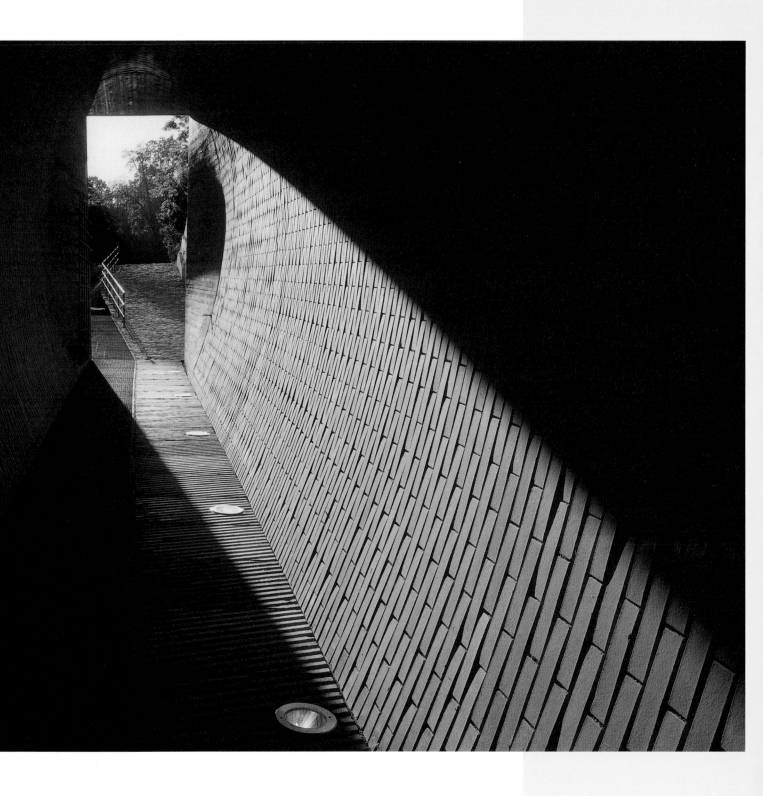

31

The appearance of Pleskot's tunnel does not necessarily have to remind us only of Plečnik. It reverberates also with the tradition of engineering construction projects, including ones as profane as the sewage system designed for Prague around 1900 by the Englishman Joseph Lindley. Roman Koucký also drew inspiration from engineering constructions from the late 19th, early 20th century when he worked on the design of the Long Bridge (Dlouhý most) in České Budějovice. This Prague architect consistently devotes his time to bridge design. His effort to lend an artistically impressive form to these constructions, however, keeps clashing with the specific variety of Czech austerity, with the pragmatic mentality of structural engineers. The arguments between the architect and engineers concerning the Marian Bridge (Mariánský most) in Ústí nad Labem (1994–1998) only ceased in 1999 when Koucký received an award from the European Convention for Constructional Steelwork for this variation on Santiago Calatrava's themes. The originality of the Long Bridge in České Budějovice is in that it combines two construction systems: the bridge deck hangs on ropes suspended from a giant frame in the centre of the bridge, as well as metal walls under the ropes, perforated in an almost Art Nouveau style with holes in the form of parabolic triangles. The engineers Josef Šanda, Vladimír Tvrzník and Václav Horák, who reviewed the bridge for *Architekt*, could have been expected to consider one of the constructions used redundant, stuck onto the other construction for no reason. These structural engineers could not understand why Koucký would "force himself to design a conceptual solution showing he does not understand".* The only person who stood up for Koucký was a professor at the Aachen Technical University, Mirko Baum, although it is precisely this former SIAL member who is the one best able among Czech architects to view the project in an engineering fashion. In his review in *Stavba*, even Baum saw a hybrid in the bridge construction; however,

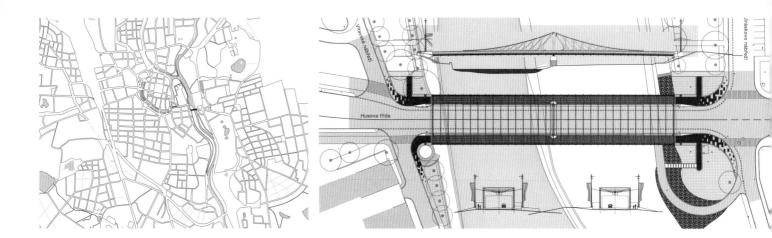

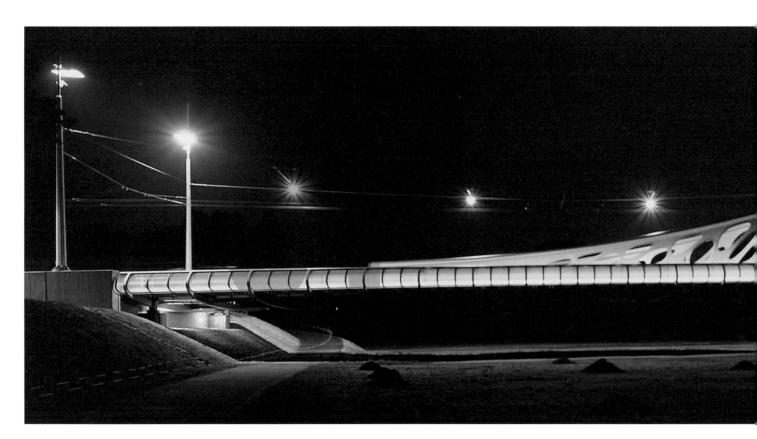

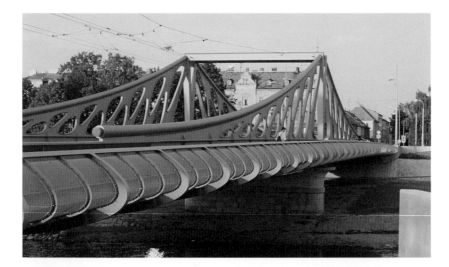

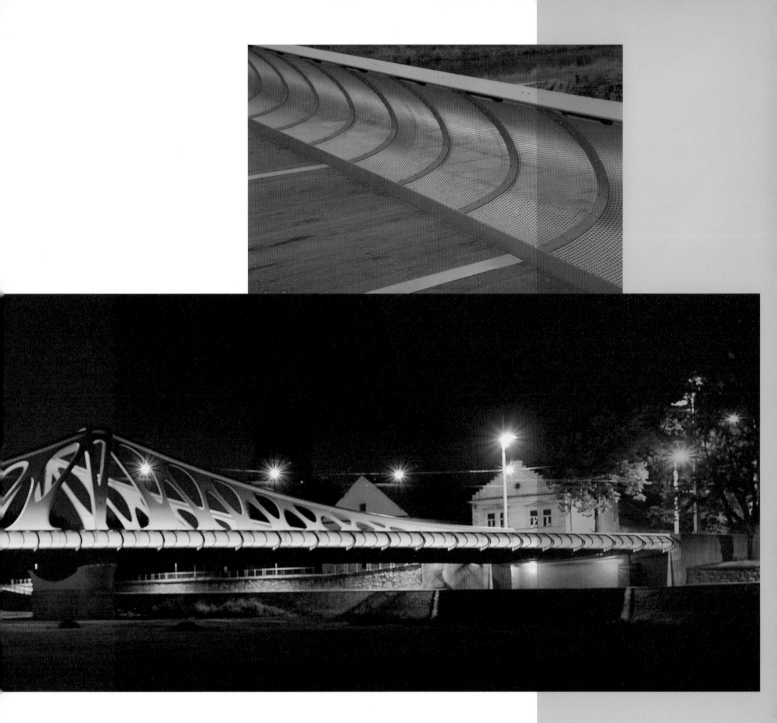

* Vladimír Tvrzník–Václav Horák, "Dlouhý těžký most". *Architekt* XLV, 1999, Issue 7, p. 39.
** Mirko Baum, "O tendencích tvarování inženýrských staveb všeobecně... a Dlouhém mostu zvláště".
Stavba VI, 1999, Issue 1, pp. 30–31.

Roman Koucký, "Dlouhý most v Českých Budějovicích". *Zlatý řez*, No. 16, 1997, pp. 52–53.
"Z autorské zprávy". *Architekt* XLV, 1999, Issue 5, p. 12.
Josef Šanda, "Na trhu s uměním?". *Architekt* XLV, 1999, Issue 7, p. 37.
Pavel Halík, "Lyrický high tech". *Architekt* XLV, 1999, Issue 7, p. 38.
"Most k mostům". *Architekt* XLV, 1999, Issue 7, p. 39.
Tomáš Rotter–Roman Koucký, "Dlouhý most v Českých Budějovicích". *Fórum architektury
a stavitelství*, 1999, Issue 2, pp. 26–29.
Roman Koucký–Milena Sršňová, "Dlouhý most v Českých Budějovicích". *Stavba* VI, 1999,
Issue 1, pp. 27–28, 32–33.
Milena Sršňová, "Rozhovor s Miroslavem Benešem, bývalým primátorem Českých Budějovic,
poslancem Parlamentu ČR". *Stavba* VI, 1999, Issue 1, p. 29.
Roman Koucký. Architektonická kancelář. Zlatý řez, Praha 2000, pp. 238–281.
Petr Kratochvíl–Pavel Halík, *Contemporary Czech Architecture / Tschechische zeitgenössische
Architektur*. Prostor – architektura, interiér, design, Prague 2000, pp. 105–107.

Roman Koucký conceived his Long Bridge in such a striking, although not very austere, fashion also because it was what the client, the City of České Budějovice, wished. The mayor, Miroslav Beneš, expressly commissioned a "landmark" from the architect: he wished, as recorded by *Stavba* in 1999, "to have a construction that belongs into the city and that is able to humanize and citify that part of the city that became, completely incomprehensibly, a transit hub in the center of Budějovice". A year before the bridge was completed, the city undertook another demanding project: an addition to the Baroque town hall designed by the Viennese architect Anton Erhart Martinelli and sited in the Budějovice's main square. The municipal council commissioned the project in 1997 from the Prague-based architects Zdeněk Jiran and Michal Kohout, whom we already know as the staunchest critics of Gehry and Milunič's Dancing Building.

In parallel to the older, transversal wing of the town hall, the architects had a new transversal wing built inside the courtyard behind the Baroque building, and added a new tower to it as an ancient symbol of European town halls. They had the courtyard around the tower newly paved, indicating archeological traces of Gothic development, and placed a monument to the famous Budějovice mayor, August Zátka, inside the courtyard. According to Jiran and Kohout's interpretation, the Constructivist-like pavilion on the roof of the tower, the glassed-in bridge leading to the tower, the horizontality of the windowsills on the facade of the main part of the addition all "date" their building to the period at the turn of the millennium.* The traditional and contextual dimension of their work, on the other hand, is guaranteed by the timeless scheme of a "house with windows", as well as the quality of craftsmanship and materials, in particular the specially cultured plaster. The most interesting idea of the addition, however, was in its "transparency" – an open approach of a democratic institution to the citizen. As Jiran recalls, it was the mayor Beneš himself who did not like the fact that the inside of the town hall retained an "Austro-Hungarian darkness", the atmosphere of Franz Kafka's novels: "corridors where man wonders through the Kafkaesque office and knocks on doors... A lady carrying a cup of coffee passes by, paying no attention to you..."** The idea of democratic lightness and transparency was to have been expressed especially by the solution of a four-storey atrium with gallery landings, formed by means of a transparent ceiling structure built between the old and new transversal wings. Jiran and Kohout, however, did not satisfy themselves with transparency as a mere metaphor of democracy for which architecture seeks appropriate forms. They took the notion literally. As if believing that the citizen would gain control over his matters if he is able to watch civil servants as if in a display cabinet, they chose clear glass for the walls of offices facing the atrium.

32

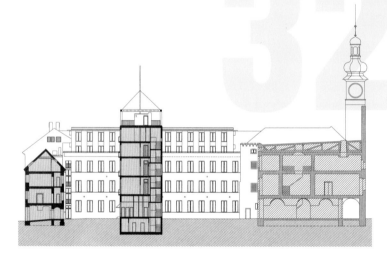

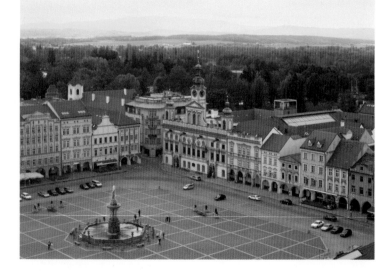

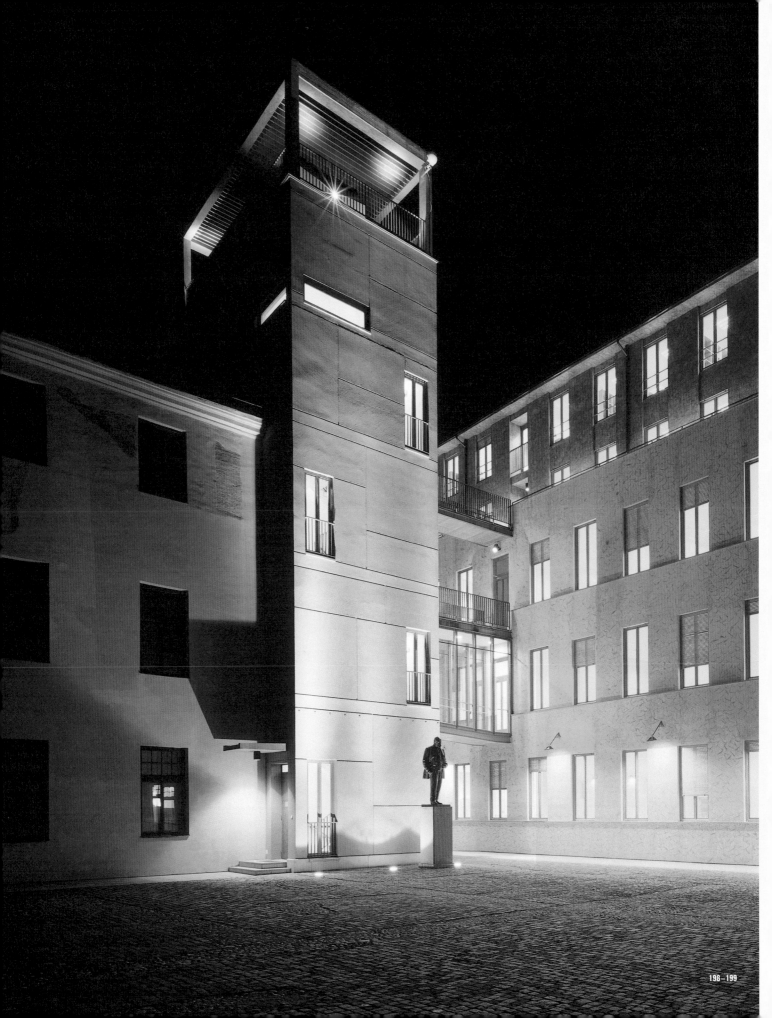

 * "Autorská zpráva". *Architekt* XLVII, 2001, Issue 1, p. 14

 ** Radek Váňa–Jiří Horský, "Profil: Zdeněk Jiran, Michal Kohout".
 Architekt XLVII, 2001, Issue 1, pp. 18–21

 "Zvláštní cena". *Architekt* XLIII, 1997, Issue 13, pp. 38–39
 Petr Pelčák (ed.), *Česká architektura / Czech Architecture 1999–2000. Ročenka / Yearbook.*
 Prostor – architektura, interiér, design, Prague 2001, pp. 100–103
 Rostislav Švácha, "Téma průhlednosti". *Architekt* XLVII, 2001, Issue 1, p. 17
 Alena Kubová (ed.), *Un Salon tchéque. Architecture contemporaine et design en République*
 Tchéque. Institut francais d'architecture, Paris 2002, pp. 26–29
 Veronika Maurer, "Postsozialistische Stadttransformation – Jiran, Kohout, Gemeindezentrum
 und St. Prokop-Kirche in Prag, Rathaus in Budweis, Tschechien". *Architektur.Aktuell*, 2002,
 No. 1–2, pp. 88–97

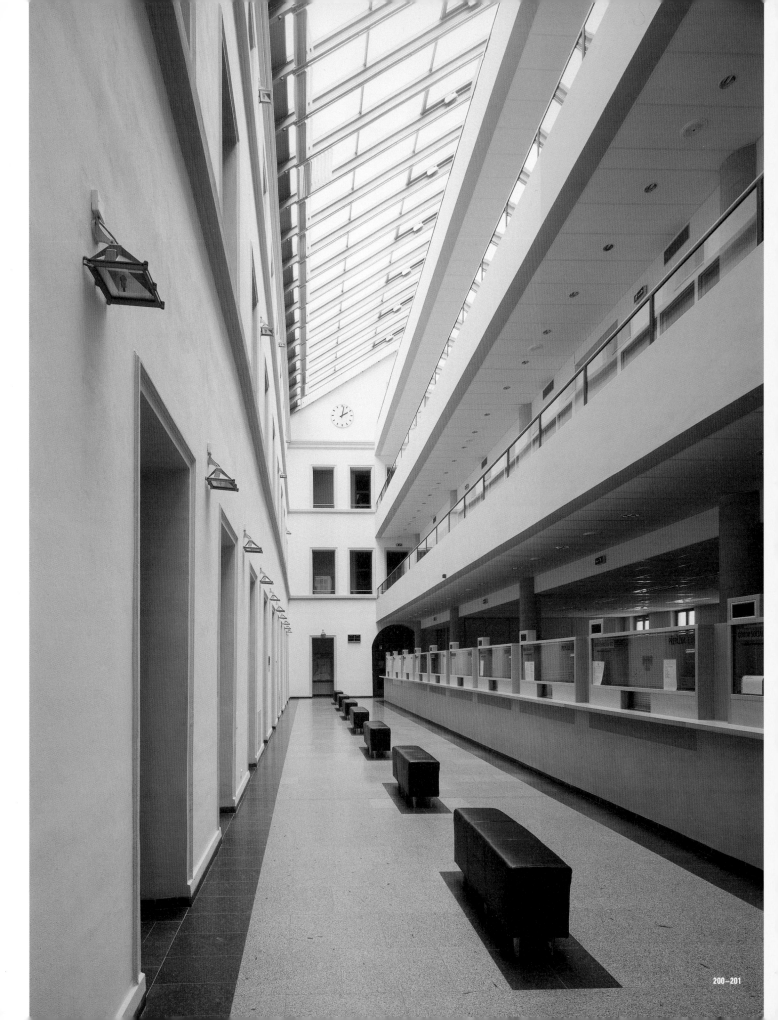

Stanislav Fiala – Daniela Polubědovová, MUZO building in Prague 10-Strašnice, V Olšinách and U Vesny Streets. 1997–2000

According to the Brno architect Petr Hrůša, designing buildings for political institutions, such as town halls, should not consist of thinking up forms or symbols of democracy, but rather in creating a normal, humanly dignified environment for the citizen, who truly is what constitutes democracy. According to Hrůša's 2003 article "Průhlednost je žvást" (Transparency Is Bullshit), one such symbol, transparency, is evolving into a cliché, "a cheap notion everybody refers to". Hrůša is of the general opinion – thus paraphrasing, to some extent, the point of a famous essay by Colin Rowe and Robert Slutzky[82] – that "today transparency is identified with what is superficial, what is not very deep".[83]

However, for many architects of the neo-modernist persuasion, transparency is too great a temptation to be convicted by such arguments. They do not comprehend why they should not reach for state-of-the-art technologies if the client appears willing to pay for them, and, moreover, if they are in line with the purpose of the building. The notion of transparency is today in such cases accompanied by yet another important notion: dematerialization. Both aptly describe the qualities that Stanislav Fiala was aiming for in his design of the MUZO building in Prague-Strašnice. This most sophisticated new building of contemporary Czech architecture, an embodiment of truly "high", rather than "low", technologies serves a function that to a significant degree justifies the architect's highly elitist vocabulary. According to Fiala, it is used to carry out "virtual", intangible activities, visible only in the form of a bar code or an intangible image on a computer monitor.* The building is occupied by a center for the control of a magnetic charge card system. While the system is operated by people, it is run by a computer that, apart from many other operations, responds to sunlight and moves the sun blinds on both the face and reverse sides of the glass facades, which are moreover printed over with bar code lines. This is certainly reminiscent of the works by Nouvel, including his Prague Golden Angel. Fiala, however, wished to be even more austere that the French architect. He strove to incorporate the building into its surroundings as a "regular office building" with an external form of "utmost simplicity".* The critic Karel Doležel noted that the interiors were "orgies in the precision of detail".** The structuring of the building's complex and deep groundplan had to comply with security and confidentiality requirements: people are not able to move around freely and a long stay in the house-machine does not necessarily have to feel pleasant. Organic curves in the groundplan, subtle illumination from cylindrical glass skylights and an effort at an unobstructed view through the transparent facade are supposed to, in Fiala's own words, "soften up and humanize the space for its inhabitants."

82 Colin Rowe–Robert Slutzky, "Transparency: Literal and Phenomenal", in: Colin Rowe,
 The Matematics of the Ideal Villa and Other Essays. The M.I.T. Press, Cambridge, Mass. 1982,
 pp. 159–183.
83 Petr Hrůša, "Průhlednost je žvást" (Transparency Is Bullshit). *Architekt* IL, 2003, Issue 8, p. 54.

33

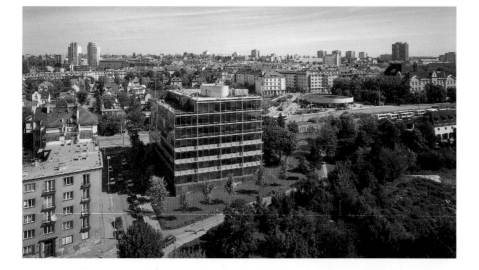

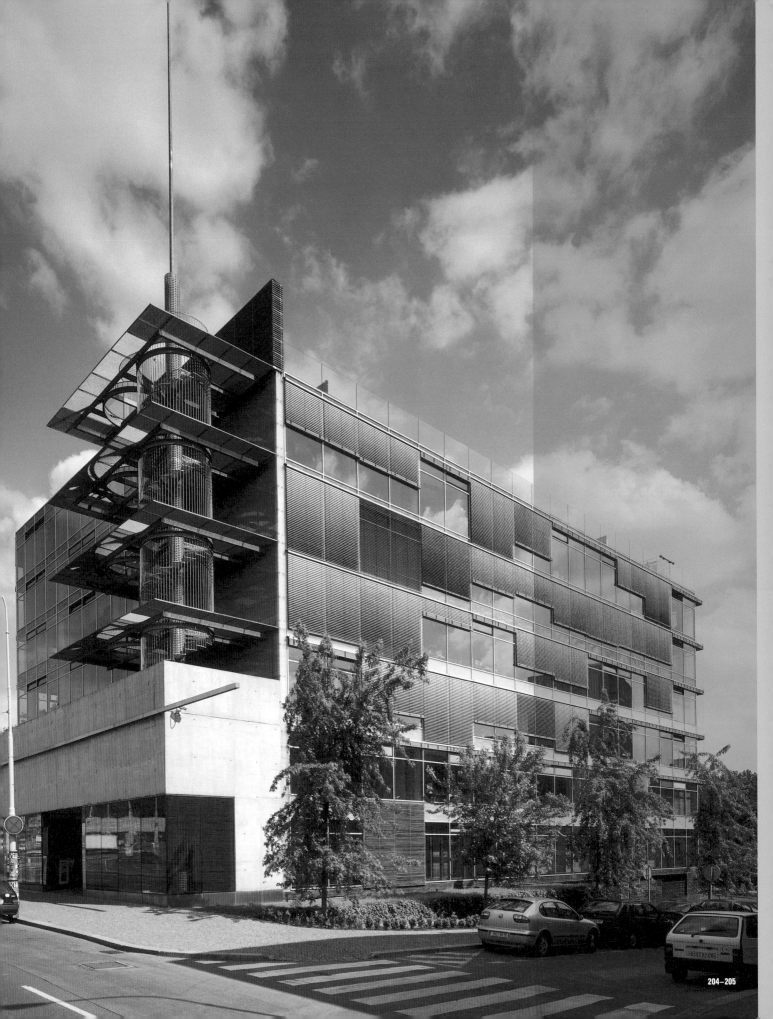

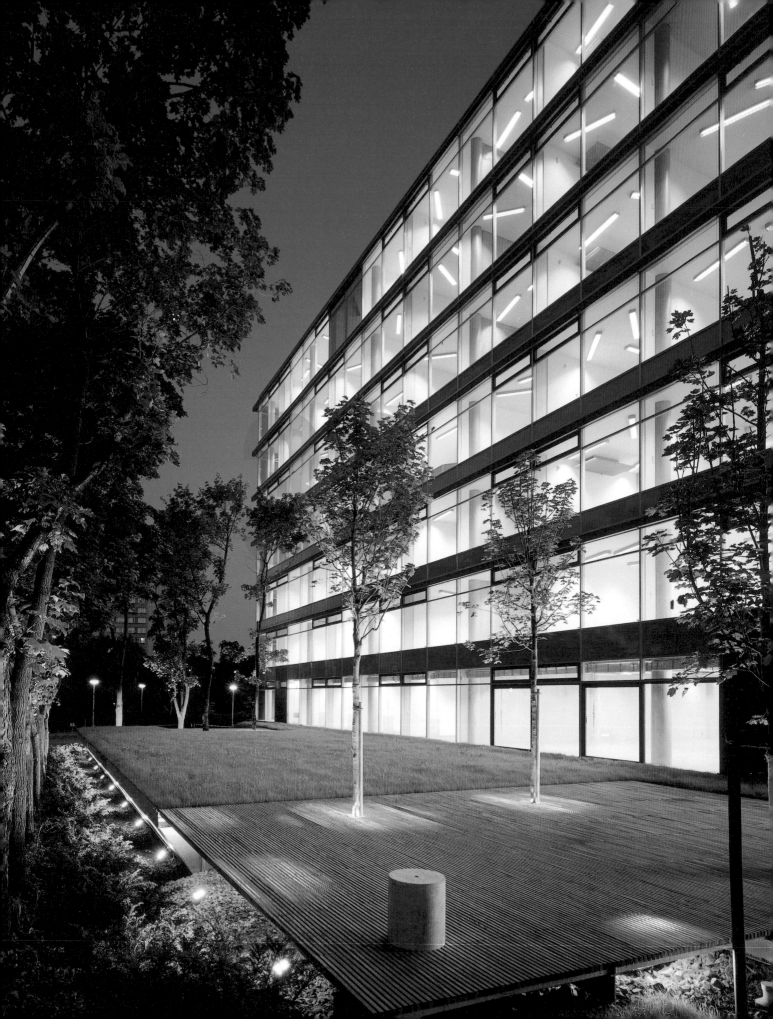

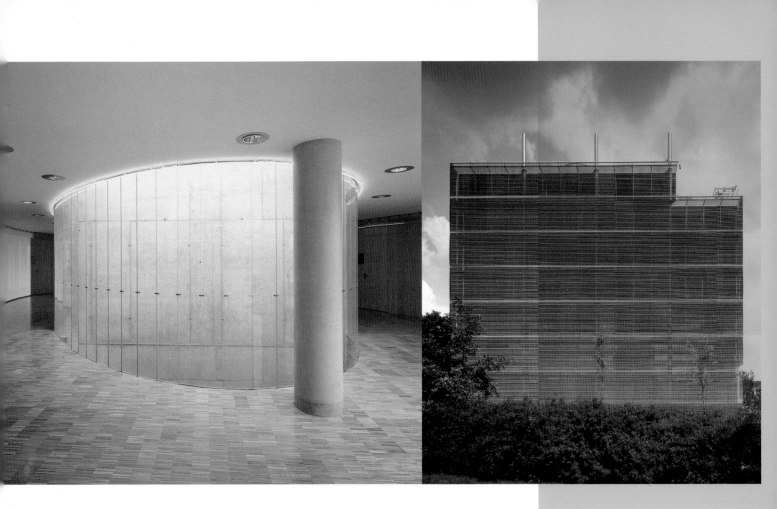

 * [Autorská zpráva]. *Architekt* XLVI, 2000, Issue 8, p. 10.
 ** Karel Doležel, "Tajemný dům v parku". *Architekt* XLVI, 2000, Issue 8, pp. 12–13.

Stanislav Fiala, "Slovo autora projektu". *Fórum architektury a stavitelství,* 2000, Issue 7–8, pp. 23–29.
Tereza Spörri, "MUZO centrum". *Stavba* VII, 2000, Issue 5, pp. 74–79.
Mies van der Rohe Award Catalogue. Barcelona 2001, pp. 74–77.
Petr Pelčák (ed.), *Česká architektura / Czech Architecture 1999–2000. Ročenka / Yearbook.*
Prostor – architektura, interiér, design, Prague 2001, pp. 22–27.
Milena Sršňová–Libor Štěrba (eds.), *Architektura 2001. Ročenka realizovaných staveb v České republice.* BertelsmannSpringer CZ, Praha 2001, pp. 14–15.
Jana Tichá, "Portfolio. Beyond the (Post)modern. *Harvard Design Magazine,* Winter–Spring 2001, pp. 60–67.
"Prague transfigurée". *Maison Francaise,* No. 520, Automne 2002.
Jana Tichá, "MUZO Centrum Praha". *Piranesi* IX, Spring 2002, No. 13–14.
Karim Rashid (ed.), *The International Design Yearbook 2003.* Laurence King Publishing, London 2003, p. 55.
The Phaidon Atlas of Contemporary World Architecture. Comprehensive Edition.
New York–London 2004, p. 593

Josef Pleskot–Peter Lacko–Radek Lampa–Pavel Rydlo–Jitka Svobodová, Metrostav headquarters in Prague 8--Libeň, Koželužská Street 2246, Zenklova Street. 1997–2000

Josef Pleskot is among the few Czech architects who admired Nouvel's Golden Angel. His review of the building in *Stavba* 2001 pays a tribute to Nouvel's nonchalance, as well as the fact that the work of the Paris architect "displays a perfect understanding of the tangled relations of Prague's genius loci". In the office complex of the construction company Metrostav in Prague 8-Libeň, Pleskot is not afraid to show that he likes the Nouvelian technicist morphology, attractive for him also because it does not become swamped in concerns over details and the availability of latest technologies. Pleskot characterizes his project as "a house as simple to operate and understand as a disposable lighter".* Pleskot's Brno colleague, Ladislav Kuba, affirmed Pleskot's feeling for a simple solution of construction problems in his review of the finished building: "Given the theme at hand, a much more fancy building with steel braces and precise joints from the repertoire of high tech proponents could have been created: however, the author of this strange building is clearly not one of those."**

Simple architecture had to respond to a complex situation here; after all, that also explains why the architect divided the Metrostav complex into two separate buildings, connected only via underground car parks. Opposite the main Metrostav building that reminded Kuba of "something between a walkie-talkie, hovercraft and a Zeppelin",** in Koželužská Street, little Baroque houses from an old fishermen's village have survived. The block where both of Pleskot's buildings stand today consists of rather larger patrician houses from the late 19th century on one hand, and strictly massive buildings on the other, such as a 1930s movie house and restaurant, Svět, built by not very well known architects-Functionalists, who attempted to complete and enclose the block. World War II brought their efforts to a halt, with two gaps remaining in the block, surrounded by three different types of "contexts" of varying scales and heights. If either one of them was preferred, it would have always been in conflict with the other two. Moreover, Pleskot stated several times that "contextuality was not about imitation", and got repeatedly angry by "pseudo-conservation" that makes modern-day architect behave with excessive respect in a historical context.

Both of Pleskot's Metrostav buildings thus became all kinds of things but inconspicuous and simple-minded fillings of the two gaps. The other building in Zenklova Street is attached only to one of its neighbors. A crack was left in the block so that people could pass into the little park behind, and stepped back behind the street line, which, according to Pleskot, is a motif typical of Prague and is frequently the case for buildings newly built in Prague in the period between the wars. The main Metrostav building in Koželužská Street does not sit on its plot at all: it floats above it "like a cloud" – in Pleskot's own words – whose reinforced concrete structure was rounded off on both ends by the architect in Nouvelian fashion and then wrapped in sheet

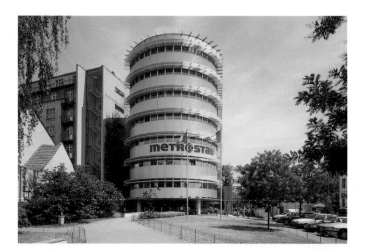

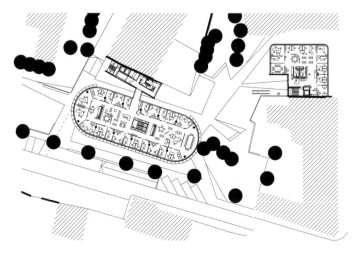

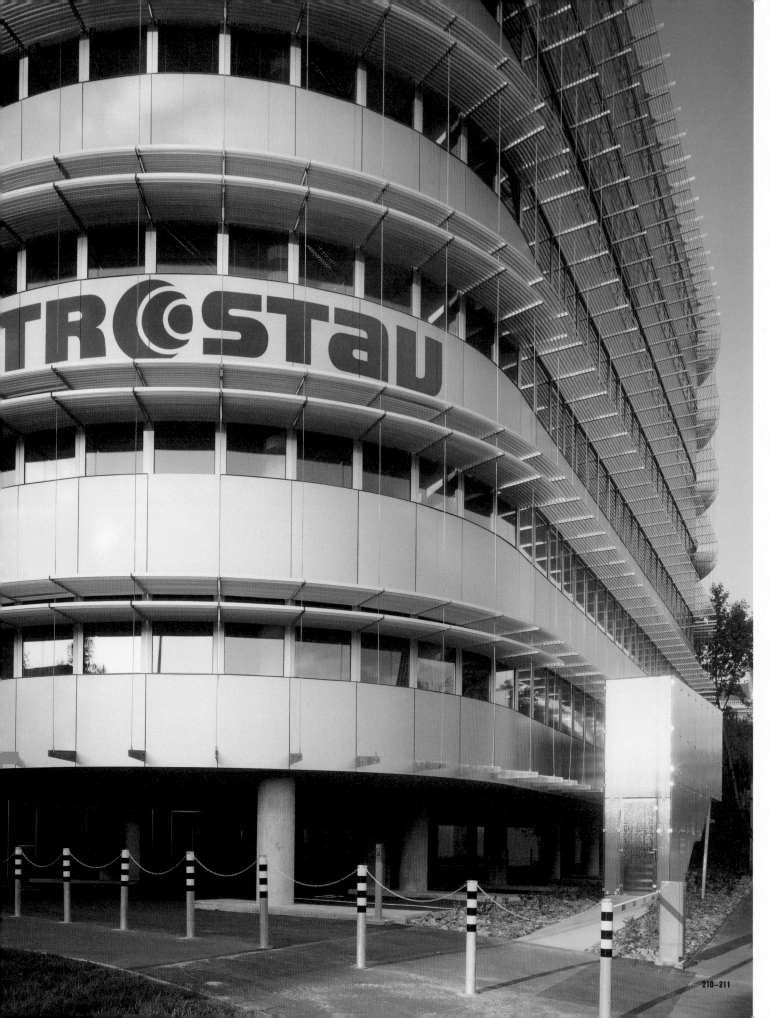

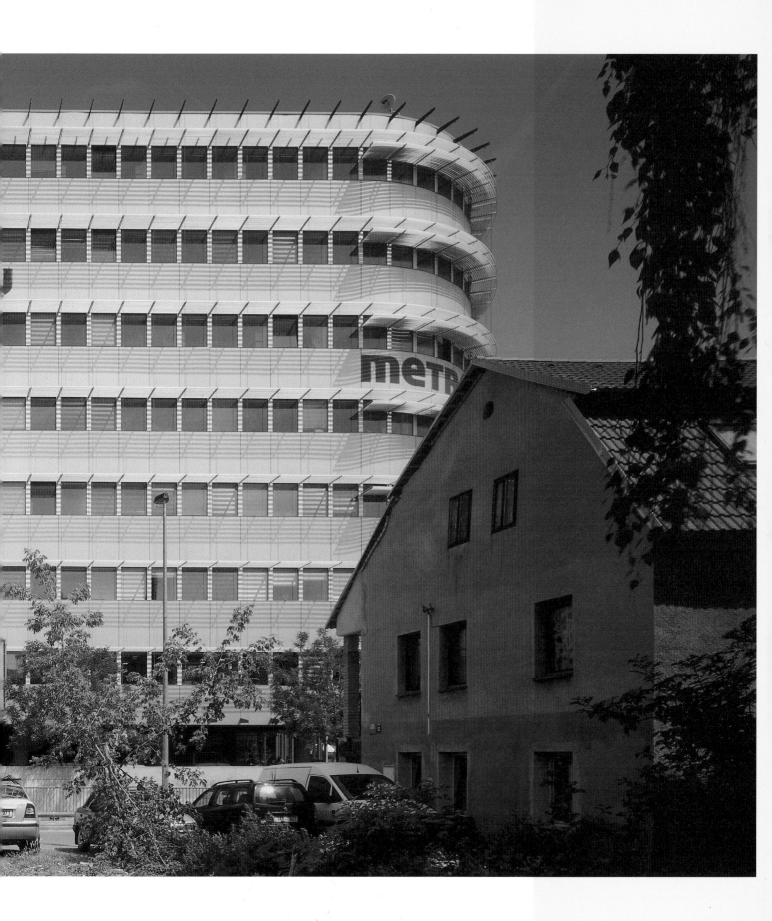

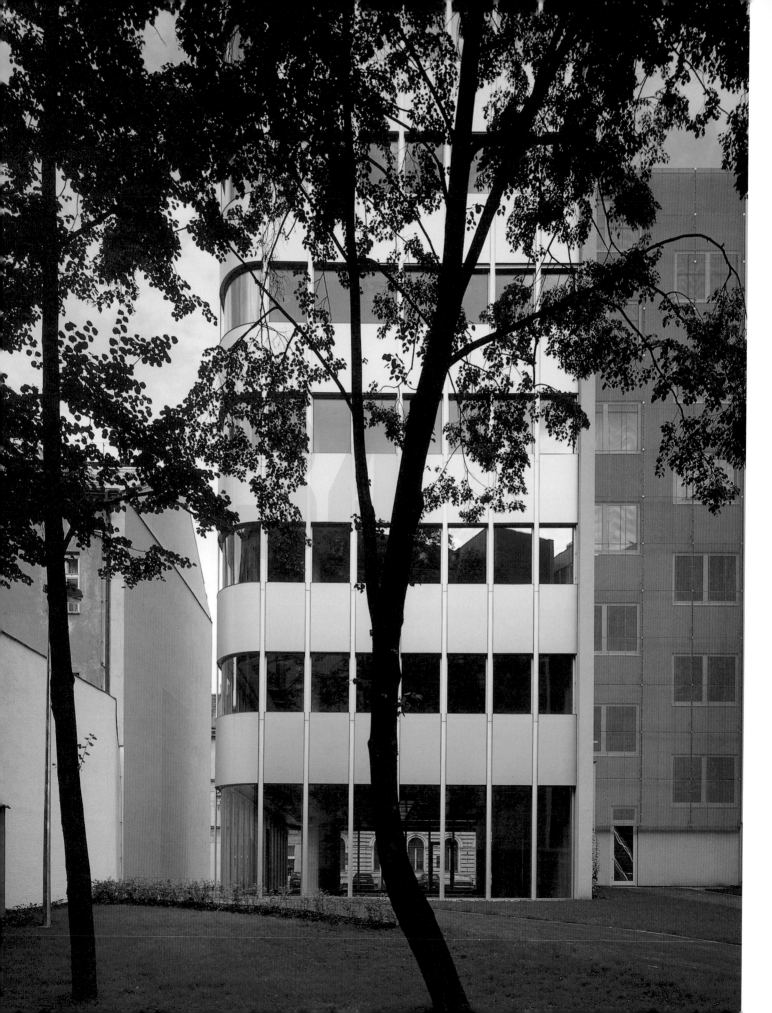

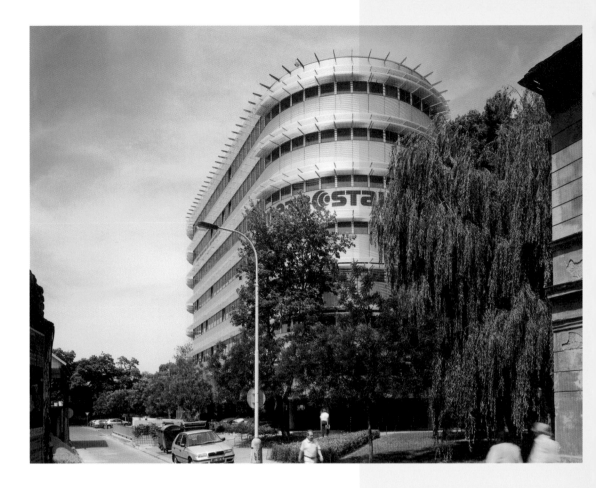

 * "Z architektonických kanceláří". *Stavba* IV, 1997, Issue 4, p. 8.

** Ladislav Kuba, "Libeňská vzducholoď". *Architekt* XLVI, 2000, Issue 9, p. 28.

Josef Pleskot. AP atelier. Galerie Jaroslava Fragnera, Praha 1997, pp. 78–79.

"Autorská zpráva". *Architekt* XLVI, 2000, Issue 9, p. 25.

Petr Pelčák (ed.), *Česká architektura / Czech Architecture 1999–2000. Ročenka / Yearbook.* Prostor – architektura, interiér, design, Prague 2001, pp. 44–49.

Milena Sršňová–Libor Štěrba (eds.), *Architektura 2001. Ročenka realizovaných staveb v České republice.* BertelsmannSpringer CZ, Praha 2001, pp. 16–17.

"Josef Pleskot. Administrativní centrum Palmovka Park". *ARCH o architektúre a inej kultúre* V, 2002, No. 12, pp. 18–20.

"Palmovka-park". *Fórum architektury a stavitelství,* 2001, Issue 5, p. 55.

Alena Kubová (ed.), *Un Salon tchéque. Architecture contemporaine et design en République Tchéque.* Institut francais d'architecture, Paris 2002, pp. 10–13.

Pleskot understands the meaning of the term context differently from most Czech conservationists. His contribution, "contextuality is not about imitation", goes against the grain of their doctrine of synthesizing 'mimicry'. Roman Koucký adopts more aggressive positions today. According to him, not only structural engineers but also monument conservationists obstruct creative architecture. He goes as far as to call for the abolition of monument conservation as an institution, arguing that a good regulation plan is sufficient to protect a historical town. According to Koucký, conservation is harmful precisely because it denies the present era the right to leave a new mark in the city, to add a new "layer".[84] Unlike Hana Zachová, Roman Koucký probably does not take into account the risk that the growth of new layers might eventually strip historical cities of their unique nature for which they are protected. He also disregards the fact that the architect's right to a new "imprint" is in competition with people's right to dwell and live in a unique historical environment. Nonetheless, today's monument conservation makes the mistake of avoiding a debate with people like Koucký, Pleskot or Lábus, not realizing that they are its allies, not enemies.

One of the incidents that prompted Roman Koucký's campaign against conservationists took place in 1994 in Slavonice, a historical town on the border between Moravia and South Bohemia. Koucký and his partner, Šárka Malá, won a competition for a remodeling of Slavonice's squares. Their idea was to pave them with bricks in order to obtain an interesting contrast between their orange surface and the black and white sgraffito facades of the Renaissance houses. The conservation authorities, however, insisted on a traditional stone pavement, similar to that used in Český Krumlov by Hana Zachová.

This new pavement, traditional in appearance, is today faced by the Renaissance Fára's house from the mid-16th century. Its owner, the photograph historian Anna Fárová, was able to create a situation that allowed the architect's yearning for an imprint of the present period, "undeniable, undisguised and undisguisable",* to finally be fulfilled in Slavonice. However, Koucký, Malá and Iveta Chitovová acted with a greater moderation than would have been suggested by the architect's extreme statements. If the review by the journalist Věra Konečná** is to be believed, the conservation authorities also adopted a "surprisingly lenient" position on the work carried out by Koucký's team.

Fára's "house" is in fact a conglomerate of three houses damaged by unfortunate additions and conversions made over the last two centuries. The architects cleansed the houses with sensitivity, and whatever was valuable was restored by restorers. Anna Fárová wished to have "vistas everywhere" to be able to "enjoy the space".*** This requirement resulted in an idea of two square concrete shells: a horizontal one through which the client passes from the library to her bedroom in the rear wing, and a vertical one into which the architects placed the new main staircase. The communication between the ground floor with its beautiful vaulted hall and the first floor is further facilitated by a second staircase, called "Escherian" by Mrs. Fárová in reference to works by the famous Dutch graphic artist. A new fireplace was added in the main section on the first floor, together with a panel with a triptych painting by the client's late husband, the painter Libor Fára, after whom the house is called. External manifestation of Koucký's intervention, described by the architect himself in *Architekt*,* has

35

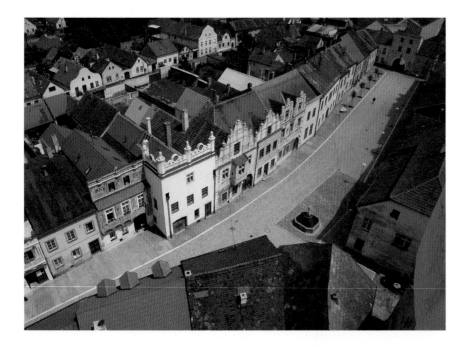

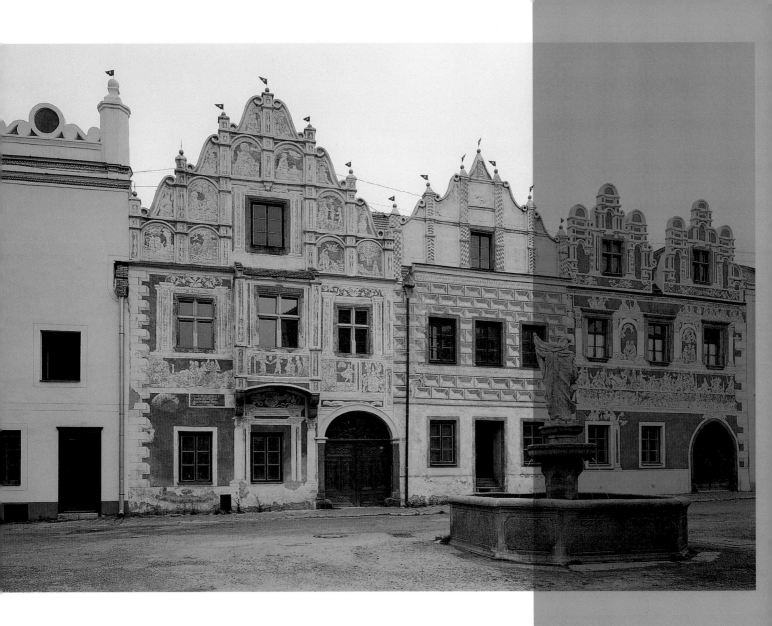

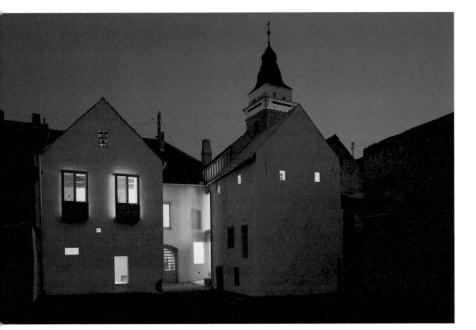

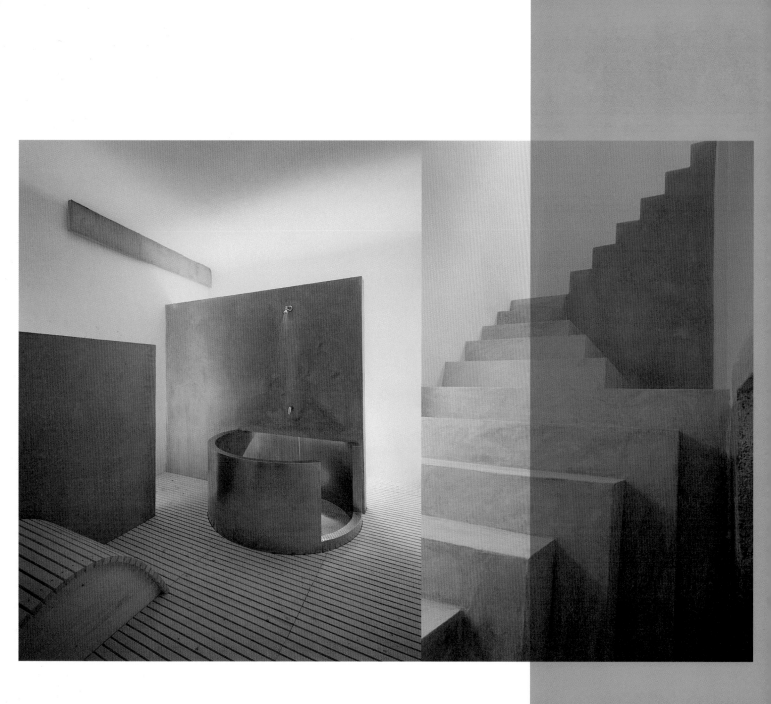

* "Autorská zpráva". *Architekt* XLVI, 2000, Issue 5, p. 7.

** Věra Konečná, "Sugestivní symbióza". *Stavba* VII, 2000, Issue 1, pp. 28–31.

*** Rostislav Švácha, "Fárovy domy". *Stavba* X, 2003, Issue 1, pp. 28–33.

Roman Koucký – Šárka Malá, "Rekonstrukce náměstí ve Slavonicích". *Zlatý řez*, No.11, Spring 1996, pp. 52–54.

Roman Koucký. Architektonická kancelář. Zlatý řez, Praha 2000, pp. 282–323.

Lenka Žižková et al. (ed.), *Český interiér a nábytkový design / Czech Interior and Furniture Design 1989–1999.* Prostor – architektura, interiér, design, Prague 2000, pp. 127–129.

Roman Koucký – Šárka Malá, "Fárův dům Slavonice". *Fórum architektury a stavitelství* 2000, Issue 5–6, pp. 20–23.

Petr Pelčák (ed.), *Česká architektura / Czech Architecture 1999–2000. Ročenka / Yearbook.* Prostor – architektura, interiér, design, Prague 2001, pp. 40–43.

36

Petr Hájek – Tomáš Hradečný – Jan Šépka – Jan Vihar – Martin Marsik, farmstead of the Archdiocesan Museum in Olomouc, Václavské Square 4. 1998 – 2003

A similar idea of involving a collage from old and new elements occurred to the architects Hájek, Hradečný and Šépka when they won a competition for the reconstruction of the capitular deanery in Olomouc in 1998. The competition was held thanks to the efforts of Pavel Zatloukal, the driving spirit of all similar undertakings in Olomouc. The buildings of the deanery are to serve the newly established Archdiocesan Museum, whose administration this art historian selflessly took upon himself although he has another local museum to run. The buildings of the deanery face the outside world through simple Baroque facades. Inside, however, they hide much older medieval fragments, starting from 11th century Pre-Romanesque ones. The Hájek – Hradečný – Šépka team won the competition for the reconstruction of the complex mainly because they limited interventions into its complex structure to a minimum.* The matter of the old monument is in no way reduced, and new elements are added as one would put on jewelry. The first stage of the reconstruction – conversion of the deanery's farmstead into depositaries, a restoration workshop and offices of the curators of the new museum – testifies to the qualities of this concept. The architects had new pavement laid in the courtyard. Series of minute Minimalist spaces were then introduced into the vaulted ground floor and the attic floor. These spaces behave as autonomous architecture, and yet their impact is based on their contrast with the historical vaults and rafters. Where the result borders on the same magic found at the Benedikt Rejt Gallery in Louny by Emil Přikryl, it can be explained by the fact that Hájek and Šépka had studied under Přikryl.

36

* "Autorská zpráva". *Architekt* XLV, 1999, Issue 3, p. 59.

Alena Kubová (ed.), *Un Salon tchéque. Architecture contemporaine et design en République Tchéque.* Institut francais d'architecture, Paris 2002, pp. 22–25.
Petr Hájek–Tomáš Hradečný–Jan Šépka, "Arcidiecézní muzeum v Olomouci, hospodářský dvůr". *Architekt* IL, 2003, Issue 9, pp. 26–35.
Rostislav Švácha, "Povýšení památky moderní architekturou". *Architekt* IL, 2003, Issue 9, pp. 26–35.
Jaroslav Wertig (ed.), *Česká architektura / Czech Architecture 2002–2003. Ročenka / Yearbook.* Prostor – architektura, interiér, design, Prague 2004, pp. 40–45.
Radek Váňa, "Successful Young Czech Architects". *Review of the Czech Republic* XI, 2004, No. 1, pp. 22–25.

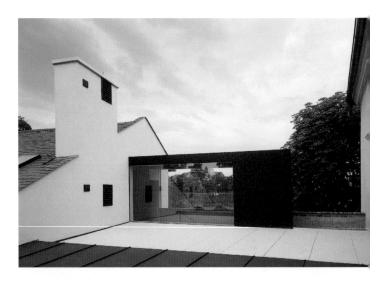

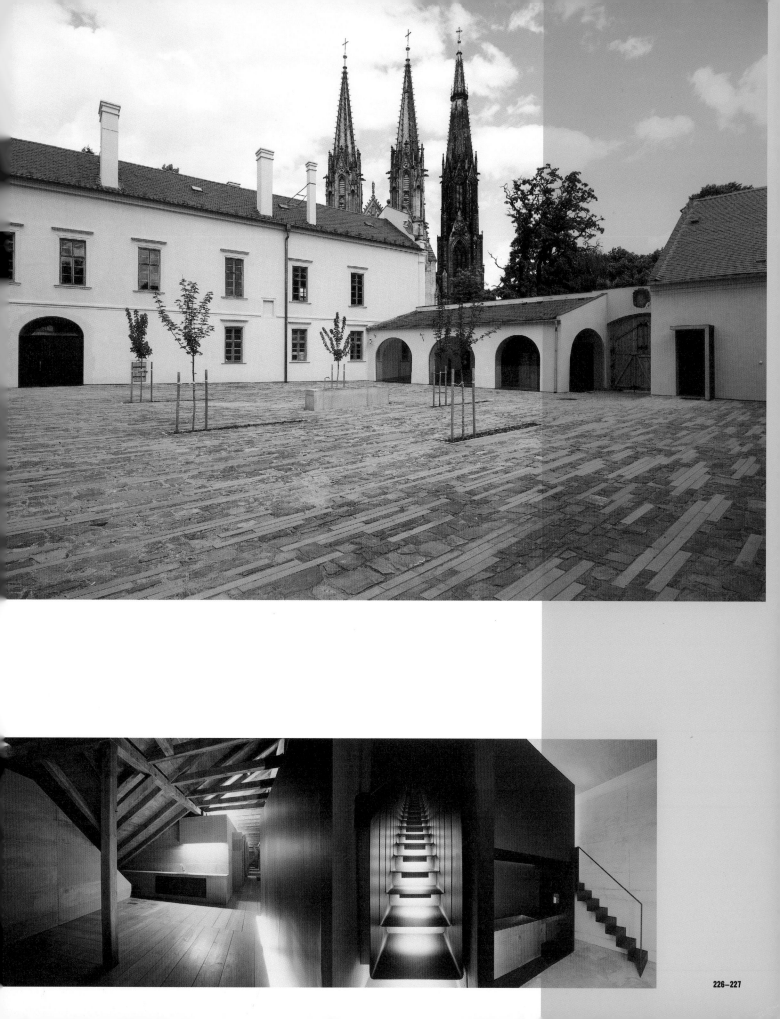

The Brno-based architects Petr Hrůša and Petr Pelčák conceived their tennis hall in Litomyšl as a tool of the anti-Minimalist polemic, or rather the Prague breed of Minimalism that is purported to be overly influenced by the Swiss architects Jacques Herzog and Pierre de Meuron and that presents buildings-boxes as objets d'art. At least that is what Josef Holeček contends in his review from 2000: "This highly functional (…) and unhierarchized exterior is far from the artsy >box< of the Herzogian--Meuronian persuasion."* Holeček cites the authors who claim they were after a "max", rather than a "mini", effect.* Although the hall does not seem to have fulfilled all of these objectives – the outcome is not so far from Minimalism or the aforesaid Swiss architects – there are fortunately other qualities present as well. First and foremost, it can be viewed as a new variation on the traditional theme of a contradiction between a poor coat and a rich lining. The building is grey on the outside, and only horizontally placed oak bars liven up its dead surface. Inside, however, one is surprised by the combination of color shades that in the basement, in a mural by Petr Kvíčala, border on loud. In an annex housing a bowling track (2000–2001), the theme of the contradiction between the face and the reverse is presented in the opposite manner.*** The hall is also an interesting example of contextual architecture: it is sited on the periphery of Litomyšl, above the Líbánky valley occupied by garden colonies and sports playgrounds. The architects were of the opinion that the atmosphere of the periphery ought to be enhanced, which is why their work speaks the deliberately lowly language of the industrial vernacular. Walter Zschokke put his finger on the architects' intent when he said: "Not knowing the purpose served by the building, one could easily assume that the building was a former industrial hall which, if watched from a distance, is not so

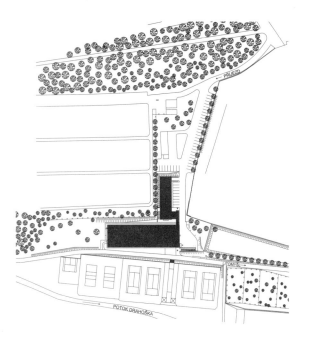

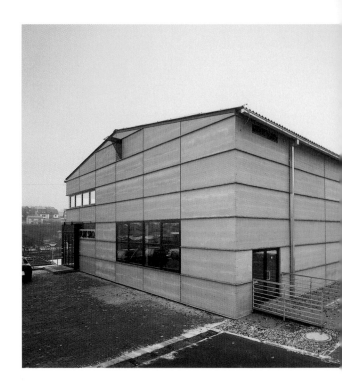

37

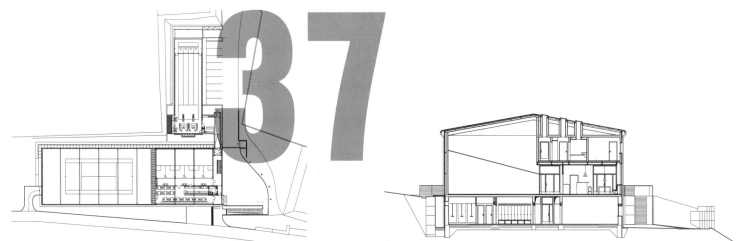

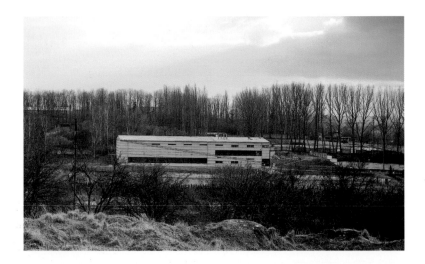

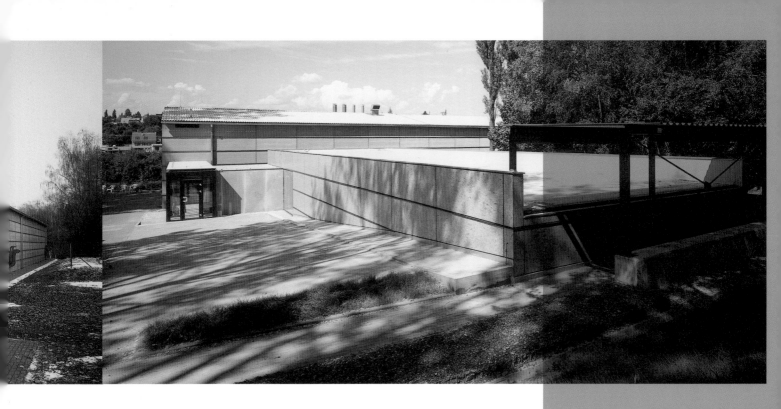

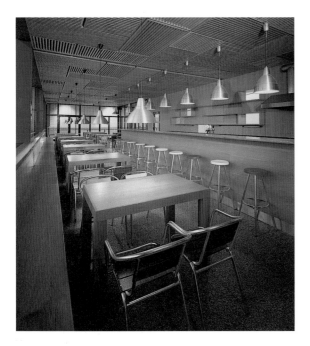

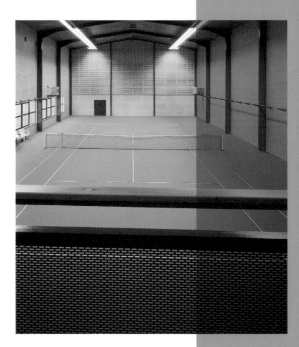

 * Josef Holeček, "O požitku z odříkání". *Architekt* XLVI, 2000, Issue 6, p. 11.
 ** Walter Zschokke, "Jednoduchost, hrdost". *Architekt* XLVI, 2000, Issue 6, p. 12.
*** [Autorská zpráva]. *Architekt* IL, 2003, Issue 6, pp. 24–25.

 "Autorská zpráva". *Architekt* XLVI, 2000, Issue 6, p. 8.
 Aleš Burian – Petr Pelčák – Ivan Wahla (eds.), *Litomyšl a soudobá architektura / Litomyšl
 and contemporary architecture*. Obecní dům, Brno 2001, pp. 72–75.
 Petr Pelčák (ed.), *Česká architektura / Czech Architecture 1999–2000. Ročenka / Yearbook*.
 Prostor – architektura, interiér, design, Prague 2001, pp. 70–73.
 Petr Němejc, "Stroj". *Architekt* IL, 2003, Issue 6, p. 25.

Ladislav Kuba – Tomáš Pilař, library of the Faculty of Arts of Masaryk University in Brno, Arne Nováka Street 1, 1998 – 2001

The "sophisticated artsy >box< of the Herzogian-Meuronian persuasion" tends to attract not only Prague-based but also Brno-based architects, as shown by the building of a library for the Faculty of Arts of Masaryk University in Brno, designed by Ladislav Kuba and Tomáš Pilař. First and foremost, however, this building shows how swiftly a good architect can change his or her vocabulary if prompted by the purpose of the project and its topography. The Regionalist and "vernacular" appearance of Kuba's village chapel at Jestřebí gave way to a universal and elitistically Minimalist form of a box for the storage of ideas in the case of a library in the centre of a large city. The form of a block in "virtually zero style", as the building was described by the jury of the Grand Prix competition of the Society of Architects in 2002,*** was in this particular case necessitated by the position of the building and its heterogeneous context. The architects conceived the library building as a neutral divide between the yards of old tenement houses and the university courtyard, enclosed by rear facades of buildings built in a variety of styles over the last 150 years.**

In his review of Kuba and Pilař's project, the art historian and Professor at Masaryk University, Jiří Kroupa, made no attempt at hiding his disappointment. According to Kroupa, the "decent", though "sanitary" architecture of the library will perhaps serve its purpose well but will not enchant us and leave the visitor with a magic impression worthy of a building of such cultural significance. It is a pity – the Brno professor voiced his regrets – that Kuba and Pilař do not entertain ambitions similar to those invested in the project of Bibliotheca Herziana in Rome by Juan Navarro Baldeweg, based on the idea of "la luz es materia", light is matter. "Such light needs to penetrate inside, into the depth of the architecture, and, together with the noble play of shadows and noble materials confess to the >Roman identity< of architecture", Kroupa wrote in 1998,* undoubtedly instructed by Norberg-Schulz or Frampton's contemplations on Regionalist aspects of natural sunlight.

Kuba and Pilař, however, do not seem to have opted for a concept so strikingly different from Baldeweg's idea when designing their library. They hung a cladding from vertical oakwood lamellas onto the concrete skeleton of the building, daringly trussed at the edges. These wooden sunscreens let only very subdued sunlight inside the library. An aperture in the roof lets in a flood of its opposite, the direct light of the sun, which descends down the staircases all the way to the ground floor in diminishing doses. Oakwood sunscreens and cold concrete were a necessity also because the university could not afford air-conditioning. On the other hand, the budget was not that meager either because the architects were able to have the little park in front of the library landscaped and adorned with a sculpture by the sculptor Michal Gabriel.

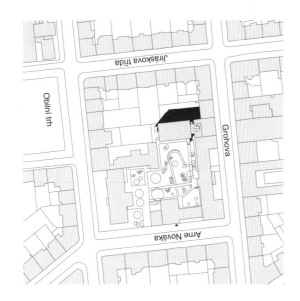

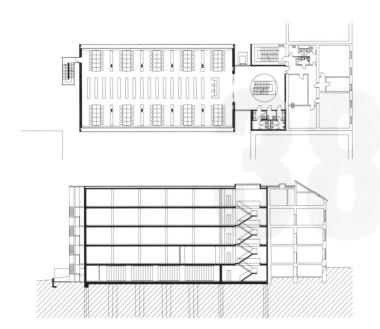

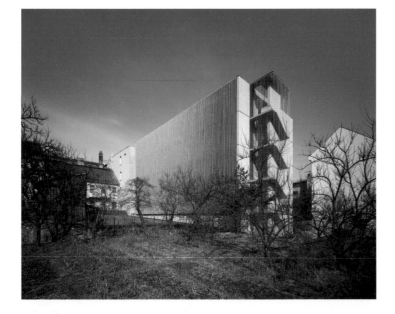

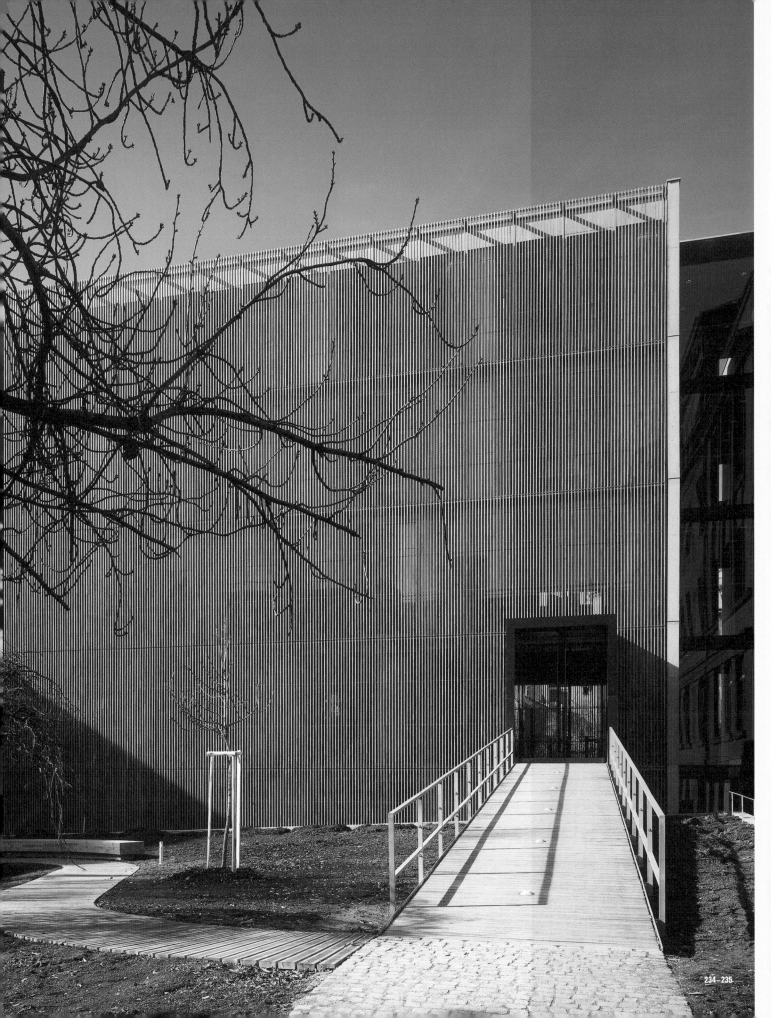

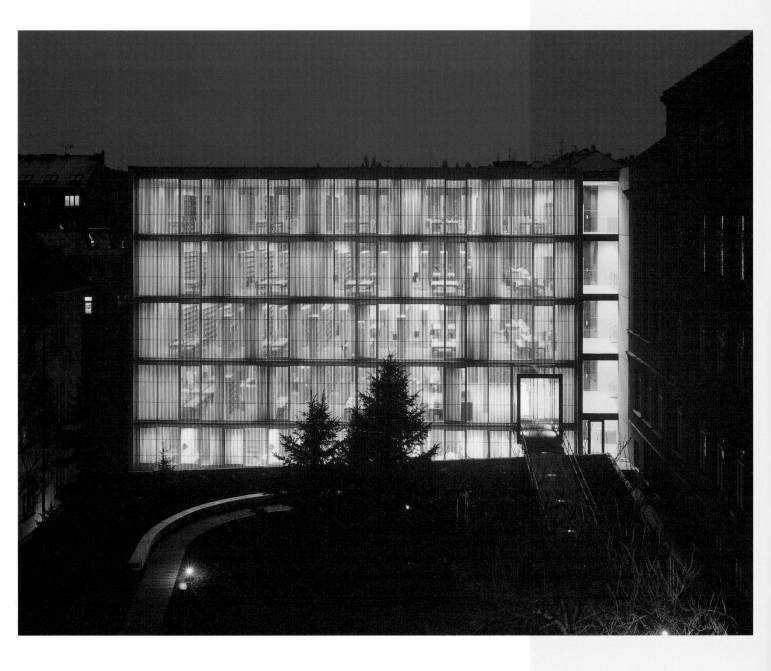

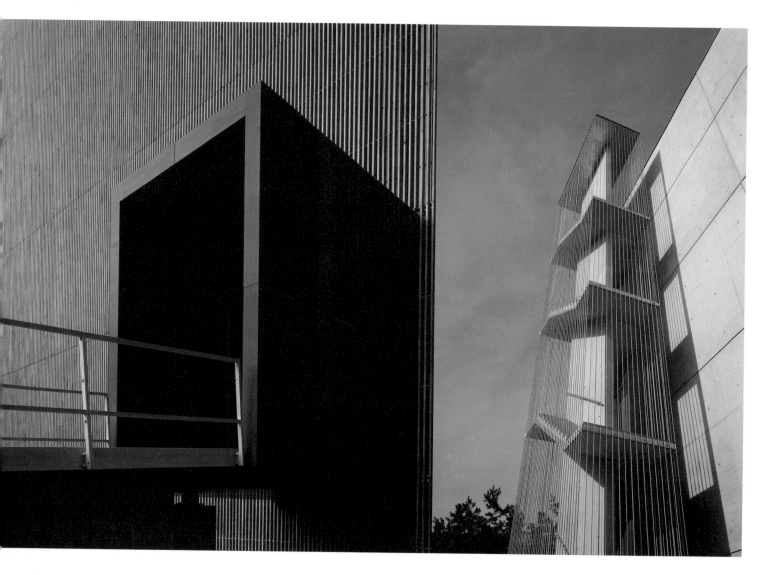

 * Jiří Kroupa, "K historii areálu a k soutěži". *Architekt* XLIV, 1998, Issue 20, p. 39.
 ** [Autorská zpráva]. *Architekt* XLVIII, 2002, Issue 4, p. 23.
*** [Grand prix Obce architektů 2002]. *Architekt* XLVIII, 2002, Issue 5, pp. 4–7.

 "Z autorské zprávy". *Architekt* XLIV, 1998, Issue 20, p. 41.
 Milena Sršňová–Lidmila Cihlářová (eds.), *Architektura 2002. Ročenka realizovaných staveb v České republice.* BertelsmannSpringer CZ, Praha 2002, pp. 56–57.
 Karel Doležel, "Opulence versus skromnost". *Architekt* XLVIII, 2002, Issue 4, pp. 28–29.
 "Soutěž Interiér roku 2002". *Architekt* XLVIII, 2002, Issue 6, p. 38.
 Michal Kohout (ed.), *Česká architektura / Czech Architecture 2001–2002. Ročenka / Yearbook.* Prostor – architektura, interiér, design, Prague 2003, pp. 98–103.
 The Phaidon Atlas of Contemporary World Architecture. Comprehensive Edition. New York–London 2004, p. 597.

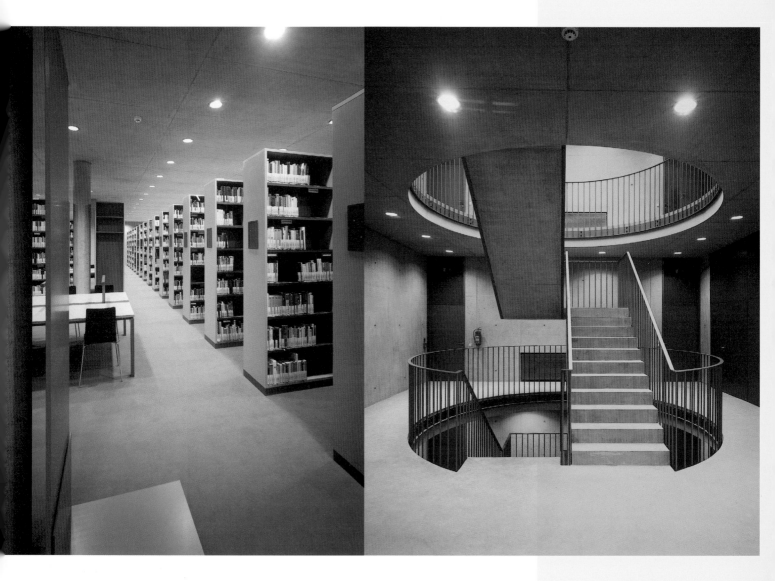

39

Markéta Cajthamlová – Lev Lauermann – Šárka Sodomková, family house in Prague 9- -Horní Počernice, Šanovská Street 19. 1998 – 2000, 2004

Debates conducted by architects in the West indicate that the word "context" went out of fashion during the course of the 1990s. In his contemplations on bigness in architecture, Rem Koolhaas refers to it with disdain. Steven Holl who, in his book *Anchoring* considered still in 1989 a carefully thought out integration into the context to be the only way to lend a spiritual dimension to a building, deems the term vacant today. Their ranks were joined from another direction by the art historian Norman Bryson, according to whom context is not an objective given, nothing that exists apriori. The web of nexuses that we call context is something we invent ourselves depending on our agenda.[85] When Markéta Cajthamlová and her husband Lev Lauermann designed houses on wooded slopes or in an emerging villa quarter, they did not hesitate to employ international modernist vocabulary. Aside from the terrain, they did not find anything in the environs of their houses in Černošice or Říčany that could serve to create a context, and there was thus no reason to pursue any contextual style. However, in Horní Počernice, on one of the village greens, certain objective constants of a context were present after all. A house designed for a Prague businessman stands in place of an old country house from which the architects retained the groundplan, size, and sandstone for a garden wall.* Small country farms and a Baroque chapel survived in the environs of the house. The new house does not respond to their appearance and scale by means of a folk vernacular but rather by means of a style generalizing the experience of West European modern Regionalism.

85 Norman Bryson, "Art in Context", in: Ralph Cohen (ed.), *Studies in Historical Change*. University
 of Carolina Press, Charlottesville 1989. — Steven Holl, "Meshing Sensation and Thought",
 in: Francine Fort–Michel Jacques–Annette Néve (eds.), *Steven Holl*. Centre d'architecture,
 Bordeaux 1993. — Rem Koolhaas, "Bigness, or the Large", in: Rem Koolhaas–Bruce Mau,
 S, M, L, XL. The Monacelli Press, New York 1995, pp. 495–516.

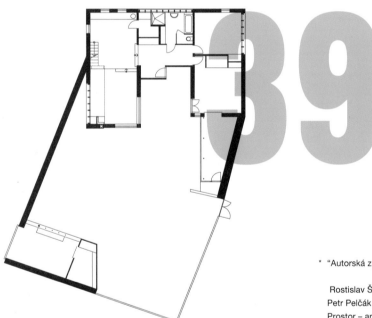

39

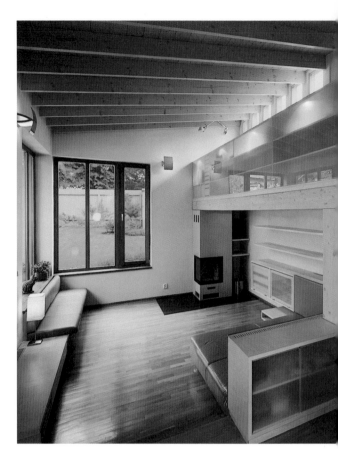

* "Autorská zpráva". *Architekt* XLVII, 2001, Issue 3, pp. 26–29.

Rostislav Švácha–Marie Platovská, "Tři odpovědi na situaci". *Stavba* VII, 2000, Issue 3, pp. 30–35.
Petr Pelčák (ed.), *Česká architektura / Czech Architecture 1999–2000. Ročenka / Yearbook.*
Prostor – architektura, interiér, design, Prague 2001, pp. 54–57.
Soňa Ryndová–Vladislava Valchářová (eds.), *Povolání: architekt[ka].*
Profession: [Woman] Architect. Kruh, Prague 2003, pp. 214–217.

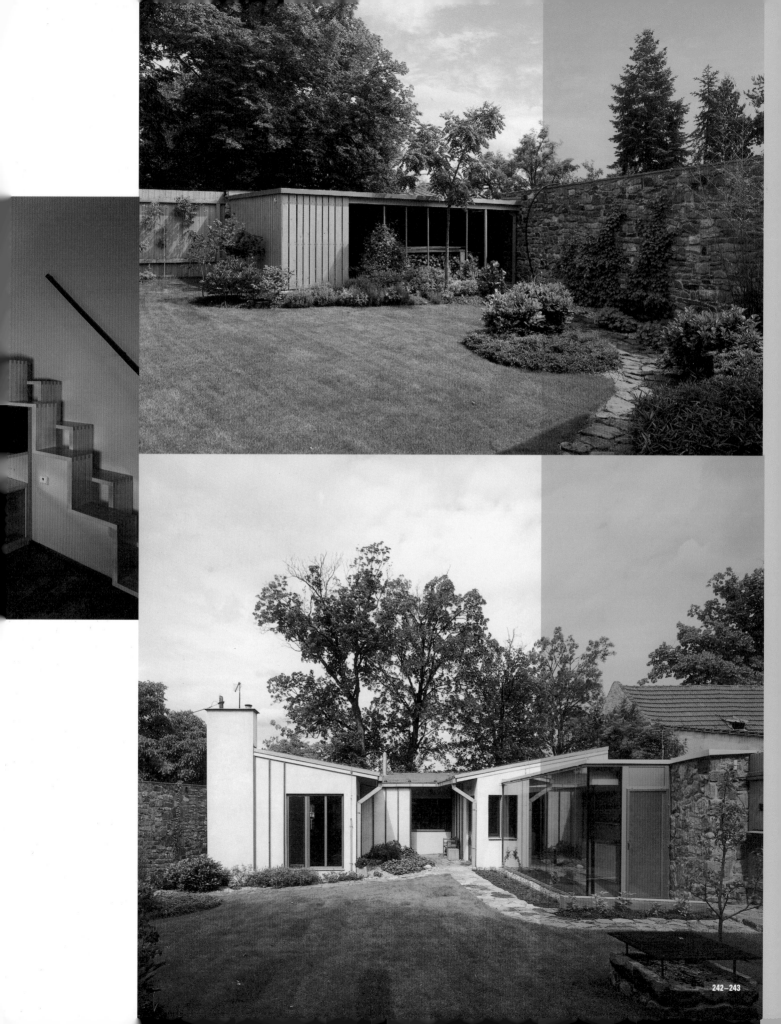

Impugnation of the role of context was a sentiment shared by Jaroslav Wertig. According to him, the presence of a new building in this or that environment needs to be legitimized by its autonomous quality: Wertig feels that to refer to context in connection with its form is superfluous. He contends that where quality architecture is concerned, it does not matter "if the genius loci is knocked out".[86] Together with Prokop Tomášek and Lábus's student, Boris Redčenkov, this young architect attempted to make his mark in Cheb, a town in the extreme western part of the Czech Republic. In the nearby Františkovy Lázně, a spa resort with the 19th century Classical and Romantic architecture, the threesome was commissioned to design a small private sanitarium. When they searched for its form, the architects took into account the adjoining small forest and its trees, with the sanitarium responding to their vertical lines with its horizontal ones. The architects' respect for the Classical concept of Františkovy Lázně, however, was manifested only by the frugality and rationality of their concept. "The general effort of the last few decades to make the environment at Františkovy Lázně even more >spa-like< is so stubborn and strong that it provokes one to adopt an attitude stripped of prejudices, to express one's relaxation and elegance through contemporary means", the architects wrote in 2002.*

In their project, the typology of the traditional spa house was replaced with a hybrid of a real sanitarium with therapeutic facilities and bedroom cabins, a large Functionalist villa and the Barcelona pavilion by Ludwig Mies van der Rohe, to which the sprawling central hall of Peták's sanitarium, including its large pool, refers.

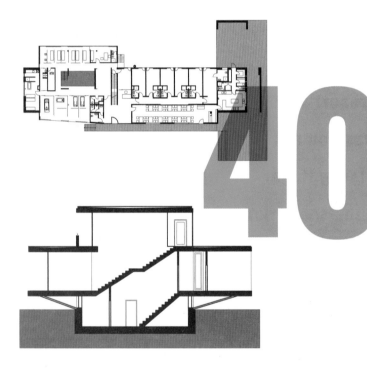

40

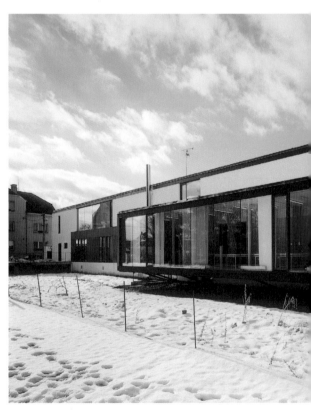

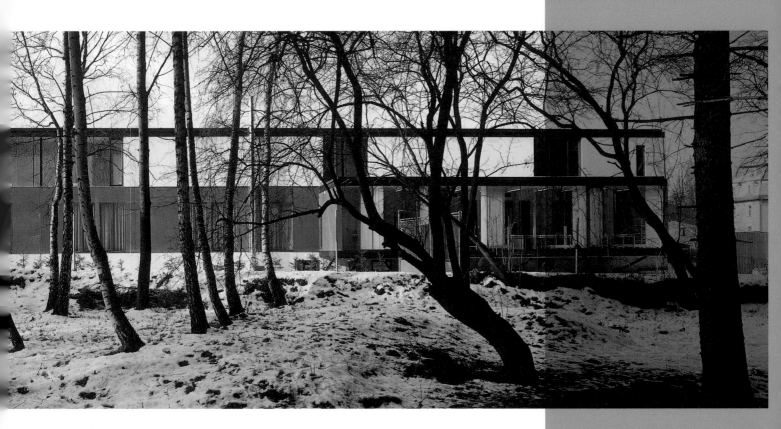

* "Autorská zpráva". *Architekt* XLVIII, 2002, Issue 3, pp. 15–19.

"Sanatorium MUDr. Petáka". *Stavba* VI, 1999, Issue 3, p. 18.
"Sanatorium". *Stavba* VIII, 2001, Issue 2, pp. 58–61.
Markéta Cajthamlová (ed.), *Česká architektura / Czech Architecture 2000–2001. Ročenka / Yearbook.* Prostor – architektura, interiér, design, Prague 2002, pp. 36–41.
Luis Marques, "Místo – program – konstrukce". *Architekt* XLVIII, 2002, Issue 3, pp. 18–19.

Alena Šrámková–Tomáš Koumar–Jan Hájek, assisted living houses in Horažďovice, Mayerova and Loretská Streets. 1998–2002

Wertig drew attention to himself also as a critic of the post-November Czech society, which, in his opinion, abandoned the ideals of the Velvet Revolution, threw itself into consumerism, and then developed a liking in the pompous architecture of various financial institutions.[87] The architect in this respect probably tuned into the views of Alena Šrámková, the deepest thinker of Czech austerity. It was precisely Šrámková who lent a new ethical charge to the program, while being aware of its subversive components. She would welcome if austere architecture worked as an educational means facilitating better morals; at the same time, she admits that she does not quite know where morals "are stuck".[88] According to her, only something modest may have a moral impact, however, the problem with modesty is that it suffers from the absence of "creative risks", and if it shows off, it looks immodest and ostentatious.

The two assisted liv ing houses for senior citizens in Horažďovice eventually enabled the architect to realize her old and hard to fulfill desire to be austere, yet kind. The houses fall into the second wave of construction of social facilities that the social democratic government attempted to speed up after 1998. They were built in the town of Horažďovice, which, thanks to its mayor, Václav Trčka, practices quality architectural patronage, similar to that found in Benešov, České Budějovice or Litomyšl. Through her houses, Alena Šrámková wished to "cheer up those who leave their habitual environment in order to enter a new, strange one".* She thus deliberately wished to achieve the correct degree of banality and ordinariness. She equipped both houses with various amenities, including a small grocery store. The comfort of smallish apartments is to be enhanced by square bay windows, with rain occasionally drumming on their canopies – too loud according to some of the senior

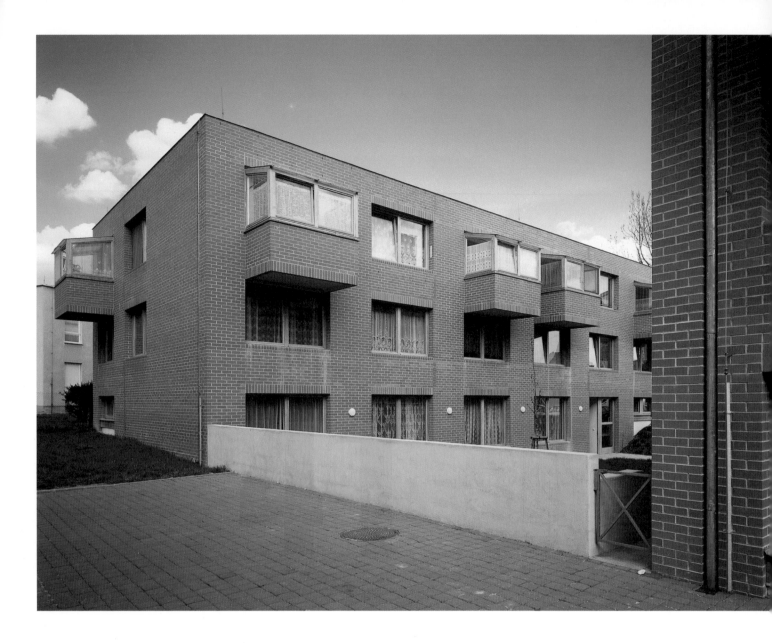

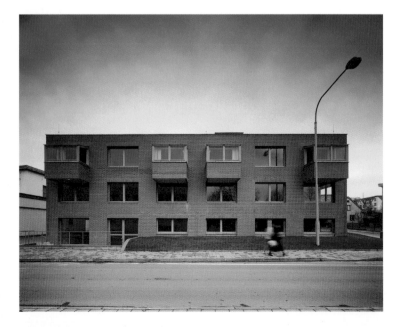

* "Autorská zpráva". *Architekt* IL, 2002, Issue 2, p. 14.
** Jakub F. Novák, "Fascinující jednoduchost". *Architekt* IL, 2002, Issue 2, p. 15.

"Dům s pečovatelskou službou v Horažďovicích". *Architekt* XLIV, 1998, Issue 13–14, pp. 48–49.
Lidmila Cihlářová–Milena Sršňová (eds.), *Architektura 2003. Ročenka realizovaných staveb v České republice*. BertelsmannSpringer CZ, Praha 2003, pp. 106–107.

Richard Doležal – Petr Malinský – Petr Burian – Michal Pokorný, Martin Kotík, Euro palace in Prague 1-Nové Město, Václavské Square 772/2. 1999–2002

As regards the external form of the building, then, according to Alena Šrámková, "creative risks" are lacking not only in Neo-Functionalist facades with windows regularly spaced out in the walls, but also in facades made entirely from glass. To the architect in question, the glass house appears to be like 'a prosthesis stuffed in to fill a particular place", as "a courage-lacking escape from responsibility".[89] When she says that, Šrámková has in mind Nouvel's Golden Angel, as well as the commercial and office building, Euro, at the bottom of Václavské Square. Commissioned by the German company LBB Reality in 1997, Martin Kotík was the first one to try his hand at the design of the building that adjoins the oldest representative of Functionalism in Prague – the Lindt department store by Ludvík Kysela (1925–1927). However, he was having problems finding good proportion between its part adjoining Lindt's building and the tower-shaped part that was, together with the tower on the Koruna palace on the opposite side of the Václavské Square, to form something like a triumphal gate separating the two historical parts of Prague: the Old Town and the New Town. The tower-like ending of Kotík's design further gave rise to concerns over the "manhattanization" of historical Prague. It did not fit the appearance of Václavské Square in terms of typology, either. Where the local buildings do sport towers – as is the case of the late Art Nouveau Koruna palace – these are conceived as extensions added onto the body of the building, rather than towers spanning from the bottom to the top of the building as the one designed by Kotík. The architect realized that he would not be able to overcome the barrier of criticism, and two years later, he handed the project over to a team of four architects, Doležal – Malinský – Burian – Pokorný. These architects dressed Kotík's ideas in a new proportional arrangement and a new, elegant coat. They wrapped the entire building in a flexible, transparent facade. Through this membrane, movable jealousies from gold-tone metal can be seen – an allusion to "Zlatý kříž" (Golden Cross), an old local name referring to the immediate environs of the building – and a tower-like extension, only slightly larger than it should be, rises from within the building. Most critics did not share Alena Šrámková's negative judgment. However, having said that, in his review of the building, Pavel Halík criticized the building for its "sensual hedonism", its "perfectly smooth, almost obsessive elegance".*** According to the Slovak critic Marian Zervan, the reason for this impact of the Euro palace is in the aesthetic conservativism of its authors, who allegedly drew on "the traditional notion of beauty".** The Czech-English historian of architecture, Dalibor Veselý, added that no matter how beautiful the mask of a narrow

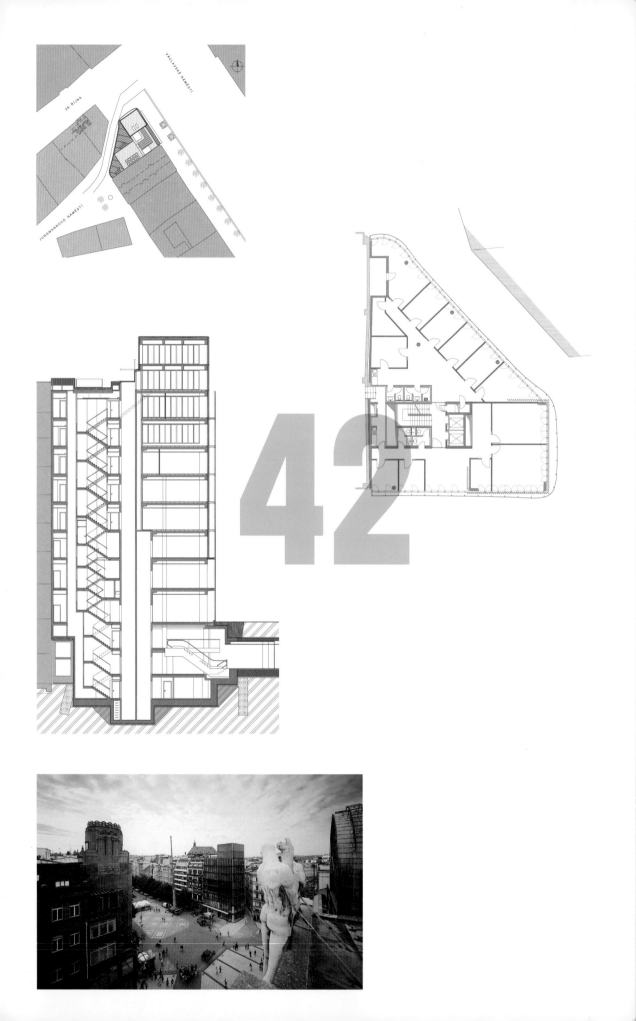

42

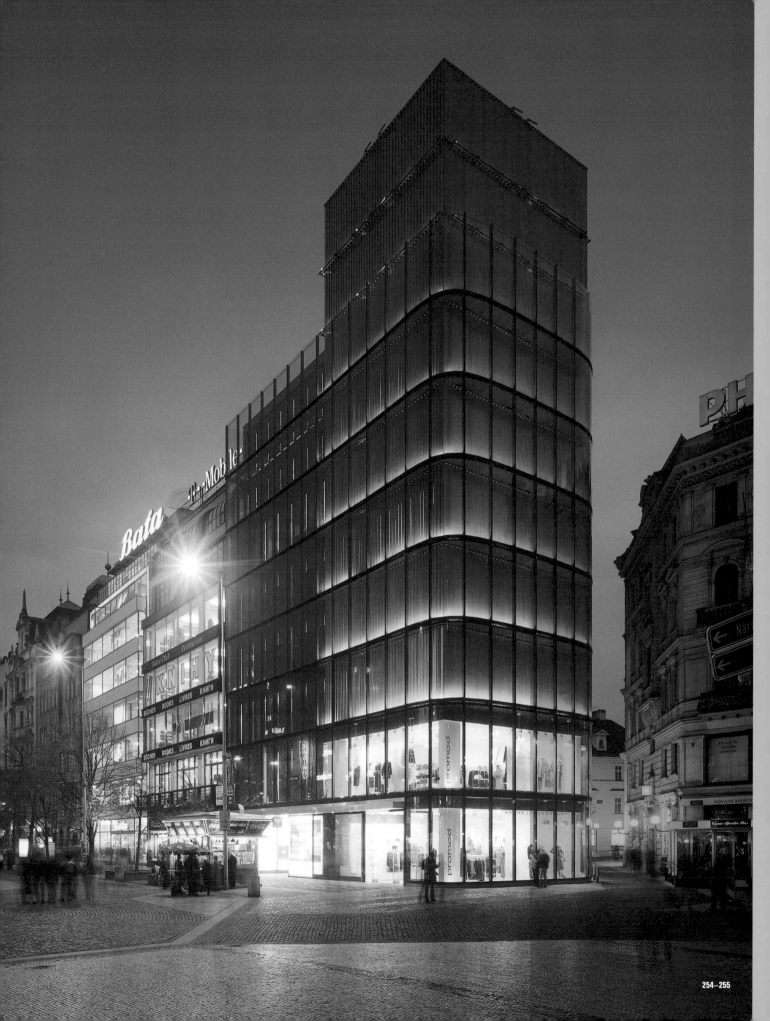

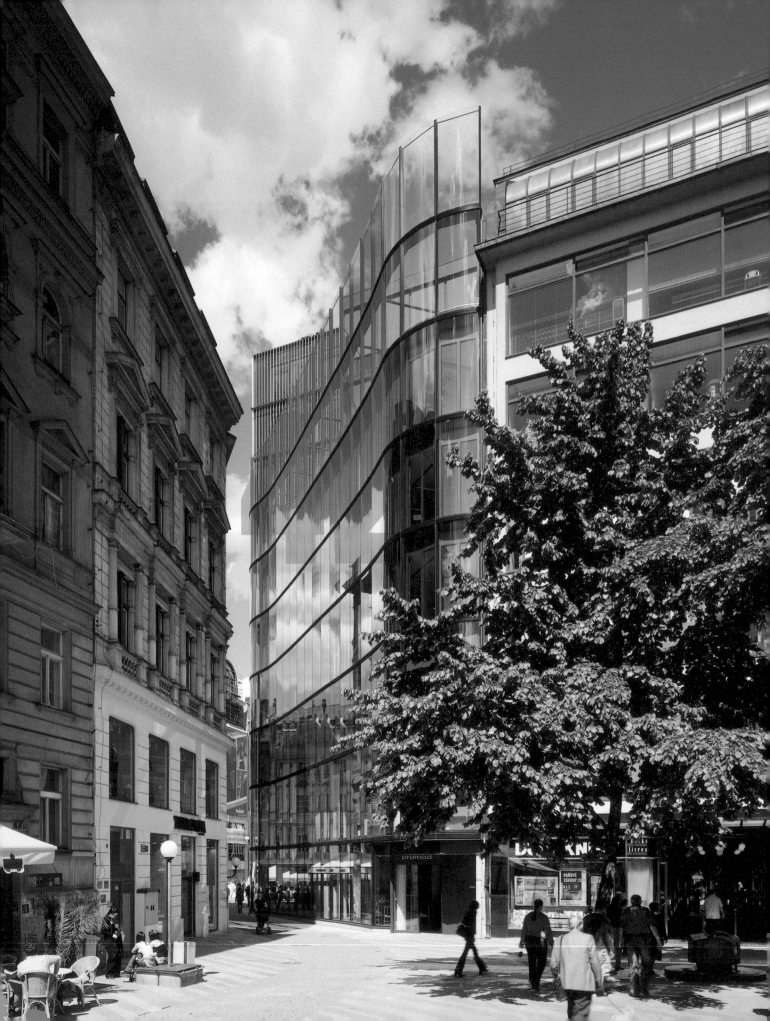

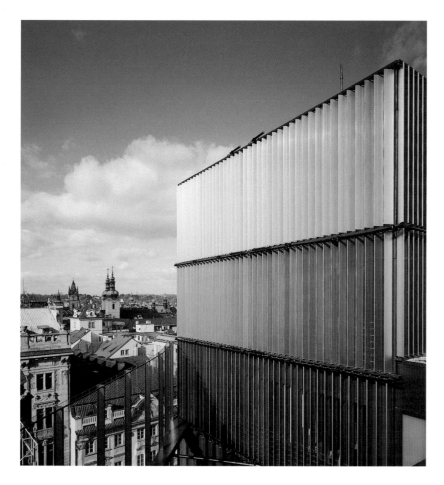

 * Dalibor Veselý, "Editorial". *Architekt* XLVIII, 2002, Issue 8, p. 2.
 ** Marian Zervan, "Palác Euro". *Stavba* X, 2003, Issue 2, pp. 44–47.
*** Pavel Halík, "Euro". *Stavba* X, 2003, Issue 2, pp. 44–47.

"Autorská zpráva". *Architekt* XLVIII, 2002, Issue 8, p. 4.
Rostislav Švácha, "Dobře zabalené zboží". *Architekt* XLVIII, 2002, Issue 8, pp. 8–9.
Lidmila Cihlářová–Milena Sršňová (eds.), *Architektura 2003. Ročenka realizovaných staveb
v České republice*. BertelsmannSpringer CZ, Praha 2003, pp. 38–39.
Mies van der Rohe Award Catalogue. Barcelona 2003.
Michal Kohout (ed.), *Česká architektura / Czech Architecture 2001–2002. Ročenka / Yearbook*.
Prostor – architektura, interiér, design, Prague 2003, pp. 124–127.
Jana Tichá, "Palác Euro". *Piranesi* X, 2003, No. 17–18, pp. 46–51.
The Phaidon Atlas of Contemporary World Architecture. Comprehensive Edition.
New York–London 2004, p. 595.

Ricardo Bofill – Jean Pierre Carniaux – Jose Maria Rocias, Corso Karlín center in Prague 8-
-Karlín, Křižíkova Street 36a. 1999 – 2001

In 1994, Emil Přikryl wrote that most new buildings in the center of Prague were merely "free-riding" on the energy of the historical reservation of Prague. As far as I know, Přikryl today considers only the Dancing House and the Euro palace to be exceptions to this rule. His 1994 contemplation further drew attention to the fact that the future of Prague was no longer determined by an urbanist vision or a standard regulation plan, but only by the local business interests of forceful investors.[90]

The capital city is indeed developed in this fashion today. Municipal offices are reluctant to create any universal rules beforehand, and are more apt to respond ex post to projects that would violate the establish usage in a particularly blatant way. That does not mean that all investment plans are to Prague's detriment. For instance, those that wish to establish new foci of development outside the boundaries of the overburdened historical reservation appear to be beneficial. The Real Estate Karlín Group has been trying to revitalize Karlín, a Prague quarter established in 1819. Aside from Classical houses dating back to the time when the quarter was established, there are many empty factory buildings from the development boom of the late 19th century. The Spanish architect Ricardo Bofill, who works for the aforesaid company, has been involved in the reconstruction and conversion of one such factory block for several years. In 1999, Bofill began to reconstruct a 140-meter-long production hall in Křižíkova Street with the aim of converting it into an office center, Corso Karlín. Under his hand, the masonry foundations of the hall were developed into an "artifact of a Chirico-like nature", as the critic Benjamin Fragner wrote.*** Bofill then set a rectangular block of glass onto this base which retains the industrial memory of Karlín,* with the glass block departing from contemporary Minimalist aesthetics perhaps only in the exaggerated handwriting of details, with a stress on "authorship", in the words

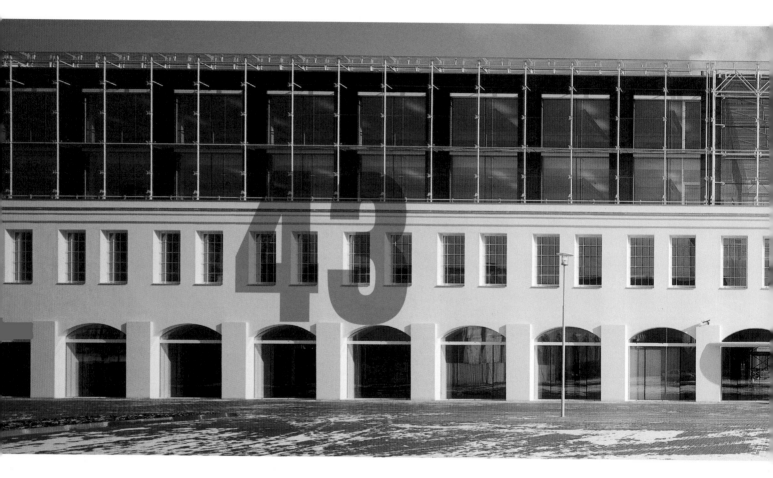

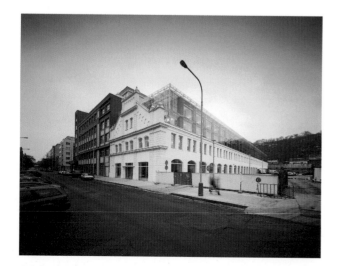

* Ricardo Bofill, "Corso Karlín". *Fórum architektury a stavitelství* 2000, Issue 1–2, pp. 62–65.

** Martin Strakoš, "Dům jako příklad hereckého paradoxu". *Architekt* XLVII, 2001, Issue 10, p. 36.

*** Benjamin Fragner, "Konverze". *Fórum architektury a stavitelství* 2001, Issue 1, p. 14.

Lenka Žižková, "Ricardo Bofill a pražský Karlín". *Fórum architektury a stavitelství* 1998, Issue 8–9, pp. 52–53.

Jiří Řezák, "Corso Karlín. Konverze průmyslové haly". *Stavba* VII, 2000, Issue 3, pp. 18–19.

Milena Sršňová–Libor Štěrba (eds.), *Architektura 2001. Ročenka realizovaných staveb v České republice.* BertelsmannSpringer CZ, Praha 2001, pp. 22–23.

"Corso Karlín". *Architekt* XLVII, 2001, Issue 5, p. 8.

"Corso Karlín". *Architekt* XLVII, 2001, Issue 10, pp. 34–37.

Pavel Halík, "Místo v Karlíně". *Fórum architektury a stavitelství*, 2001, Issue 1, pp. 4–5.

Jiří Grosz, "Architektonické řešení". *Fórum architektury a stavitelství*, 2001, Issue 1, pp. 11–13.

Ricardo Bofill–Jean Pierre Carniaux, "Corso Karlín". *Fórum architektury a stavitelství*, 2001, Issue 5, pp. 20–23.

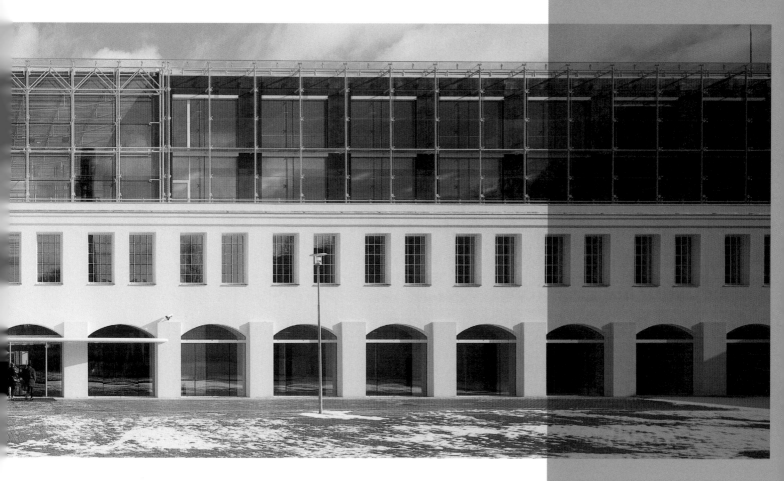

Jan Aulík – Jakub Fišer – Veronika Müllerová, villa houses in Prague 4-Michle, Želetavská Street 1449/9, 1448/7, 1447/5. 1999 – 2002

Activities similar to those taking place in Karlín are taking place today also in Smíchov, behind Nouvel's Golden Angel, or in Holešovice by the mouth of the Libeňský Bridge – that is, in quarters not far from the center of the metropolis. Certain investors and developers involved in these projects assume that it will be easier to put forward their projects if they come with a brand name, an "authorship," and thus invite famous foreign architects to come to the city: Gehry, Nouvel, Bofill, Erik van Egeraat or Richard Meier, the latter of whom designed a group of skyscrapers for the Pankrác plain in 2000 – 2001 but failed to obtain a building permit for his project. Other investors try to establish new development foci in places further from the center, and have to do without the glitter of architectural stars. BB Centrum, for instance, opted for the Michle quarter. The company has already built several office buildings in a place where the Brno-Vienna highway cuts across Prague, and the row of buildings protects the entire development area from traffic noise. The buildings turn ambitious glass facades onto the highway, while the facades on the other side are in a modest Neo-Functionalist style. Jan Aulík, BB Center's chief architect, was most successful in tackling this contrast between the front and rear parts of the building in his three villa houses sited behind the row of office buildings, on the edge of a future park. Aulík placed the rectangular blocks of the villa houses on a shared base and segmented them by means of continuous windows adopted from the Functionalist inventory. The selection of the second protective cladding also follows the principal rule of this style, "form follows function": either glass jealousies or sliding acrylate panels are used, depending on whether the building in question is an office building or an apartment house.

44

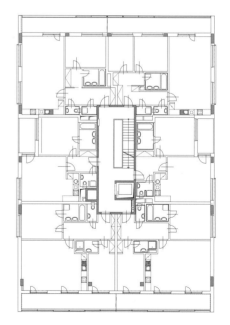

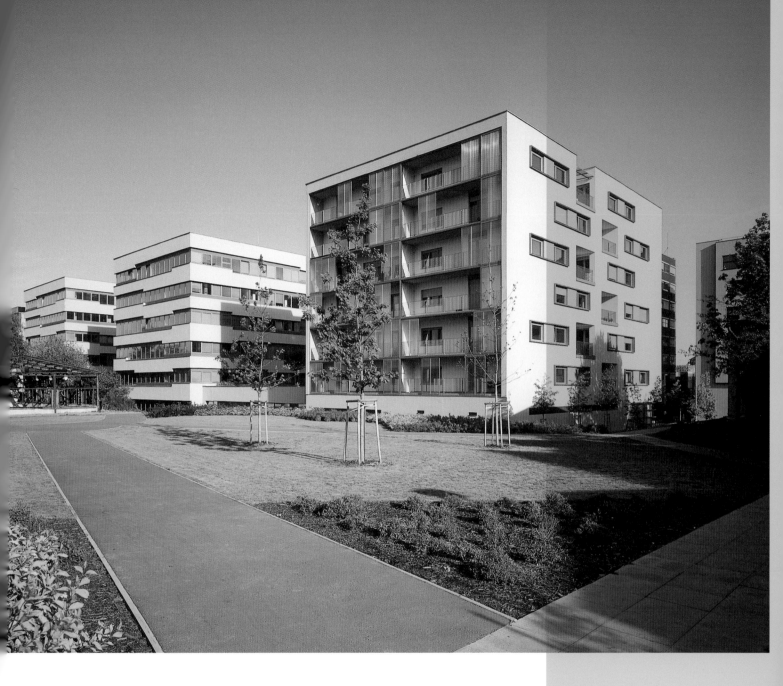

Michal Kohout (ed.), *Česká architektura / Czech Architecture 2001–2002. Ročenka / Yearbook.*
Prostor – architektura, interiér, design, Prague 2003, pp. 68–71.
Lidmila Cihlářová–Milena Sršňová (eds.), *Architektura 2003. Ročenka realizovaných staveb
v České republice.* BertelsmannSpringer CZ, Praha 2003, pp. 44–45.

Milan Rak – Iveta Raková – Libor Rydlo – Pavel Rydlo – Alexandr Skalický, semi-detached houses at Rudník 550–567. 1999–2000

More direct references to Functionalism, in particular the "Zeilenbauten" of the German and Dutch avant-garde of the 1920s, can be found in a colony of semi-detached houses at the small town of Rudník. These were designed by the architects Rak, Raková, the Rydlo brothers, and Alexandr Skalický, who have their studio in Náchod, a town near the Polish border. The colony can thank a government program supporting the construction of social housing for its existence. If I said that Přikryl's gallery in Louny and Pleskot's tunnel at the Prague Castle were the pinnacles of Czech architecture of the 1990s, then the houses at Rudník became the most problematic project. This fact became apparent already during the deliberations of the jury of the 2001 Grand Prix of the Society of Architects. While most jurors, led by the Austrian Hermann Czech, awarded the main award to this project of the architects from Náchod, the Slovak juror, Peter Pásztor, insisted on a negative minority vote. He felt that the Rudník colony was "humanly impoverishing":* contemporary Czech architecture "cannot be any more Minimalist and grayer" than that.** Pásztor first and foremost denounced the asceticism of the means of expression employed within the colony, whose flat walls have, as the critic Pavel Halík wrote in 2001, "the feel of a Neo-Plasticist painting". The Slovak architect was equally irritated by the dubious execution of the construction of the houses and, last but not least, by their sociological concept that, it seems, does not adequately protect the privacy of the inhabitants and forces them to live in an excessively collectivist manner.

The architects financed the construction of the colony themselves, and this approach backfired because there subsequently was a lengthy lawsuit against the town of Rudník for overpayment of the construction works. The roofs and transversal walls are from concrete, the facades from wood-concrete boards that the architects left untreated, in their natural colors in the interest of the "materials' aesthetics", and without any elements protecting them from the rain in the interest of Minimalist planarity. These artistically motivated gestures, which undoubtedly resulted in further technical drawbacks, began to be attacked by an expert in wooden buildings, Josef Smola, as soon as the colony was completed. He did so in journals, *Architekt* and *Era*, and at various discussion forums with a zeal bordering on obsession. The critics, on the other hand, paid minimum attention to the colony's inhabitants. The only person who bore witness in this respect in print was a Grand Prix juror, the Czech-Australian architect Josef Horný: "One house was shown to us by its new inhabitants who were very happy with it, and noted that their neighbors complained of various defects in order to obtain a price reduction."***

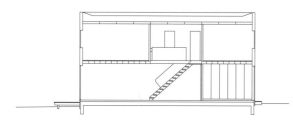

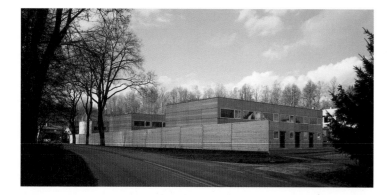

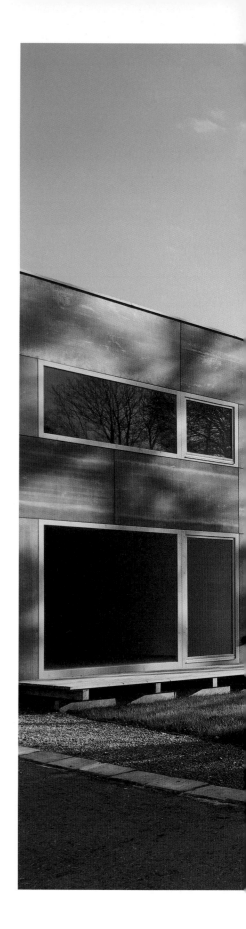

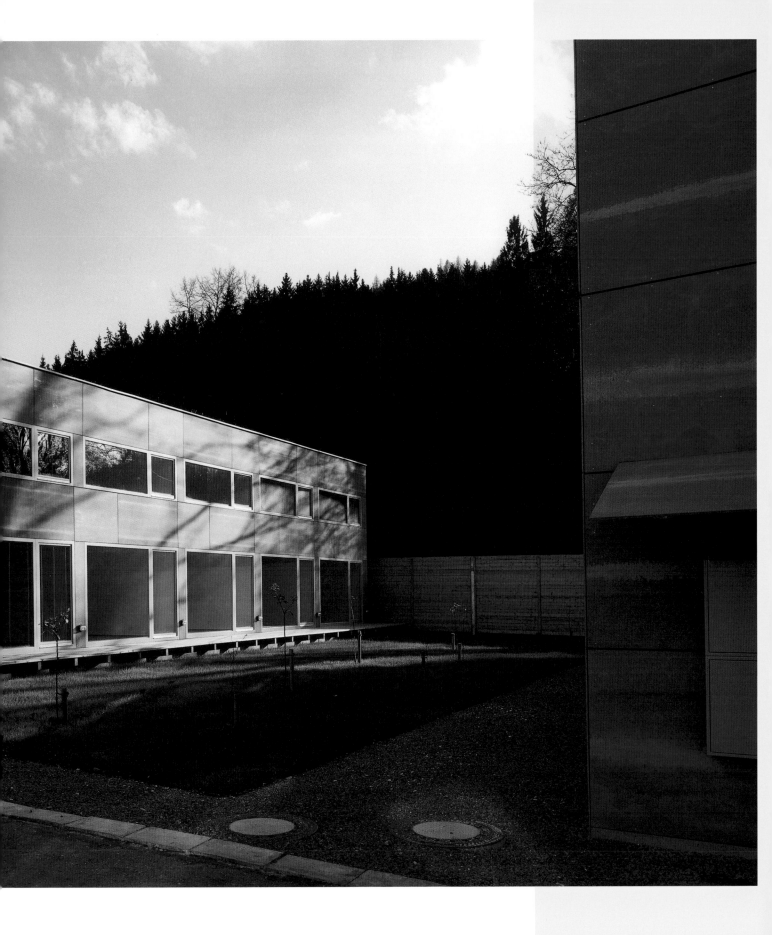

* [Vyjádření poroty Grand prix Obce architektů 2001]. *Architekt* XLVII, 2001, Issue 5, pp. 4–5.

** Peter Pásztor, [názor porotce na soutěž Grand prix Obce architektů 2001]. *Architekt* XLVII, 2001, Issue 5, p. 14.

*** Rostislav Koryčánek, "Architektura je rámec pro lidskou vzájemnost. Rozhovor s akad. arch. Josefem Horným". *Era* II, 2002, Issue 4, pp. 31–33.

"Tres hileras, Rudník, República Checa". *AV Monografías*, No 86, 2000, pp. 30–33.

Petr Pelčák (ed.), *Česká architektura / Czech Architecture 1999–2000. Ročenka / Yearbook*. Prostor – architektura, interiér, design, Prague 2001, pp. 132–135.

Milena Sršňová–Libor Štěrba (eds.), *Architektura 2001. Ročenka realizovaných staveb v České republice*. BertelsmannSpringer CZ, Praha 2001, pp. 116–117.

"Autorská zpráva". *Architekt* XLVII, 2001, Issue 3, p. 13.

Pavel Joba, "Série s nadstandardními prvky". *Architekt* XLVII, 2001, Issue 3, p. 14.

Pavel Halík, "Před zakotvením". *Architekt* XLVII, 2001, Issue 3, p. 15.

Kamil Dvořák, "Domy, ve kterých se nedá bydlet". *Architekt* XLVII, 2001, Issue 5, p. 93.

Pavel Joba, Roman Brychta, "Domy, ve kterých se nedá bydlet". *Architekt* XLVII, 2001, Issue 7, p. 76.

Josef Smola, "Kolonka Rudník". *Architekt* XLVII, 2001, Issue 10, pp. 79–81.

"Starterhauser in Rudník". *Bauwelt* XCII, 2001, No. 1–2, p. 61.

David Kraus, "Kůže na trhu". *Stavba* VIII, 2001, Issue 4, pp. 54–56.

Milan Rak, "Co děláme". *Stavba* VIII, 2001, Issue 4, pp. 56–57.

Marcin Kwietowicz, "Domy v Rudniku". *Architektura-Murator*, 2002, No. 11, pp. 34–36.

Pavel Halík, "Reihenhauser in Rudník". *Bauwelt* XCIII, 2002, No. 10, pp. 12–14.

Josef Smola, "Projektování dřevostaveb v České republice". *Era* II, 2002, Issue 4, pp. 49–53.

The Rudník affair, thus, does not present clear evidence that the people of today would hate modern architecture. A person who remembers the greatest boom of the Liberec SIAL studio, Martin Rajniš, contends, despite that, that there is something wrong with the general public's relationship to contemporary architecture: "…the vocabulary, morphology, the entire repertoire of >modern< architecture has not found its way into the hearts of most ordinary people" Rajniš wrote in 2002: "I would like houses to talk, in a natural and normal way, to anyone."* In his opinion, for instance, simple houses from wood, a material that most Czech people know well from traditional folk architecture and their own weekend cottages, could do without the mediation of critics and popularizers – without "interpreting", as Rajniš calls it. However, when Rajniš was commissioned to design a residential studio at Černošice, he decided to use wood in a fashion different "than that expected in this country",* and of course differently than the authors of the Rudník colony. During his trips to North America, Rajniš became familiar with the principle of baloon framing. He designed the ceiling, terrace and other parts of the house according to this principle. Americans nail wooden boards to both sides of a frame construction, thus creating flat walls and ceiling. Rajniš, however, liked the plastic effect of this construction; in some places, such as the ceiling, he did not disguise it in order to achieve a "block system".* The impressive construction was naturally not intended to steal the show from the spatial impression of the house's interior and the beautiful view offered by its residential part. Rajniš's client had a few words to say on this topic: "The treatment of space is not just about developing the area (…), but also about what you can see from where, and other tricks that architects

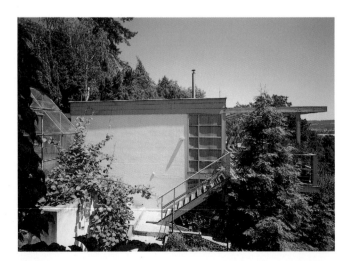

* Martin Verner, "Zpráva o návratu Martina Rajniše". *Architekt* XLVIII, 2002, Issue 8, pp. 29–32.
** Milena Sršňová, "Obytný ateliér-vejminek". *Stavba* IX, 2002, Issue 3, pp. 24–26.

Luis Marques, "Obrácený úhel pohledu". *Architekt* XLVIII, 2002, Issue 8, p. 32.
Renata Vrabelová (ed.), *Současný český dřevěný dům*. Galerie architektury, Brno 2003.

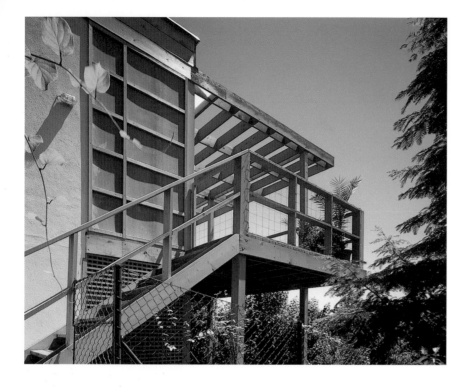

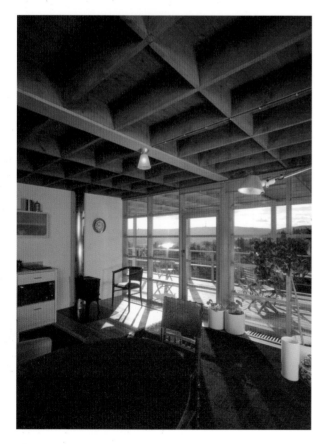

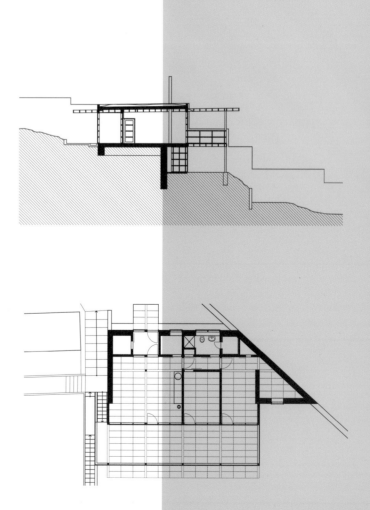

47

Rajniš's residential studio at Černošice probably cannot serve as a test whether a simple wooden house would talk to an ordinary person because the client is a person well versed in contemporary architecture. A client of this kind is able to estimate just how the architect will be able to satisfy his, the client's, requirements. Clients who do not know contemporary architecture as well as he does will have a much harder time identifying with the architect's design; however, they are sometimes able to accept even highly shocking solutions. For instance, Stanislav Fiala decided in 1999 that he would convince a future home-owner in Prague-Nebušice to build his house from gray slag-cement molded components without a coat of plaster on either the interior or the exterior. These would be held together by a construction from oak wood pillars. The client, whose feelings were captured by *Architekt* journal, found already Fiala's groundplan difficult to swallow – "squares and rectangles like a row of cells" – but eventually gladly accepted both the oak wood pillars and fair-face molded pieces.* Fiala sunk the building into a slope and conceived it as a more or less single-storey body with a longitudinal central space that on one side extends into a terrace roofed over with a pergola and, on the other side, is lined with a row of five bedrooms, each with its own bathroom. The entrance to the house is one floor below, from the space under the massive construction of the marquee. The obstacle to the execution of the project eventually turned out to be the local building authority rather than the client and his family. The officials, precisely those "ordinary people" who, according to Martin Rajniš, had not warmed up to modern architecture did not want to issue a permit for the "weird building with a flat roof", and were equally reluctant to grant an occupancy permit. "When are you going to finish this?", they were supposed to have asked the

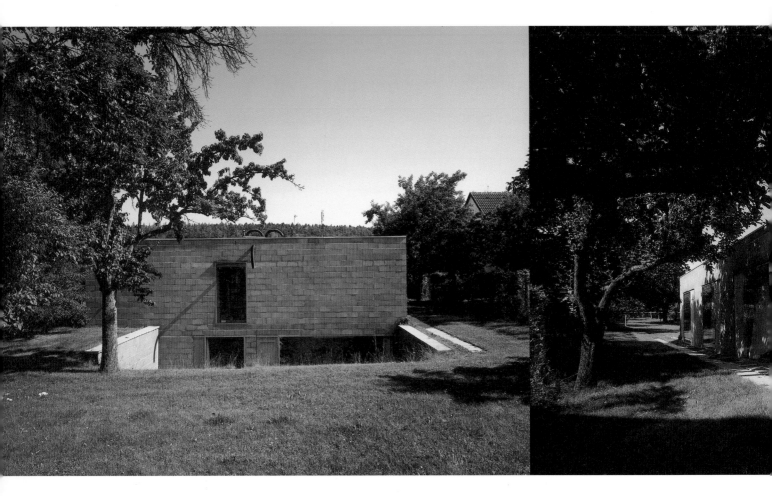

* "Josef (otec, 54)". *Architekt* XLVII, 2001, Issue 9, p. 16.

 "Autorská zpráva". *Architekt* XLVII, 2001, Issue 9, p. 12.
 "Eva (dcera, 23)". *Architekt* XLVII, 2001, Issue 9, p. 16.
 "Olga (matka, 53)". *Architekt* XLVII, 2001, Issue 9, p. 20.
 Markéta Cajthamlová (ed.), *Česká architektura / Czech Architecture 2000–2001. Ročenka /
 Yearbook*. Prostor – architektura, interiér, design, Prague 2002, pp. 150–155.
 The Phaidon Altas of Contemporary World Architecture. Comprehensive Edition.
 New York–London 2004, p. 593.

Marek Chalupa – Miroslav Holubec – Štěpán Chalupa – Kamila Venclíková, vestibule of subway station Kolbenova in Prague 9-Vysočany, Kolbenova Street 40. 2000–2001

The daughter of Fiala's client from Nebušice, Eva, was so enchanted with the house that she decided to study architecture. The *Architekt* 2001 journal published her own description of the building: "The molded blocks are genuine molded blocks, the wood ceiling is made from honest beams, and the iron joists are from genuine iron." Charles Jencks used to refer to such approach to materials on the architect's part, where no further metaphorical meaning is attributed to them, as "literal",[91] and this word covers also the objectives of "materials" architecture of the 1990s. Fiala, however, employs one more material in the space within his buildings: glass panels, which, as they can be both transparent and highly reflexive, challenge the direct impression of the perception of all the other masses and turn their figures into aesthetic objects. In an early work of this "materials" line, the villa at Vrané nad Vltavou, designed by Josef Pleskot (1994–1995), glass did not play such a subversive role yet. It is taken to the extreme in the above-grade vestibule of the Prague subway station Kolbenova, designed by the team of Chalupa – Holubec – Chalupa – Venclíková. In place of the station, there was supposed to have been an eight-storey building whose construction did not progress beyond the massive first two storeys. The architects clad this concrete torso into a semi-translucent glass cladding and dressed the entire interior of the vestibule in an opaque mirror surface. The architects wanted the mirror reflection to completely suppress any traces of their own intervention; to replace it with "an image of the goings-on in the street, the movement of people, cars, trams…", as they explained in 2001.* The rear facade of Kolbenova in particular testifies to the Swiss provenance of this breed of materials aesthetics: it is a variation on the theme of Herzog and de Meuron addition to the

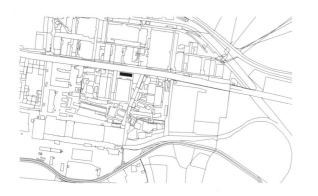

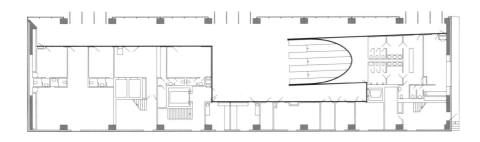

48

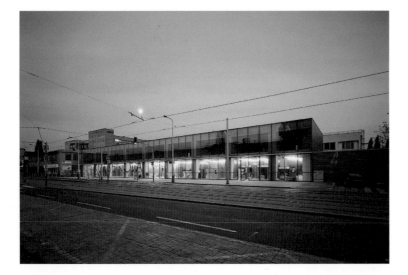

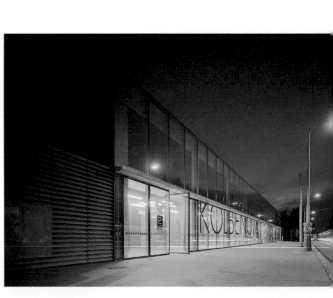

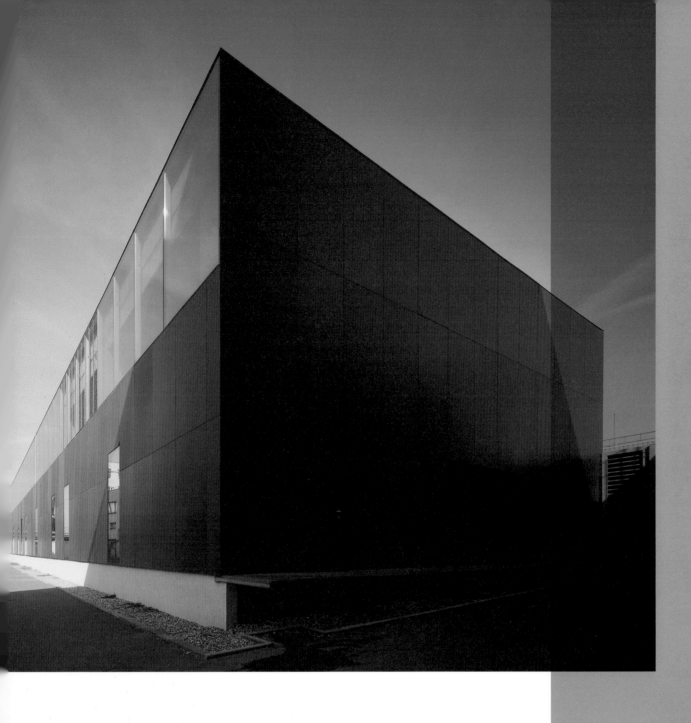

* "Autorská zpráva". *Architekt* XLVII, 2001, Issue 9, p. 6.

David Kopecký, ksa, [review]. *Architekt* XLVII, 2001, Issue 9, p. 9.
Osamu Okamura, "Příští stanice Kolbenova". *Architekt* XLVII, 2001, Issue 9, p. 10.
Markéta Cajthamlová (ed.), *Česká architektura / Czech Architecture 2000–2001. Ročenka / Yearbook*. Prostor – architektura, interiér, design, Prague 2002, pp. 128–129.
Milena Sršňová–Lidmila Cihlářová (eds.), *Architektura 2002. Ročenka realizovaných staveb v České republice*. BertelsmannSpringer CZ, Praha 2002, pp. 112–113.
The Phaidon Atlas of Contemporary World Architecture. Comprehensive Edition. New York–London 2004, p. 592.

49

Josef Pleskot – Pavel Fanta – Isabela Grosseová – Jiří Trčka – Veronika Škardová, improvements of a housing estate at Komenského Square in Litomyšl. 2001–2002

The leading Czech architects' preoccupation with Minimalism and its materials aesthetics is gradually changing the view on prefabricated housing estates with which the previous regime surrounded all Czech towns and cities. Before and after the Velvet Revolution, we believed that by building prefabricated housing estates, thousands of boxes from truly raw concrete, this regime had committed one of the worst crimes against architecture, landscape and humanity. Important post-Velvet politicians, including Václav Havel, compared them to "rabbit hutches", without realizing that they were thus offending people lacking both the money and the will to move elsewhere. In the 1990s, both the television and daily press kept reinforcing the idea that housing estates were even uglier than they appeared to be. At the same time, the entire society was coming to terms with the realization that it did not have sufficient funds for a radical solution to these residential colonies. Only some of the houses in the housing estates underwent a "humanization process", whereby the patterned rectangular blocks received a coat of colored paint and traditionally shaped roofs. Starting around 1997, some architects initiated a polemic with this trend. "We will not help the people living in housing estates by identifying further negative features of this type of development", Ladislav Lábus stated in one such debate. "These efforts to >humanize< contain a greater deal of irony and patronization than the ability to work in a truly professional and sensitive manner", Josef Pleskot shared Lábus's sentiments.[92]

In 2001, Josef Pleskot's studio began to address improvements in a small prefabricated housing estate, Komenského Square, built in the 1970s at the very edge of the historical core of Litomyšl, on the bank of the small river Loučná. Pleskot realized even before that despite their poor architectural quality, housing estates boast one quality that is lacking in old towns: free space and green areas – wannabe parks. According to Pleskot, both these parts of the city – a compact historical core and a more loosely conceived modernist outskirts – offer two kinds of valuable perception of space. Therefore, they are able to complement each other, provided we take good care of them and find an intelligent way of connecting them. Pleskot's design did not touch the prefabricated houses proper; it did not humanize them. Instead, it focused on the banks of the Loučná River and the pathway alongside the river. Small additions – benches, terraces and footbridges – help lend the estate space a park touch, making it "literate", as Pleskot wrote in 2002,* and the pathway itself becomes a means of integration

49

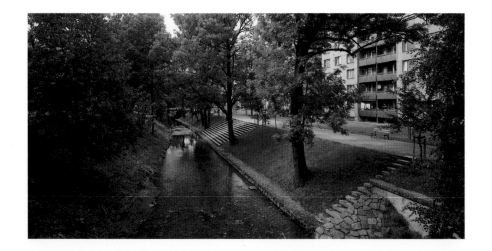

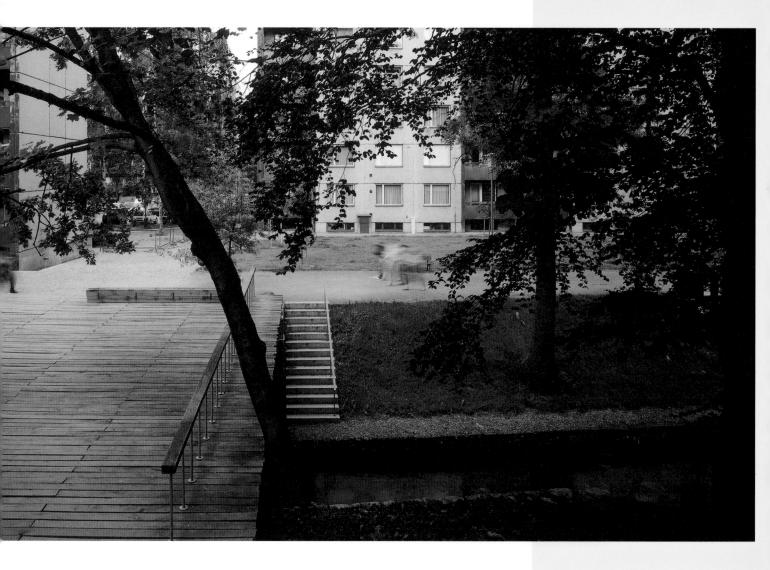

* "Z autorské zprávy". *Architekt* XLVIII, 2002, Issue 12, p. 17.

 Josef Pleskot, "Regenerace panelového sídliště. Komenského náměstí v Litomyšli". *Stavba* IX,
 2002, Issue 4, pp. 64–71.
 Lidmila Cihlářová–Milena Sršňová (eds.), *Architektura 2003. Ročenka realizovaných staveb
 v České republice.* BertelsmannSpringer CZ, Praha 2003, pp. 146–147.
 "Modification of the Loučná River Embankment in Litomyšl". *C3Korea*, 2003, No. 226,
 pp. 130–133.

50

Hana Maršíková – Jitka Ressová – Helena Víšková – Lucie Delongová, Sporten building in Nové Město na Moravě, U Pohledce Street 1347. 2001–2002

Most people continue to hate prefabricated housing estates, however, and tend to expect architects to design something like an antithesis to their raw material and boxy shapes. That is precisely why the Dancing Building by Gehry and Milunič drew such an intense response from the public. The situation was typical in this respect in Nové Město na Moravě, a winter sports center in the hills of the Czech-Moravian Highlands, a place whose appearance had been marred by prefabricated houses in a particularly brutal fashion. A group of young architects, Maršíková, Ressová, Víšková and Delongová, who at that time established the first all-women studio in Zlín, were commissioned by a ski producer located in Nové Město na Moravě, Sporten, to design its entrance building. The building was to serve as a reception area, showroom, club and sports hall; at the same time, it was to advertise Sporten. The architects wished to reflect the "surrounding undulating landscape" in the design,* without abandoning the orthogonal scheme at first. At the same time, the building was to manifest the materials aesthetics, as clearly shown by its facades. The architects even decided to use the waste from ski production in the interiors, which means that whoever would wish to search for feminine or gender motifs in the architecture of the Sporten building, may as well search for environmentalist motifs as well. However, the decision that the Minimalist "materials" surfaces would not be rendered in a Minimalist boxy shape was made by men, Sporten's owners. This is evidenced by Barbora Krejčová's 2003 review: "The client expressly requested a striking concept from the very beginning. When presented with two variants, the client rejected a strictly orthogonal solution, opting instead for a mass defined by rounded lines."**

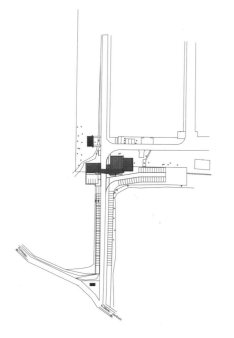

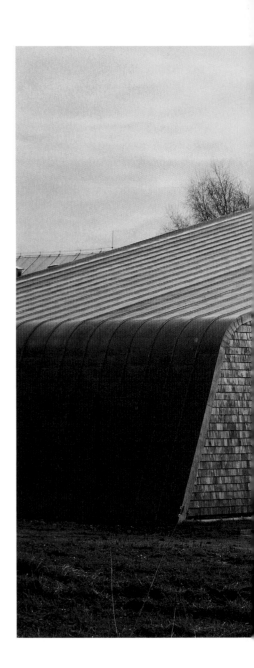

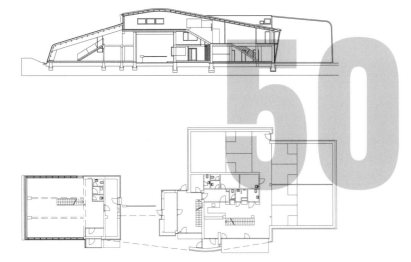

50

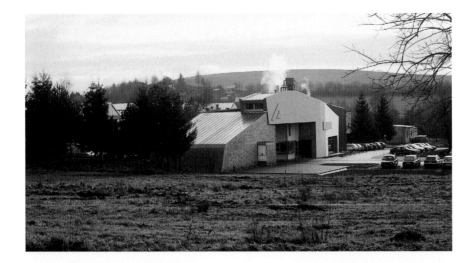

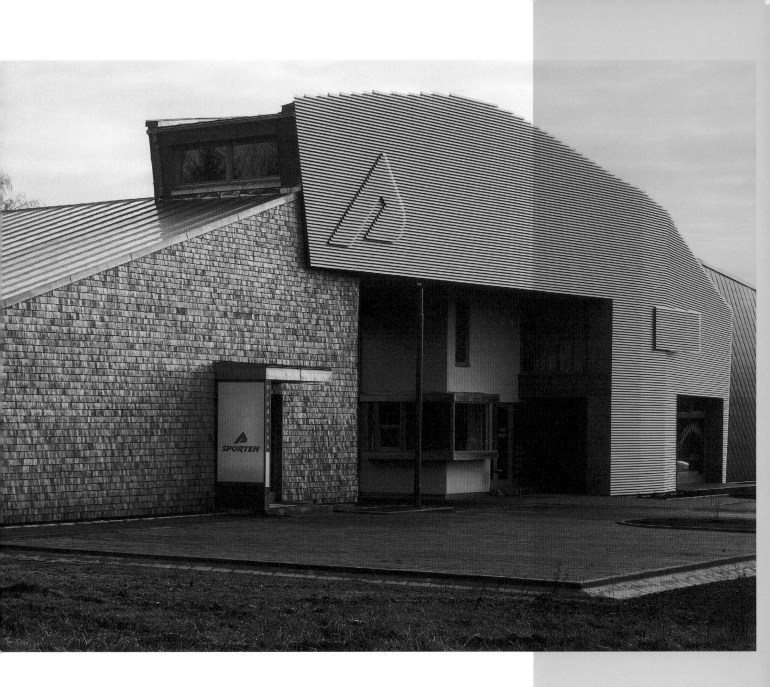

* "Autorská zpráva". *Architekt* IL, 2003, Issue 5, p. 26.
** Barbora Krejčová, "Architektura jako součást marketingové strategie". *Era* III, 2003, Issue 1, pp. 12–13.

Lidmila Cihlářová – Milena Sršňová (eds.), *Architektura 2003. Ročenka realizovaných staveb v České republice.* BertelsmannSpringer CZ, Praha 2003, pp. 24–25.
Michal Kohout (ed.), *Česká architektura / Czech Architecture 2001–2002. Ročenka / Yearbook.* Prostor – architektura, interiér, design, Prague 2003, pp. 140–141.
Soňa Ryndová – Vladislava Valchářová (eds.), *Povolání: architekt[ka]. Profession: [Woman] Architect.* Kruh, Prague 2003, pp. 250–253.

Author's last words on austerity

Could the curvaceous forms of Sporten be deemed to be a symptom of Czech architecture's latest escape from simple geometric forms typical of the Czech austerity? Do these curves indicate that the concept of Czech austerity is eroding?

That would probably be a rash conclusion. The results of architectural competitions held over the last few months, projects seen on computer monitors of most important Czech studios, or interviews with their managers in both specialized and daily press do not imply that any significant change is in progress in Czech architecture today. The rhetoric of prominent architects of today – Josef Pleskot, Stanislav Fiala, Ladislav Lábus, Petr Pelčák, Petr Hrůša and others, including Alena Šrámková – continues to revolve around values such as "ordinariness", "simplicity" or "lack of pretentiousness", with the corresponding visual equivalents of these notions in the latest projects of the aforesaid architects.

While the representatives of Czech austerity used to reject any extravagance, some of them currently entertain the notion whether austerity ought to be cultivated as a specifically Czech extravagance. In an interview that addressed issues such as the implications of globalization for the Czech construction industry, Stanislav Fiala touched upon this paradox:

„I find it interesting that cheap ordinariness gradually became a luxury viewed as an excess and exhibitionism." [93]

Does that mean that in the years to come, Czech architecture will not surrender the austere traits that this books attempts to describe and interpret? It is not likely to do so, and the history of Czech austerity probably will not approach its end in the near future. I would not like to make hasty prophesies in this respect, however. The interesting, exciting and frequently traumatic feature of contemporary history is precisely in that we never know what will actually happen. I thus agree with the contention made by the Slovak theoretician and historian of architecture, Marian Zervan:

„The history of contemporary architecture is thus hard to conclude and grasp with finality. One may only keep on adding and rewriting." [94]

93 Jana Tichá, "Rozhovor se Stanislavem Fialou" (Interview with Stanislav Fiala). *Zlatý řez* No. 26, 2004, pp. 50–51.

94 Marian Zervan, *K dejinám architektúry a architektonických teórií v 20. storočí* (On the History of 20th Century Architecture and Architectural Theory). Unpublished manuscript. Bratislava 2004, p. 12.

01

Pavement in the historical center of Český Krumlov, 1989–1992

Architectural design – Hana Zachová / investor – City of Český Krumlov / contractor – Budimex / awards – *Architekt* Journal Award

Hana Zachová, Faculty of Architecture of Prague Technical University, Academy of Fine Arts in Prague / Other projects: reconstruction of outdoor space in Beroun (Husovo Square), Telč (Belpské Square, Zachariášova Street), Prague 1 (alterations of Zlatá Street, intersection of Konviktská – Průchodní Streets, Dlouhá Street and others); original public lighting (Český Krumlov); new technical facilities in the historical center of a gas regulation station (Český Krumlov); grant project of the Ministry of Culture of the Czech Republic – Exterior Historical Stone Pavements (a collective research assignment carried out in 1997–2003); reconstruction of urban greenery and parks – studies: Prague 1 – the environs of the building of Radio Free Europe, the park by the Main Railway Station; Hradec Králové – terrace gardens

02

Tower for a scientist at Košík, 1993–1994

Architectural design – Alena Šrámková / investor – Ivan Havel / contractors – Tonstav Service, České Budějovice; Zámečnictví Minařík, Kladno

Alena Šrámková *1929 Prague, Faculty of Architecture of Bratislava Technical University, Academy of Fine Arts in Prague. Worked in state planning and design institutes, has been lecturing at the Faculty of Architecture of Prague Technical University since 1991. 1992 founded her own firm, Alena Šrámková Architekt, 1999 appointed professor / Other projects: below-grade hall of Prague main railway station, 1977; office building Na Můstku in Prague 1, 1983; business center in Prague 13-Lužiny, 1983; meteorological station in Cheb, 2001; villas in Prague / Exhibitions: triennale of world architecture in Belgrade; Czech Saloon of IFA in Paris, 2002–2003; several self-promotional exhibitions: Single House Exhibition in Prague, Three houses of Alena Šrámková in Brno and Munich, profile exhibitions in 1996 in Prague, Brno, Cheb and Barcelona

03

Office building in Prague 2-Vinohrady, 1993–1994

Architectural design – Václav Alda, Petr Dvořák, Martin Němec, Jan Stempel – A.D.N.S. architekti /

investor – OMG / contractors – IPS, Brema, Nera, Jež, Snidex / awards – Building of the Year 1994

Václav Alda *1957, Faculty of Architecture of Prague Technical University, Faculty of Civil Engineering of Prague Technical University, Academy of Fine Arts in Prague. Worked in state planning and design institutes until 1991, the last one having been Stavoprojekt Liberec / Exhibition: Venice Biennale, 1985 / **Petr Dvořák** *1964, School of Architecture, Technical University Weimar. 1989 Büro Franzmair in Salzburg, 1990–1991 Büro Naumann in Regensburg and Stavoprojekt Liberec / Exhibition: St. Pölten, Austria, 1989, 1990 / **Martin Němec** *1957, Faculty of Architecture of Prague Technical University, Academy of Fine Arts in Prague. 1983–1991, Stavoprojekt Liberec / Exhibitions: Florence and Berlin, 1987; National Technical Museum in Prague, 1988 / **Jan Stempel** *1959, Faculty of Architecture of Budapest Technical University. 1984–1991 Stavoprojekt Liberec / Exhibitions: 1983–1988 five exhibitions – France, Budapest, Bratislava, Berlin, Prague. / Established A.D.N.S. architekti studio in 1991. / Other projects: Czech pavilion at EXPO 92 in Sevilla, 1992; Municipal House in Prague – reconstruction, 1997; Congress Center in Prague, building C, Prague 4, 2000; Glockner's house in Prague 4, 2000; River City Prague in Prague 8, 2003 / Joint exhibitions: Venice Biennale 1991; exhibitions in Prague in 1992, 1994; Budapest, 2000

04

Benedikt Rejt Gallery in Louny, 1993–1998

Architectural design – Emil Přikryl / investor – Ministry of Culture of the Czech Republic represented by GBR in Louny / main contractor – OSP Louny / awards – Record Interiors Award for Excellence in Design (award conferred by the *Architectural Record* journal)

Emil Přikryl *1945 Bílovec, Faculty of Architecture of Prague Technical University (1968), Academy of Fine Arts in Prague (1972). Joined the SIAL studio in Liberec in 1969, later also lectured at the Academy of Fine Arts in Prague, in 1990 appointed full professor / Other projects: museum in Most, 1975; regulation plans for Česká Lípa, 1985; project for an annex to the Old Town Hall in Prague, 1987; cultural center in Prague-Vysočany, 1989; projects for the General Consulate of the Czech Republic in Shanghai, 1995 / Exhibitions: 1992–2002 four solo and over 20 collective exhibitions, mainly abroad – e.g., Tokyo, 1988; Baustelle: Tschechische Republik, Berlin, 1997; Piranesi Award, 1998; Czech Architecture 1989–1999 through the Eyes of Critics, Prague, Pilsen, Brno, Cheb, Ostrava, Chrudim, Český Krumlov, 2000–2001; Contemporary Czech Architecture, Prague, Berlin, Munich, Delft, London, Brussels, 2000–2002; Miejsce budowy: Republika Czeska, Wroclaw, 2002; Czech Saloon of IFA in Paris, 2002–2003

05

Office building in Prague 1-Nové Město, 1993–1997

Architectural design – Frank O. Gehry, Vlado Milunič / plans – Studio VM Praha, Kappa Praha / investor – ING Real Estate / general contractor – Besix, Belgium / main contractors – Permasteelisa, Soletanche – Zakládání, Croon Elektrotechniek, Hydrostav Bratislava, Panelárna Malešice, Techo, Rheinzinc / awards – honorary mention in AIA LA 1993 Design Awards; Best Design 1996 – *Time Magazine* award; Award of Lord Mayor of Prague 2000 / **Frank Owen Gehry** *1929 Toronto, University of Southern California (1954), Harvard University´s Graduate School of Design. 1963 first practice, Frank O. Gehry and Associates. 1979 this practice was succeeded by Gehry & Krueger Inc. Member of the American Academy of Arts and Letters since 1987. Awards: Pritzker Architecture Prize, 1990, American Institute of Architects Gold Medal, 1999 / Other projects: Experience Music Project, Seattle, 2000; Gehry House, Santa Monica, 1987; Guggenheim Museum, Bilbao, 1997; Beach House, Venice, 1986; Vitra Design Museum, Weilam-Rhein, 1989; Walt Disney Concert Hall, Los Angeles, 2004 / **Vlado Milunič** *1941 Zagreb, Faculty of Architecture of Prague Technical University (1966). 1966–1969 worked in Paris, 1969–1989 Planning and Design Institute of the Capital City of Prague (cooperation with J. Línek), since 1990, Studio VM Praha / Other projects: homes for senior citizens in Prague – Bohnice, Malešice, Chodov, Háje (with J. Línek), 1982–1989; dormitory for nurses in Prague 8-Prosek, 1985; reconstruction of the U Prstenu house in Prague 1; Youth Center in Prague 12-Modřany, and several family houses / Exhibitions: Interarch, Sophia, 1986; Confrontations, Prague, 1988; Contemporary Czech Architecture, Prague, Berlin, Munich, Delft, London, Brussels, 2000–2002

06

Czechoslovak Commercial Bank in České Budějovice, 1993–1994

Architectural design – Martin Krupauer, Jiří Střítecký – Atelier 8000 / investor – ČSOB, Prague / general contractor – Vodní stavby Bohemia D1 / awards – Building of the Year 1996 – honorary mention

Martin Krupauer *1960 České Budějovice, Faculty of Civil Engineering of Prague Technical University (1983), Prague Academy of Fine Arts in Prague (1989) / **Jiří Střítecký** *1954 Třebíč, Faculty of Architecture of Brno Technical University (1980). Following their graduation, both worked in construction design organizations, joined Atelier 8000 in 1990. Joint fellowship in Paris in 1991 / Other projects: Fitness center Pouzar, 1991; State Scientific Li-

brary, 1993; Helmich department store, 1994; Roller department store, 1997 – all in České Budějovice; Czech Bar Association in Prague, 1995 / Exhibitions: 2000–2004 six joint exhibitions, e.g., Venice Biennale 1996; Contemporary Czech Architecture, Prague, Berlin, Munich, Delft, London, Brussels, 2000–2002; exhibition of Jean Nouvel's works, Paris, Tokyo, Ósaka, 2001, 2003–2004; exhibition of works of Atelier 8000, Prague, České Budějovice, 2004

07

Grammar school in Orlová-Lutyně, 1993–1996

Architectural design – Josef Kiszka, Barbara Potyszová / investor – Grammar school in Orlová / contractor – IPS Praha, závod 07 Třinec / award – Grand Prix of the Society of Architects 1996 – award for new building

Josef Kiszka *1952 Životice, Faculty of Civil Engineering of Brno Technical University (1976). Own studio, Josef Kiszka – architekt / Other projects: multi-purpose building with a hotel in Havířov, under construction; school building in Hnojník (with B. Potyszová and J. Wojtasová), 2003; home for senior citizens in Česká Ves (with B. Potyszová and J. Valert), 1999; cultural center in Frýdlant nad Ostravicí, project 2003 / Exhibitions: 1987–2000 over ten joint exhibitions at home and abroad, e.g.; Grand Prix '94 and '96, Prague, Brno, Ostrava, 1995, 1997; Piran Days of Architecture, 1998; Czech Architecture 1989–1999 through the Eyes of Critics, Prague, Pilsen, Brno, Cheb, Ostrava, Chrudim, Český Krumlov 2000–2001; Contemporary Czech Architecture, Prague, Berlin, Munich, Delfts, London, Brussels, 2000–2002 / **Barbara Potyszová** *1967 Bohumín, Faculty of Civil Engineering of Brno Technical University (1989) and Faculty of Architecture of Cracow Polytechnic (1995). Own studio, Ing. arch. Barbara Potyszová – architekt / Other projects: theatre in Český Těšín – reconstruction of a bistro and gallery (with J. Kiszka), 1998; interiors of the production hall of Remak (with J. Kiszka), 2003; villa in Životice, 2003 / Exhibitions: see Josef Kiszka

08

Town hall in Benešov, 1993–1995

Architectural design – Josef Pleskot, Radek Lampa, Vladimír Krajíc, Jana Vodičková – AP atelier / investor – City of Benešov / contractor – Kuželka – obnova staveb, Benešov / awards – Grand Prix of the Society of Architects 1995 – main award

Josef Pleskot *1952 Písek, Faculty of Architecture of Prague Technical University (1979). Worked briefly as a lecturer, then worked for ten years at the Regional Design and Planning Institute in

Prague; established his own studio, AP atelier, in 1991. Member of S.V.U. Mánes since 1995 / Other projects: Megafyt R factory in Vrané nad Vltavou – Phase 2 (with P. Lacek, R. Lampa), 1995; apartment house in Horažďovice (with R. Lampa, F. Tittelbach), 1998; BDO office building in Prague 4-Krč (with R. Lampa, F. Tittelbach), 2000; General Consulate of the Czech Republic in Munich (with J. Svobodová, P. Zvěřina – interiors), 2002; apartment houses A2, A3 U Nemocnice in Litomyšl (with R. Lampa, F. Tittelbach, P. Fanta, Z. Rudolf), 2002 / Joint exhibitions: Venice Biennale 1991, 1996; 4x Prague architecture, Ljubljana, 1994; Baustelle: Tschechische Republik, Berlin, 1997; comprehensive exhibition in Prague, 1998; Contemporary Czech Architecture, Prague, Berlin, Munich, Delft, London, Brussels, 2000–2002; Czech Saloon IFA in Paris, 2002–2003; participates regularly in annual exhibitions of S.V.U. Mánes

09

Office and laboratory building in Olomouc, 1994–1995

Architectural design – Petr Hrůša, Petr Pelčák – Architekti Hrůša & Pelčák, Ateliér Brno; cooperation – Miroslava Hanzelková, Michal Blažek – ceramic reliefs / investor – Povodí Moravy, Horní Morava branch / general contractor – Gemo Olomouc / awards – Building of the Decade in the Olomouc Region, Olomouc 1999 – Grand Prix for new building

Petr Hrůša *1955 Brno, Faculty of Architecture of Brno Technical University (1981). 1981–1990 Stavoprojekt Brno, Viktor Rudiš's studio. 1990–1992 chief architect of the city of Telč and member of the Heritage Conservation Board of the Prague Castle. In 1990, participated in the Prince of Wales' Summer School in Architecture in Oxford and Rome. Part-time lecturer at Faculty of Architecture of Brno Technical University. Member of the Obecní dům Brno and S.V.U. Mánes associations. / **Petr Pelčák** *1963 Brno, Faculty of Architecture of Brno Technical University (1986), Masaryk University in Brno (extramurral study of art history, 1986). 1986–1990 Stavoprojekt Brno, Viktor Rudiš's studio, 1990–1991 studio of Prof. Wilhelm Holzbauer in Vienna, 1995–1996, and from 2003 onwards a part-time lecturer at Faculty of Architecture of Brno Technical University. Publications in the area of theory of history and criticism of architecture since 1984, editor and co-author of various publications, since 1992 also exhibition curator. Member of DOCOMOMO and Obecní dům Brno / Publications: e.g., *Brno Jewish Architects, Litomyšl and contemporary architecture; Obecní dům Brno 1997–2002; Česká architektura / Czech Architecture 1999–2000 /* In 1992, Petr Hrůša and Petr Pelčák founded their own studio, Architekti Hrůša & Pelčák, Ateliér Brno / Other joint projects: Česká pojišťovna in Telč, lido in Litomyšl – both 1995; crypt of St. Peter and Paul Cathedral in Brno, 1996; tenement house in Slavonice, 1997; home for mentally handicapped people

in Velehrad, 2000 / Exhibitions: e.g., Contemporary Czech Architecture, Prague, Berlin, Munich, Delft, London, Brussels, 2000–2002; Czech Saloon of IFA in Paris, 2002–2003

10

Office building in Brno, 1994–1996

Architectural design – Aleš Burian, Gustav Křivinka / investor – Geodis Brno / general contractor – Unistav Brno / contractor – Brtník Sivice / awards – Grand Prix of the Society of Architects 1997 – honorary mention

Aleš Burian *1956 Brno, Faculty of Architecture of Brno Technical University (1981). 1981–1991 Stavoprojekt Brno, 1986 participated in architectural seminar La citta e il Fiume in Florence / **Gustav Křivinka** *1961 Brno, Faculty of Architecture of Brno Technical University (1986). 1986–1991 Stavoprojekt Brno, 1990 studio of Prof. A. Schweighofer in Vienna. 1991 Aleš Burian and Gustav Křivinka founded an architectural firm, Burian – Křivinka. Part-time lecturers at Faculty of Architecture of Brno Technical University. / Other joint projects: diagnostic pavilion of Masaryk Oncological Institute in Brno, 1995; Investiční a poštovní banka in Brno, 1995 (European Union Prize for Contemporary Architecture, Mies van der Rohe Award – finalist); reconstruction of areas of the historical center of Litomyšl, 1998; apartment houses in Znojmo-Přímětice, 2002; addition to dormitories of vocational schools in Litomyšl, 2003; reconstruction of a house in Prague – interiors, 2003

11

Assisted living houses in Český Krumlov-Vyšehrad, 1994–1997

Architectural design – Ladislav Lábus, Lenka Dvořáková, Zdeněk Heřman; interiors – Jitka Říhová / investor – City of Český Krumlov / main contractors – Saremo České Budějovice; Pozemní stavby České Budějovice / contractor – Eurolux České Budějovice / awards – Grand Prix of the Society of Architects 1998 – awards for new building and residential building; European Union Prize for Contemporary Architecture, Mies van der Rohe Award – nomination

Lenka Dvořáková *1968 Prague, Faculty of Architecture of Prague Technical University (1993), Theater Academy and Film Academy in Prague (1989–1990). Member of a free association of architects, Nová česká práce. Collaboration with the Lábus AA studio in 1993–1999 / Other projects: interiors of an information center in Vrchlabí (with J. Říhová), 1999 / Exhibitions: NČP, Prague, 1994; Bratislava, 1995; Berlin, 1996; Profession: [Woman] Architect, Prague, 2003 / **Zdeněk Heřman** Faculty of Architecture of Prague Technical University

(1985). Planning and Design Institute until 1989, after 1990, free-lance architect, 1992–1997 collaboration with the Lábus AA studio / Other projects: annex to a family house in Jinonice; Mušketýr restaurant and loft conversion in Prague 1; conversion of an apartment into a dependency of a rooming house in Prague 1; interiors of a family house in Znojmo; family house in Višňová – all of the above with Arch.and. D. Loskotová, 2002 and 2003 / **Ladislav Lábus** *1951 Prague, Faculty of Civil Engineering of Prague Technical University (1976). 1977–1991 Planning and Design Institute of the Capital City of Prague (collaboration with A. Šrámková). Founded his own architectural studio, Lábus AA, in 1991. Lecturer at Faculty of Architecture of Prague Technical University since 1990, member of the Academic Senate / Other projects: shopping center at Lužiny in Prague 13 (with A. Šrámková), 1991; reconstruction of an apartment house in Prague 2 (with P. Burešová), 1999; design of color schemes for thermally insulated prefabricated apartment blocks in Prague 8-Bohnice (with D. Mareš and D. Prášilová), 1999; family villa in Roudnice nad Labem (with M. Matiska and D. Prášilová), 2001; family villa at Mukařov (with J. Drahozal), 2003; reconstruction of a villa and a house in Prague 6 (both with M. Matiska and M. Novotná), 2003, 2004; reconstruction of a family house, Palička, in Prague 6 (with N. Schmidt), 2003 / Exhibitions: STL – Středotlací, Prague, Bratislava, Turnov, 1989; Czech and Slovak Neo-Functionalism, Prague, Bratislava, Budapest, 1992; Arquitectura en Capitales Europeas, Madrid, Paris, London, 1992; Czech Architecture 1945–1995, Prague, 1995; Contemporary Czech Architecture, Prague, Berlin, Munich, Delft, London, Brussels, 2000–2002; Architect Ladislav Lábus, Prague, 2004

12

Residential complex Hvězda in Prague 6-Břevnov, 1994–1999, 2000

Architectural design – Vlado Milunič / investors – Rodop (parts B, C), Areas (currently Areass, part D), Vosarea (section A) / contractors – Metrostav (parts B, C), Posista (part A), P. S. Jihlava (part D)
Vlado Milunič see 05

13

Family estate at Kostelec nad Černými lesy, 1995–1998

Architectural design – Jan Línek / contractor – Šafařík / awards – Building of the Year – Union of Entrepreneurs with the Economic Chamber, Kolín District; Old Prague Lovers' Club Award 1996–2001 – nomination
Jan Línek *1943 Prague, Faculty of Architecture of Prague Technical University (1966). 1969–1990

collaborated with Vlado Milunič, has his own architectural studio in Prague, L&P, since 1991. Member of S.V.U. Mánes / Other projects: waste water treatment plant in Kostelec nad Černými lesy (with T. Velínský), 1993; Mr. Písařík's villa, 1993; geriatric center in Týniště nad Orlicí (with J. Sezemský and V. Dubská), 1995; assisted living home in Loučná nad Desnou, 1999; home for senior citizens in Benešov, 1999

14

Villa at Vrané nad Vltavou, 1994–1995

Architectural design – Josef Pleskot, Radek Lampa, Vladimír Krajíc, Jana Vodičková, Marco Švimberský – AP atelier / investor's agent – Novota, Prague / general contractor – Ing. Sládek stavební firma, Benešov / awards – Grand Prix of the Society of Architects 1995 – honorary mention for a residential building
Josef Pleskot see 08

15

Family house and garden house-studio at Mukařov, 1995–2000

Architectural design – Ivan Kroupa; cooperation – Radka Exnerová / contractors (family house) – Ireko, Metrostav, Truhlářství Maleček, Ladislav Doležal, fa Němec / awards (garden house-studio) – ARCE – Architekturpreis, Berlin – Lobende Erwähnungen, 1998
Ivan Kroupa *1960 Kolín, Faculty of Architecture of Prague Technical University (1985). 1993 scholarship to Akademie Schloss Solitude Stuttgart / Awards: Berliner Kunstpreis 2001; Forderungspreis Baukunst 2001 / Other projects: family houses – Černošice, 1998, 2003; Vrané nad Vltavou, 2001; Chomutovice, 2003; snowboarding cottage in Herlíkovice, 2001; Printing works Jaroslav Karmášek, 2003 / Exhibitions: Kroupa – Llinas – Ungers, Oslo, 1995; Kroupa – Róna, Prague, 1995; Present and Future, Barcelona, 1996; solo exhibitions: Stuttgart 1993, Kostnice 1995, Turin 2000, Prague 1994, 2003

16

Improvements at Horní Square in Olomouc, 1995–2001

Architectural design – Petr Hájek, Jaroslav Hlásek, Jan Šépka; cooperation – Vít Máslo, Ladislav Monzer, Jana Zlámalová / investor – City of Olomouc / main contractor – Horstav Olomouc / awards – Piranesi Award – honorary mention, 2001;

Grand Prix of the Society of Architects 2002 – award for reconstruction
Petr Hájek *1970 Karlovy Vary, Faculty of Architecture of Prague Technical University (1995), Academy of Fine Arts in Prague (1998) / **Tomáš Hradečný** *1969 Prague, Faculty of Architecture of Prague Technical University (1995) / **Jan Šépka** *1969 Prague, Faculty of Architecture of Prague Technical University (1995), Academy of Fine Arts in Prague (1997). In 1998, Petr Hájek, Tomáš Hradečný and Jan Šépka founded an architectural and design firm, HŠH architekti / Other joint projects: Powder Bridge project at the Prague Castle, 1993; pavement of Jiřské Square at the Prague Castle, 2002; interiors of a family house in Prague, 1997; stairs in a loft apartment in Prague, 1998; staircase in Libeň u Prahy, 2001 / Exhibitions: participation and creative involvement in Nová česká práce 1990–1994, Prague, Bratislava, Berlin, 1994–1996; Spatial House, Liberec, Prague, Cheb, Brno, Budapest, Oslo, 1999–2003. Joint exhibitions – e.g., Praha 2000 in Prague, MEGA – Megamanifeste in Vienna, 2002; Czech Saloon of IFA in Paris, 2002–2003

17

School and sports hall in Litomyšl, 1995–1998

Architectural design – Aleš Burian, Gustav Křivinka / investor – City of Litomyšl / general contractor – 1. litomyšlská stavební / awards – Grand Prix of the Society of Architects 1999 – honorary mention
Aleš Burian, Gustav Křivinka see 10

18

State Scientific Library in Liberec, 1995–2000

Architectural design – Radim Kousal, SIAL / investor – Ministry of Culture of the Czech Republic, represented by the State Scientific Library in Liberec / main contractor – Stavební podnik Ralsko, Stráž pod Ralskem / awards – Building of the Year 2001 – *Stavitel* Journal Award
Radim Kousal *1951 Benešov near Semily, Faculty of Architecture of Prague Technical University (1976). Worked in Algeria in 1982–1986, in Jean Nouvel and Emanuel Cattani's studio in Paris in 1990–1991, partner of SIAL Liberec in 1991–2003, and partner of the architectural studio SIA architects since 2003 / Other projects: headquarters of Pragobanka Praha, 1995; District Archives in Chrudim, 1999; industrial building of Netto electronic Praha, 1999; one of the authors of Charles Square Center Prague, 2002, and the office building of Polygon House Prague, 2003

19

Sipral factory in Prague 10-Strašnice, 1995–1996

Architectural design – Stanislav Fiala – D. A. Studio; cooperation – Irena Fialová, Ondřej Beneš, Lucie Doskočilová / investor – Sipral / contractor – Vodní stavby Bohemia / awards – Award of Lord Mayor of Prague 2000

Stanislav Fiala *1962 Most, Faculty of Architecture of Prague Technical University (1985), Academy of Fine Arts in Prague (postgraduate course, 1986). 1986–1999 worked in D. A. Studio with Tomáš Prouza (*1961, Faculty of Architecture of Prague Technical University), Martin Rajniš (*1944, Faculty of Architecture of Prague Technical University) and Jaroslav Zima (*1961, Faculty of Architecture of Prague Technical University), currently works in studio D₃A with Tomáš Prouza and Jaroslav Zima / Other joint projects: Holport Café in Prague 7-Holešovice, 2000; Sipral showroom in Prague 10-Strašnice, 2002; business and administrative building Anděl City in Prague 5-Smíchov, 2002; scenography of the exhibition České sklo – art & interior, Prague, 2003; interiors of Bristol Myers Squibb in Prague 1, 2003 – all of the above with D. Polubědová / Exhibitions: 1994–2004 approximately 20 exhibitions, e.g., D.A. Studio 1986–1996, Prague 1996; Czech Architecture 1989–1999 through the Eyes of Critics, Prague and other cities in the Czech Republic, 2000; European Union Prize for Contemporary Architecture, Mies van der Rohe Award – exhibition of selected works, London, Dublin and other European cities, 2001; Contemporary Czech Architecture, Prague, Berlin, Munich, Delft, London, Brussels, 2000–2002; Works in Process – Designblok, Prague, 2001; Exhibition of Czech and Foreign Design, Prague, 2002; Salone Satellite – Design Fair in Milano, 2002; Czech Saloon of IFA in Paris, 2002–2003

20

Orangery in the Royal Garden of the Prague Castle, 1995–1998

Architectural design – Eva Jiřičná, Duncan Webster; cooperation - Mathew Wells / investor – Správa Pražského hradu / contractors – Seele CZ, Dopravní podniky Praha, Ziegler / awards – European Union Prize for Contemporary Architecture – Mies van der Rohe Award – nomination; Award of Lord Mayor of Prague, 2000

Eva Jiřičná *1939 Zlín, Faculty of Architecture of Prague Technical University (1962), Academy of Fine Arts in Prague (1963), RIBA member (1973). Currently works at EJAL – Eva Jiricna Architects Limited (London), AI-Design (Prague). In 2002 appointed professor at Academy of Arts, Design and Architecture in Prague / Awards: e.g., Royal Designer for Industry, 1991; C.B.E, for Services to

Interior Design, 1994 / Publications: *Eva Jiricna: Staircases – stair design, history + technology,* 2001 / Other projects: Marcus jewellery shop, London, 1997; De Montfort University's new library, Leicester, 1997; bus terminal Canada Water, London, 1998; pavilion Faith Zone – Millennium Dome, London, 2000; Hotel Josef, Prague, 2002 / Exhibtions: e.g., Eva Jiřičná, Prague, 1998; joint exhibition Profession: [Woman] architect, Prague, 2003

21

Rowing club in Prague 5-Smíchov, 1996–2000

Architectural design – Petr Kolář, Aleš Lapka – ADR / investor – Rodop / general contractor – O.T.A. Praha

Petr Kolář *1967 Prague, Academy of Arts, Design and Architecture in Prague (1996). 1990–1992 internship at Eva Jiricna Architects Ltd. studio in London. / **Aleš Lapka** *1970 Prague, Academy of Arts, Design and Architecture in Prague (1997). Both architects currently have their own studio, ADR / Other projects: reconstruction of the Permanent Mission of the Czech Republic in the EU, Brussels, 1999; premises of the Czech Embassy in Tashkent, 2001; reconstruction of the building of the Ministry of Foreign Affairs – O.I.R.T., Prague, 2002; golf range, Prague, 2003; residential complex Pod Kozincem, Prague, 2003 / Joint awards: Best of Realty 2003 – award; Building of the Year 2003 – nomination and award from the Association of Building Entrepreneurs of the CR; National Design Award 2002; Red Dot Award 2003

22

Golden Angel center in Prague 5-Smíchov, 1996–2000

Architectural design – Jean Nouvel; general design – Atelier 8000, Martin Krupauer, Jiří Střítecký / investor – ING Real Estate represented by ADC – Anděl Development Company / general contractor – PSJ holding / contractors – Zakládání staveb, Vodní stavby Praha, Průmstav, MAB Anlagenbau Bohemia, Metal progres, Sipral / awards – Building of the Year 2001 – *Stavitel* Journal Award

Jean Nouvel *1945 Fumel, France. École Supérieure des Beaux Arts in Bordeaux (1972). In 1975, he opened his own office. 1976 co-founder of the Mars 1976 movement of French architects and 1979 co-founder of the Syndicat de l´ Architecture. / Awards: Grand Prix National d´Architecture, 1987; the Aga Khan Award, 1989; Honorary fellow, AIA Chicago, 1993; Honorary fellow, RIBA, 1995; Commandeur dans l´Ordre des Arts et des Lettres, 1997 / Other projects: Institut du Monde Arab, Paris, 1987; Némausus residential building, Nimes, 1987; library, Nancy, 1989; factory for Cartier, Villeret, 1992; Congress Center, Tours, 1993; the Euralille

shopping centre, 1994; the Galeries Lafayette, Berlin, 1996; cultural and congress center, Luzern, 1992–1999; law-court house, Nantes, 1993–2000; Dentsu Tower, Tokyo, 1998–2002

23

Studio building of Czech Radio in Prague 2-Vinohrady, 1996–2000

Architectural design – Václav Alda, Petr Dvořák, Martin Němec, Jan Stempel, Peter Jurášek – A.D.N.S. architekti / investor – Český rozhlas / contractor – Konstruktiva Branko

Václav Alda, Petr Dvořák, Martin Němec, Jan Stempel see 03

24

Theatre Alfred ve dvoře in Prague 7-Holešovice, 1996–1997

Architectural design – Jindřich Smetana, Tomáš Kulík – Anima-tech; cooperation – Lo-tech / investor – Sdružení Alfred, Ctibor Turba / contractors – Metrostav, Kasper Trutnov, Revyko Praha / awards – Grand Prix of the Society of Architects 1998 – award for a new building; European Union Prize for Contemporary Architecture, Mies van der Rohe Award – nomination

Tomáš Kulík *1954 Prague, Faculty of Architecture of Prague Technical University. Until 1991, he focused on the design of sports facilities and complexes, mainly in cooperation with J. Louda; in 1991, they founded the Lo-tech studio. He has been working with J. Smetana since 1991 / **Jindřich Smetana** *1954 Prague, Academy of Arts, Design and Architecture in Prague (1979). Collaborated with Prof. Svoboda at the National Theatre – Laterna Magica up to 1990. Lecturer at Academy of Arts, Design and Architecture in Prague since 2001. Specialization: stage design, exhibition design, audiovisual projects, cultural-purpose facilities / Other joint projects: Atmosphére, Paris-La Villette, 1985; pavilion of the Republic of France at EXPO 88 in Brisbane, 1988; Spirála theatre, Prague, 1991; Globe theatre, Prague, 1999 / Exhibitions: Contemporary Czech Architecture, Prague, Berlin, Munich, Delft, London, Brussels, 2000–2002

25

Villa at Vonoklasy, 1996–1998

Architectural design – Ladislav Lábus, Lenka Dvořáková; cooperation – Daniel Hakl, Zdeněk Heřman, Markéta Jurečková / main contractor – Sefimota / contractors – Termostat České

Budějovice, Sinai, Pudil, Final, Jaroslav Prošek
a syn / awards – Grand Prix of the Society of Architects 1999 – award for a new building
Ladislav Lábus see 11

26

Langhans palace in Prague 1-Nové Město, 1996–2002
Architectural design – Ladislav Lábus, David Mareš, Lenka Dvořáková, Zdeněk Heřman, Pavla Burešová / investor – Zuzana Meisnerová-Wismerová & Rolf Wismer, Zurich / main contractor – Průmstav / contractors – Attl, Pracom, František Ondráček, Jofo, Prošek a syn, Thermostar / awards – Grand Prix of the Society of Architects 2003 – main award and honorary mention for the investor; Building of the Year 2002; European Union Prize for Contemporary Architecture, Mies van der Rohe Award – nomination
Ladislav Lábus, Lenka Dvořáková, Zdeněk Heřman see 11 / **Pavla Burešová** *1969 Pilsen, Faculty of Architecture of Prague Technical University (1995). 1995–1996 collaboration with J. Kosek – Atelier K3, 1997–2001 with Lábus AA, free-lance since 2001 / Other projects: villa in Prague 6 (with J. Kosek), 1997; reconstruction of a house in Pilsen, 1998; reconstruction of a house in Prague 2 (with L. Lábus), 1999; restaurant, bar and wine cellar Dominik in Pilsen, 2002; interior of an apartment in Pilsen-Roudná, 2002 / Exhibitions – collaboration with L. Lábus / **David Mareš** *1971 Olomouc, Faculty of Architecture of Brno Technical University (1997), internship at L'école d'architecture de La Villette in Paris. 1998–2002 collaboration with the architectural studio Lábus AA in Prague, 2003 cofounded the studio třiarchitekti / Other projects: reconstruction of portals of Česká spořitelna in Brno (with J. Sapák), 1995; new building of a warehouse of Global Express in Brno (with R. Antl), 1997; loft conversions in Troubsko near Brno (with K. Horáková), 1999; reconstruction and annex to a house in Prague-Braník (with O. Hofmeister), 2003; interior of Municipal Museum in Kadaň, 2003

27

Office building Kapitol in Brno, 1996–2000
Architectural design – Jindřich Škrabal, Jan Sapák, Ludvík Grym / investor – Kapitol, pojišťovací a finanční poradenství, pojišťovna Kooperativa, Brno / contractors – Zakládání Group Praha; OKM Ocelové konstrukce a mosty; Mechanika Prostějov; Lamar Trading; Hasil Ostrava; Erco Leuchten; DVD Jaroměřice / awards – Grand Prix of the Society of Architects 2000 – award for interiors; Old Prague Lovers' Club Award – nomination

Ludvík Grym *1961, Faculty of Achitecture of Brno Technical University (1985). Own practice with J. Škrabal since 1990 / **Jan Sapák** *1957, Academy of Fine Arts in Prague (1984). Own practice / **Jindřich Škrabal** *1961, Faculty of Achitecture of Brno Technical University (1985). Own practice with L. Grym since 1990 / Other joint projects: home for senior citizens in Hodonín (project by J. Škrabal and L. Grym), 1996

28

Municipal office at Šarovy, 1996–1997
Architectural design – Svatopluk Sládeček, Luděk del Maschio; cooperation – Dušan Mikulášek, Alice Šimečková / investor – Municipal Office Šarovy / contractor – K.G.Mont / sub-contractor – M-stolárna Zlín / awards – Grand Prix of the Society of Architects 1998 – honorary mention and investor award
Luděk Del Maschio *1962 Děčín, Academy of Arts, Design and Architecture in Prague (1986). V.A. studio with J. Svoboda and J. Sládek till 1995. 1996–2001 cooperation with New Work studio, since 2001, studio Overal. Specialization: interior and furniture design / Other projects: reconstruction and interiors of a family house in Šarovy; community areas of DIS in Fryšták u Zlína; reconstruction and interiors of Klub 603 in Zlín; interiors of office center Roplasto CZ in Brno; family house in Zlín-Štípa – all of the above in 2001 / **Svatopluk Sládeček** *1969, Academy of Arts, Design and Architecture in Prague. Head of New Work studio since 1995 / Other projects: family house in Zlín-Štípa, 1998; summer school center in Lipnice-Chotěboř, 1999; villa in Kroměříž-Barbořino, 2002; family house in Brno-Medlánky, 2002; institution for mentally handicapped people in Fryšták, 2002; family house in Rajhrad 2003

29

Chapel of Queen Virgin Mary at Jestřebí near Brtnice, 1996–1998
Architectural design – Ladislav Kuba / investor – municipal office Jestřebí / awards – Old Prague Lovers' Club Award 2003 – nomination
Ladislav Kuba *1964 Brno, Faculty of Architecture of Brno Technical University (1986), Academy of Fine Arts in Prague (1990). Together with Tomáš Pilař, he established the achitectural firm Kuba, Pilař architekti / Selected projects (with T. Pilař): residential colony Tichá Šárka in Prague, 2003; Faculty of Chemistry and Technology and sports facilities for Pardubice University, both 2003; shopping center at Svobody square in Brno, 2004

30

Pathway through the Deer Moat at the Prague Castle, 1996–2002
Architectural design – Josef Pleskot – AP atelier, Křístek, Trčka a spol. – statická kancelář, Čestmír Dobeš; cooperation – Jana Kantorová, Jitka Svobodová, Jiří Trčka, Zdeněk Rudolf, Isabela Grosseová / investor – Nadace Vize 97, Prague Castle Administration / contractor – Metrostav, divize 5 / awards – European Union Prize for Contemporary Architecture, Mies van der Rohe Award 2003 – finalist; Best Brick Award 2004 – first prize; Old Prague Lovers' Club Award 2002–2003 – nomination
Josef Pleskot see 08

31

Long Bridge in České Budějovice, 1996–1998
Architectural design – Roman Koucký, Tomáš Rotter – Roman Koucký architektonická kancelář; cooperation – Libor Kábrt, Martina Portyková / investor – City of České Budějovice / general contractor – VSB divize 1, České Budějovice / awards – European Convention for Constructional Steelwork Award 1999 – second prize in the category; Building of the Year 1999 – nomination and *Stavitel* journal Award; European Union Prize for Contemporary Architecture, Mies van der Rohe Award 1999 – national nomination; Bridge of the Year 1998; Grand Prix of the Society of Architects 1998 – honorary mention for a new building
Roman Koucký * 1959 Pilsen, Faculty of Architecture of Prague Technical University (1985), Academy of Fine Arts in Prague (1991). Has his own architectural and design firm, Roman Koucký architektonická kancelář. Roman Koucký and Šárka Malá are the owners and executives of the firm / Other joint projects: publishing house Labe in Ústí nad Labem, 1993; Slavonice square, 1994; own office in Prague, 1997; Marian Bridge in Ústí nad Labem, 1998

32

Town hall in České Budějovice, 1997–2000
Architectural design – Zdeněk Jiran, Michal Kohout; cooperation – Filip Ditrich, Pavel Hicz, Jiří Hladký, Markéta Lepilová / investor – City of České Budějovice / main contractor – OSP České Budějovice / awards – Presta 2000 – first Prize and Prestige Award for a Construction Project in South Bohemia in 1996–2000; Grand Prix of the Society of Architects 2001 – award for reconstruction; Old Prague Lovers' Club Award 2002 – nomination

Zdeněk Jiran *1959, Faculty of Architecture of Brno Technical University (1983). Practice at Stavoprojekt Liberec, 1989–1990 in Vienna (Prof. W. Holzbauer), in Regensburg (arch. Naumann) and Salzburg (arch. Franzmair). Worked at SIAL and its Prague branch, lectured at the Faculty of Architecture of Prague Technical University. Member of the Society of Architects and S.V.U. Mánes / **Michal Kohout** *1964, Faculty of Architecture of Prague Technical University (1988), Academy of Fine Arts in Prague (1988–1989). Several internships abroad (Chassay – London, Shepard, Epstein & Hunter – London, Torres–Sevilla), 1988–1991 collaboration with A. Šrámková at the Prague branch of Stavoprojekt Liberec (SIAL). 1990–1993 lecturer at Faculty of Architecture of Prague Technical University. 1995–1999 chief editor of the architectural journal and publishing house, *Zlatý řez*. Publications: e.g., *Prague – 20th Century Architecture; Česká architektura / Czech Architecture 2001–2002*. Since 1992, Zdeněk Jiran and Michal Kohout have been partners in an architectural firm, JBKM, and since 1995, executives of an architectural design company, Jiran Kohout Architekti. / Other joint projects: assisted living apartment house in Liberec-Ruprechtice, 1996; OCS – business-office center IPS-PRE in Prague 10-Vršovice, 1997; glass school in Železný Brod, 2000; St. Prokop community center in Prague 13-Nové Butovice, 2001; assisted living house in Úvaly, 2002; Modern gallery of the Academy of Fine Arts in Prague, Prague 7-Bubeneč, 2004 / Exhibitions: 1988–2003 over ten joint exhibitions, e.g., Contemporary Czech Architecture, Prague, Berlin, Munich, Delft, London, Brussels, 2000–2002; Ten Centuries of Architecture, Prague, 2001; Czech Saloon of IFA in Paris, 2002–2003

33

MUZO building in Prague 10-Strašnice, 1997–2000

Architectural design – Stanislav Fiala – D₃A; co-author – Daniela Polubědovová / cooperation – Martin Kloda / investor – MUZO Praha / general contractor – IPS, OZ 10; Sipral / awards – Building of the Year 2000; Award of Lord Mayor of Prague, 2000; European Union Prize for Contemporary Architecture, Mies van der Rohe Award – finalist 2001

Stanislav Fiala see 19 / **Daniela Polubědovová** *1968 Prague, Faculty of Architecture of Prague Technical University (1994). Currently works at the studio D₃A / Other projects see S. Fiala, 19

34

Metrostav headquarters in Prague 8--Libeň, 1997–2000

Architectural design – Josef Pleskot, Peter Lacko, Radek Lampa, Pavel Rydlo, Jitka Svobodová – AP atelier / investor – Metrostav, developer activities division / contractor – Metrostav, division 9 / awards – European Union Prize for Contemporary Architecture, Mies van der Rohe Award 2001 – nomination

Josef Pleskot see 08

35

Fára's house in Slavonice, 1997–1999

Architectural design – Roman Koucký, Šárka Malá, Iveta Chitovová / investor – Anna Fárová / contractor – Pepino, Slavonice; Agrostaving Dačice / awards – European Union Prize for Contemporary Architecture, Mies van der Rohe Award 2001 – national nomination; Bydlení 2000 – award; Grand Prix of the Society of Architects 2000 – award for reconstruction, investor award

Roman Koucký see 31

36

Farmstead of the Archdiocesan Museum in Olomouc, 1998–2003

Architectural design – Petr Hájek, Tomáš Hradečný, Jan Šépka – HŠH architekti; Jan Vinař, Martin Maršík – MURUS; cooperation Ondřej Hofmeister, Jan Kolář, Rastislav Komínek, Petr Trávníček, Jana Zlámalová / investor – Muzeum umění Olomouc / main contractor – IMOS Brno, SA / contractors – Institut restaurování a konzervačních technik Litomyšl, ZUKOVpro, Glass experts, MY DVA holding

Petr Hájek, Tomáš Hradečný, Jan Šépka see 16

37

Sports hall in Litomyšl, 1998–2001

Architectural design – Petr Hrůša, Petr Pelčák – Architekti Hrůša & Pelčák, Ateliér Brno; cooperation – David Mikulášek, Jan Sochor, Zdena Pavelková, Hana Ryšavá, Petr Uhrín; Petr Kvíčala – mural / investor – Sport, Litomyšl / general contractor – 1. litomyšlská stavební

Petr Hrůša, Petr Pelčák see 09

38

Library of the Faculty of Arts of Masaryk University in Brno, 1998–2001

Architectural design – Ladislav Kuba, Tomáš Pilař / investor – Masaryk University in Brno / main contractors – Imos Brno, Brest, Imos, Truhlářství Brtník, Styl 2000, Šebek Intebo / awards – Grand Prix of the Society of Architects 2002 – award, awards for new building and interiors, honorary mention for the investor; Interior of the Year 2002 – main award; UVU Award 2002; Award of the Ministry of Industry and Trade of the Czech Republic; Building of the Year 2002 – nomination; European Union Prize for Contemporary Architecture, Mies van der Rohe Award 2003 – nomination

Ladislav Kuba see 29 / **Tomáš Pilař** *1963 Brno, Faculty of Civil Engineering of Brno Technical University (1987), Hochschule für angewandte Kunst Wien (1991) and Academy of Arts, Design and Architecture in Prague (1994) / Other joint projects see L. Kuba, 29

39

Family house in Prague 9-Horní Počernice, 1998–2000, 2004

Architectural design – Markéta Cajthamlová, Lev Lauermann, Šárka Sodomková / main contractors – V.I.K.; interiors – truhlářství Čermák

Markéta Cajthamlová *1959 Prague, Faculty of Architecture of Prague Technical University (1984), Academy of Fine Arts in Prague (1986). 1989–1991 internship in Vancouver (Perkins & Cheung Architects Ltd.). Has her own architectural design firm in Prague since 1999 / Publications: *Česká architektura / Czech Architecture 2000–2001* / **Lev Lauermann** *1960–†1999, Faculty of Architecture of Prague Technical University (1985), Faculty of Arts of Charles University in Prague (art history, 1984). 1989–1991 internship in Vancouver (Perkins & Cheung Architects Ltd.) / **Šárka Sodomková** *1971 Sušice, Faculty of Architecture of Prague Technical University (1997), 1998–1999 internship (Müller Reimann Architekten Berlin) / Other joint projects: family houses in Říčany and Černošice (both M. Cajthamlová with L. Lauermann), 1999; multi-functional building in Benešov (M. Cajthamlová, with Š. Šochová), 1999; family house in Velká Chuchle (M. Cajthamlová, with Š. Sodomková), 2003; family house in Říčany (M. Cajthamlová, with Š. Šochová), 2003 / Exhibitions: Profession: [Woman] architect, Prague, 2003; Contemporary Czech Wooden House, Brno, 2003, Prague, 2004

40

Peták's sanitarium in Františkovy Lázně, 1998–2001

Architectural design – Prokop Tomášek, Boris Redčenkov, Jaroslav Wertig – Atelier 69; cooperation Miroslav Veselý / investor – Josef Peták / main contractor – Západní stavební, Cheb / awards – Grand Prix of the Society of Architects 2001 – finalist, European Union Prize for Contemporary Architecture, Mies van der Rohe Award 2003 – nomination

Boris Redčenkov *1969 Cheb, Faculty of Architecture of Prague Technical University (1994) / **Prokop Tomášek** *1969 Liberec, Faculty of Architecture of Prague Technical University (1994) / **Jaroslav Wertig** *1969 Cheb, Faculty of Architecture of Prague Technical University (1997) / Publications: *Česká architektura / Czech Architecture 2002–2003* / In 1994, B. Redčenkov and P. Tomášek established an association, Atelier 69 – Architekti, in Cheb. The studio was joined by J. Wertig in 1997. An office in Prague since 2000. In 2003, the association Atelier 69 – Architekti was transformed into A 69 – architekti / Other projects: residential complex Villa Park Strahov in Prague, 2003

41

Assisted living houses in Horažďovice, 1998–2002

Architectural design – Alena Šrámková, Tomáš Koumar, Jan Hájek / investor – town of Horažďovice / contractors – Geosan Group, Pilsen; Karel Smejkal; Řemesla AZ, Strakonice / awards – Nový domov 2003 – award

Alena Šrámková see 02

42

Euro palace in Prague 1-Nové Město, 1999–2002

Architectural design – Richard Doležal, Petr Malinský, Petr Burian, Michal Pokorný, Martin Kotík / investor – LBB Reality Praha / general contractor – Metrostav Praha / awards – European Union Prize for Contemporary Architecture, Mies van der Rohe Award 2003 – finalist; Best of Realty 2002 – award; Piranesi Award 2002 – honorary mention; Grand Prix of the Society of Achitects 2003 – award for new building; Building of the Year 2003 – Award of Lord Mayor of Prague; Old Prague Lovers' Club award 2002–2003 – nomination

Petr Burian *1970 Prague, Faculty of Architecture of Prague Technical University (1995) / Exhibitions: Spatial House, with P. Hájek, T. Hradečný, J. Šépka,

Liberec, Prague, Brno, Cheb 2000; Budapest 2002; Oslo 2003 / **Richard Doležal** *1953 Ostrava, ETH in Zurich (1980) / Exhibitions: EXPO Vienna Weltausstellung, 1991; Baustelle: Tschechische Republik, 1997; an exhibition in Berlin, 2004 / **Martin Kotík** *1943 Prague, Faculty of Architecture of Prague Technical University (1968) / Exhibitions: Atelier 7, 1984; Omicron – Martin Kotík, 1999 / **Petr Malinský** *1961 Prague, Faculty of Architecture of Prague Technical University (1985). Internship with I+B architekten in Zurich, 1992 / Exhibitions: see Richard Doležal / **Michal Pokorný** *1966 Prague, Faculty of Civil Engineering of Prague Technical University (1989) / Other joint projects: residential complex in Prague 8 (R. Doležal, P. Malinský, P. Burian, J. Holna, G. Šatrová, M. Holnová), 1998; villa in Prague 8 (P. Burian, R. Doležal, P. Malinský, M. Holnová), 1999; reconstruction of a house in Prague 1; alterations of the Old Royal Palace and the permanent exhibit, The Story of the Prague Castle, Prague (both by P. Burian, R. Doležal, P. Malinský, M. Pokorný), 2002 and 2004

43

Corso Karlín center in Prague 8-Karlín, 1999–2001

Architectural design – Ricardo Bofill, Jean Pierre Carniaux, José Maria Rocias – Ricardo Bofill Taller de Arquitectura, Barcelona; project – Jiří Koukolík, Jiří Grosz, Jiří Řezák, Miroslav Pánek – sdružení Atrea – Qarta, Praha / investor – Corso Karlín, member of Real Estate Karlín Group / main contractors – Metrostav, Sipral, EBM, KAST, Grafiet / awards – Best of Realty 2001 – award; Building of the Year 2001 – award

Ricardo Bofill *1939 Barcelona, School of Architecture in Geneva. In 1963 he founded the Taller de Arquitectura (Architectural Workshop) / Other projects: city planning – Bordeaux, Luxembourg, Rome, Warsaw etc., infrastructure – Barcelona Airport extension; cultural facilities – Valladolid Auditorium in Spain, Shepherd School of Music, Rice University Houston; large housing projects – Villes Nouvelles Paris and the construction of several residential complexes in Barcelona, Stockholm, Luxembourg and the Hague; office building projects – Paribas Marché Saint Honoré, Cartier and Christian Dior headquarters Paris, Shiseido Building in Tokyo, Dearborn Center in Chicago etc. / Awards & honorary mentions: in the period of 1963–1998 he has received 25 awards: e.g., awarded Officier de l'Ordre des Arts et des Lettres Degree, Ministry of Culture, Paris, 1984 / Exhibitions: in 1969–2001 he took part in 39 exhibitions / **Jean-Pierre Carniaux** *1951 in France, the Université de Paris (mathematics, 1972), Massachussets Institute of Technology (art and design, 1974; architecture, 1976). He has been working with the Taller de Arquitectura of Ricardo Bofill. In 1986 he also opened the Taller's New York office / Other projects: The National Theatre of Catalonia; Cartier Headquarters in Paris; a development for a district of Montpellier in Antigone,

including housing, offices and commercial areas; the new airport of Barcelona; two office buildings in Prague / **José Maria Rocias** *1953 Barcelona, Paris School of Architecture (1988). A project manager and associate coordinator at Ricardo Bofill's Taller de Architectura in Paris 1977–1982 and Casablanca, Morocco 1995–1998 / Other projects: Housing projects – Walden 73 Barcelona, Les Arcades de Lac, Paris, Marne-la-Vallé, Paris; business and office projects – Taller de Arquitectura Head Office, Barcelona, SWIFT Head Office, Brussels, GAN Building, Paris, Atrium Saldanha, Lisbon, Casablanca Twin Center, Casablanca, Karlin Palace, Prague

44

Villa houses in Prague 4-Michle, 1999–2002

Architectural design – Jan Aulík, Jakub Fišer, Veronika Müllerová – Studio A; cooperation – Building / investor – BBC viladomy (PSJ Invest) / general contractor – PSJ holding

Jan Aulík *1958, Faculty of Architecture of Prague Technical University (1983). Planning and Design Institute of the Capital City of Prague until 1990, established Studio A in 1991 / **Jakub Fišer** *1972, Faculty of Architecture of Prague Technical University (1996). At Studio A since 1995 / **Veronika Müllerová** *1975, Faculty of Architecture of Prague Technical University (2000). At Studio A since 1999 / Other joint projects: BB Centrum – Building C, 1998; BB Centrum – Building B, 1999; apartment houses in Brno-Bystrc, 2001; group of residential houses Terasy Červený vrch in Prague, Phase 1, 2001; office building Alpha in Prague 4-Michle, 2003

45

Semi-detached houses at Rudník, 1999–2000

Architectural design – Milan Rak, Iveta Raková, Libor Rydlo, Pavel Rydlo, Alexandr Skalický / investor – town of Rudník / contractor – Archteam, Náchod / awards – Grand Prix of the Society of Architects 2001 – main award, honorary mention for urbanism, investor award

Milan Rak *1967 Hronov, Faculty of Architecture of Brno Technical University (1991) / **Iveta Raková** *1965 Kroměříž, Faculty of Architecture of Brno Technical University (1990) / **Libor Rydlo** *1958 Nové Město nad Metují, Faculty of Architecture of Brno Technical University (1982). All of the above work at studio Archteam / Other joint projects: office building for Pekárny Náchod (with P. Rydlo), 1998; car saloon in Trutnov, 1999; family house in Kroměříž (with P. Rydlo and A. Skalický), 2000 / Exhibitions: Bauwelt Prize 2001 – BAU Munich / **Pavel Rydlo** *1969 Nové Město nad Metují, Faculty of Architecture of Brno Technical University, Aca-

demy of Fine Arts in Prague (1995). Works in his own studio, Atelier Pavel Rydlo / Other projects: logistic center Schrack Brno, 2002 / **Alexandr Skalický** *1958 Náchod, Faculty of Architecture of Prague Technical University (1983) / Other projects: interiors of Komerční banka in Nové Město nad Metují, 1992; discotheque Babylon in Náchod, 1993; lodging house for senior citizens in Nové Město nad Metují, 1994

46

Residential studio at Černošice, 2000–2001

Architectural design – Martin Rajniš; cooperation – Milan Hakl, Pavel Mikulenka – Studio 4DS, Václav Cigler – glass sculpture

Martin Rajniš *1944 Prague, Faculty of Civil Engineering of Prague Technical University (1969), Academy of Fine Arts in Prague (1972). Worked at Ateliér SIAL under the direction of K. Hubáček until 1979; 1986–1998 founded and managed D.A. Studio. Lectured at the Academy of Arts, Design and Architecture in Prague till 1997, at the Technical University in Liberec till 2002, appointed professor in 1994. 2004 a contracts-founder of H.R.A. Hoffman Rajniš architekti studio / Other projects: office buildings in Prague 4 and Prague 1, 1995 and 1997; glasshouses at the Prague Castle (D.A. Studio), 1998; Anděl Business Centrum in Prague 5 (A, B, C), 2001; lighting fixtures plant in Prague 9, family house with a studio in Prague 6 (both H.R.A. Hoffman Rajniš architekti), 2003 / Exhibitions: D.A. Studio 1986–1996, Prague, 1995; Contemporary Czech Wooden House, Brno, 2003, Prague, 2004

47

Family house in Prague 6-Nebušice, 2000–2001

Architectural design – Stanislav Fiala – D₃A; co-author – Daniela Polubědovová / general contractor – IPS Skanska, OZ 10 / contractors – Dřevona Lovčice, Ruininvest, Gradus, Konsepti, Vitra Koncept

Stanislav Fiala see 19 / **Daniela Polubědovová** see 33

48

Vestibule of subway station Kolbenova in Prague 9–Vysočany, 2000–2001

Architectural design – Marek Chalupa, Miroslav Holubec, Štěpán Chalupa, Kamila Venclíková – D.U.M. Architekti; Pavel Hrach – graphic design

of the facade / investor – Inženýring dopravních staveb / general contractor – Metrostav, divize 7; Metal Progres, ABB Consulting, Techfloor / awards – European Union Prize for Contemporary Architecture, Mies van der Rohe Award 2003 – nomination

Miroslav Holubec *1974 Prague, Faculty of Architecture of Prague Technical University (1998) / **Marek Chalupa** *1968 Kutná Hora, Faculty of Architecture of Prague Technical University (1992) / **Štěpán Chalupa** *1973 Prague, Faculty of Architecture of Prague Technical University (1999) / **Kamila Venclíková** *1974 Prague, Faculty of Architecture of Prague Technical University (1999). The architects worked in the D.U.M. Architekti studio / Other joint projects: wooden tower in Čimelice, 1997; roof over an exterior staircase on the terrace of the château at Orlík nad Vltavou, 1999; Czech pavilion at EXPO 2000 in Hannover, 2000; facilities for visitors to the Orlík nad Vltavou château, 2000; family house Štajner, 2000

49

Improvements of a housing estate at Komenského Square in Litomyšl, 2001–2002

Architectural design – Josef Pleskot, Pavel Fanta, Isabela Grosseová, Jiří Trčka, Veronika Škardová – AP atelier / investor – City of Litomyšl / general contractor – Východočeská stavební Olomouc / contractors – SaM Silnice a mosty Litomyšl, Grano Skuteč

Josef Pleskot see 08

50

Sporten building in Nové Město na Moravě, 2001–2002

Architectural design – Lucie Delongová, Hana Maršíková, Jitka Ressová, Helena Víšková; cooperation – Jan Pavézka (interiors) / investor – Sporten Nové Město na Moravě / main contractor – Ing. František Brychta / contractor – TR styl

Lucie Delongová *1973 Karviná, Faculty of Architecture of Brno Technical University (2000). Scholarship to L'école d'architecture de Paris La Villette in France. Worked at S.H.S. Architekti, Jiran Kohout architekti, 4DS, currently Ateliér 69 / **Hana Maršíková** *1973 Zlín, Faculty of Architecture of Brno Technical University (2000). Scholarship to L'école d'architecture de Paris La Villette in France. Practice at MaR studio of M. Matyáš and D. Urbanzcyk, at mmCité Zlín of R. Hegmon and D. Karásek and at New Work of S. Sládeček in Zlín. Lecturer at Tomáš Bata University in Zlín since 2002 / **Jitka Ressová** *1970 Zlín, Faculty of Civil Engineering (1993), Faculty of Architecture of Brno Technical University (1999). Two years at P. Pelčák and

P. Hrůša's studio after 1993, in 1997, scholarship to L'école d'architecture de Paris La Villette in France. Lecturer at Academy of Arts and Crafts in Zlín since 1999. / **Helena Víšková** *1971 Nové Město na Moravě, Faculty of Architecture of Liberec Technical University (1997). Practice at New Work in Zlín and Chief Architect's Office in Zlín. / In 2003, L. Delongová, H. Maršíková, J. Ressová and H. Víšková founded the Ellement studio / Other projects: study of a farmstead in Zádveřice (L. Delongová, H. Maršíková, J. Ressová, H. Víšková), 2002; reconstruction of a house in Uherské Hradiště (H. Maršíková, J. Ressová, H. Víšková, J. Pavézka), 2003; urbanist-architectural study of Tržiště pod Kaštany in Zlín (Ellement), 2003; conversion of a building in Zlín – interiors of a bowling hall (Ellement), 2004 / Exhibitions: Profession: [Woman] architect, Prague, 2003

Czech Architecture and its Austerity
Fifty Buildings 1989–2004

Author Rostislav Švácha

Consultants Matúš Dulla, Pavel Halík,
Martin Strakoš, Pavel Zatloukal

Translation Veronika Hanušová

Language consultation Albert Friess

Text-editing Dagmar Vernerová

Bibliography the author and architects' archives

Facts and figures Hana Sobotková on the basis
of architects' archives

Photographs Štěpán Bartoš – s. 24,
Lubomír Fuxa – 02, 25, 26, Ester Havlová –
12, 16, 31, 32, 33, 35, 36, 39, 44, 45,
František Illek – s. 14, 16, Aleš Jungmann –
06, 18, 11, Gabriela Kontra – 26, Iveta Kopicová –
21, 23, Jan Malý – s. 10, 11, 14, 17, 18, 19 / 04,
08, 11, 14, 25, 26, 30, 34, 49, Marek Novotný –
40, Alexandr Paul – s. 16, Tomáš Rasl – 25,
Libor Stavjaník – 28, Václav Šedý – 27, Filip Šlapal –
19, 22, 24, 29, 33, 37, 38, 40, 41, 42, 43, 47, 48,
Pavel Štecha – s. 16 / 02, 03, 05, 07, 09, 10, 13,
17, 19, 20, 21, 24, 46, Michal Tůma – 01, Jiří Víšek –
50, Pavel Vopálka – 17, 37, Archives of Jan Štenc –
s. 8, 9, 12, archives of Regional gallery in Zlín – s. 15
and architects', author's and publisher's archives

Drawings the architects concerned

Graphic layout Mikuláš Macháček (Studio Najbrt)

Type-setting Bohumil Vašák (Studio Najbrt)

Litography Pavel Lorenc

Technical collaboration Daniel Chocholatý

Printing AF BKK Praha (Jiří Kylar, Jaroslav Šlezar)

Binding Ueberreuter Print Pohořelice

Publisher Prostor – architektura, interiér, design
CZ Nábřežní 87/2, 150 21 Praha 5 - Smíchov
www.prostor-ad.cz
1st edition